THE PHOTOGRAPHIC ART OF

HOYNINGEN-HUENE

William A. Ewing

Foreword by George Cukor

With 225 illustrations
11 in colour

Thames and Hudson

Frontispiece: Ernor Carise, 1930

© 1986 Thames and Hudson Ltd, London
Illustrations by George Hoyningen-Huene are protected by copyright
as noted on page 239

First paperback edition 1998

British Library Cataloguing-in-Publication Data
A catalogue record for this book is available from the British Library
ISBN 0-500-28035-5

Printed and bound in Hong Kong by Dai Nippon

THE PHOTOGRAPHIC ART OF

HOYNINGEN-HUENE

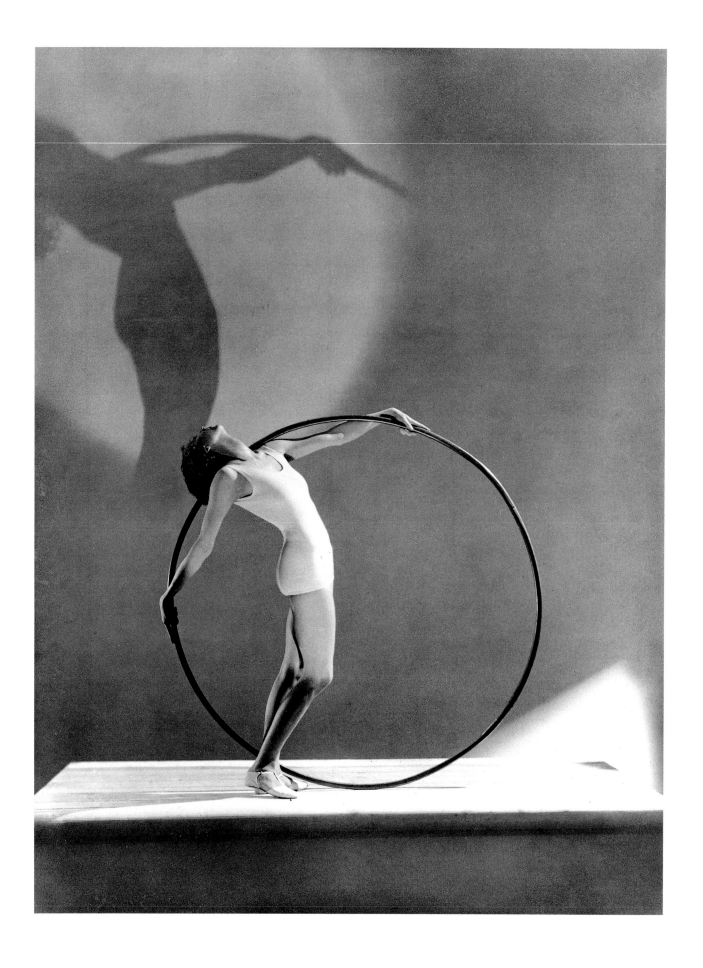

CONTENTS

FOREWORD

George Huene and I were fast friends from the moment we set eyes upon each other. I don't recall where we met. It may have been here in Los Angeles, or New York, or even Paris. It really doesn't matter, because he comes to mind wherever I go. He was a delightful travel companion, and I have a wealth of rich memories – of places, people encountered, or arguments about art, about film, about color, about this or that. George knew a great deal about a lot of things – although he certainly wasn't above a little creative editing! He owed a lot to his upbringing, certainly, but his mind was constantly challenging accepted conventions and simple solutions. George was vigorous, both mentally and physically. Of course he could be awfully temperamental and highhanded too, but somehow we let him get away with it. Even in those moments he was entertaining, and his arguments were penetrating and resourceful.

He was in my house many, many times, and his personality is stamped on the place. His own tastes were quite simple, rather surprising in view of his background, one would suppose. But he had not an ounce of snobbery or pretension in him! He hated the fickleness of the fashion world, and those society women drove him around the bend! Of course, he had the greatest respect for the creative women of the day – Edna Chase, Carmel Snow, and Diana Vreeland, and although I am sure they fought him tooth and nail half the time, I am also sure they felt the same respect for him. In many ways they were alike – no-nonsense people.

After World War II, George realized that the time of true elegance was over, and he gave up the fashion world. I was delighted to have him come to Southern California. I had been asking him to come for years, but he had always been too busy. Now suddenly he was here. I know that he had tried his hand at documentary filmmaking, but experience taught him that there wasn't any viable means of earning a living at it, so he was quite ready to turn to feature films.

He was indispensable to me. We worked for eighteen years together, on and off, and I would listen to every suggestion he made. Whether or not I would integrate them into my conception of the film was open to question, but listen I did! He was never stubborn about it, although he would do his best to make a convincing case. It was an ideal situation for me as director. He was a true professional, although he made his own independent career here. He would offer thoughts on costume, color coordination, sets, and so on. He was very quick to see when something didn't work and would rush to change it. He was a great friend of one of my closest associates, Gene Allen, the art director, and they would conspire together to produce wonderful effects.

George had the greatest respect for great talents, and struck up the closest of relationships with Hepburn and Garbo. He once recounted an amusing story about Garbo. They met in New England at a house party, and she wouldn't give him the time of day! The next morning, there she was at his window, at dawn. "Come on out for a walk," she offered, and off they went through the woods. After that, they always kept

Huene by Arnold Genthe, c. 1940

in touch. Kate felt a similar attraction to George, and she gave a very moving tribute to him at his funeral.

I can see him in my mind's eye now, sitting here looking at his own book quite dispassionately. He would be very critical and yet supportive. He could be very funny, too, and he knew when not to take things seriously. George was a complex man, and yet so direct and simple. I must say, I miss him tremendously, and I welcome the publication of his best photographs.

GEORGE CUKOR
11 August 1982

Huene at home, Paris, *c.* 1929

INTRODUCTION AND ACKNOWLEDGMENTS

From 1926 to 1945 George Hoyningen-Huene photographed extensively, both as a means of livelihood and for his own pleasure. In doing so he earned the profound admiration of his illustrious colleagues, including Edward Steichen, Man Ray, Cecil Beaton, Louise Dahl-Wolfe, and Diana Vreeland; of his successors, among them Horst, Irving Penn, and Richard Avedon; and of a wider public that grew to treasure his cool refined images which appeared bountifully in the pages of the finest fashion and photography magazines. But if, today, it is only his fashion work which springs to mind, we shackle our appreciation. His achievement, I hope to demonstrate, is far more significant. His portraits and documentary studies are equally worthy of our admiration, and in fact it is the totality of his oeuvre which holds the greatest significance.

Huene took – more accurately, made – many thousands of photographs in those twenty years. Many found their way onto the pages of the magazines, and a good number of others were published in his five books. Yet despite this wide and regular public exposure, a surprisingly large number of pictures have never been seen. And many of his well-known photographs have never been seen properly. How can this be so?

For his fashion and portrait assignments, Huene would usually take several images. One would be chosen for publication and the others discarded. They would not necessarily be rejected because they were inferior, but because they did not fit the needs of the layout as well. Or possibly because they did not show off the dresses, or accessories, to equal advantage.

Once selected, all kinds of liberties would be taken by the editors, art directors, and re-touchers. The photograph might be drastically reduced in size, tilted dramatically, hand-colored, reversed (flopped), and severely (often savagely) cropped. In the most extreme example, the graphic designer Alexey Brodovitch ripped unevenly a Huene photograph on all four sides so that it appeared as a discarded fragment. It is hardly an exaggeration to say that, on occasion, the original photograph is so transformed as to be unrecognizable in print. Add to these barbarities bold overlays of graphic elements and text, and the photographer's despair becomes understandable. Only on one or two occasions have I respected these editorial considerations, as when Huene was careless about framing in the knowledge that the editor would "clean up" rough edges. The pyramidal frames of plates 61 and 62 are two such examples. But in every case I have turned to Huene's original prints (almost no negatives survive), whether published or unpublished. Here are his images as he conceived them.

Huene was not as adept with color as some of his rivals, most notably Louise Dahl-Wolfe and Anton Bruehl, although there were a certain number of fine works produced (some of the best examples are included in this book). His work as color coordinator in Hollywood has confused the picture, and people have projected his cinematic accomplishments onto his photographic oeuvre, but this is misleading.

The plates are exhibited thematically and graphically rather than chronologically, because I believe that this best illuminates Huene's originality and style. Huene came to photography with a mature vision, his art training complete, and not on the first rung of the career ladder. Even his early work demonstrates mastery, and his very best work was achieved fairly early on. Every book has its bias, and I freely admit mine. Although the representation of images covers his work in all areas of still photography, the selection is skewed in favor of the *Vogue* years of the late Twenties and early Thirties. I believe this to be the period of his finest work, which reached its zenith between 1932 and 1934. His later work for *Harper's Bazaar* was (with notable exceptions, I must stress) of a lesser order. In this sense, my book presents the quintessential Huene.

Sixty years have passed since Huene embarked on his extraordinary career. Although he achieved a measure of fame in his own day, many years were to pass before his work would be given the focused attention it deserved. The occasion was the exhibition "Eye for Elegance," which opened in New York at the International Center of Photography in 1980 and travelled to London, Paris, and Los Angeles, the cities where he lived and worked. The one hundred and fifty or so original prints shown in the exhibition provided the groundwork for this book, with the addition of numerous outstanding images unavailable or unknown to me then.

I owe a debt of gratitude to the International Center of Photography for allowing me the resources and time to pursue the project over a period of five years. I particularly wish to thank Cornell Capa, Executive Director of the Center, who in spite of his great passion for the documentary tradition had the foresight to recognize a great achievement in another genre; Ann Doherty, Ron Cayen, Steve Rooney, Ruth Silverman, Harriet Wood, and Anna Winand offered invaluable help.

An exceptional contribution was made by Huene's lifelong friend and colleague Horst P. Horst, who participated in every phase of the project and lent generously from his private collection. Both Horst and his biographer, Valentine Lawford, read the text for accuracy, and I am grateful to them. I also wish to thank Mr Horst's studio manager, Richard Tardiff, for his assistance and in particular for his cooperation and help in arranging for the production of copy prints. Dr Oreste Pucciani is also due special thanks for help on the text, access to Huene's memoirs, and much of the chronology. Ian Jeffrey and David Mellor were most helpful with advice on the text.

Many individuals contributed to the success of the project. I wish to thank: Gene Allen; Richard Avedon; Mrs Boecler-Mathews; Irene Burns; Henri Cartier-Bresson; Cynthia Cathcart; Diana Edkins; Jacques Faure; Otto Fenn; Lisa Fonssagrives-Penn; Marvin Gasoi; Rudi Gernreich; Liz Gibbons-Hanson; Ruth Gilbert; F.C. Gundlach; Yvonne Halsman; Katharine Hepburn; Baroness von Hoyningen-Huene; Scott Hyde; Robert Kaufmann; Alan Klotz; Toto Koopman; François Meyer; Dominique Nabokoff; Catherine Negroponte; Jacqueline Onassis; Irving Penn; Antony Penrose; William Rayner; Ursula Retzki; Adrianna Skaab; Holly and Horace Solomon; Dianne Spoto; Ethaline Staley; John C. Waddell; Robert Walker; and Taki Weiss. I also owe thanks to the following institutions: The University of Southern California, Los Angeles; The University of California, Los Angeles; J.J. Augustin, Publisher, New York; Staley-Wise Gallery, New York; George Eastman House, Rochester, New York; The National Endowment for the Arts, Washington, D.C.; The J. Paul Getty Museum, Los Angeles; The Museum of Modern Art, New York; and Photocollect Gallery, New York. Lastly, I wish to thank Sal Lopes, who made superb copy prints from the originals (many of which had deteriorated) with an eye to the finest reproduction possible.

Arrangement by Constance Spry, 1934

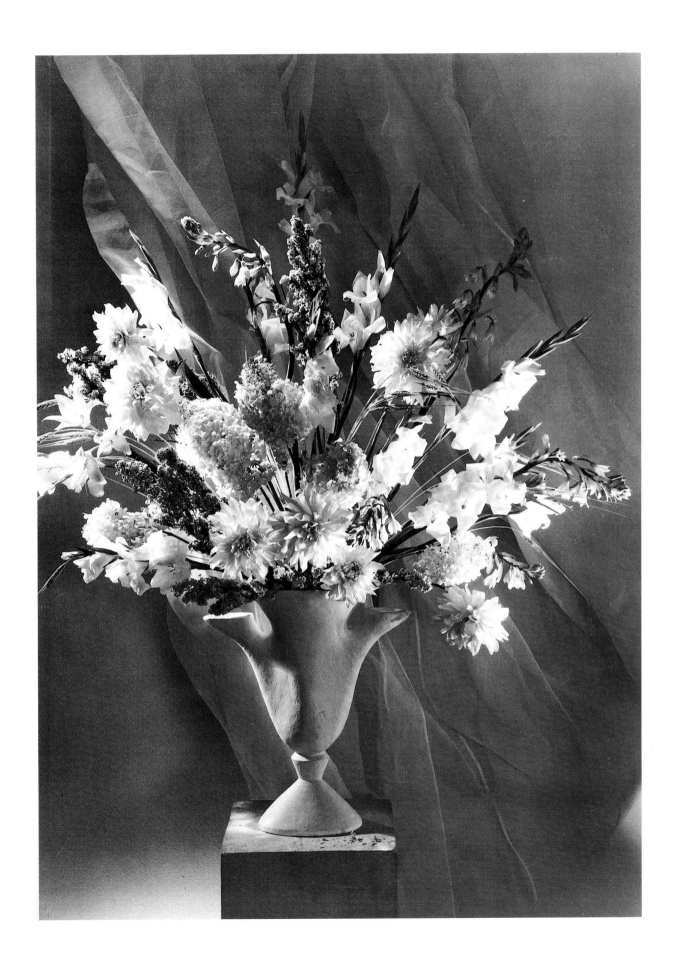

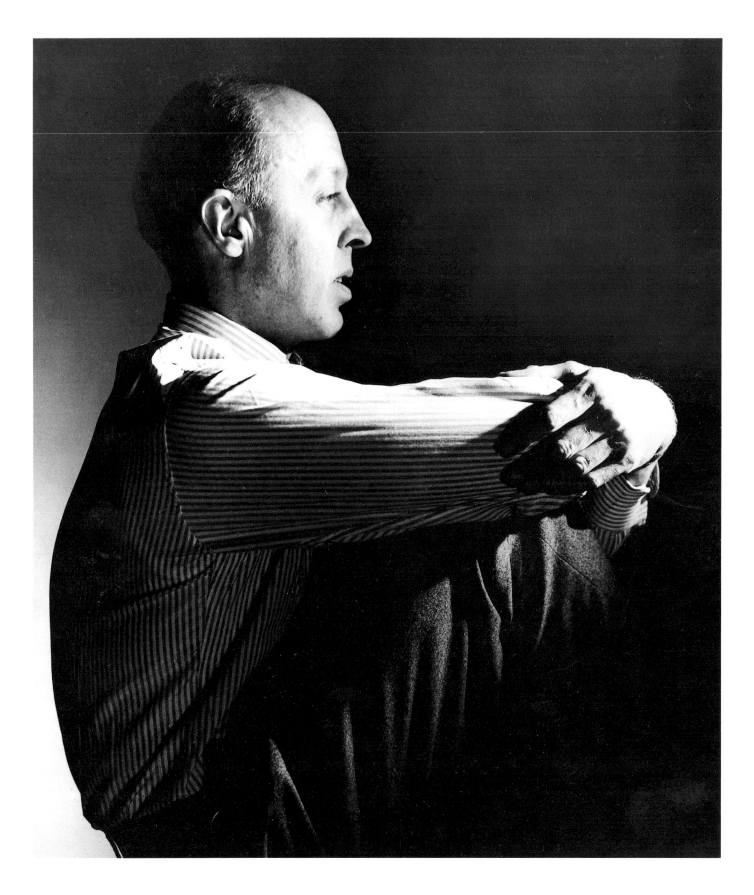

Huene by Horst. Undated

Chapter One

A GENTLEMAN'S EDUCATION

George Hoyningen-Huene was born in St Petersburg on 4 September 1900, the son of a Baltic nobleman who proudly traced his Rhineland ancestors to the time of the Crusades, and an American mother from Grosse Pointe, Michigan, whose father had been the United States Minister Plenipotentiary and Envoy Extraordinary to the court of Tsar Alexander III (a position decidedly below ambassadorial rank, despite its grandiose title, but still the highest-ranking American official in the land). The proud parents marked the occasion with a visit to one of the city's leading photographic studios, where "Georgy" was depicted in a delivery basket, perhaps of the kind borne by a hot-air balloon. But almost simultaneously with the happy event at W. Clasen, Lenin was putting the finishing touches to the first issue of *Iskra* ("The Spark"), which heralded a birth of a different kind. "Out of this spark," read the Decembrist slogan, "will come the conflagration." Even before the end of his childhood, Huene* would learn the bitter truth of this prophecy. But in the elegant confines of the portrait studio, as a new century dawned, a happy mother looked forward to raising a fine gentleman.

Huene's mother, Anne Van Ness Lothrop, had already made quite a stir in St Petersburg society before her marriage, judging from a report in the St Petersburg *Novosti*:

At the third ball, or rather *soirée-dansante* given yesterday, the 30th December, at the hospitable house of the American minister, all the *haut-ton* of St Petersburg was assembled. By eleven o'clock the magnificent salons and halls, decorated with rare Gobelin tapestries, were already crowded with fashionable society and the diplomatic corps ...

Elegance reigned everywhere and the hospitality of the host could be seen at every step. Supper was served in the dining room of the first floor. Card tables were laid out in the adjoining room, the minister's library. The majority of the guests, including the diplomatic corps, seemed to prefer remaining in the grand salon on the *bel-étage*, while the young people formed a group in the ball-room ... In the salon the guests were met by Miss Lothrop, the elder daughter of the minister. The young hostess was dressed in a charming toilette of sea-water color, which showed itself through the light tulle trimming.[1]

In her mother's letters, Anne is always off to a ball, sightseeing, or excited about a sporting event, "battledore and shuttlecock in hand."[2] Anne probably met her husband-to-be, Baron Barthold von Hoyningen-Huene, during an equestrian event such as the glittering affair described by her mother in this letter home:

They have every year a Carousel, in which twelve or fourteen ladies and gentlemen ride. The *manège* was beautifully decorated with helmets, cuirasses, flags ... When everyone had assembled and the imperial family had arrived, the doors at the opposite end leading to the stables were opened and in came two trumpeters on white horses. The horses of the regiment itself are bay and very handsome. Then four officers appeared in beautiful scarlet and silver uniforms, wearing brass helmets with great eagles on top. Then came the riders, the ladies of course in habits and silk hats, the officers in white and silver with saddle cloths of scarlet ... The

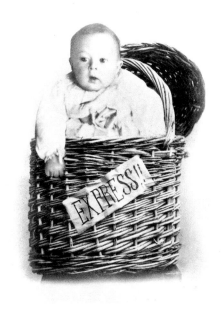

"Georgy von Huene," 1900. W. Clasen Studio, St Petersburg

* As an adult, Huene preferred the shortened form of his surname, and I have therefore chosen to use it throughout this book. However, his photographs were usually captioned "Hoyningen-Huene." (Condé Nast Inc. always added an acute accent, in conformity with French pronunciation, although the second "e" in "Huene" is strictly not the French "é" sound, but the German "eh.")

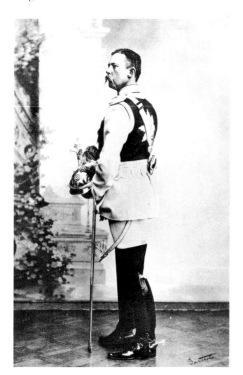

Huene's father, Baron Barthold Theodor von Hoyningen-Huene, 1896. Unknown studio photographer, St Petersburg

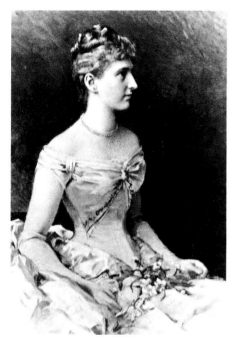

Huene's mother, Anne Van Ness Lothrop, painted by Gari Melchers, Paris, *c.* 1890

band played a polonaise, which was performed by the riders. They danced quadrilles and all sorts of dances that were very graceful and pretty. The evolutions lasted for nearly two hours; thereafter we had tea and refreshments ... Shall I be weak enough to tell you that some of the officers and many other people said that Anne rode best of all the ladies?[3]

Even as a young girl Anne was a favorite. She once told her son of an incident at a ball during the reign of Alexander III in which the daughters of the diplomatic corps were formally lined up to await the Tsar's entrance. As he entered and Anne went into her curtsey, she was given a push by a mischievous Greek girl. She suddenly found herself sprawled at the Tsar's feet, but jumping up quickly, she met his shocked gaze with a burst of laughter. Apparently charmed by this unexpected departure from protocol, the Tsar's surprise gave way to amusement. The two remained on warm terms thereafter. Anne's nonconformist spirit did not subside with maturity. On the famous Bloody Sunday of 1905, when Nicholas II's troops were cutting down the demonstrators in front of the Winter Palace, we find her driving through the streets of St Petersburg in one of her husband's *droshkies*. She had heard that there was a revolution on and she wanted to see what it was all about.

For her three children – George, Helen, and Betty – life was fanciful and rich. In his memoirs Huene recalls the magic of these early years:

The three most wonderful things I saw in my childhood were the sea, when my mother took me to Cannes ... a railway engine arriving at the station; and a Christmas tree lit up with real candles as the drawing room doors were opened and I was allowed to stand in front of this bewildering and beautiful sight my mother had prepared for me with loving care.[4]

With the passing of the years, however, the boy saw less of his mother, who was increasingly preoccupied with the social calendar of her two daughters, both of whom were older than George. He had never been close to his father, who as Chief Equerry to the Tsar was constantly busy with the imperial family's equestrian activities, which extended even to responsibility for an equestrian museum. In these matters, the Baron's authority was absolute, and he played the role of imperious overlord to some twelve hundred men. Arrogant in the extreme, he considered most society to be beneath him. The whole house of Hohenzollern, among others, he considered upstarts. Even Kaiser Wilhelm, his personal friend, was not spared this evaluation. Unfortunately, he extended this high-handed treatment to his son. Apart from injustices and minor cruelties (he once poisoned George's pet dog to teach the boy a lesson), he was rarely at home. "I seldom saw my father," Huene wrote. "He was usually on his estate or travelling and buying horses for the Emperor."[5]

Love and affection were foreign to his father's nature. The Baron expected the boy's governess to fulfil those needs. But while Huene found solace and consideration from this kindly woman, nothing could dull the pain of his parents' remoteness. "My mother devoted her entire existence to the girls' social life," he explained, and he remembered seeing her only "on rare occasions." Such occasions were the evenings of important balls, when his sisters were allowed to show off their pretty clothes to their admiring brother: "Before they would go off to a ball they would always come up and say goodnight to me. I was always amazed by the beautiful dresses they wore and the slight smell of eau-de-Cologne and powder."[6]

The task of chaperoning her daughters in endless rounds of at-homes, *soirées*, parties, and balls did not, however, distract Huene's mother from supervising her son's social life; after all, there were future marriages to be considered. "Sunday chores," recalled Huene painfully, "meant getting all dressed up in sailor suits with knickers and black stockings and pumps and going to some house or palace and being

put through the routine of minuets, gavottes, waltzes, mazurkas, and the contradance."[7]

The family often vacationed in the south of France and the Italian lake district. Regular trips to Paris were arranged to buy clothes and there were visits to Berlin for the dentist. Most summers were spent at Nawwast, the family estate in Estonia. The roomy, brightly painted residence, with its extensive facilities, including a village for the servants, bakery, sawmill, sauna, smithy, silos and barns, and sheds for American agricultural equipment, was a child's paradise. There were formal and informal parks and immaculately tended lawns for tennis and croquet and, in the stables, superb horses discarded by the Tsar for infinitesimal flaws. The estate also boasted a grand collection of carriages from Russia, England, France, and America. A genre painter, charged with rendering scenes of domestic bliss, accompanied the family to Nawwast on occasion. Perhaps in order to bring the landscape up to the standards of a good painter, the Baron imported fir trees from Canada. On one fondly remembered birthday Huene was presented with a wigwam, tomahawk, and moccasins.

Every summer Huene's mother organized a party for the peasant children:

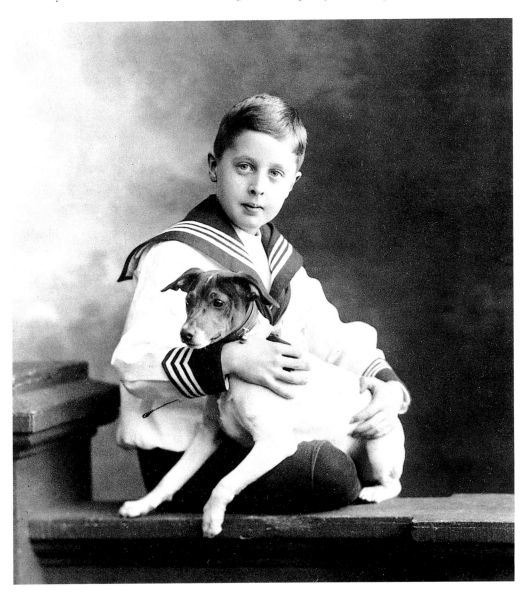

Huene in 1905. Boissonas et Eggler Studio, St Petersburg

This took place on a lawn outside the house. There was a small band of concertinas and the barn was decorated with flags and streamers. The youngsters would perform various feats as they competed in races and various games, and the winners would get prizes. After the merrymaking we all sat down to tea, cakes, soft drinks and candy. Then we would fly balloons made of multicolored tissue paper mounted on a ring of wire with a ball of cotton soaked in paraffin and ignited. Some of the balloons would soar up and tip and burst into flame, but many would go straight up and vanish in the sky.[8]

Huene tells us that both his parents were concerned for the peasants in their charge. The Baron was particularly proud of the model farm houses he had built for them on the estate. These houses, together with other projects which improved both the lot of the peasants and the working of the estate, such as the digging of irrigation canals, consumed his energies at Nawwast.

In his later years Huene never spoke as kindly of life in St Petersburg. He could never forget the bitter cold which enveloped the city during the long winters, nor the short days with their endless gray skies. Yet his reminiscences of city life were ambivalent. For one thing the family lived in apartments close by the Winter Palace, where the children had a ringside view of the pomp and pageantry of the court. Life on the River Neva was an unceasing panorama of memorable natural and ceremonial events. Not to be missed in early January was the Blessing of the Waters (the Fête of Three Kings), the laying of tracks on the ice, and the first tram across. In the spring he watched the tracks taken up at the first hint of thaw, followed soon after by the thunderous sound of the ice cracking open. Then, in rites as ancient as the city itself, the Tsar and his retinue made their way to the river bank for the ceremonial reopening of the river to navigation.

Huene has left us with an account of other aspects of life which impressed him as a boy. He could always picture the delicate ladies of the court as they stepped lightly from their gilded carriages in front of Fabergé and other elegant shops on the Nevski Prospekt and he never ceased to be amazed by the mountains of exotic fish, venison, and caviar on the tables of the rich, and the exquisite flowers imported daily from the French Riviera. And while he hated the bleak winter months, he never tired of the glorious "white nights" and midnight sun of the brief northern summer. Perhaps Huene's mixed feelings about St Petersburg were in part a reflection of his deteriorating relations with his father. "Now I seldom saw my father," he explained years later. "Eventually the failure of my attempts to win his attention turned into fear, then open defiance, and finally hatred."[9]

And so a portrait sketch of Huene begins to emerge: of a sensitive, affectionate, and dutiful child, eager to prove his worthiness to his parents but saddened by his mother's preoccupation and deeply wounded by his father's indifference. He is somewhat in awe of his fanciful surroundings, yet appreciative of his family's station in life. In a photograph from this period Huene appears in a sailor suit of the type much favored by Edwardian boys. He is already physically striking, if not conventionally handsome, with heavy Bourbon features, and one might easily surmise that the casual elegance which was later to be such a distinguishing characteristic of his personality was already second nature.

Schooling was another matter. He particularly detested the tedium of the academic curriculum. "I was a visual person,"[10] he explains, "I was very backwards in school."[11] But although his formal education – first at an austere Lutheran school and then at the Imperial Lyceum, a semi-military academy with harsh discipline (renowned for Pushkin having studied there) – was not to his liking, Huene was grateful for the personal instruction and guidance he received from relatives and

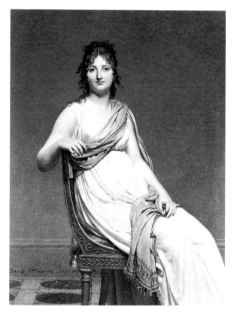

Huene's early lessons in art appreciation led to a wide knowledge of painting that he later put to use in his fashion photography: compare, for instance, the spare style of Mlle Diplarakou, evening wear by Vionnet, 1932 (*opposite*) with David's portrait of Madame de Verninac (1799)

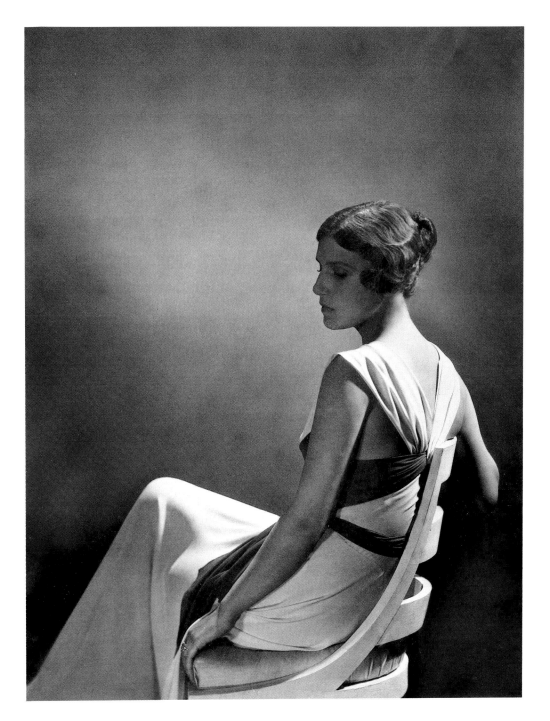

friends of the family. He was particularly fond of his Aunt Anna, who often travelled with the family, and of his Uncle Oscar, who brought books, exotic maps, and magic-lantern shows to the family estate. Especially treasured as a family friend was Baron Foelkersam, a curator at the Hermitage,[12] who introduced the boy to the work of Fragonard, Raphael, Houdon, and Leonardo.

One pictures the boy strolling through the great galleries at the side of his mentor. He is learning about pictures from a connoisseur, and as they approach each masterpiece, the Baron points out its unique attributes and place within the grand scheme of art history. Of particular importance are the classical ideals – balance, harmony, nobility, and restraint. Little wonder that Huene would later enjoy making

references to the great masters in his photography and film work. (Note, for instance, the reference to David's *Madame de Verninac* in Huene's *Mlle Diplarakou, evening wear by Vionnet, 1932.*)

"But as a youngster whose taste was not yet formed," Huene reminisced, "my favorite museum was the Alexander III (now the Russian Museum). The paintings there were of the nineteenth-century academic period, full of reconstructions and conversation pieces!"[13] Here a boy's imagination could run wild, unfettered by subdued classical ideals. Here, wrote the Russian poet Alexander Sumarokov, "the paintings offered enlightenment, the power of being infected by glorious deeds." On the museum walls were masterpieces by Feodor Rokotov, Feodor Bruni, Ilya Repin, and Vasili Surikov, and the famous collection of Russian icons. Many great works of art were not in museums, but in the palaces of the family's noble friends and acquaintances. Repin's famous *Barge Haulers on the Volga* (1870–72), for instance, a panorama of heroic rural folk, was not displayed publicly until 1917. But Huene would have had the opportunity of seeing it in the palace billiard room of Grand Duke Vladimir Alexandrovich.

Painting was central, but it was by no means the only form of art to which the boy was exposed from an early age. For his introduction to ballet, which he grew to love, he saw Karsavina and Nijinsky in *The Sleeping Beauty*; his first opera was *Eugene Onegin*. Meanwhile he studied acrobatics, secretly determined to become a professional when grown up. He read avidly, eagerly awaiting the books and magazines which were delivered regularly to the house: *Punch*, *The Illustrated London News*, *Vogue*, *Vanity Fair*, *Harper's Weekly*, and *Elegante Welt*. He prized Jules Verne and the Brothers Grimm. Two especially favored books were *Uncle Tom's Cabin* and *Tom Sawyer*.[14]

As his education progressed, Huene was increasingly steeped in Greek and Roman history, and as his knowledge of the classical world expanded, so did his enthusiasm for it. His lessons in antiquity were not restricted to the museums and palaces of St Petersburg. The family travelled frequently to Italy and, "while my sisters were riding to the hounds with Italian officers," recalled Huene, "my Aunt Anna and I were travelling in pursuit of archeological sites."[15] It was in Rome that he first discovered the work of Michelangelo, an enthralling experience that prompted him to enroll in art school on his return to St Petersburg. Here the students were given plaster casts of architectural detail such as Corinthian capitals which they had to render first in line and then with intricate shading and painstaking academic realism. If these exercises proved tedious to the young man, in later years he would have no cause for regret: as we shall shortly see, they would provide firm foundation for a career in studio photography.

As his sisters neared the age of betrothal, their mother had less time than ever for her adolescent son, and tutors were charged with the responsibility for his education. It was through these tutors – young men themselves – that the boy received his first exposure to radical social thought. In view of his class, its refinements and privileges, and his own sheltered upbringing, one might have expected Huene to have suffered a shock when confronted with such inflammatory ideas. On the contrary, he appears to have accepted them. One suspects that they were a welcome substitute for the rigid world-view of his father's caste; more to the point, they were a weapon with which to counter the domineering figure of the man himself. "These tutors opened my eyes," explained Huene. "It was a secret world which the young socialist students and I shared, and a secret world which I treasured because of the faith and confidence they inspired in me."[16]

How astonishing to find such disruptive ideas in the bosom of the nobility. "One is astounded," writes Nabokov, "to find what violent ideas these men were able to express in a country ruled by an absolute monarch."[17] Incredibly, it appears that no one took the threat very seriously; those with everything to lose couldn't in their wildest dreams conceive of the disadvantaged organizing themselves sufficiently to take power. But to the more open-minded young, it was not all idle talk. Huene's earnest tutors had little difficulty convincing him of the progressive nature of scientific thinking and the absolute need for the replacement of an antiquated social system. With his own eyes he could see the structure disintegrating, and he judged his own class powerless to stop it. Moreover, he found his tutors to be sensitive, passionate young men who were willing to become his friends. Here was an opportune means of distancing himself still further from his father, in whom he now despaired of finding even a modicum of affection: "This craving for affection created a vacuum which I sought to fill with love from other sources," he states obliquely.[18]

One such source was a tutor called Ivan Ivanovich Losev. He was, in his student's eyes, "a saintly man." His gentle ways and erudition were profoundly appreciated by Huene who admitted: "I loved the man more than any human being." When the relationship came to an end Huene suffered a great emotional crisis accompanied by physical illness.

In 1914 Huene's world truly began to disintegrate. War had broken out, and the Baron sent his wife and children off to Yalta on the Black Sea, where he believed they would be out of harm's way.[19] Huene has not told us much of this period. We know that the family purchased a house and he was sent to the local Gymnasium, although his father elected to remain in St Petersburg. Perhaps momentous events overshadowed the quotidian. In 1916 news of the murder of Rasputin by the Yussupovs ("friends of ours") reached the family; it was cause for celebration.[20] For once father and son could agree on the rightness of radical action; however, George hoped that Rasputin's demise was a step towards reform, whereas the Baron believed that with the exorcism of his evil influence, which had oppressed the court and misguided affairs of state, the great Russian bear could come to its senses and throw off the German invader. Later there was also some common ground for satisfaction over the abdication of the Tsar. For Huene's father, it was not the actual overthrow of autocracy which was a cause for joy; now the humiliating tide of military defeats might be reversed, with competent supreme command. Much more than is commonly realized today, much Russian revolutionary sentiment had its roots in such patriotism.[21]

Disillusionment was quick to set in. It came in the form of a humiliating house-search by Red sailors from the naval base at Sevastopol. The family typewriter, discovered under a bed where it was customarily stored, was taken to be a secret radio transmitter of devilish ingenuity. The danger was compounded by the fact that Huene's mother had been seen visiting the Dowager Empress, sister of Britain's Queen Alexandra and considered to be a possible spy. The family was briefly placed under house arrest.

Although the incident was resolved without further mishap, it drove home to Huene the real danger they faced. Although he continued to believe in the need for socialist reform, he foresaw that the new order would be no more than the old despotism modernized and mechanized. He realized that he would have to convince his mother that there was no alternative but to flee. Of this anxious time he later wrote in his memoirs:

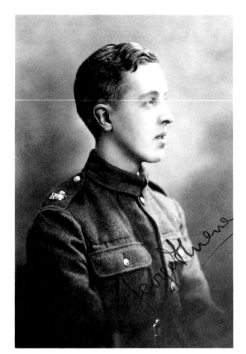

Huene in the uniform of the British
Expeditionary Force, *c.* 1918. Unknown
studio photographer, London

Although I felt very deeply that I had no affinity with the social setup into which I was born, I lacked the burning passion to become a revolutionary. So I looked forward to the day when I would continue my life in a more liberal climate ... I had a premonition that I was leaving Russia for good and that I would never see it again. I knew that a new order was in the making and that the storm which would sweep away the world we lived in was just beginning. I knew how fortunate we were to be able to leave with our lives. I was going, and the outside world was full of adventure and change. I hated the climate of Russia and I was sick of all the social injustices, the backwardness and squalor, and although my mother did not recognize that this was a grand finale, I knew that before any economic or social order was established there would be chaos and more chaos.[22]

They returned to St Petersburg – now Petrograd – and with exit permits obtained by Kerensky through the American ambassador, mother and son (he still in his school uniform), made their escape by land through Finland, Sweden, and Norway, finally crossing the hazardous North Sea to London. Betty had already left, and Helen would find her own means of escape. The Baron slipped away shortly thereafter, disguised as a peasant. He had been ordered off his estate by the Bolsheviks, and allowed to take only one valise. Everything of value that was left behind there, in St Petersburg and Yalta, was lost.

Although they had been cut adrift, their funds outside Russia kept them financially secure. They settled briefly in London, where they had influential relatives and friends, and Huene was sent to school in Surrey. There "I had to learn everything all over again."[23]

He had planned to take up university studies at St Andrews in Scotland.[24] However, current developments in Russia gave him cause to reconsider. By 1918 several fronts had opened up against the central Communist government and the British were organizing an Expeditionary Force. Although critics such as Osbert Sitwell spoke sarcastically of this undeclared war of Churchill's ("It is not a war really, it is only a training for the next one and saves the expense of army manoeuvres"), for Huene the British enterprise presented an opportunity for positive action to set right the situation back home. Although still loyal to his socialist ideals, he believed strongly that the Bolsheviks had betrayed the spirit of the revolution. They had to be confronted, and it was a matter of striking while the iron was hot. Although he would have preferred to enrol as an officer, as a foreigner he could not hold a commission. Undaunted, he volunteered and was assigned as an interpreter to a unit of instructors on its way to Archangel.

Inexplicably, however, the unit found itself posted to southern Russia. Hoping for the heat of battle, the young soldier and his fellows were disappointed to learn that there were no plans to engage the enemy in direct action. A series of postings followed – Batum, Ekaterinodar, Taganrog. Eventually the would-be combatants had their wish, and lived to regret it: the unpredictability of war deposited them on the battlefield at Tsaritsyn (later Stalingrad, now Volgograd). Here Stalin himself was commanding the enemy forces, and it was clear to all that he had the upper hand. The horrors of modern war were compounded by the onslaught of disease. Typhus broke out in the ranks of the White Russian forces and quickly reached epidemic proportions. Huene recalled the chaos as the evacuation of the White forces began:

Tens of thousands of people were lying dead on the streets and on the railway station platforms. You had to thread your way among these wretched people. The dead would be hauled onto trucks and their boots taken off, because the living needed boots ... It was sinister, like the later photographs of Buchenwald.[25]

He himself soon fell victim to the disease. By his own reckoning he came close to death several times in the following weeks. Somehow, in the midst of his misfortune, he found the strength to record the essence of his struggle in his diary:

February 11th: Give up bed for Fatty, who nearly dies; 12th: Spend two nights in cement works, floor flooded, icy cold wind and fog, rain through the roof; 17th: Base prepares for attack of Green Guards [who were fighting both Whites and Reds], "All men stand to!"; March 5th: Fire breaks out at 4 a.m. Witness many cruel scenes.[26]

The diary also records bedside visits by Countess Tolstoy and Baroness Wrangel, wife of the Commander-in-Chief and a relative of Huene's through marriage. These and other female members of the aristocracy were dutifully and hopefully fulfilling the obligations of their class. But for one soldier, experience had made it brutally clear that the old order – his order – had been swept away forever. By this time the allies had decided to abandon Wrangel, and, with the armistice, overwhelming forces were now unleashed against him. Wrote Huene: "Three weeks later I asked to see a newspaper and I saw that the war was lost. That was a terrible disillusionment because the anti-Communist troops had almost reached Moscow, and if we had had a little more help, probably Russia would have become a social democracy instead of a Communist state."[27] Defeated and sick after a year in action, he was evacuated aboard a British vessel. His illusions of righting Bolshevik wrongs had been shattered. While a soldier, he had almost reached the age of maturity. Now, no longer a child, he was forced to face the drastically changed circumstances of his life.

Chapter Two

A NEW LIFE IN PARIS

While Huene was serving with the British forces in Russia, his family moved to the south of France, which promised a social life reminiscent of their past. But the family's choice of a new home was not to the young man's liking. "To start life all over again in France seemed incongruous to me," he explained, "Why not America? After all, I was one-half American!"[1] Although he was to bow to his parents' wish that he settle in France, he rejected the morose posture of his father, for whom "life was reduced to bitterness, having lost the two things he loved most in life – his estate and his horses."[2]

Turning his back on the refined social milieu of Biarritz, Huene – along with tens of thousands of other refugees in less favored circumstances – made for Paris. He had certain advantages: a worldly education, a bearing that would appeal to cultivated circles, a modest allowance (amount undisclosed), and, not least, important family connections. He was also fluent in English and French. Not surprisingly, he took to Paris immediately. Wishing to be independent of his parents, he found a number of odd jobs. Among the more interesting was that of translator for an American firm with lumber interests in Poland. Travel through the Polish countryside made an indelible impression on him. The primitive peasant villages seemed to have been inspired by Marc Chagall's vibrant visions.

None the less, the employment itself was of little intellectual nourishment, and the young man was impatient to return to Paris and immerse himself in the cultural life of the city. Of particular appeal was the new art of cinema and Huene took every opportunity to follow developments. *The Cabinet of Dr Caligari* he found "too theatrical," but D.W. Griffith's *Broken Blossoms* convinced him of the expressive potential of the medium, as a few years later Eisenstein's *Battleship Potemkin* would open his eyes to the ominous propaganda value of film. One day Huene would walk out of the *Vogue* studio in Paris, leaving it in the hands of his assistant moments before Eisenstein was to arrive for a sitting; he had suddenly recalled the horrors of the past, and found the task of honoring a political adversary too great a compromise.

Huene soon fell under the spell of the new screen idol Greta Garbo, whom he first saw in G.W. Pabst's *Joyless Street* (1925). In middle age he would become a friend; now he only thought: "Here was an entirely new type of cinema actress, a contemporary girl, different and fresh. She seemed to have a naturalness combined with a mysterious quality of dignified pathos and unrequited love. I could never forget her."[3]

Before long the young man had a legitimate position in the film world. The one thing of value he had rescued from St Petersburg was his tuxedo, and with it he was able to take advantage of the demand for elegantly attired extras. Outlining the routine at the Epinay Studios of Eclair Films, Huene recalled:

You had to get up at five in the morning and take a trolley way out of town. It was all a new adventure and a new world, and it did one thing for me: it taught me how to light people and

Virginia Kent and Peggy Leaf, informal daywear by Lelong, 1934. One of Huene's comparatively rare excursions out of the studio on a fashion assignment for Condé Nast, this shot embodies the new image of women that he helped to create. The models' relaxed stylishness and air of independence is his answer to the problem, "How would I represent the modern woman in the true light of the period?"

Opposite: the logo which Huene designed for Yteb, his sister Betty's dressmaking establishment, *c.* 1925. *Overleaf:* left, an Easter greeting card for Yteb; right, a drawing for *Harper's Bazaar*. Both *c.* 1925

light sets. I was observing and watching all the time how they did it, and I was fascinated by the motion picture medium and by photography."[4]

The world of celluloid phantasy did not, however, offer the means of a real livelihood (at some point Huene was screen-tested for a love scene, but rejected) and he was forced to look for opportunities closer to home. His sister Betty had been living in France since 1917 and it was she who provided the opening. Both Betty and Helen were involved in dressmaking – Helen for the designer Robert Piguet, Betty on her own. Betty's business, Yteb, was growing, and she needed help in promotion. Recognizing her brother's talents as a draughtsman, she offered him her attic as living quarters in return for art work.

Huene was delighted with the proposition. He loved to draw, and this arrangement would give him an opportunity to utilize and develop his skills. In addition to the catalog sketches required, there were social events of all descriptions to record, greetings cards to design, and advertisements to prepare. He threw himself into the work.

The demands of the business and the pace at which he was required to work rekindled his interest in technique. Recognizing that a handsome salary could be earned by a top-flight illustrator, and at the same time admitting to his own limitations, he began to attend La Grande Chaumière and Colarrosi, open studios where artists could sketch from live models without instruction. There were different studios for five, ten, twenty minute or longer sketching sessions. In this way the student could train his speed as well as his eye. Huene found the environment a great stimulus and felt his skills noticeably improved.

He soon realized, however, that major progress could be made only with an exceptional teacher; after making careful enquiries he settled on the studio of André Lhote (1885–1962). Lhote was a much admired Cubist painter and theoretician, although it now appears that writing and teaching were his most lasting contributions; among his students who later testified to his gifts as a teacher were Henri Cartier-Bresson and Pavel Tchelitchev.

Huene described Lhote's style as "a well-known method of alternating lines and curves."[5] Lhote's Cubism countered radical Cubist theory with a more straightforward geometrical transformation of visual experience. Huene found the lessons fruitful and soon was incorporating his new-found knowledge and technique into his assignments for Yteb. One of his proud accomplishments was a Cubist-style logo for his sister's business.

Yteb was only a foothold in the industry. Huene was soon to discover a more lucrative outlet for his skills. A "pirate" manufacturer employed him to copy designer dresses in precise detail, a task which entailed viewing an entire collection of a hundred or more dresses, then rushing home to the drawing board and committing them to paper, complete with accessories. This called for a prodigious feat of memory, and it was a measure of Huene's talent and skill that he could rise to the occasion. Although he was quick to grasp the unsavory aspects of the business, he recognized that the discipline which the work demanded would serve him well in the future. Within the year he had reverted to respectable assignments. By 1925 he was selling his illustrations to *Harper's Bazaar*, *Women's Wear*, and *Le Jardin des Modes*.

Huene's initial successes and the encouragement he received from clients, family, and friends may have prompted him to embark on a bold entrepreneurial venture with Man Ray, who had become a close friend. Together they decided to produce a portfolio of, in Huene's words, "the most beautiful women in Paris." Each subject was to display a different object of adornment such as a piece of jewelry, a fur, scarf, or hat.

The Artist's Wife by André Lhote, painted in 1923, the year before Huene took lessons from him

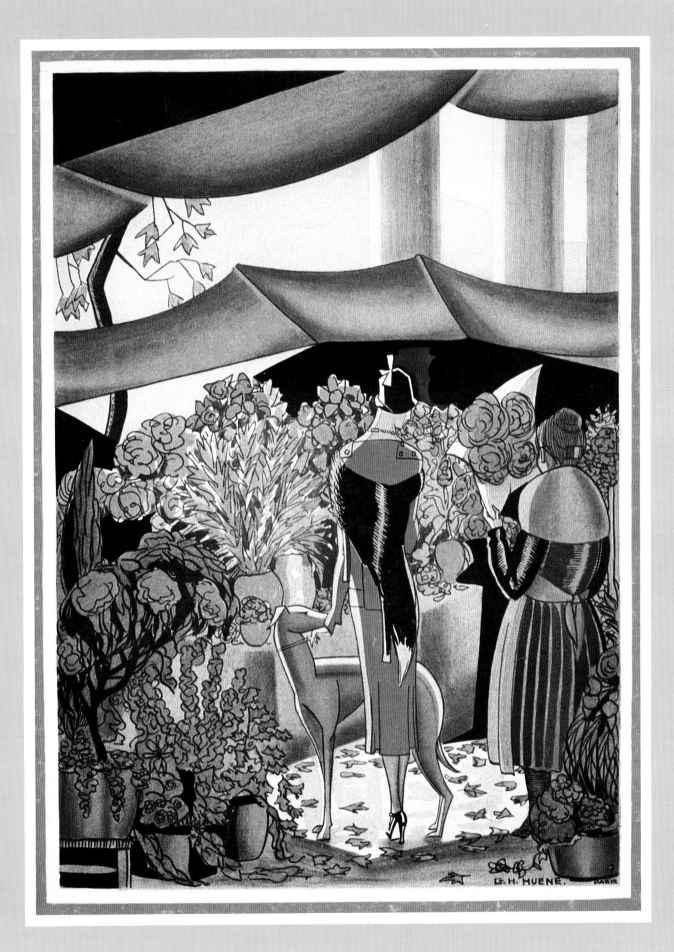

As Huene outlined the project, "Man was to take the pictures and I was to supply the sitters as well as the props and backgrounds. The ladies were outstandingly lovely and Man's photography was brilliant. This attracted the attention of *Vogue*'s Paris fashion editor, the American-born Main Bocher (later to be known as the couturier Mainbocher), in particular as one of the ladies was the Baroness Eugènie de Rothschild. This was a scoop, and *Vogue* wanted just that one picture, but Man and I held out and instead sold the portfolio to a New England department store."[6]

Main Bocher was nevertheless impressed by their handling of the project and offered to arrange an interview for the young illustrator with Edna Woolman Chase, the editor-in-chief of *Vogue*. (However, Huene's friend Horst P. Horst – see below, p. 32 – remembers that Huene's mother had arranged this meeting.) After some polite bickering with Mrs Chase over terms, he was offered an exclusive contract for his work. This was his first "real job," as he put it, and he was elated.

Not surprisingly he had certain qualms – after all, it marked the end of his cherished independence. Furthermore, he did not entirely approve of Mrs Chase. He was particularly put off by her condescending attitude towards her own readers: "As far as I was concerned," he reasoned, "the dubious climate of fashion was to be taken at face value. It was not conceit but the certainty of my creative ability which made me turn the tables and maintain the attitude that *Vogue* was to be honored by *my* presence. My arrogance was a form of self-defence and as long as I was in demand, it worked."[7] For her part, Mrs Chase disapproved of his arrogance – "typically Prussian" – and his moods – "typically Russian."[8]

He immediately brought his strong personality to bear on the magazine. On his recommendation *Vogue* hired a well-known society woman who would be able to recruit the cream of Parisian society as models. Nor did he spare his opinions as to the magazine's policy and direction. Luckily, in view of this high-handedness, his own illustrations continued to improve under the pressures of the job and the encouragement of Main Bocher. When *Vogue* opened its first photographic studio, Huene was asked to design backdrops for the photographers and generally be on hand to render them assistance.[9] Within a year of arriving at the magazine, he was well on his way to a

Opposite: Huene's design for a cover of *Fairchild's International Magazine*, August 1925

What price this crowning glory?, a drawing by Huene for *Harper's Bazaar*, 1925. It was captioned, "We sit in sweet and damp communion, our shoulders almost touching."

Huene's apartment in the rue St Romain, Paris, 1931

comprehensive appreciation of the complex and varied operations which were the prerequisites of fine fashion photography.

During their many friendly discussions Huene and Main Bocher had talked about photography, which seemed so full of promise for the future of the magazine. Huene always promoted Man Ray, urging the editor to give his friend an opportunity for regular work. In the course of these conversations, the astute Main Bocher detected a passionate interest in the medium on Huene's part. He surmised that his young protégé, with his eye for detail, his drive and enthusiasm, might be better equipped to handle the task.

One day Main Bocher received an urgent call from the studio. Huene was on the line: the photographer scheduled for the day's sitting had not shown up. Dress and accessories were arranged, the props had been positioned, the background prepared, and the set carefully lit. Even the camera was in place and loaded. It was a costly undertaking, now threatened. What should be done? The editor fired back: "Take it yourself!" For all we can tell, Main Bocher may have known that the photographer would not show up. It may well have been a test of Huene's ability not only as a photographer, but as an adaptable professional; after all, studio fashion photography called for a gifted problem-solver. In any event, the young man jumped at the opportunity and to his delight found the picture published full-page in the subsequent issue of *Vogue*. Whether fortuitous event or trial, circumstance had brought Huene to the threshold of a new career.

He had in fact been gravitating toward photography for some time. "My fashion illustrations were improving but somehow I was temperamentally unsuited to this work," he explained. "I disliked sedentary activities. In the back of my mind I was veering toward another medium. Now the die was cast. It was sink or swim. I had plunged into a new world utterly unknown to me."[10]

He saw the task ahead in terms of two distinct sets of problems: on the one hand those imposed by the technical limitations of camera, lighting and film; on the other,

considerations of esthetics. Technical problems were truly formidable: "We had very poor lighting equipment, and the camera was a clumsy contraption," he recalled, "There were no light meters and the plate emulsion was considerably slower than the slowest film today."[11] On the level of esthetics, there were daunting conceptual problems. Fashion photographers had, with only a few notable exceptions, brought little creativity to bear on their work. Models tended to be nothing more than clothes-horses woodenly posed before the camera. Movement, atmosphere, the realm of the sensual, had seldom been effectively rendered. "I asked myself over and over," said Huene, "how would I represent the modern woman in the true light of the period?"[12]

Searching for answers, the photographer gravitated to the artistic milieu of 1920s Paris. In café life he found an exhilarating forum for unorthodox thought, encouragement for an unconventional life-style, and a circle of friends willing to risk society's disapprobation to pursue their intense personal visions. He enjoyed encounters with such diverse figures as Kiki de Montparnasse, Jean Renoir, and the mystic Gurdjieff. With friends among the ranks of Dadaists, Expressionists, Romantics, and Neo-romantics, Huene had no difficulty keeping abreast of art-world developments, but though he kept an open mind, he never allowed himself to be swept away by fads, or isolated within a particular circle. He found no reason to question the foundations of his own education. He was looking for useful ideas, not vaguely for some notion of meaning. And if his position at *Vogue* anchored him in the world of commerce, it also gave him security, a degree of fame, and social entrée.

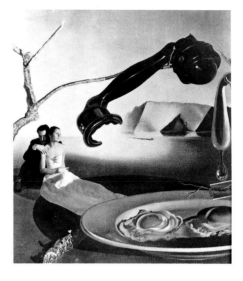

Huene occasionally collaborated with artists he first met in 1920s Paris: this montage, *Portrait of the Dalis in "l'instant sublime"* (1939), combines a photograph by Huene of Dali and his wife with a painting by Dali

Among his male acquaintances (other than his colleagues in photography) he counted the painters Joan Miró, Salvador Dali, and André Derain, the designer Paul Poiret, and the filmmakers Jean Renoir and Erik Charell. Foremost among them was Jean Cocteau, whose finger seemed to Huene to be on the pulse of Parisian artistic life. Among particularly admired women were the Russian princess Natalie (Natasha) Paley and her half-sister, the Grand Duchess Maria Pavlovna, the charming social hostess Marie Louise Bousquet, the nightclub sensation Josephine Baker, the stripper Suzy Solidor (much loved by artists for her off-hours readings of poetry, notably Baudelaire and Mallarmé), and the famous couturière Coco Chanel, in whose sense of chic (and self-worth) the photographer found attitudes that mirrored his own.

Of central importance to Huene in this period were two painters, Pavel Tchelitchev and Christian "Bébé" Bérard, and he counted both men as close friends. From the beginning of their friendship, Pavel Tchelitchev encouraged Huene to expand his mind. "You have no idea about intellectual things," admonished his fellow Russian.[13] And of Bérard, Huene later wrote: "He was the greatest single influence in my life during that period."[14] Such admissions are worth a closer look. Tchelitchev's influence makes itself clear, but the case of Bérard is somewhat perplexing.

Tchelitchev's background was surprisingly similar to Huene's. He was born an aristocrat and his family had substantial holdings in town and country. Tchelitchev had also received an informal education at the hands of tutors and family, and he took an early delight in the whims of the couturiers and the caprices of the fashionable set. "He retained the manners," his friend Lincoln Kirstein tells us, "of a nineteenth-century *Barin*."[15]

The Revolution forced him, like Huene, to abandon Russia forever. By the time Huene arrived in Paris, Tchelitchev was firmly established as an artist. He painted fabulous covers for luxury trade-magazines, exhibited his paintings to acclaim, and designed spectacular sets for Diaghilev and Louis Jouvet. Huene was mesmerized by his friend's accomplishments and impressed by his claim to be the "greatest Russian artist since the ikon makers Andrei Rublev, Daniel Chorney, and Theophanes the

Charles Peignot by Huene, 1934. Peignot, editor of the annual publication *Photographie*, helped to further Huene's reputation

Greek."[16] He admired Tchelitchev's skill as a draughtsman, his innovative spirit (the projection of film in live dance to cite one example), and love of what was truly fashionable (Tchelitchev was the first to see in commonplace clothes such as workman's outfits and army surplus gear the stuff of genuine novelty). Thus the two men shared views of the present and childhood experiences from the past – with one notable exception; Huene had come to hate his overbearing father, while Tchelitchev had enjoyed with his a warm and loving relationship. Could this one great difference not have invested Huene's admiration with envy and awe?

Like his fellow "Neo-romantic" Tchelitchev, Christian Bérard (see plate 131) was a fine painter and accomplished set designer for film and stage (although in fact the two men did not get on). He had worked for Massine, Jouvet, and Kochno and for poets such as Cocteau, providing maquettes, decor and costumes. Bérard was flamboyant and outrageous, which made him, in Colette's words, "necessary for opening nights." His painting was far from the otherworldly dreams of Tchelitchev, a spare style, loose and confident. A portrait by him of Huene's friend the photographer Horst conveys a casual elegance bordering on *ennui*. Huene must have respected this air of authoritative style, and appreciated Bérard as a leader of fashion with impeccable taste. But perhaps Huene also admired the painter for what he himself was *not* – short, uncouth, loud, unrestrained – a Dionysian to Huene's Apollonian.

Closest of all to Huene was a young German emigré by the name of Horst P. Bohrmann (known after World War II as Horst P. Horst, and professionally simply as Horst). Trained as an art student in Hamburg, Horst had come to Paris on his own initiative to apprentice with Le Corbusier. To his disappointment, however, he found the commission on which the *atelier* was working – an apartment for a wealthy Mexican – inconsequential, and the great architect himself a stiff and ungiving figure. Wandering about Paris cafés in search of something more vital, he encountered Huene, to whom he took an immediate liking. To Horst's surprise, as he considered himself lacking in the worldly attributes of the older man, the feeling was returned. Soon the two men were seen everywhere together, and it was not long before Huene arranged for Horst to rent an apartment adjoining his own.

Having by now left Le Corbusier, Horst had the time to visit his companion at the *Vogue* studio, where he lent a hand assembling and lighting sets. On occasion he was pressed into the role of model, featuring in a number of Huene's most celebrated compositions (for example, plates 58 and 66). Huene also took Horst to visit friends outside Paris. While some of these encounters were wildly amusing (Horst recounts how Huene, in a moment of pique at some imagined slight, jumped out of a ground-floor window only to land ignominiously on his nose in the flower garden), others were discomfiting. A visit with Cecil Beaton in the south of England turned into a most unpleasant experience for Horst, as Beaton treated him with extreme condescension. But trips abroad, whether for work or pleasure, gave Horst a measure of the professional fashion photographer's role.

In the spring of 1931 Horst was given a chance to try his own hand by Dr Agha, *Vogue*'s American art director, then visiting Paris. Provided with studio time and assistance, Horst put Huene's instruction to the test and to his delight found the results were praised; his first photograph was published in the magazine that November. It was followed by a series of innovative still-lifes, for which he seemed to have a particular aptitude. His work soon earned him the admiration of the entire staff, and he was given increasing responsibility. Later, when Huene left Paris for a *Vanity Fair* assignment in Hollywood, Horst was able to shoulder the added load, and when Huene eventually left *Vogue* for good, it was Horst who inherited the mantle.[17]

Opposite: Pavel Tchelitchev by Huene, who expresses his affection by including his own arm. Paris, *c.* 1930

Few if any of Huene's friends had much regard for territorial rights among the arts. If painters weren't at their easels they were busy writing or acting in films, designing sets, curtains, fabrics, and furniture, decorating automobiles, or creating new approaches to graphics, typography, and advertising. Huene himself made three short films, one in collaboration with the dancer Serge Lifar, and one a domestic drama with Natalie Paley and Horst, of which Horst notes, "the movie was not merely underground; it had no title and no plot, and it was never shown."[18] Of the third, nothing is known. Huene also appeared in Seymour Nebenzal's *The Hands of Paris*, and in 1933 produced a documentary on fashion photography for *Vogue*. Unfortunately, no copies of Huene's early films have been found.[19]

Jean Cocteau asked Huene to work on *Le Sang d'un Poète*, although Huene's memoirs are not clear as to what form the collaboration was to take. It is possible that Cocteau wanted him as cinematographer. In any event, Huene refused. Horst recalls his high-handedness surfacing here: if there was to be a film, it would be his, and not Cocteau's. Some collaborative projects did get off the ground. The legendary entertainer Bricktop (the red-headed American nightclub owner and singer known to her closest friends as Ada Beatrice Queen Victoria Louise) recollects Huene's role in the design of her new club:

It was at 66 rue Pigalle, a great big room that could seat about a hundred people ... I had Hoyningen-Huene do the lighting – he did lighting for a lot of theaters, but he was most famous as a society photographer. Neil Martin did the decorating. The walls were lined with

Natalie Paley and Horst in a still from Huene's unnamed amateur movie of 1932

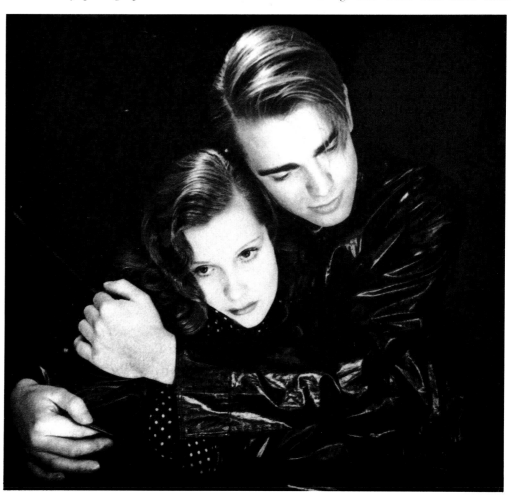

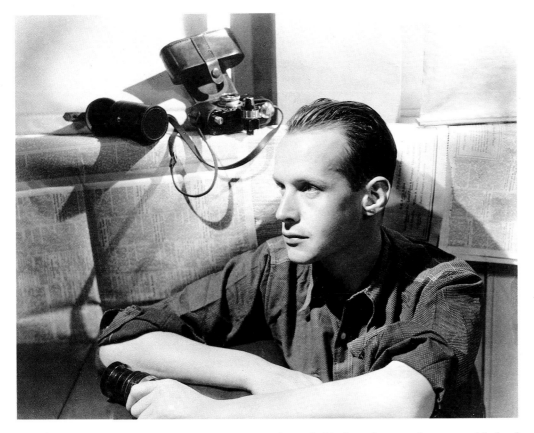

Cartier-Bresson by Huene, 1935. Huene
was envious of the freedom given to
Cartier-Bresson by his small, portable Leica
camera. See also plate 128

banquettes, and Hoyningen-Huene lit them from behind and created a cozy, kind of
mysterious atmosphere. There were heavy, patent-leather curtains around the door, and as
you approached you could see only shadows – the silhouettes of people's heads. The carpet was
red, the banquettes were red and black, everything was done in red and black – and with that
lighting, well, when it opened in November 1931, it was the talk of Paris.[20]

Our "society photographer" also had a contribution to make at La Quatrième
République, a little restaurant in the rue Jacob, home to a number of minor Surrealist
painters. As his friend the *New Yorker* Paris correspondent Janet Flanner (who
published under the pseudonym Genêt), recalls:

The bistro itself was very avant-garde in decor ... On the wall of the restaurant's narrow
circular staircase, which like the newel of a snail's shell wound upstairs to the second floor, he
had painted a series of false steps in a Cubist design, very striking as a lesson in abstract
distortion, since if you looked at the wall's false painted treads while going up or down, you
were likely to miss the reality of the shallow wooden steps beneath your feet. In a Russian pun
he had nicknamed Yvonne, the young waitress, Yvonne the Terrible, which was palpably
untrue since she never once fell down the steps during the years I lunched there.[21]

Huene's ingenuity extended to his role as host. He gave a fancy-dress party at the
Vogue studios on the theme of Sternberg's 1932 film *Shanghai Express*. It was
attended by Elsa Maxwell, Boris Kochno, Serge Lifar, and Jean Michel Frank, among
other well-known artists and personalities, and was an unqualified success – until the
guests woke up the next day with eyes in pain from over-exposure to the Klieg lights.

The late Twenties in Paris was a period of ferment in photography. Its practitioners
had embarked on a new exploration of the medium, breaking on the one hand the
shackles of commerce and on the other the pretentious, turgid conventions of
"pictorialism," a school of thought which seemed to the new breed of photographer to

"The modern woman," as reflected in Huene's work for *Vogue*: Colette Salomon, 1927

be primarily concerned with a slavish imitation of the fine arts. The youthful enthusiasts found champions for their ideas in Germany, Russia, and the United States, where similar movements flourished. "The camera alone has the technical ability to give a true image of present-day life" announced Alexander Rodchenko in 1928. Photographers turned their cameras upwards and downwards at odd angles, and focused on objects, materials, and details previously considered unworthy. They took pictures without cameras and without film, perched like birds on the new radio towers, or hitched rides in the latest aeroplanes, dirigibles, speed-boats and record-breaking automobiles, all the while keeping pace with rapid developments in camera and film technology. Books, journals, and exhibitions of photography multiplied. It was an atypical European art review that did not feature photography. Of particular

importance in France were *Vu*, *Minotaure*, and *Verve*, founded 1928, 1933, and 1937 respectively. They featured many of the best photographers of the period, such as André Kertész, Germaine Krull, Robert Capa, Henri Cartier-Bresson, Herbert List, Bill Brandt, and Huene himself.

Huene was much impressed by the work of Edward Steichen, Cartier-Bresson, and Paul Outerbridge. For a brief period when mannequins were the rage, Huene and Outerbridge worked together designing and photographing them.[22] But although he admired Outerbridge's work, Huene ruled out the possibility of a close friendship: he could not for long tolerate his colleague's humorless disposition.

Huene spent long hours with Man Ray, and made a passing acquaintance with Berenice Abbott, who had been Man's darkroom assistant and was now coming into her own as a portrait photographer. He enjoyed the company of the highly influential and supportive Charles Peignot, editor of *Photographie*, a lavishly illustrated photography annual which featured the most inventive photographers of the day. In the Premier Salon Indépendant de la Photographie in 1928 (a modest tribute to the upstart art-form which was hung in a stairway of the Comédie des Champs-Elysées and self-mockingly trumpeted as the "Salon de l'escalier"), Huene's work hung alongside that of Abbott, Laure Albin Guillot, Kertész, Krull, Man Ray, Nadar, d'Ora, Outerbridge, and Eugène Atget.

To Huene, the world of fashion was a fertile ground for creative endeavor. World War I had changed the very concept of clothing for women. Shortages of traditional fabrics had resulted in the production of new synthetics and women had worn uniforms and performed physically demanding work that had demonstrated the need for more functional and less restrictive garments. Suddenly, fashion historian Anne Hollander tells us, "attention came to focus on a woman's actual structure, with its full human complement of noticeable bones and working joints, including two complete, moveable legs with articulated and supportive feet."[23]

A reconstituted social hierarchy demanded new fashion symbols for the display of power and prestige. Glamour in the new order now meant not only wealth and class, but also freedom and mobility. After centuries of restriction women were demanding simple, functional, and youthful fashions in keeping with the promise of new lives.

A fundamental change in female fashion had been occasioned by the Ballets Russes' introduction of orientalism just before the war. Soft, flowing draperies and bold new colors replaced rigid bodices, bell-shaped skirts, and pale pink and mauve hues. With the introduction of the hobble skirt, notes James Laver, "every woman ... was determined to look like a slave in an oriental harem."[24] Immediately after the war fashion picked up again with the "barrel" line – cylindrically shaped skirts with a boyish look. This led to the short skirt of 1925, denounced by the church and other moral authorities but greatly appreciated by women. Style moved toward androgyny, curves were suppressed, young women cut off their long hair. Ideas derived from Art Déco became influential. But there were economic consequences: when skirts reached an all-time high in 1927, clothing manufacturers saw their profits vanish. In retaliation they began to promote the long evening dress. This had the desired effect and by the end of the Twenties skirts were longer.

Economic and political forces made the fashion industry possible, as new forms of mass production and the growth of the artificial silk industry were matched by France's determination to promote clothing as a major industry. It only remained to reach a mass market, and here photography came into its own. Photography copied couturier dresses inexpensively and perfectly, while the new mass-circulation women's magazines issued them forth in two-dimensional replicas, enhanced by the

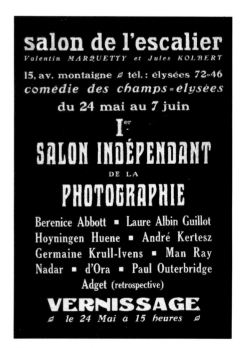

The poster for the first photographic exhibition to include work by Huene, 1928

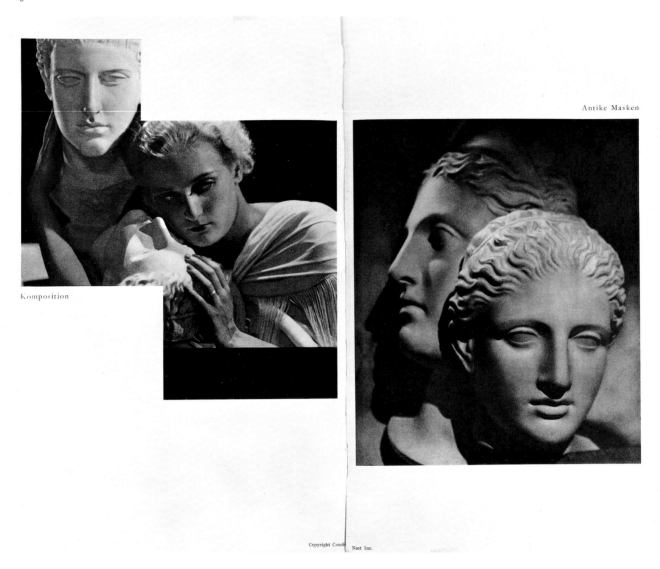

Komposition

Antike Masken

A double-page spread from *Hoyningen-Huene: Meisterbildnisse* by H.K. Frenzel, a small book of Huene's photographs published in Berlin in 1932

phantasy of exotic surroundings. The clothes themselves may have been beyond reach for the average woman, but the "image-clothing" (to quote French critic Roland Barthes) was easily purchased. Moreover, this image clothing was the *reality* for the majority of women. The real garments were in a sense purely imaginary. According to Barthes, at least half of all French women read fashion magazines on a regular basis. Therefore, he points out, the photographic image and its written description were "incontestable elements of mass culture."[25]

This could all be translated into dollars and cents. Photography would soon outstrip drawn illustration. In 1930 Condé Nast, the publisher of *Vogue* and *Vanity Fair*, spent approximately $100,000 on art and $40,000 on photography. By 1933 the figures were $73,000 and $60,000 respectively. By 1940 photography had captured the lion's share of the budget.[26]

As fashion historian James Laver has noted, "the camera was an engine for imposing certain types of beauty."[27] These are strong, unequivocal words, which underline the tremendous manipulative powers of the medium. There can be no doubt of their validity. But it is also true that the written word has always played a complementary role in the fashion magazines. Seeing is believing, but the written

word sanctifies. After a glance at a Huene fashion study in *Vogue*, the viewer's eye would catch the magazine's seal of approval:

The fronds of the palm tree, the crimped edge of the brim, the curl of the hair – they all contribute to the effective picture that Lady Abdy makes in her new Provençal peasant sun-hat ... Because she wears this hat, all smart women on the Riviera will do so, too.[28]

It only remained to determine *what* types of beauty to impose and here modernism stepped in. All man-made objects were being scrutinized by the modernists and women were still the most highly prized and valued of all "objects." Poiret had been the first to throw caution to the wind with his simple, bold designs and bright colors. He was soon followed by such highly inventive designers as Chanel, Alix, Vionnet, Schiaparelli, and Balenciaga, all of whom were responsive to the avant-garde. The advent of Cubism had helped them to see their creations with fresh eyes, in terms of simultaneous profile and frontal views. Cubism also helped them find the principles governing structure in undulations, taperings, and contrasts of line. "The plane, cone, sphere and cylinder are actually becoming logical!" trumpeted a fashion advertisement, in tune with the temper of the times.

Neoclassicism was immensely popular. Such artists as André Gide, Igor Stravinsky, Arthur Honegger, and Jean Cocteau believed that classical antiquity could be brought to bear on the present, that ancient ideals could mitigate the otherwise dehumanizing, so-called rational principles of the machine age. No better example of this enthusiasm can be found than in the introduction to a slim volume of Huene's portraits that appeared in Germany in 1932:

The ancient world celebrated its entry into Montmartre to the beat of jazz. Ionic columns rose alongside of factory smoke-stacks, Greek temples alongside of railway tunnels and depots. Monte Carlo became Hellas, Hellas became Monte Carlo; and the ladies and gentlemen from Paris, London, New York, and Biarritz enjoyed the sunshine among pedestals from which the gods of ancient Greece looked down in naked silence, between snorting stallions and muscular heroes.[29]

Among the designers who turned to the classical world for inspiration was Alix Barton (later Madame Grès). Alix's creations were worked out not on paper, but on the models themselves. By draping fabric over a real body the designer was working directly with her material. This enabled her to react spontaneously to volume and contour. Alix's work was fluid, harmonious and sculptural. Years later, photographing in Africa, Huene would find native costume which reminded him of Alix's creations.

Of Madeleine Vionnet, Huene wrote: "Her clothes were built like great architecture. The cut of her dresses mostly on the bias was a superb equilibrium of geometric units combined with gowns of regal distinction, impeccable workmanship, color and texture."[30] But in Huene's eyes, the most imaginative of designers was Coco Chanel. The Chanel style, which meant adapted sailor's jackets and men's pullovers, jersey wool dresses, beaded evening gowns, Chanel's "suits" and costume jewelry, was, in fashion historian Elizabeth Ewing's words, "a poor look of infinite *chic*."[31] "Chanel is the fashion of the twentieth century," Huene maintained, and he identified with her "absolute assurance of her own talent, competence, and authority."[32] With his sense of his own worth, he had no trouble in accepting her unabashedly imperious decree, "L'Elégance, c'est moi."

Huene admired the designers for their courage in breaking with tradition. He believed as they did that fashion would no longer be the exclusive prerogative of the rich, but an emancipating force for all women. Photography would be *his*

This Huene advertisement for Caron (1934) demonstrates the all-pervasive cult of the classical

Alix Grès by Huene, 1937. "Madame Alix" was one of the couture designers Huene most admired; her concentration on elegant and sophisticated simplicity in her clothes, which often resemble classical Greek sculpture, precisely mirrored his standards and interests

contribution. At the age of twenty-five he was eager to learn from the creative people around him and yet sufficiently mature to formulate his own unique style. He was based at *Vogue* in Paris for almost a decade (1926–35), adapting, borrowing, discovering, and inventing. During these years *Vogue* and its sister publication, the more high-brow *Vanity Fair*, would amuse and beguile their readers in no small measure thanks to Huene's conceptions.

Plates 1–47

COUTURE
AND
CLASSICISM

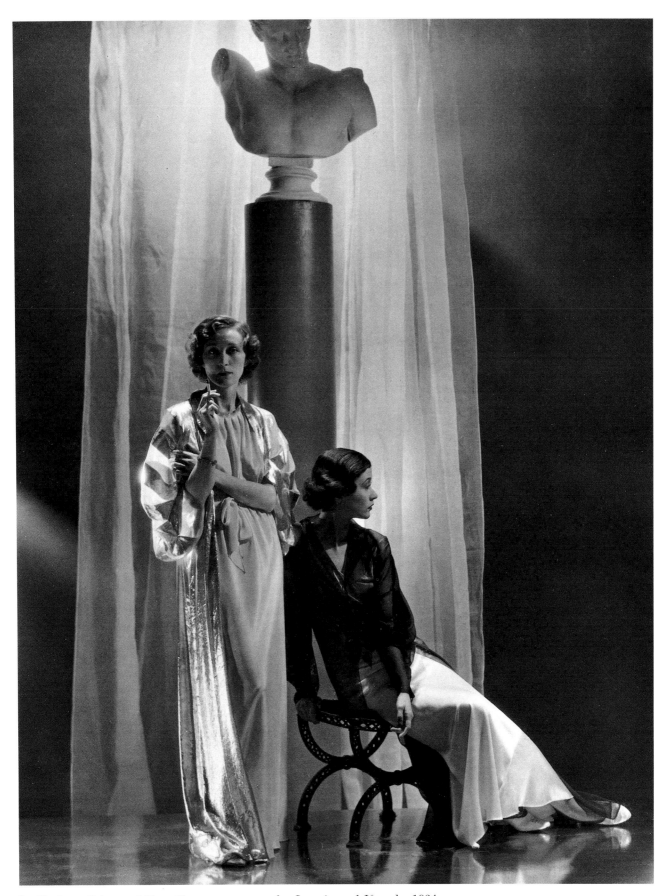

1 Evelyne Grieg and Toto Koopman, gowns by Lanvin and Yrande, 1934

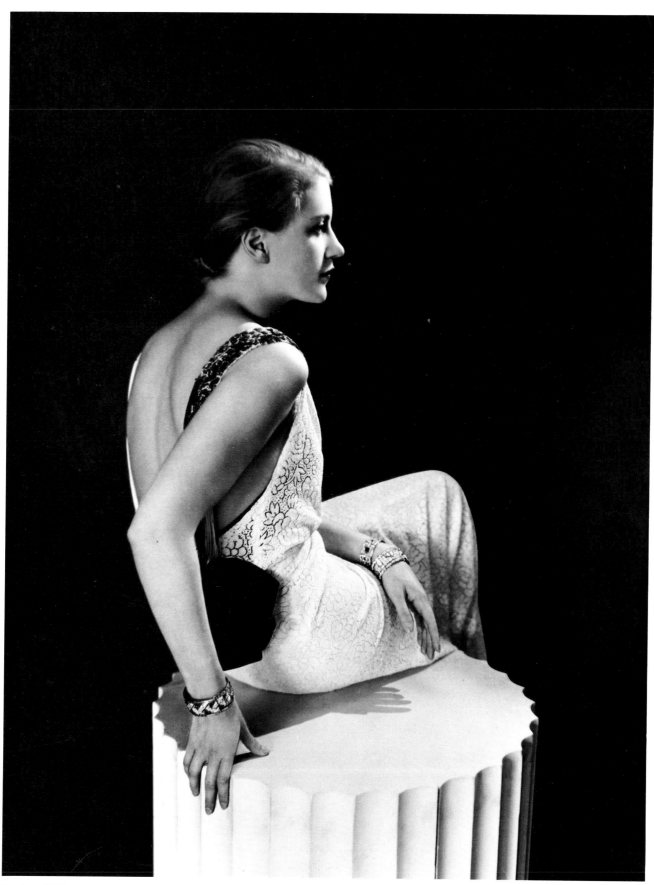

2 Lee Miller, evening dress by Lanvin, 1932

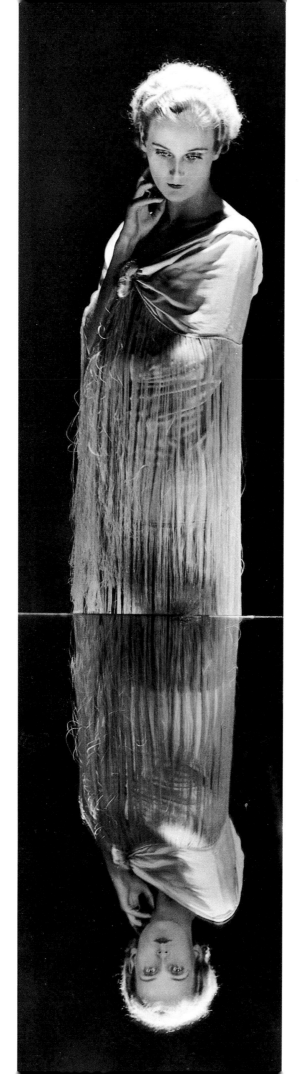

3　Mrs Hubbell, 1930

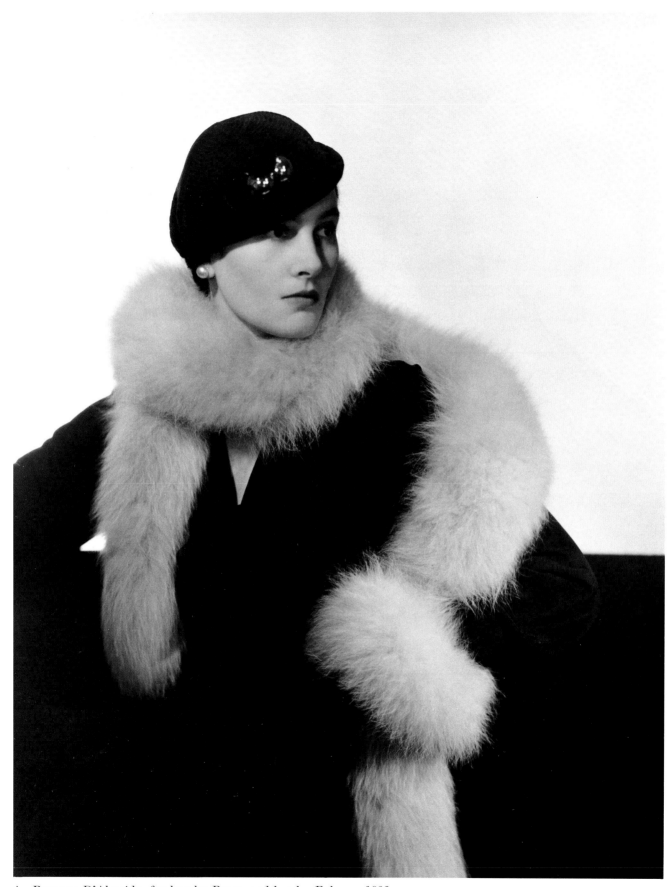

4　Baronne D'Almeida, fur boa by Patou and hat by Reboux, 1932

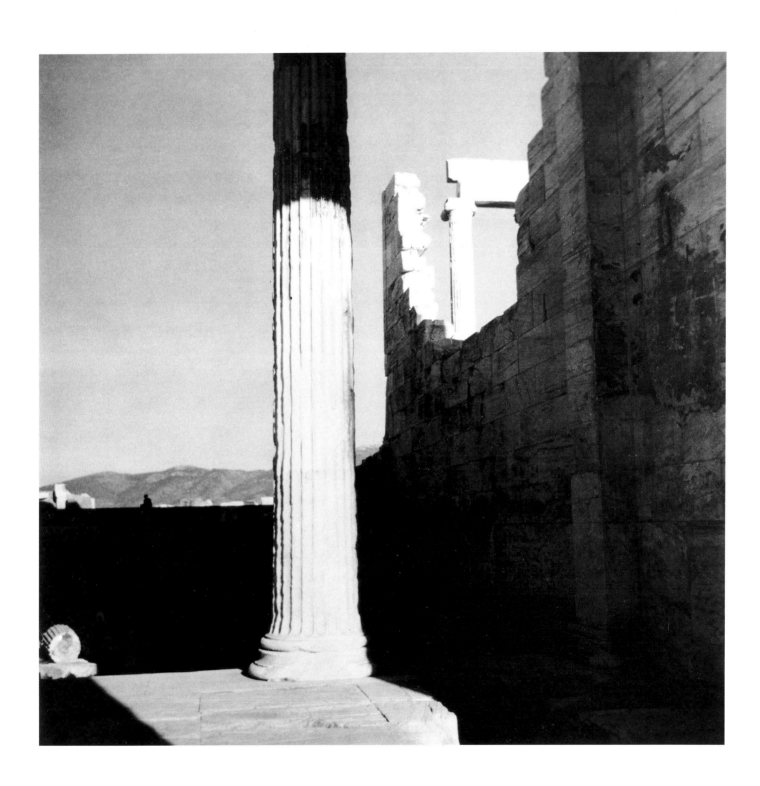

5 The Erechtheion, Athens, *c.*1939

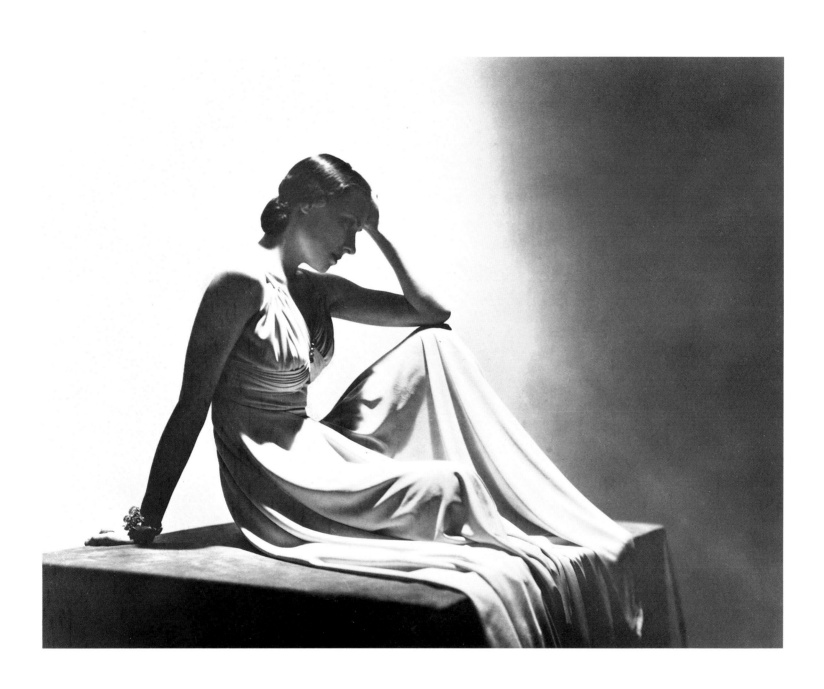

6 Nana Gollner, evening dress by Celanese, 1940

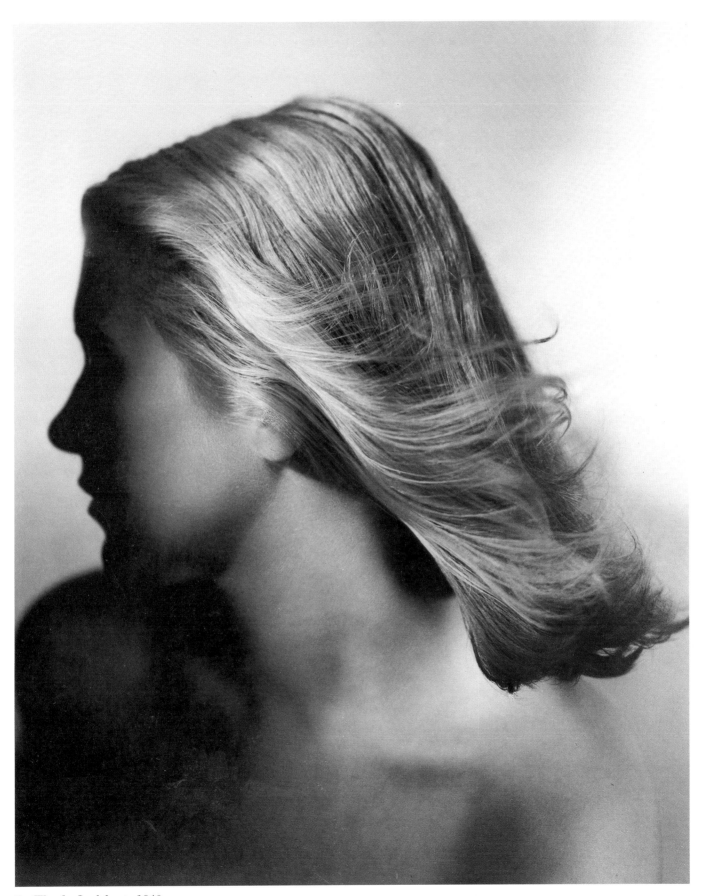

7 Wendy Inglehart, 1940

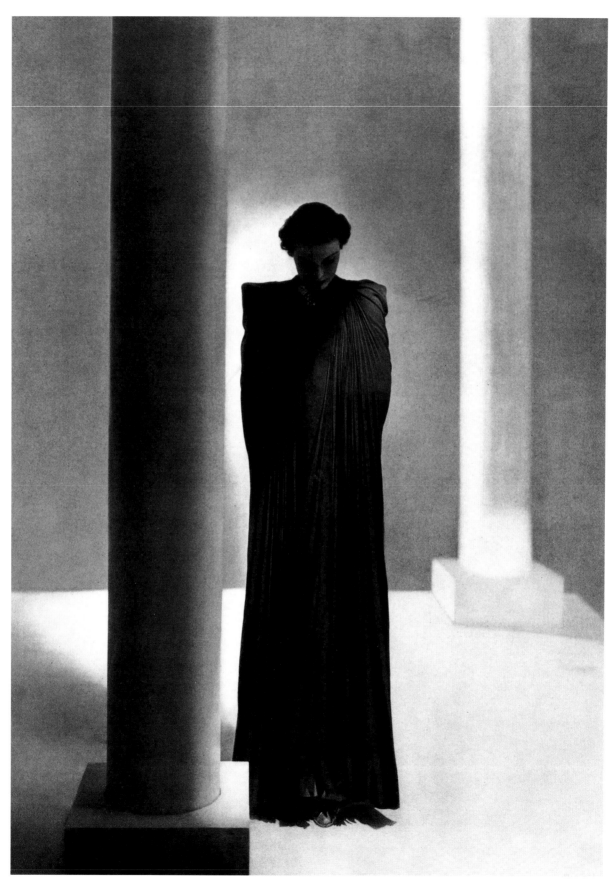

8 Evening dress and cape by Patou, 1936

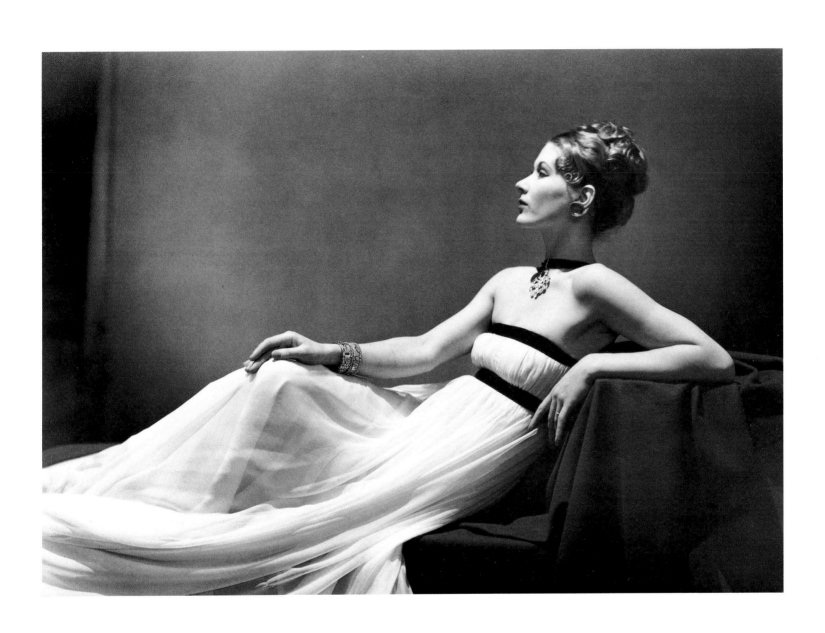

9 Lisa Fonssagrives, evening dress by Vionnet, 1938

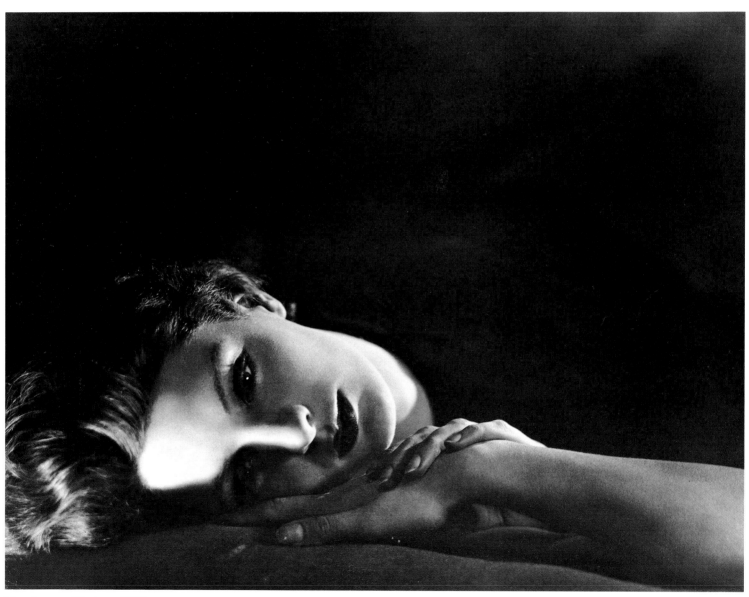

10 Agneta Fischer, 1928

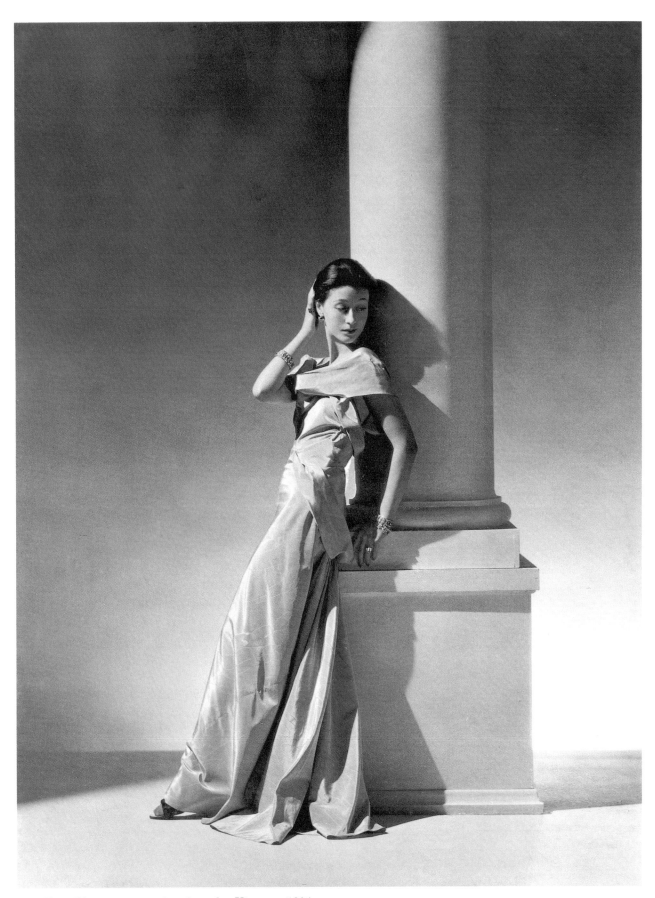

11 Toto Koopman, evening dress by Vionnet, 1934

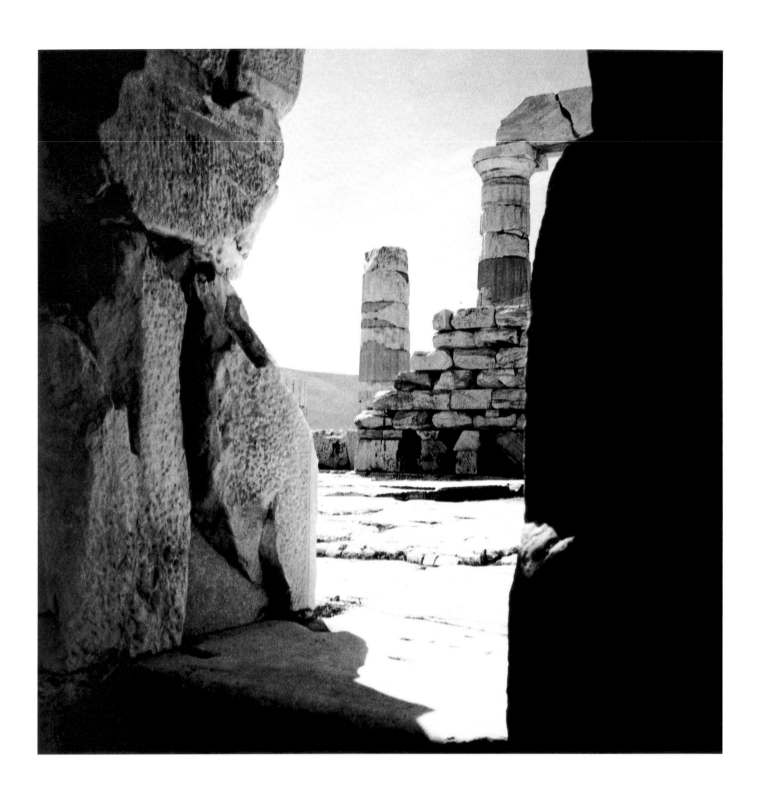

12 The Parthenon, Athens, *c.*1939

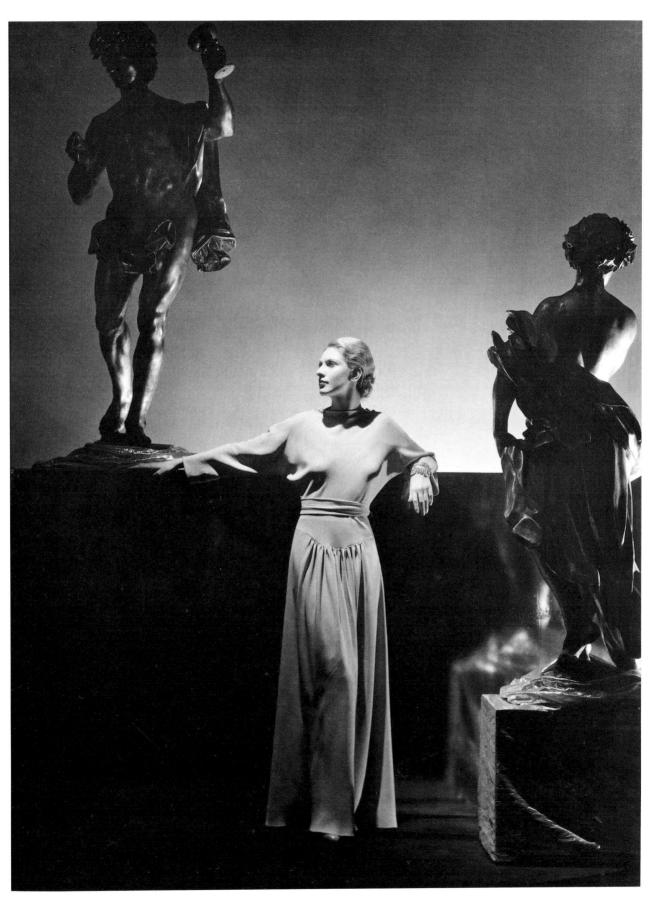

13 Peggy Leaf, dress by Augustabernard, 1934

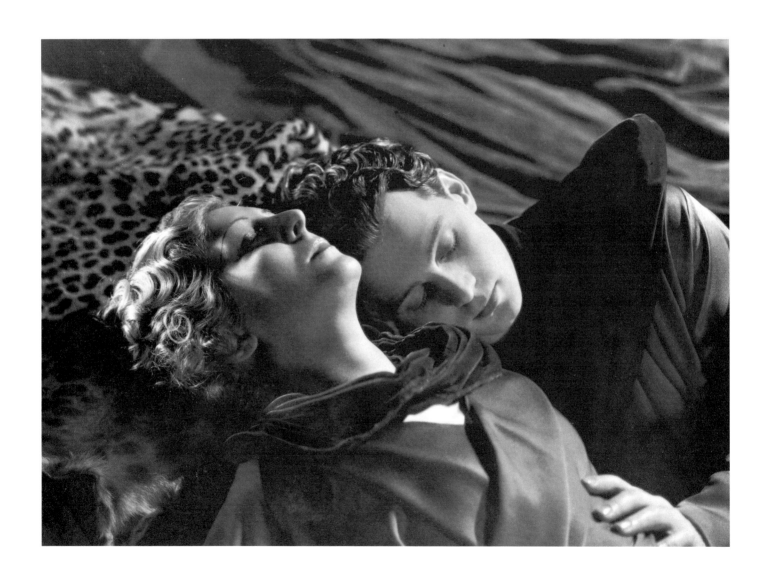

14 Marthe Régnier and Jean-Pierre Aumont, 1934

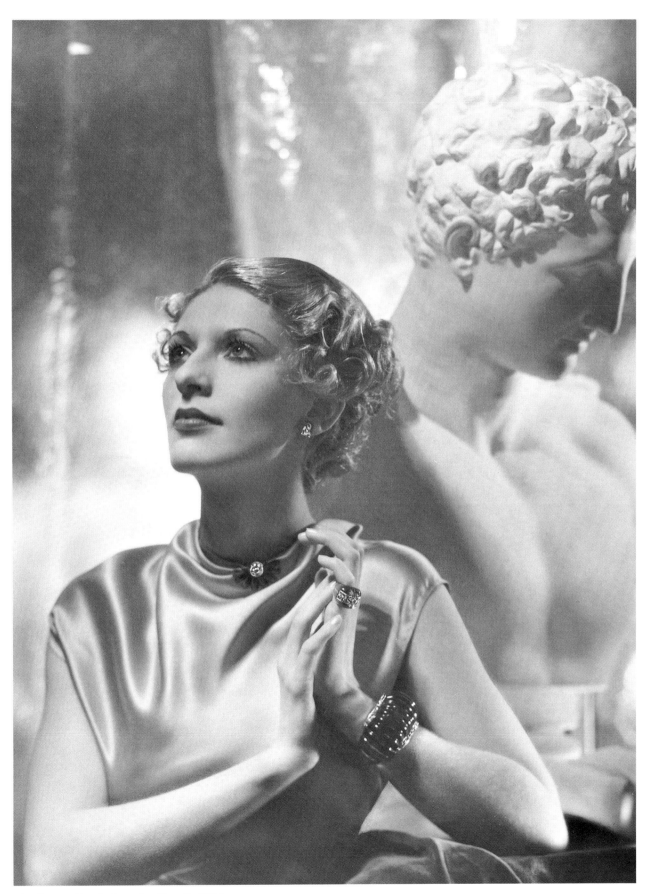

15 Peggy Leaf, dress by Rouff, 1934

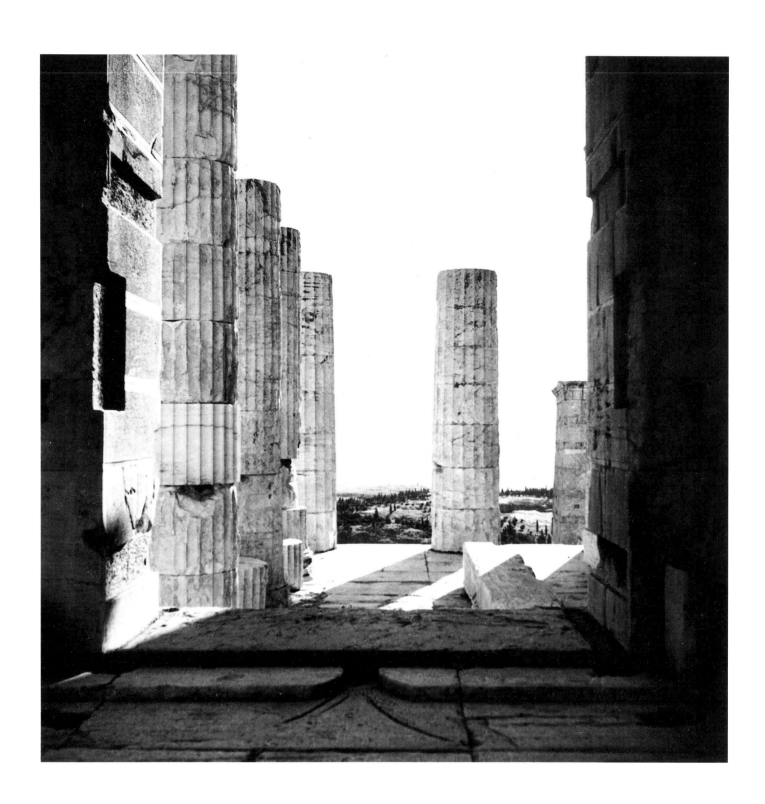

16 Columns of the Propylaea, the Acropolis, Athens, *c.*1939

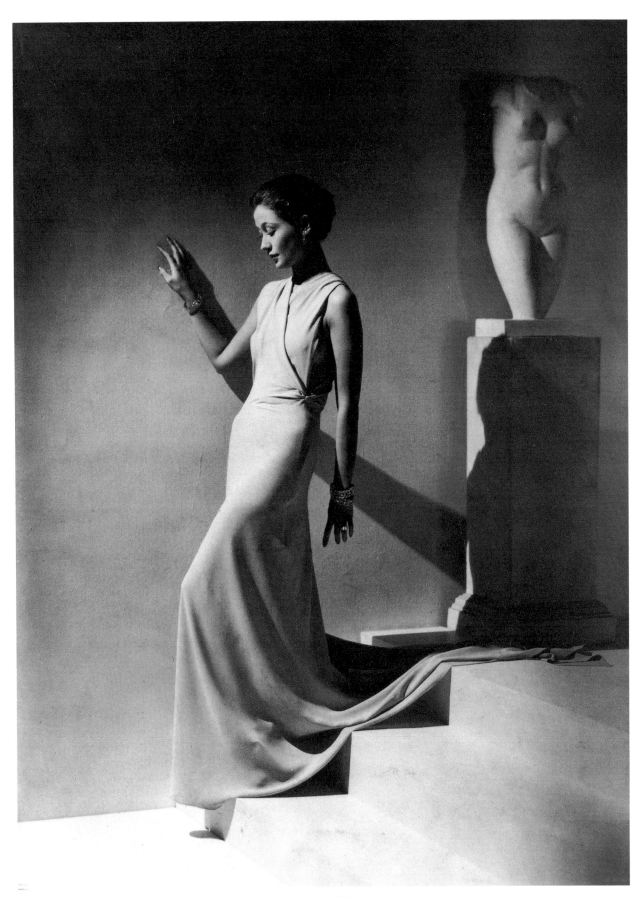

17 Toto Koopman, evening dress by Augustabernard, 1934

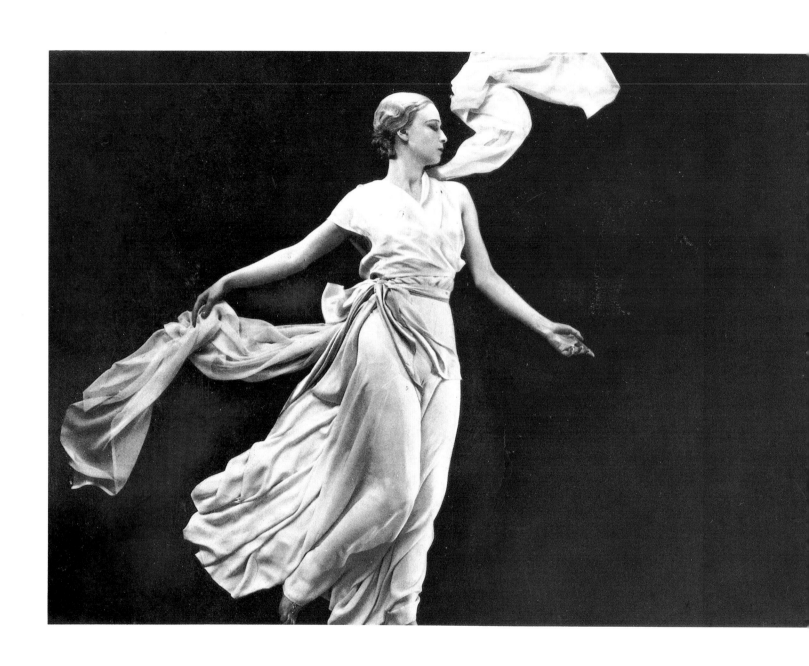

18 Miss Sonia, evening pyjamas by Vionnet, 1931

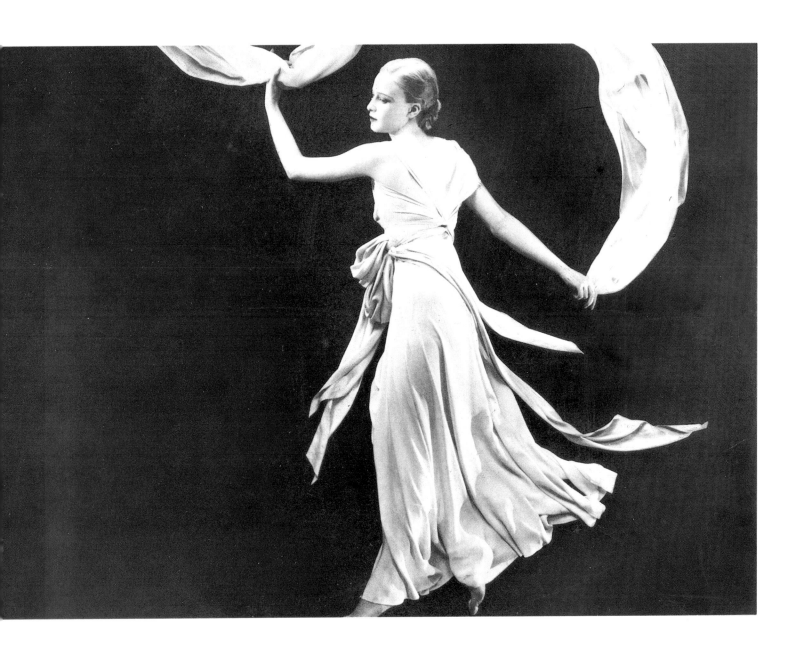

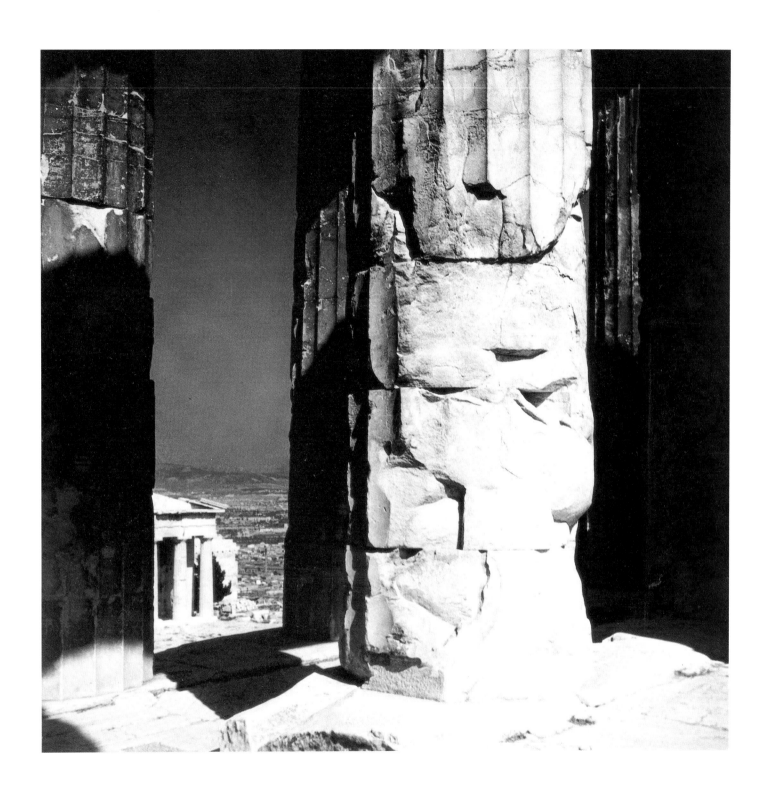

19 The Propylaea, through the columns of the Parthenon, Athens, *c.*1939

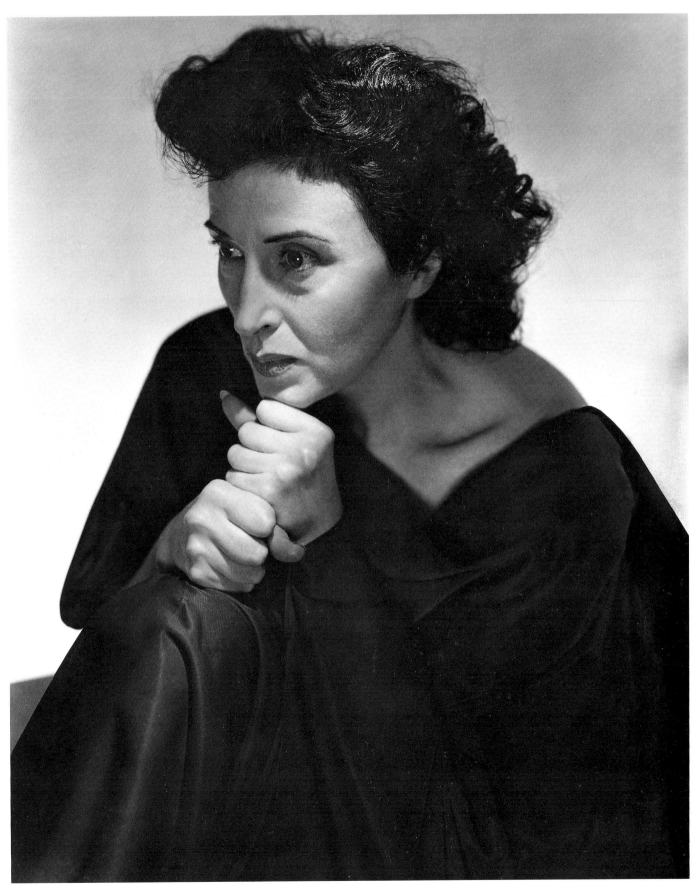

20 Katina Paxinou, 1943

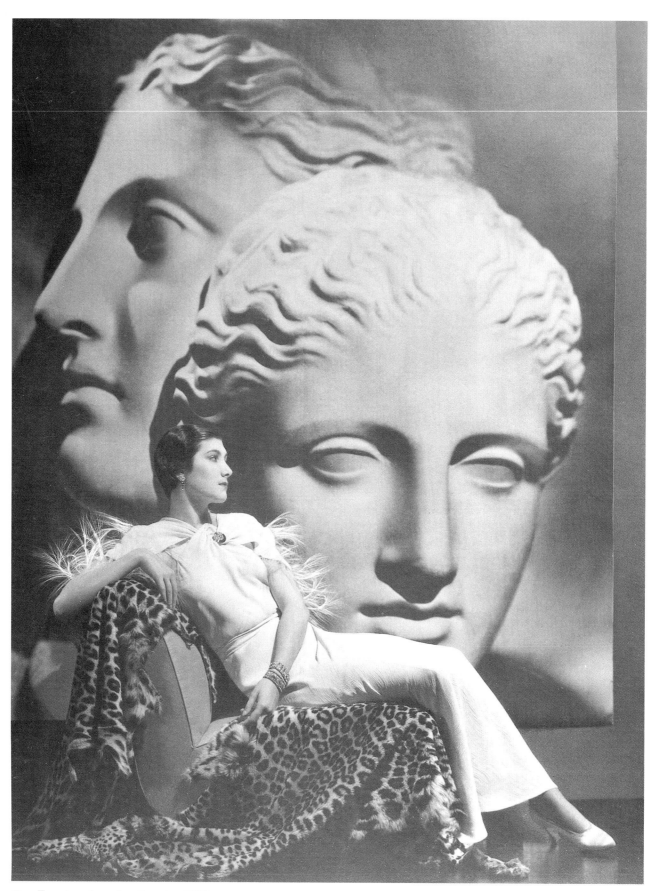

21 Evening dress by Paquin, 1934

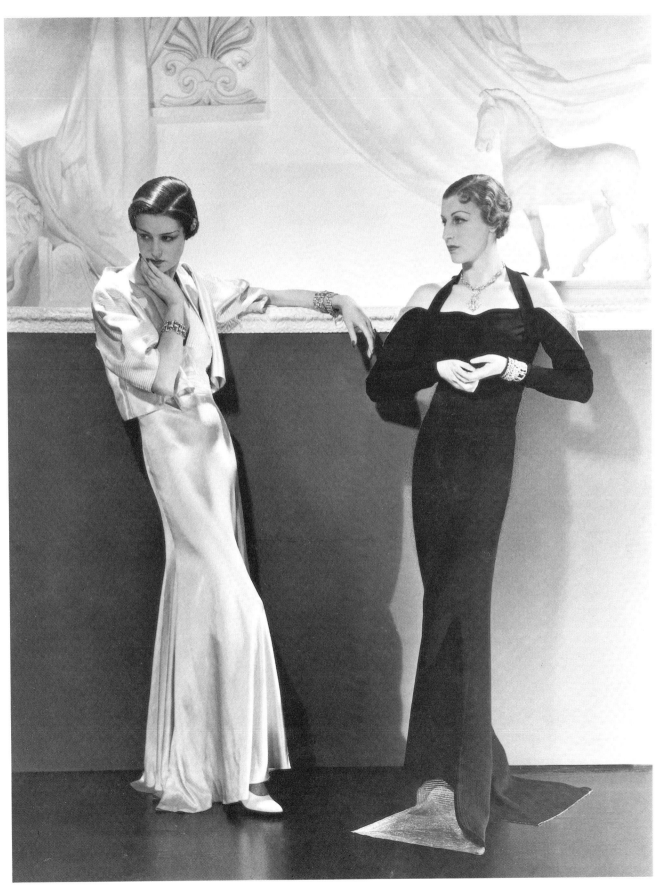

22　Jeanne Salmond and Mlle Boecler, evening wear by Lanvin, 1934

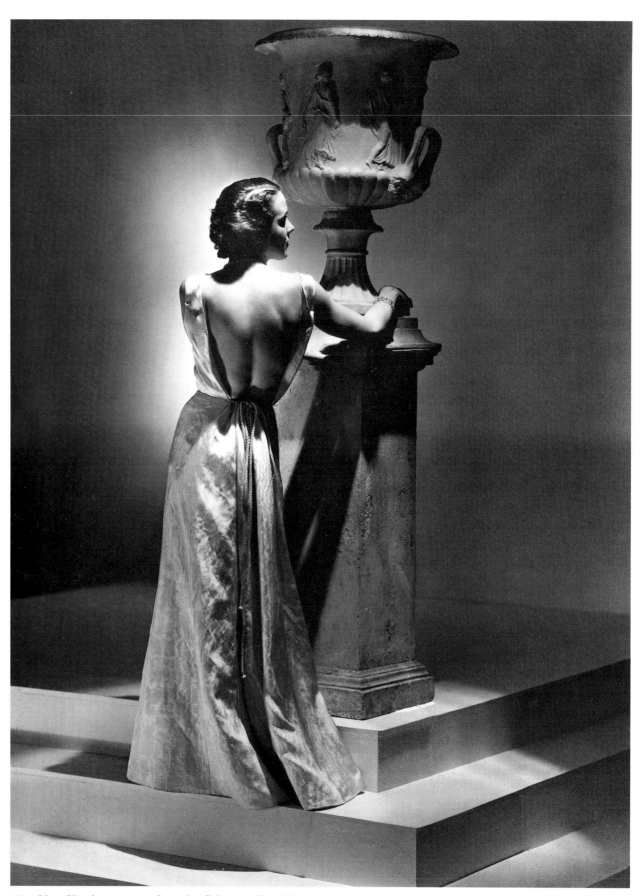

23 Miss Nicole, evening dress by Schiaparelli, 1934

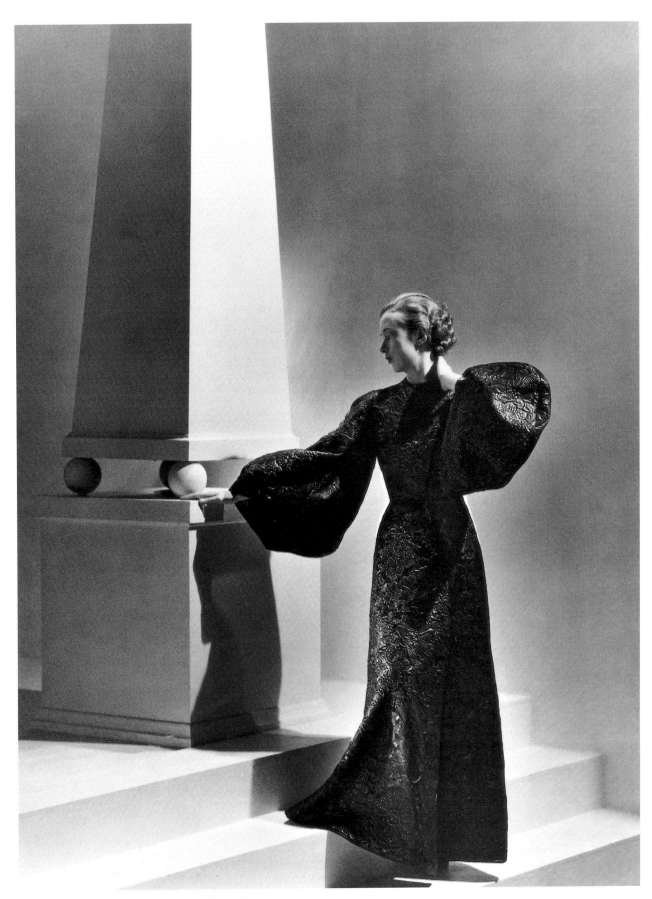

24 Marie Wolkonsky, dress by Alix, 1934

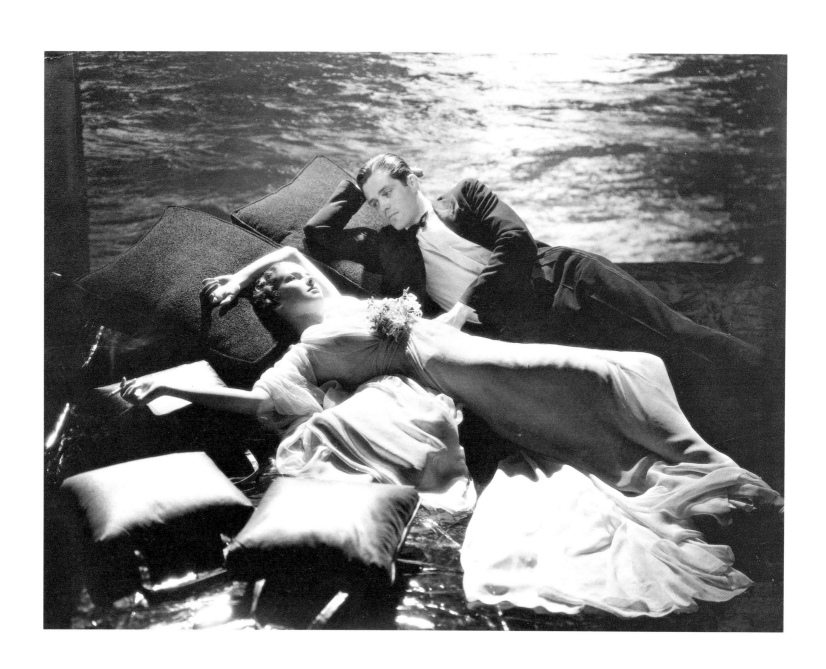

25 Fashions in chiffon, 1935

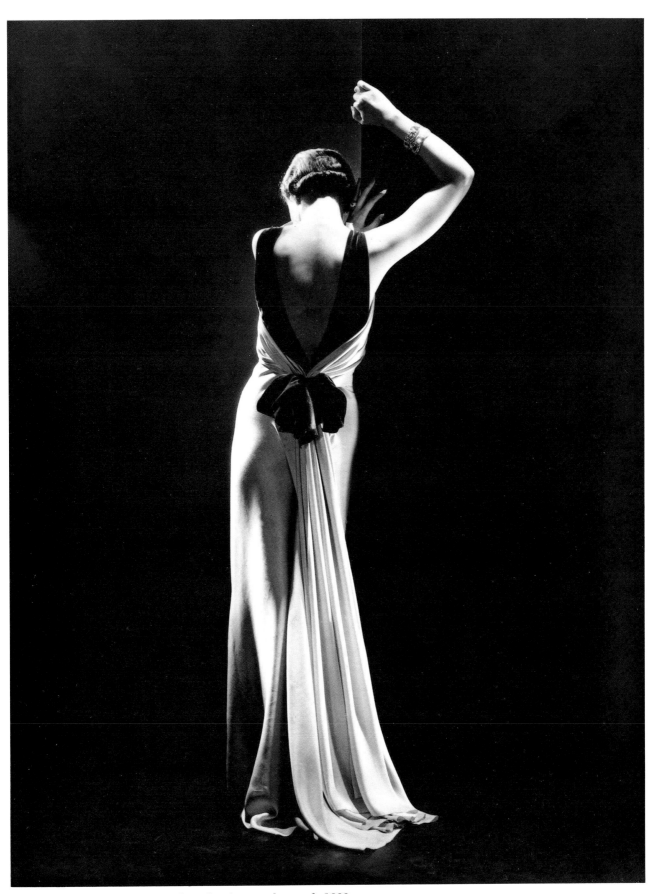

26 Toto Koopman, evening dress by Augustabernard, 1933

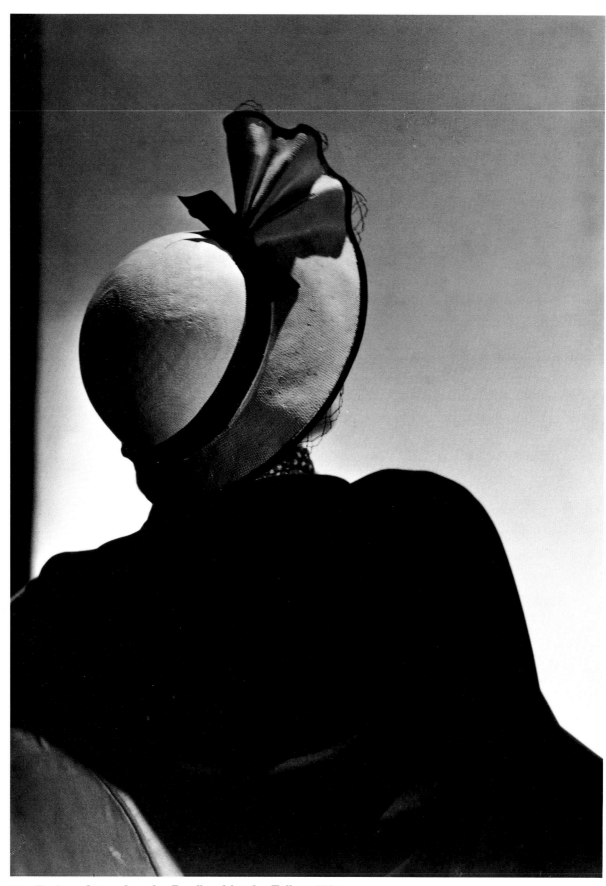

27 Evelyne Grieg, dress by Rouff and hat by Talbot, 1934

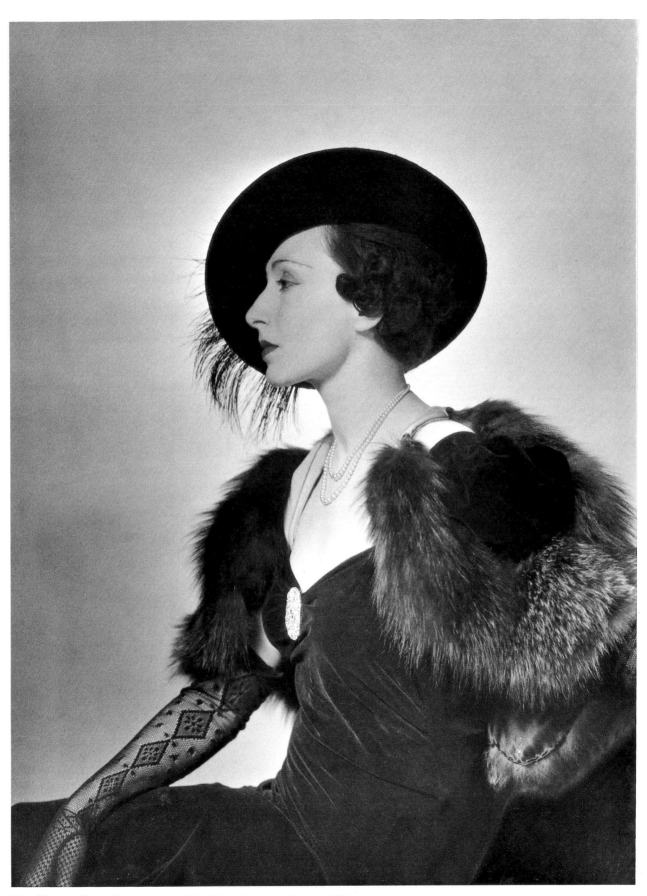

28 Nimet Eloui Bey, cape by Rouff and hat by Suzy, 1933

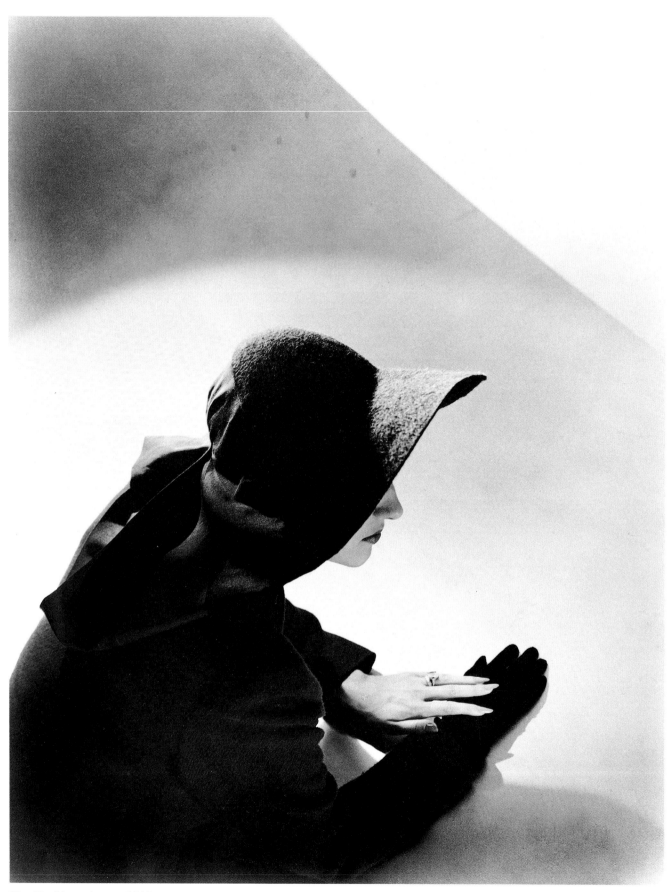

29 Fashion plate, *c*.1940

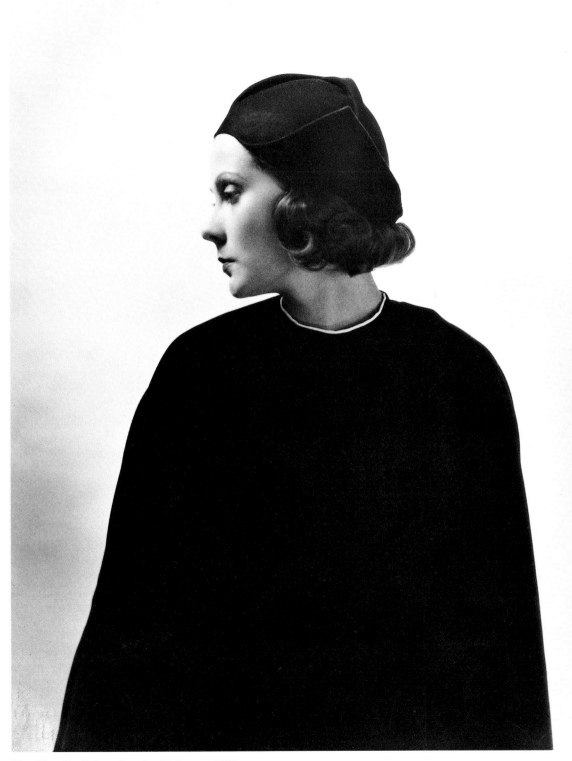

30 Natalie Paley, hat by Reboux, 1931

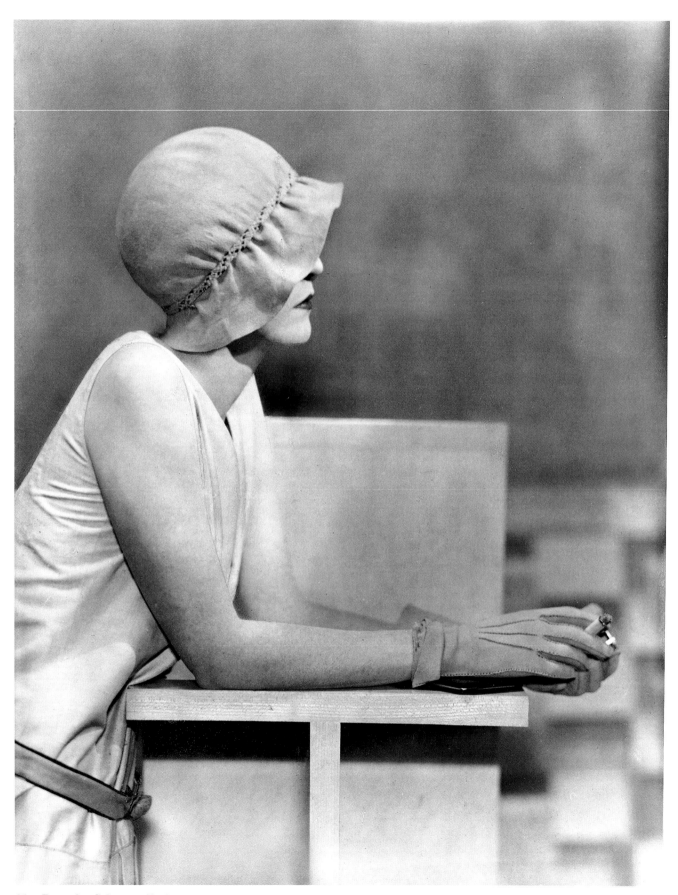

31 Dress by Schiaparelli, hat and belt by Maria Guy, 1929

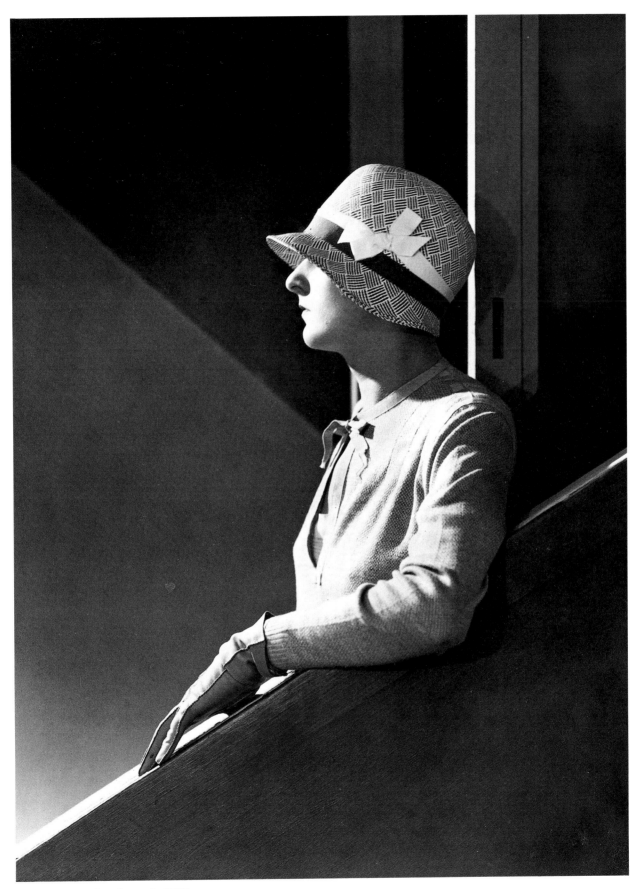

32 Daywear by Goupef, 1927

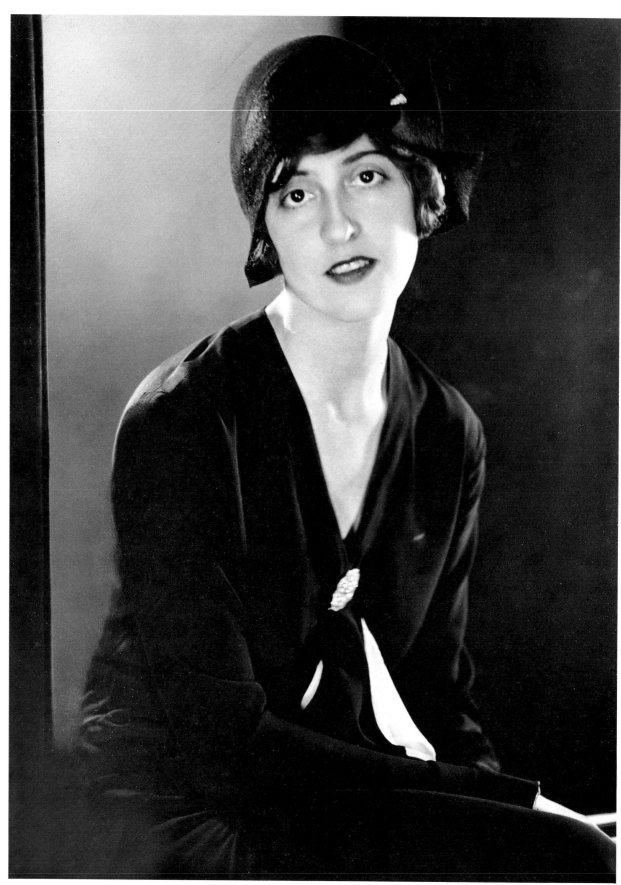

33 Unknown woman, Berlin, *c*.1930

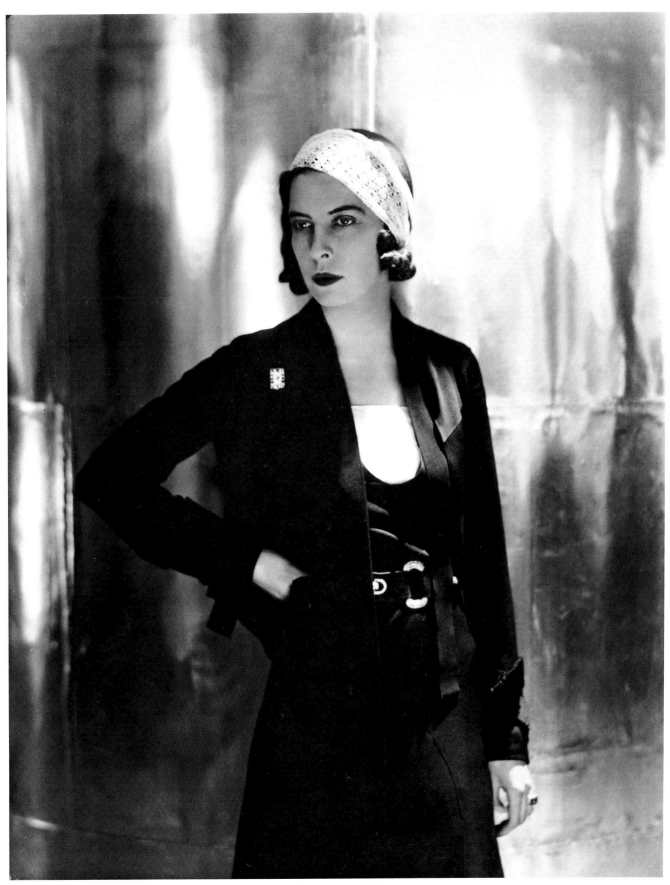

34 Princess Jean Louis de Faucigny-Lucinge, hat by Agnès, 1931

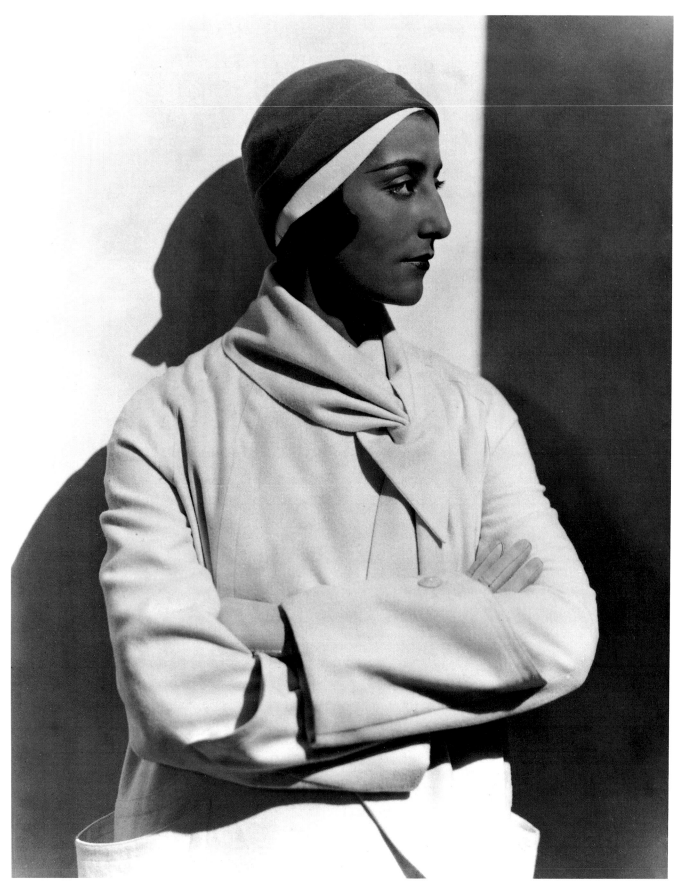

35 Simone Demaria, coat by Rouff and hat by Alphonsine, 1930

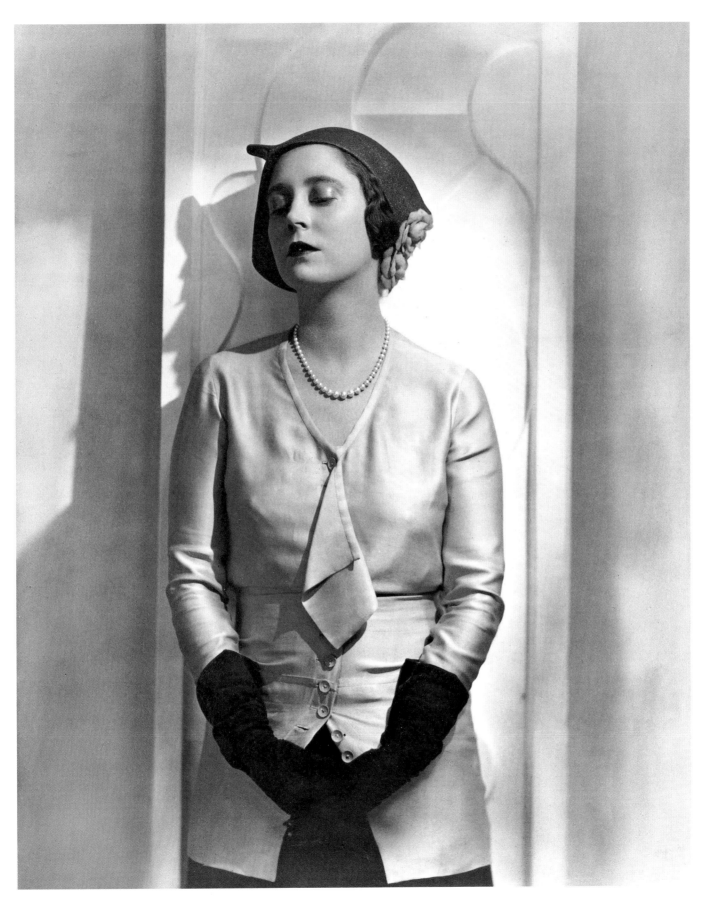

36 Mrs André Lord, outfit by Patou, 1931

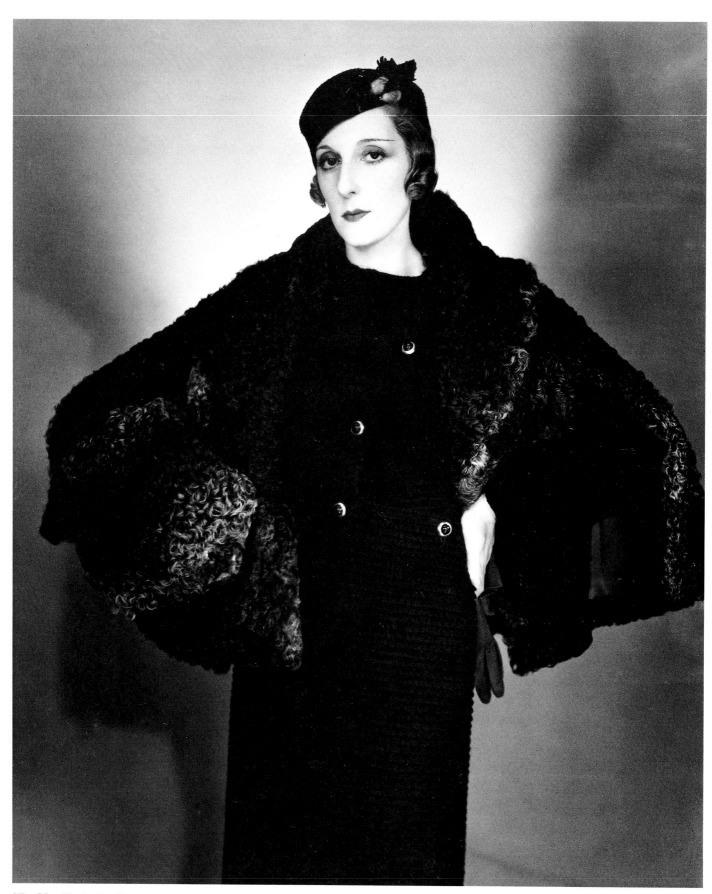

37 Mrs Nada Ruffer, cape by Heim, 1932

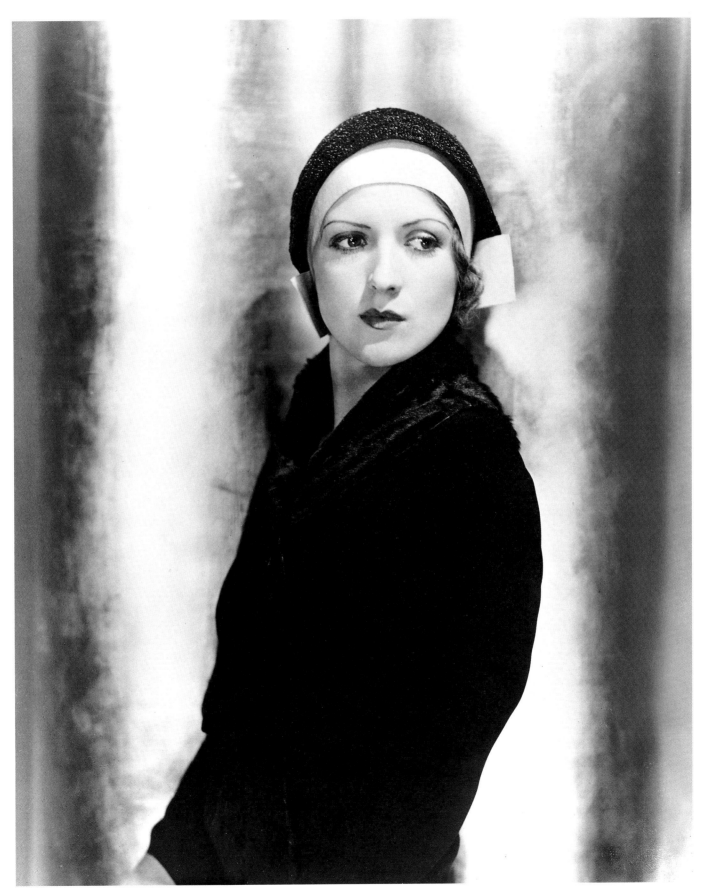

38 Miss Stutz, hat by Talbot, 1929

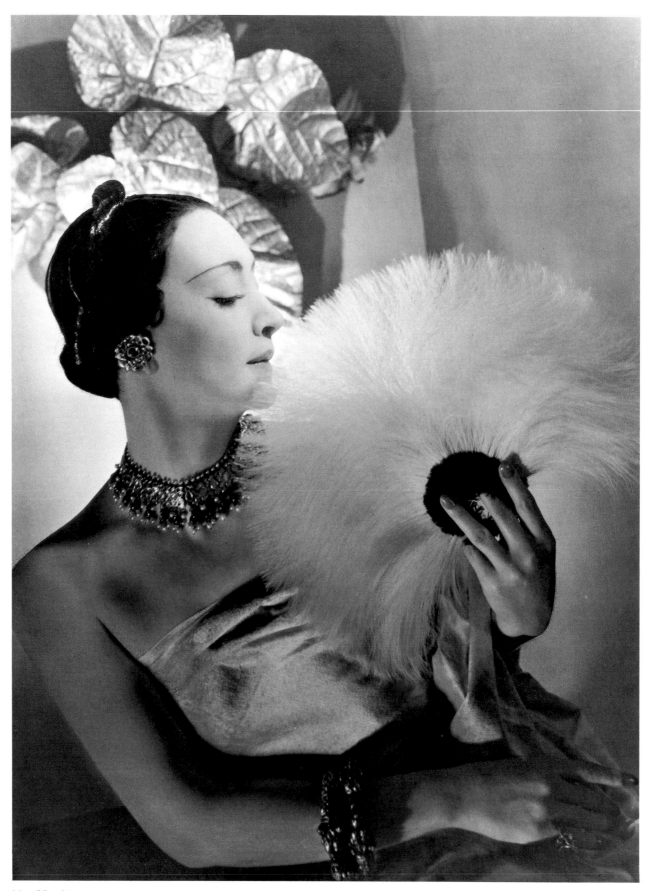

39 Mrs Muñoz, jewels by Cartier, *c.*1932

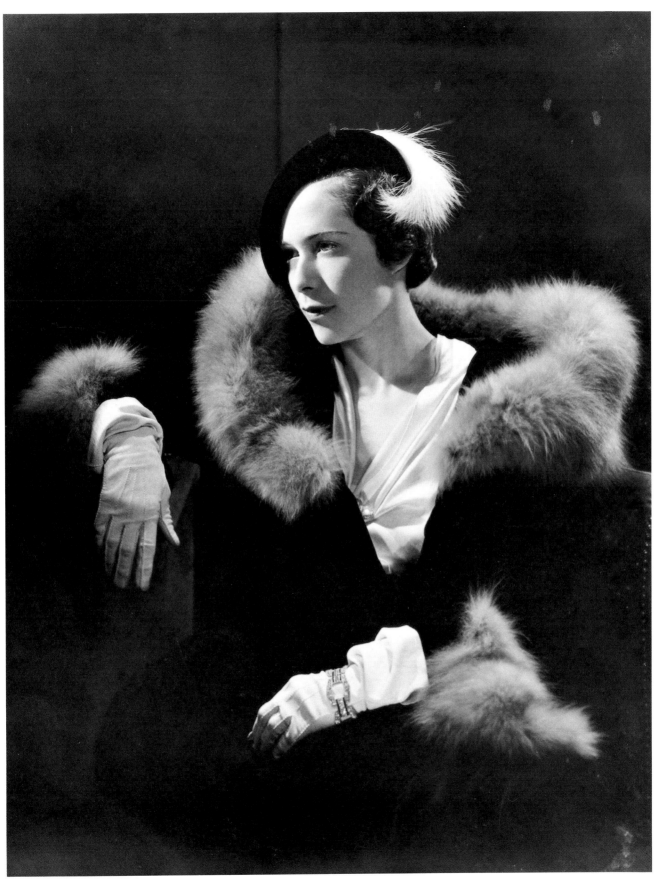

40 Mme Jean Bonnardel, coat by Paquin and hat by Reboux, *c.*1932

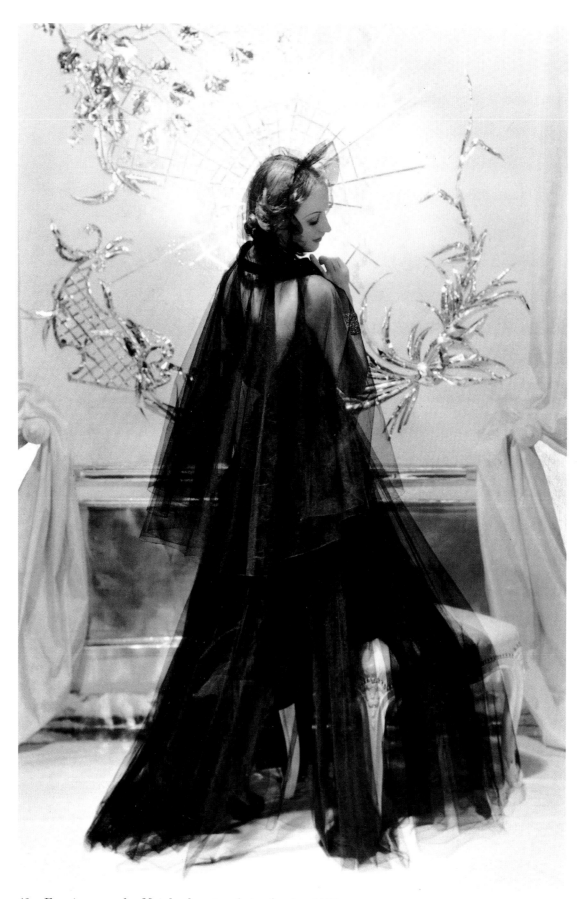

41 Evening wear by Mainbocher, jewels by Cartier, 1935

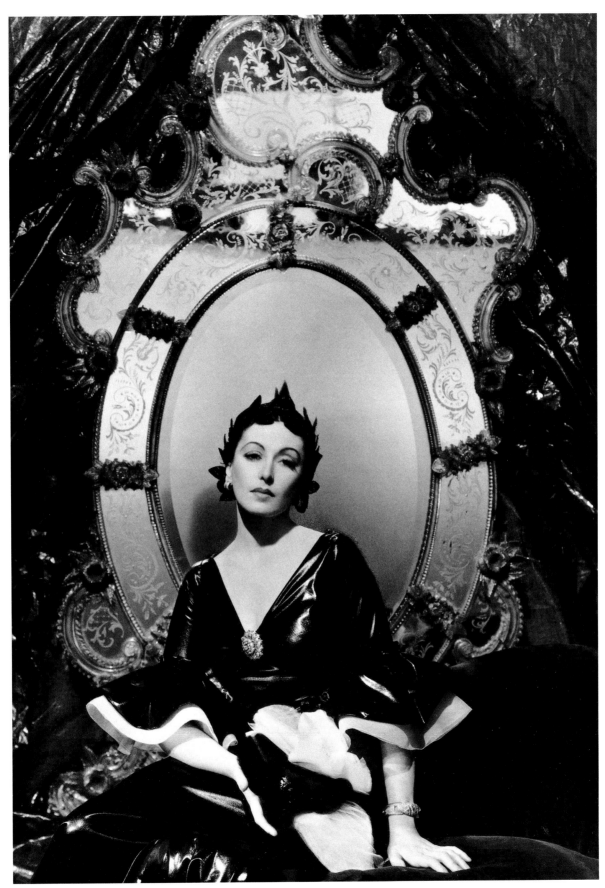

42 Nimet Eloui Bey, evening dress by Mainbocher, 1935

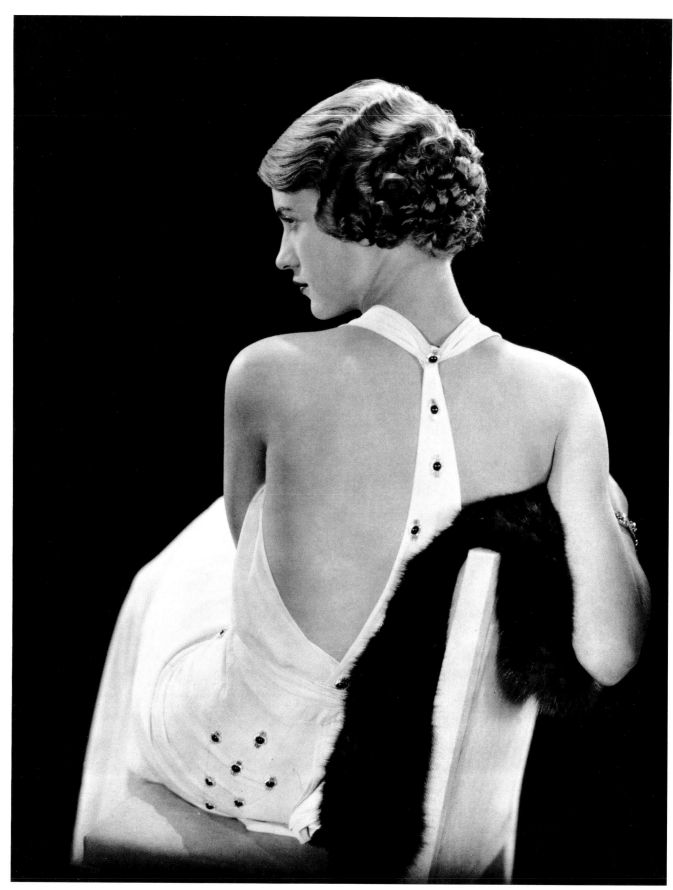

43 Lee Miller, coiffure by Callon, 1930

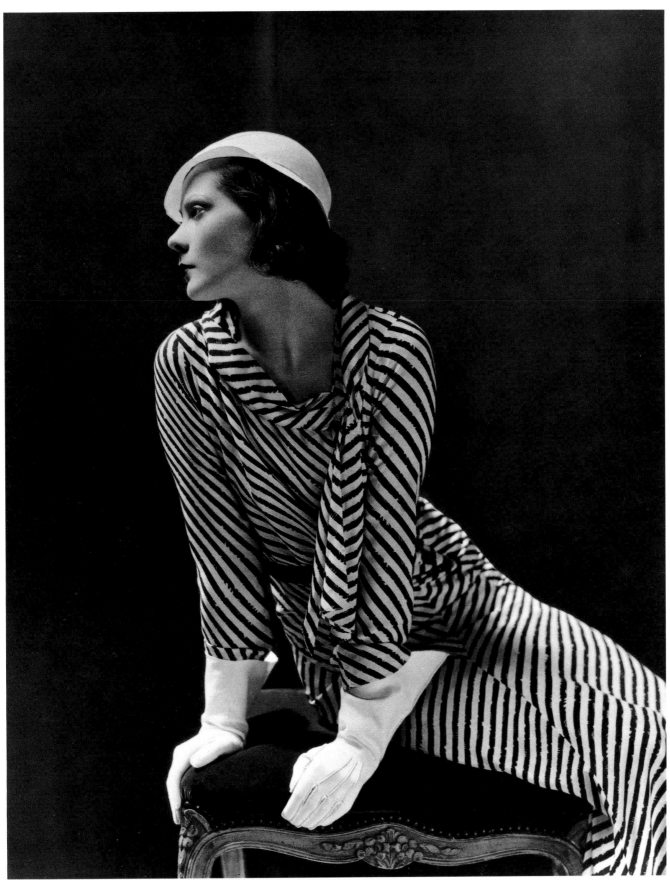

44 Mme Lucien Lelong, dress by Lelong and hat by Maria Guy, 1931

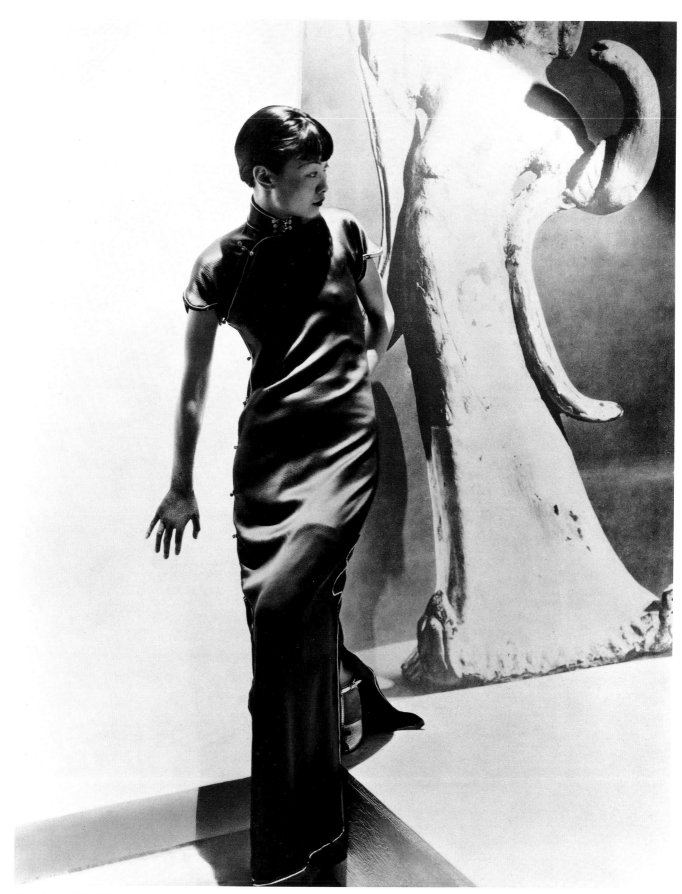

45 Anna May Wong, 1929

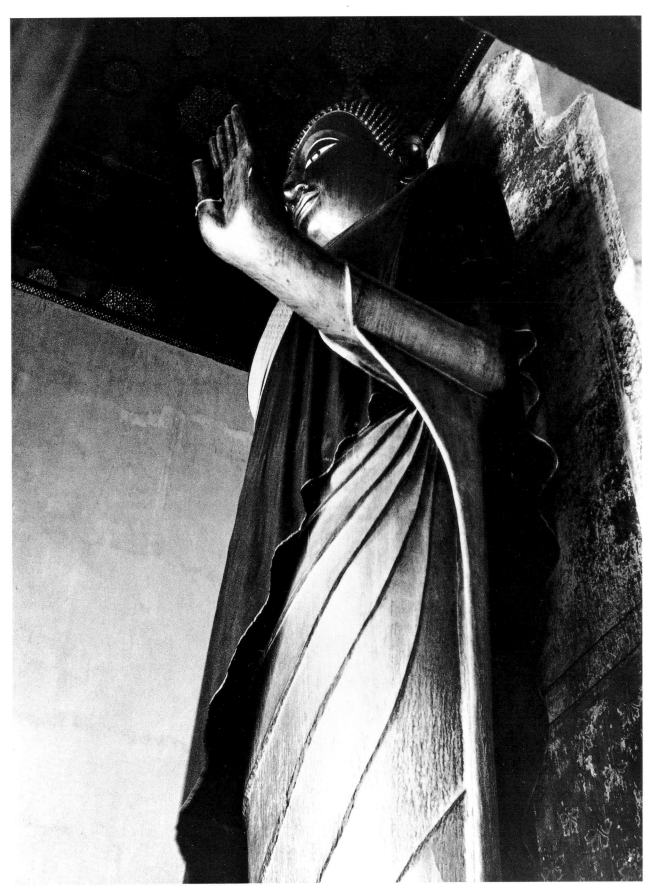

46 Temple, Bangkok, 1937

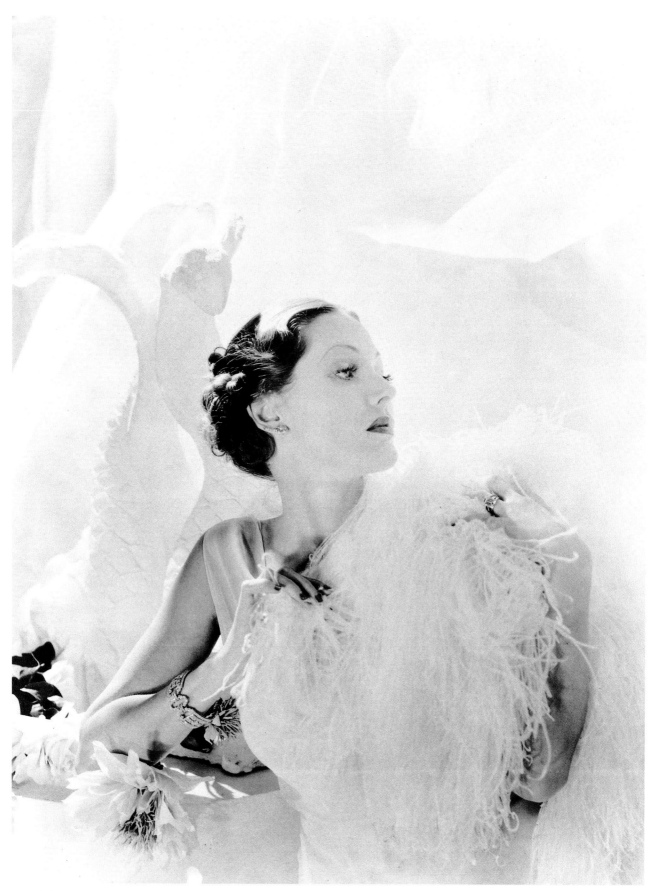

47 Adrienne Ames, 1934

Chapter Three

FOUNDATIONS
FOR A STYLE

Huene's position at Condé Nast was enviable. From a number of points of view he was ideally suited to the task; who among potential competitors had his savoir-faire, connections, grounding in art and firm friendships with artists? He was well aware that the answer lay partially in the immediate past – in the impressive contributions of Baron de Meyer and Edward Steichen, both in turn chief photographers at *Vogue*. Their highly developed styles, coupled with a willingness to experiment (de Meyer once shocked a dowager by dropping a light down her bodice an instant before snapping the shutter), paved the way for the risks Huene knew he would have to undertake in the quest for his own style. Their great successes were the best form of encouragement. They had extended the boundaries of fashion photography, and Huene's respect was based on close examination of their work and what had gone before, not only in their field but also in creative photography as a whole.

Huene knew that prior to 1914, when de Meyer had been appointed by Condé Nast, the photography of fashion had essentially been a matter of straightforward documentation. A number of atypical "expressive" studies can be found,[1] and there was certainly any number of pictures of fashionable society, but de Meyer was the first to approach fashion photography as a professional creative artist, and there is no question that the man whom Cecil Beaton once called "the Debussy of photographers"[2] made a spectacular contribution.

Huene rightly credited de Meyer with several achievements. For one, he had made fashion photography a highly regarded activity. Until de Meyer, explains Philippe Jullian in a biographical essay, "a gentleman might just possibly publish his poems or perhaps exhibit his watercolors, but as for photographing his friends and selling the prints . . . impossible! A photographer was then a little man one sent for at the end of a house party to photograph its members, grouped in order of precedence around some illustrious guest. Or else it meant the owner of a studio, such as Lafayette or Reutlinger, who used tricks of lighting and background so that their models looked as though they had been posing for some Academy painter."[3] The Baron and his wife, Olga, were considered terribly chic, and with his casual, elegant air he professed only an amateur's appreciation of photography (he once listed his hobbies, in order, as "music, painting, photography"[4]). The offhand attitude suited his public image, but we now know that he approached his work with the utmost seriousness. He once wrote to his friend Alfred Stieglitz that his claim to be "the finest photographer in the world" – an attitude endorsed by *Vogue* and *Vanity Fair* – was "a much needed bluff."[5]

Clearly, Huene saw through the pose. He tells us what impressed him about de Meyer's photographs:

They had the mysterious air of making every woman look like a vision in a dream or an apparition inside a backlit aquarium. Most of his subjects were posed against shimmering backgrounds thrown out-of-focus and accentuated with highlights against which the subject appeared in an even and diffused fill. de Meyer had studied with Gertrude Kasebier, who was

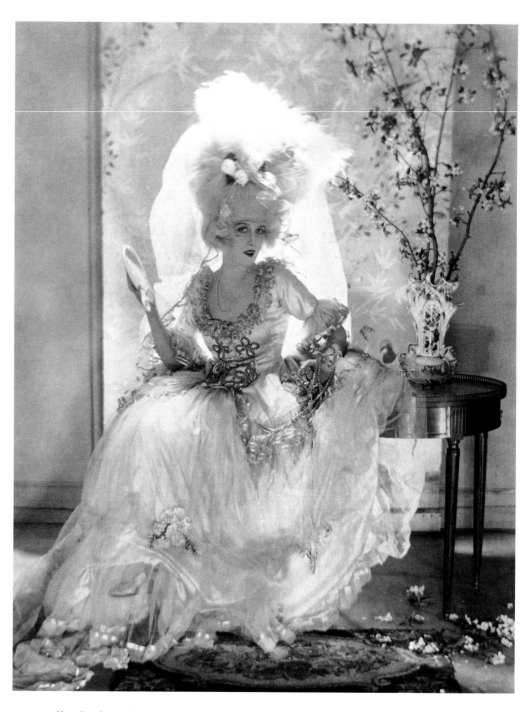

The quintessential de Meyer: a portrait of *Follies* star Helen Lee Worthing in 1920, when the baron was at the height of his reputation

supposedly the first photographer to introduce backlighting ... There is no doubt that de Meyer was a master of the medium, which gave him in all justice an outstanding position in the domain of creative photography.[6]

Huene never gave de Meyer's extravagance much rein in his own work. He was of a different era, and the conceits of the pictorialist school which de Meyer had adopted – such as imitations of charcoal or pastel effects – were no longer as appealing. In the essence of his style, Huene was to follow the modernism of Steichen, although a number of his photographs, even in his later work for *Harper's Bazaar*, demonstrate his unwillingness to jettison entirely de Meyer's dreamy treatments. On an earlier occasion, as one of a series of six images imitating the styles of other famous

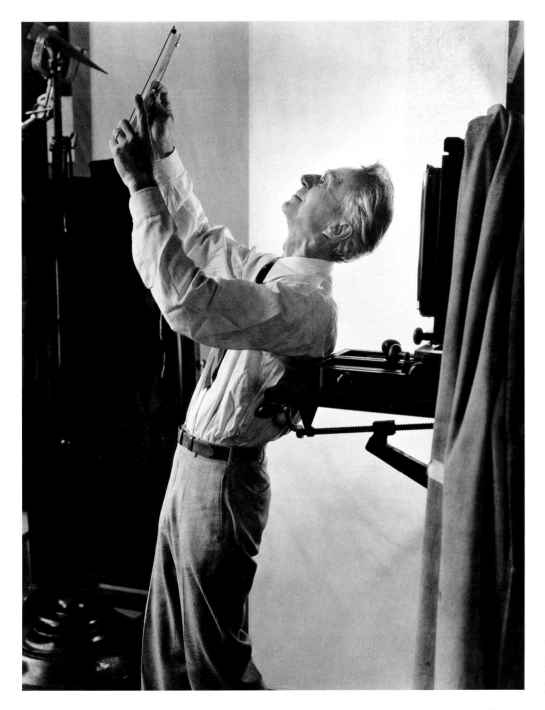

Edward Steichen by Huene, probably photographed *c*.1941 when Steichen was working as an official US government war photographer

photographers (*overleaf*), he constructed a marvelous facsimile of a Baroque de Meyer. It was only partly in fun; he was also paying homage.

Huene considered Edward Steichen to be the greatest figure in photography since its invention. He was familiar with examples of his work well before Steichen went to work at *Vogue* in 1923: "For years I had admired Steichen's great masterpieces of photography, the famous study of Rodin the sculptor contemplating *The Thinker*, the portraits of George Bernard Shaw, Isadora Duncan, and the outstanding portrait of J. Pierpont Morgan, with the highlight on the arm of the chair like a dagger in the hand of the millionaire."[7] Now, as a professional photographer himself, he could appreciate Steichen's fashion work: "His fashion photographs were sharp and crisp, in contrast to

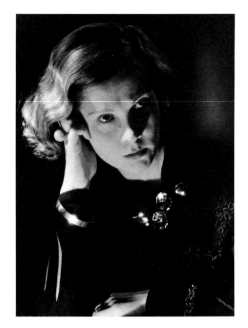

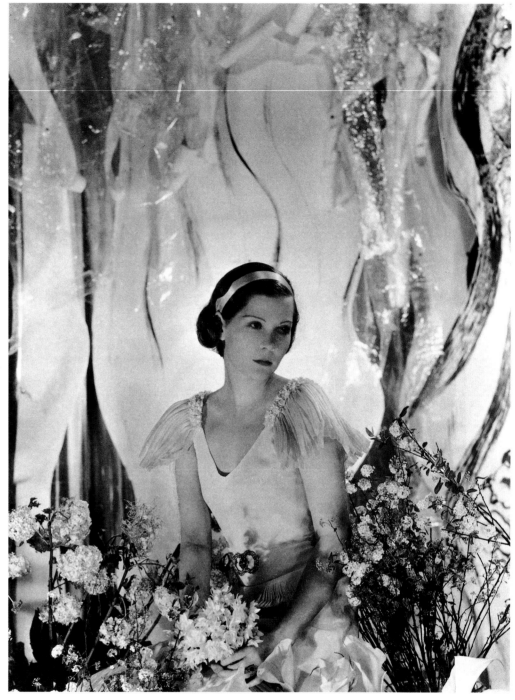

"The man behind the camera:" six portraits by Huene of Mme Lucien Lelong in the manner of various photographers. On this page: Edward Steichen (*top left*), Man Ray (*bottom left*), and Cecil Beaton (*right*). Opposite: Baron de Meyer (*left*), Helmar Lerski (*top right*), and David Octavius Hill (*bottom right*). 1933

de Meyer's. Steichen's models were alive, as if about to step out of the pages of the magazine."[8] Huene approved of Steichen's portrayal of women – bold, independent creatures, resolute yet relaxed. In contrast, de Meyer's women were the most precious of objects, increasingly anachronistic in the postwar social order.

There was an appreciation of Steichen's technique as well. Huene noted his control of solid blacks and stark whites, his brilliant accents of light and use of overall flood to penetrate the shadows. Huene deduced that Steichen's aerial photography for the Americans during World War I had led him to a new awareness of pattern, line, and,

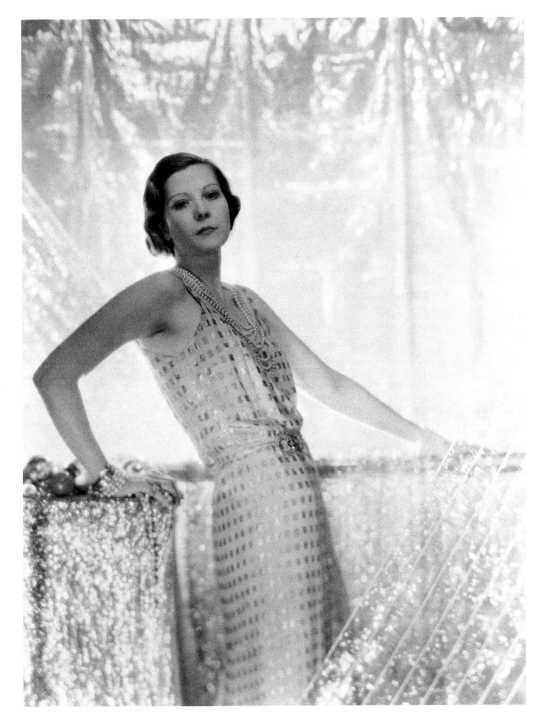

most important, visual clarity – a key consideration in view of the fact that high-definition images allowed superior reproduction by photo-engraving.

On his visits to France Steichen allowed the younger photographer to observe him at work. Huene made careful observations and jotted down his mentor's advice. Among the techniques advocated was speed: "Never let the sitter get bored. Never let on that you are at a loss, even if you are. Ideas will come up as you work. Never lose control of your sitter. Keep moving. Keep taking pictures. Then when you know you have it, stop."[9] Such advice was priceless, the pragmatic kind handed down directly to

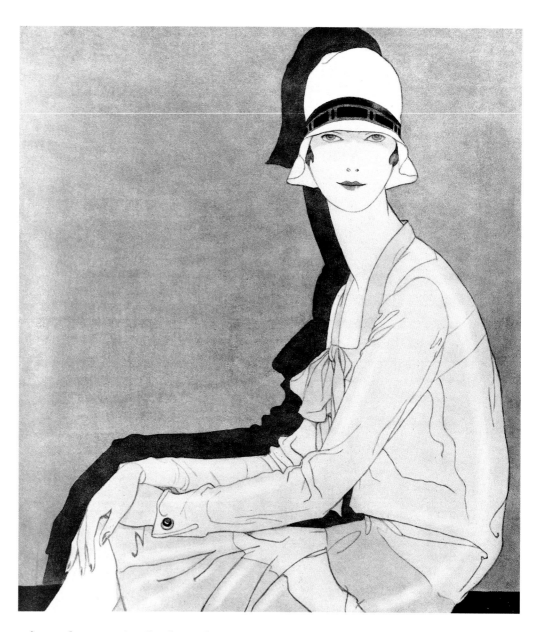

There was a considerable amount of give-and-take between fashion drawing and photography. Douglas Pollard's *Hat by Alphonsine*, 1927 (*right*), anticipates photographs like Huene's 1933 portrait of the actress Elisabeth Bergner (*opposite*)

a favored apprentice. Lacking glamour, it was not intended for public consumption. *Vogue* and *Vanity Fair* also issued tidbits of advice to would-be photographers. In their idealized descriptions the photographer was *always* in control. Huene kept a clipping of such advice attributed to Steichen: "In addition to directing the activities of his assistants the photographer plays the clown, the enthusiast, the flatterer. He acts and talks about other things while his mind is watching the building up of the picture—its lights, shadows, and lines; its essential fashion photograph requirements— distinction, elegance, and chic."[10]

Steichen's preeminence at *Vogue* was underlined at every turn by Condé Nast himself, who sincerely believed that the photographer's approach and his distinctive style could not be improved upon. Nast admonished the younger photographers to adopt the master's methods, even, it seemed to Huene, to the point of slavish imitation. In no way begrudging Steichen his position, Huene naturally rebelled, determined to make his own mark.

Photography was not the only pictorial influence. Huene had great admiration for

the first-rate illustrators who graced the pages of *Vogue*, many of whom had begun illustrious careers with the small but exquisite production *La Gazette du Bon Ton* – Georges Lepape, André Marty, and Edouard Benito for instance. He appreciated the diverse influences they had assimilated – the Fauvism of Matisse or Van Dongen, the geometrics of Mondrian, or the Surrealism of Dali and de Chirico – and the enthusiasm with which they kept abreast of the modern movement. Huene's own style showed affinity with the cool, elegant look of Polly Francis, a fellow American living in Paris; with Benito, who loved audacious pattern and severe line; with Lepape and Ernst

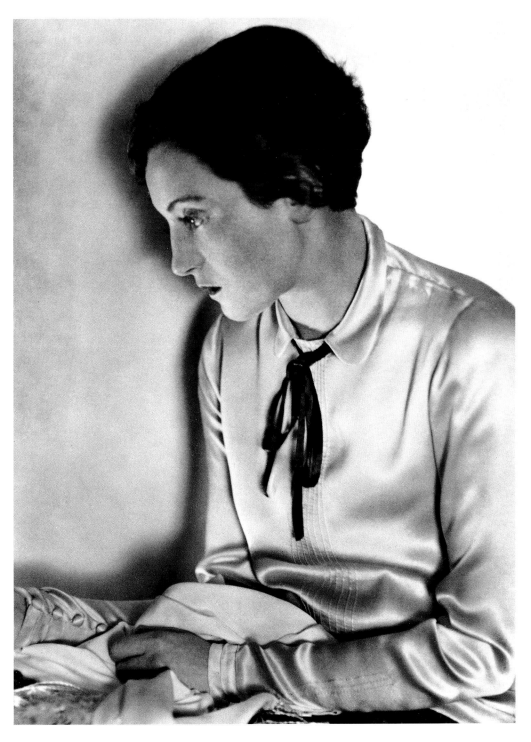

Dryden, whose creations conveyed the new freedom of movement accorded the modern woman by the automobile and airplane; and with Douglas Pollard, whose robust clarity of composition and relaxed, confident women mirrored his own.[11] As a studio-bound photographer Huene envied the illustrators for their freedom to depict women in dramatic settings – at the races, fox-hunting, aboard liners, at the opera. His own elaborate sets would reveal his determination to devise equally arresting images. In his later years, as a teacher, he advised aspiring fashion photographers to begin by learning to draw.

Huene launched his career with a thorough study of the technical obstacles and esthetic problems of depicting fashion through photography. "Was there no way to render images of women the way you saw them," he wondered, "in their normal surroundings, pausing for a moment during their daily activities and not posing for a photograph? Somehow the photographers had as yet not captured the attitudes and gestures that women assumed. The models seemed to freeze in front of the lens, as if posing for their portraits, whereas the top fashion illustrators would render them as they actually saw them in real life. Was there no way of achieving the same results with photography?"[12]

Compared with modern equipment, the technical difficulties were formidable. The smaller cameras that were available could more easily capture the moment, but the only film for these instruments was excessively grainy and did not allow for satisfactory reproduction. The larger cameras, which did produce good results, used glass plates with slow emulsions and required difficult and time-consuming technical preparations for each take. Huene described the "agonizing moment" when, after manipulating the ground glass in four directions and focusing on the subject, the lens was stopped down, the shutter closed, the plate holder inserted, the plate holder cover removed, the camera steadied, and the exposure made. Besides, the timing for this was guess work, since light meters had not yet been invented. Huene recalls the frustration: "If for some reason the subject changed position during these manipulations, she would move out of the focal range and we would have to start afresh. The delays invariably brought about limitations, and the results tended to become static. No matter how fast we worked, the problem of creating an impression of movement seemed insoluble."[13]

Light, too, posed unique problems. Huene experimented as much as the time would allow in an effort to come to grips with the tricks light played. He grappled with double, overlapping shadows that threatened the essential form and its volume. He also reported difficulty detaching the subject from the background without losing the subtle background values he wanted to retain. As he progressed, he was forced to concede that the problems inherent in studio lighting seemed to increase in complexity rather than diminish. He grew to appreciate Steichen's wry observation, "Light is a charlatan."[14]

Huene's difficulties were compounded by the diverse demands of designers, fashion editors, accessories editors, beauty editors, and models. Each dress required a fresh approach. Each would be enhanced by the right gestures and movements. In Huene's experience, the models needed to convey an appearance of absolute naturalness in order for the photograph to come alive. This meant that he would have to come to terms with what he called the "structure" of each model. He would work at projecting convincing mood, femininity and grace, or "inner charm" as he liked to put it, for the next twenty years.

Chapter Four

THE ELEMENTS
OF STYLE

In the most general sense, Huene's style was the quintessence of early Thirties functional elegance. It was of a kind with Mies van der Rohe's German Pavilion at the 1929 International Exhibition in Barcelona, Marcel Breuer's furniture, Charlotte Perriand's chairs, Richard Neutra's Los Angeles Health House, and A.M. Cassandre's posters, a famous example of which sums up the spirit of the day in one word: "Exactitude." Style around 1930 meant, in the words of K.-J. Sembach, "Precision, luminosity, transparency, immediacy, sensitivity to material, logic and freedom from sentiment and dogma."[1] In fashion, it was epitomized by Mrs Wallis Simpson, later the Duchess of Windsor, elegantly dressed by Molyneux (see plate 129): of her, *Vogue* wrote "our present standards demand beauty of figure and finish."[2]

A full appreciation of Huene's individual style must begin with his masterful handling of light. Keeping in mind the relatively crude technical apparatus of the day, as well as the insensitive film (which, moreover, did not permit color), it seems only natural that the photographer would turn his attention to the most malleable ingredient of the photographic enterprise – light itself. In view of the physical confines of the studio, only the manipulation of light sources could transcend the four walls and create illusions of unlimited space. A studio photographer could take few liberties with dress, accessories, or model, but light was his exclusive domain – in the words of a contemporary of Huene, Albert Renger-Patzsch – to be fashioned into a thousand creative forms.[3]

An able technician and gifted artist, Huene learned to fabricate complex imagery by building up blacks, whites, and subtle half-tones into a rich chiaroscuro. He employed a variety of lights and lighting devices (some of his own invention), and delighted in the expressive possibilities buried in the preliminary profusion of overlapping shadows. That his Cubist studies helped him sort out the problems posed by such an array of lights is evident from his early drawings, which had always included striking shadows. In these illustrations, the geometric patterns of shadows seem to have been as important to the artist as the ostensibly primary subject matter, the dresses themselves.

With each assignment Huene strove for a novel approach to lighting, keeping in mind the salient characteristics of the clothes. The intentions of the designer were always considered. Simplicity in a garment was matched by simplicity of image. A dress with an arresting cut might have its silhouette projected enlarged on the rear wall: a dramatic pattern of such silhouettes might even be created by employing a number of lights from different angles. Or, when sensuous contours, diaphanous fabric, or delicately feathered hats were to be featured, the photographer would use diffuse rear-lighting. He knew that different materials responded differently to light, and he knew how to make them appear to their best advantage when translated to the surface of a photograph. This was also true when it came to rendering exquisite hues monochromatically, on black and white film.

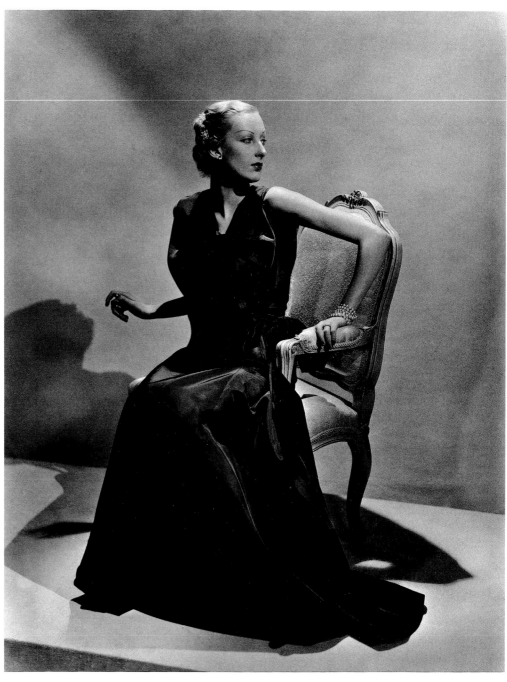

This fashion study for *Vogue* of 1934 was described by the magazine as embodying "an eye for detail and sense of anticipation;" in its complex handling of light and shadow, its clarity of effect, and suggestion of imminent movement in the model it represents a distillation of the essential elements of Huene's style

In portraits and fashion studies we detect André Lhote's method of "alternating lines and curves;" where strong rectilinear elements characterize the subject, Huene molds shadows into rounded forms; where curvilinear forms are dominant, shadows are structured as rectilinear elements. Strong shadows are also used to frame white-clad figures on a black ground, and to model dramatic features of face and body. Sometimes such features are thrown into shadow to impart a sense of mystery and ambiguity, or merely to play down distracting detail. Slivers of shadow are consistently employed as vertical and horizontal accents in the overall composition.

Shadows were not always ancillary; a shadow could be the subject itself, or rather an extension of the subject. For example, in one of Huene's portraits of Igor Stravinsky (plate 96) the shadow thrown on the wall by the composer's head dissolves

seamlessly into his shoulder. Here is clear evidence that Huene recognized that light could have concrete substance. In Stravinsky's portrait he has utilized shadow to create a bold sculptural effect which suggests superhuman proportions. It was Huene's way of paying tribute to Stravinsky's uncompromising art.

In *Toto Koopman, evening dress by Augustabernard, 1934* (plate 17), we can observe a system of such shadows, carefully contrived to set off the dress in a most refined and sensuous manner. A raking light from the left of the set accents Miss Koopman's pronounced cheekbones and creates a long, dark scimitar of shadow which sweeps back from the delicately poised hand. A shadow cast by the model's lithe body is framed by the pedestal; this shadow relates to the naked torso on the pedestal, thus titillating the viewer with a suggestion of Miss Koopman's thinly veiled nudity. Raking light also fashions deep, curved shadows among the undulating folds of the dress, establishing this as the primary focus of the picture. Dark angular shadows are formed on the stairs beneath her, creating a popular Art Déco motif. A small pool of shadow falls gracefully at her feet, themselves hidden from view to suggest an etherial creature. Nothing is left to chance in this remarkable image, in conception and execution one of Huene's most brilliant.

Lighting was only one area subject to Huene's control. His training in drawing had impressed upon him the importance of the minutest detail in the overall composition; an eyelash, a finger, a ring on a finger – even a fingernail – could make the difference between excellence and mediocrity. Although his pictures seemed the epitome of casual elegance, they were painstakingly composed and choreographed. On composition he wrote, "One factor was a great help to me. I had to compose in the ground glass of the 18 × 24 cm camera upside down. This had the advantage of enabling me to view the image as a series of abstract elements."[4] Here he touched on a factor in perception: although we assume that we "see" the real world objectively through vision, scientists tell us that our perception is not purely an optical phenomenon, but is mediated by complex mental processes. Thus we are prone not to recognize familiar things seen upside down. For a photographer, however, at pains constantly to see the commonplace anew, such disorientation is a constructive thing, allowing him to view a particular segment of reality with fresh eyes, or, as Huene has explained, as an abstract image.

Drawing had also taught him about the importance of line. He adopted the straight lines and geometrics of Art Déco, which had come into prominence with the great Paris exhibition of 1925, but the lessons had been learned from Constructivism. Art Déco was about pattern and decoration; Constructivism was about order and strength. Huene found such ideas useful in structuring dynamic imagery, all the more so in view of the fact that strong straight lines and angles offset the soft, flowing contours of fashionable garments.

Huene relied on his directorial talents when dealing with his models. His pictorial objectives were casual elegance and pose, or what he called "serene inner content-ment" on the part of the model. He was careful, therefore, to spare the model fatigue in the setting-up stage. Lisa Fonssagrives-Penn, one of Huene's favorite models in his *Harper's Bazaar* period, recalls how stand-ins were used to allow Huene to work out problems at his leisure. The model was then invited to take up her position.

Mrs Penn remembers the aura of firm command Huene projected in the studio:

He had a quiet, authoritative manner, always in control, but at the same time he was always polite and extremely considerate. He knew precisely what he wanted, or at least appeared to know. I always looked forward to an assignment with him. He was a professional and he treated those around him as professionals.

Huene's handling of light and shadow. *Above:* detail from plate 54; *below:* detail from plate 17

But for me personally there was something even more important. You knew upon entering the studio that this was not going to be an ordinary experience. Each time I worked with him I felt his studio was something of a temple, and the way we worked was like a worship ritual. The events which transpired there were of value that eclipsed the moment. Perhaps it had to do with making art – not that he would ever have put it in those terms. The sittings there were always meaningful for me and I can't remember ever being disappointed.[5]

Not everyone was so charmed. One editor remembers that "he would walk into a sitting late, take one withering look at the models standing nervously in the dresses . . . turn to the editor in charge, and say, 'Is this what you want me to photograph?', snap the camera a few times and walk away. Everyone was terrified of him."[6]

It is likely that Huene's intention was to instil discipline rather than to intimidate. Mrs Penn's recollections match Huene's own account of sittings:

I always insisted on complete silence, no noise, no music, no muttering behind my back. The model had to be under my control completely. I was patient and always encouraging; even if she did not at first do what I wanted, I would make an exposure and praise her and then improve until we reached the desired climax, by which time the model was elated and after the last shot felt a let-down. It was almost hypnotic. I purposely avoided any conversation with the model in order to maintain the discipline of intense concentration. One psychological expedient was to make them conscious of their femininity. Someone once said that in many of my stills the models looked as if they were about to be kissed.[7]

Vogue once employed a writer to let their readers in on some of their master photographer's secrets. In reverent terms he described a sitting:

The photographer, Baron George Hoyningen-Huené, very lightly clad in white linen trousers and a vest (for when the lights warm up the heat becomes intense), moves here and there shifting this and that, directing with a gesture robot-like men, clad from head to heels in dark overalls, their hands protected by heavy leather gloves, the eyes by enormous goggles, who noiselessly supervise the array of lamps. He says a word to the mannequin who moves into the circle of light, looking like a weird ethereal creature from another world. A shining silver pillar is put behind her, she takes an easy pose . . . a female figure slips forward from the surrounding shadows and adjusts a fold of drapery, a lock of hair, a voice says "Hold that pose, please . . . again, please." The silver screen is replaced by a black velvet screen, a big bowl of sweet white lilies placed on the floor. "Do something different with your hands . . . there, hold that, don't move." The figure in the circle of light moves as if hypnotized.[8]

Experience quickly taught Huene that "less is more" in the studio:

I would plan backgrounds and introduce various props; then in the middle of a sitting I would discover that they hindered me, and I would instantly discard them, no matter how much I had planned the overall effect; and once I had freed myself of all unessential contraptions, I would return to the simplicity and calm of an unencumbered scene and concentrate on the mood and attitude of the model.[9]

Among the finest groups of Huene's work are the swimwear and sportswear pictures he produced in the early Thirties (see plates 48–67). Full of light and air, their crisp, bold treatments were perfectly in tune with the fashions themselves and with the contemporary cult of sunbathing. Although each image seems composed only of basic essentials, the photographer managed time and again to recombine them in fresh arrangements, with deceptively simple lighting effects, strong graphic elements, and elegant poses. A study of detail convinces us that nothing was left to chance.

Such focus on essentials is readily apparent in the photographer's prolific portraiture as well as in fashion studies. Huene was content with the simplest of backdrops, preferring to concentrate on physiognomy, profile, a nuance of expression,

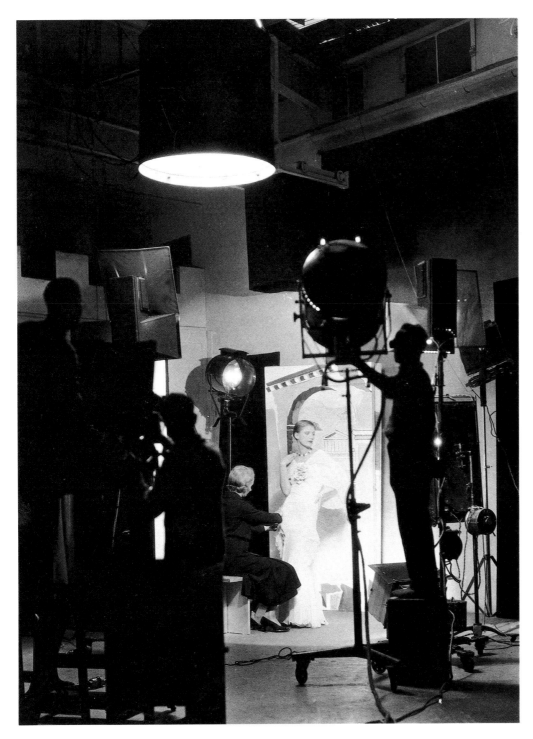

Huene at work: a fashion sitting in the Paris *Vogue* studios in 1931. The model is Lee Miller

the slightest gestures, and such details of dress (a protruding cuff, jewelry, handkerchief) as might enrich the composition. And as we have seen with his fashion shots, much was made of shadow and light. Huene had not forgotten the effectiveness of the dagger-like light in Steichen's portrait of J. Pierpont Morgan.

His strength with portraiture was not only a matter of his usual technical virtuosity – this alone would not have been sufficient to produce significant work. A good portrait has two requirements: a credible likeness of the sitter, and strong pictorial effect. The first without the second, as in the case of passport photographs, interests no

Huene's portraiture is seen at its most
simple and sympathetic in this study of
Lee Miller and her brother Erik,
photographed in Paris in 1930

one but the sitters themselves. When the second requirement is met but not the first,
the result is a good *picture*, but not a good *portrait*. But the ultimate test of a good
portrait is whether it stimulates our interest when we know nothing of the subject.
This is the case with many of Huene's portraits. Although most of us have no idea who
Nimet Eloui Bey, Koval, or Marie Louise Bousquet were, or what they accomplished,
we are charmed by his tender portrayals, which bring to mind Dr Johnson's
observation that the successful portrait is "a reasonable and natural consequence of
affection."

Possibly this has to do with the terms on which he approaches his subjects; one feels
that they were at ease in his company and sensed his confidence in the enterprise. As a
result, the portraits seem more like collaborations. Huene admired the great
nineteenth-century photographer Nadar, who described the fundamental require-
ment of a striking portrait: "that instant understanding which puts you in touch with
the model, helps you to sum him up, guides you to his habits, his ideas and his
character and enables you to produce, not an indifferent reproduction, a matter of
routine or accident ... but a really convincing and sympathetic likeness, an intimate
portrait."[10] Huene would certainly have endorsed this objective.

By definition, portraits depict static subjects; the representation of fashion requires
an illusion of fluid movement. Even in a static pose the clothing must appear as if it has
fallen into place naturally. In the late Twenties and early Thirties, however, film stock

suitable to indoor use was not sufficiently sensitive to arrest movement without blur. Initially, therefore, Huene was perplexed by the problem of conveying movement.

This was not true of outdoor photography, where the instantaneous had been possible since the 1850s. But photographers had long been familiar with a paradox: they could stop action, freeze a split-second of activity, but the image conveyed just that – a moment frozen in time. This was good for a joke (a beach ball apparently stuck in the air could provoke gales of laughter) or useful for purposes of scientific analysis, but a failure as a convincing picture of a moving object. Serious photographers would have to devise pictorial conventions to *express* movement.

Eadweard Muybridge's famous late nineteenth-century studies of animal and human locomotion are a case in point. These "split-seconds" were unwelcome news in some quarters, even greeted with derision. The fractured image did not seem to correspond with human perception, or even optical "truth." Muybridge's Plate 419, *Toilet, Stooping and Throwing Wrap around Shoulders*, may have been an objective record of a mundane activity, but the camera's version of the truth upset conventional esthetics. The information was of value, but only as raw material for interpretation by the artist. In short, Huene's problem was not truly a result of studio limitations, but a conceptual matter which touched at the very essence of photography.

Huene turned to his knowledge of the human body which he had gained in his academic training and put to use as an illustrator. As we shall shortly see, he would make much use of his lessons in classical art, but to some extent his boyhood passion for acrobatics, which had matured into a strong commitment to rigorous exercise, must also have played a role, as did his appreciation of dance. Paying particular attention to gesture, he looked for "the point at which one image is translated into another."[11] For example, an ever-so-slight glance backwards over the shoulder could convey forward motion. Hair shot slightly out of focus could suggest a head that had suddenly turned. Shawls billow out of the picture frame, as if caught by a sudden wind.

Huene came to his solutions through imaginative stagings rather than the camera and darkroom fakery so enthusiastically promoted by authors of popular "how-to" photographic handbooks. Huene's solutions were conceptual, meaning that he would work out the desired effect in his mind – "previsualizing," in the jargon of modern photography, the final image. While his models appear as dancers treading lightly on air (plate 18), their gowns billowing out behind them, they are in fact lying static on the floor, their clothing painstakingly arranged to impart a sense of graceful motion. A contrived illusion – and yet how much more satisfying than Muybridge's literal truth!

Movement in photography: *below*, realism, in the form of Eadweard Muybridge's Plate 419, *Toilet, Stooping and Throwing Wrap around Shoulders*, from his *Human and Animal Locomotion* (1887); *above*, illusion – Huene's Agneta Fischer, evening wear by Augustabernard, 1932, in which the model is not moving at all but was photographed lying on the studio floor

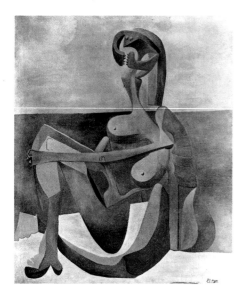

Pablo Picasso, *Seated Bather* (early 1930), one of his many seaside paintings of the period that shares the mood of Huene's beachwear studies, in particular *Swimwear by Izod*, 1930 (plate 66)

Such ingenuity was applied to other problems as well. A fine example is *Swimwear by Izod* (plate 66). Here, apparently, is a couple perched on the end of a diving board gazing out on a calm sea. We take for granted that this is a "location" shot; if not, what we are seeing is a brilliant studio contrivance. But the contrivance lies somewhere in between: the two models were simply taken to the roof of the *Vogue* studio on the Champs Elysées, where they were posed on boxes. The top of the parapet, thrown slightly out of focus, functions as the horizon; the parapet itself suggests the sea. Here was an elegant, economical solution, rather than complex technical machinations. (Huene was also the first to use photographic enlargements – of his own photographs – as backgrounds in place of costly props and sets.)

Swimwear by Izod also serves to demonstrate the photographer's debt to painting, in particular Metaphysical Painting, and to classical Greek art. The two companions are fused, as it were, into a single form. Details are obscured, depersonalizing the image; faces, fingers, and hands are concealed. Here is a picture of solidity and harmony (note the strong vertical and horizontal elements, in particular the parallel lines of the woman's legs) not without the latent disquiet we associate with the "magic realism" of de Chirico. There is also a striking relationship with Picasso's paintings of bathers, such as the 1930 canvas reproduced *left*. *Swimwear by Izod* is also reminiscent of the same painter's *Pipes of Pan* (1927), sharing its brilliant clarity, monumental human forms, and the timelessness we also associate with Metaphysical Painting. De Chirico is evoked in Huene's mannequins, which fascinated him as much as real women (see plates 68–70, in which mannequins appear lifelike and women resemble mannequins). Huene also appreciated de Chirico's fascination with perspective, dramatic foreshortening and close-ups, and his profound sense of space. The painter himself wrote "of the absolute awareness of the space that an object must occupy in a painting, and of the space that divides each object from the others."[12]

Above all, it is the classical currents in the image which do most to illuminate both structure and substance of Huene's art. The attitude struck by the two companions in *Swimwear by Izod* would have qualified for J.J. Winckelmann's Neoclassical ideal of "noble simplicity and calm grandeur." As we have seen, Huene was well versed in antiquity from childhood on, and particularly appreciated the great achievements of fifth-century BC Greek sculpture. So central are its characteristics to Huene's approach that they must be briefly summarized:[13]

A representational and naturalistic style, with no distortion of the human figure or any suggestion of abstraction (except in the sense that all idealizations are abstractions). Careful attention is given to anatomy, even to the point of exaggerated musculature. In the Greek view sculpture was meant to be a direct visual experience free of symbolic association, that is, to be appreciated for what it was rather than as a symbol of something else.

The idealized human body, in perfect physical health and harmoniously proportioned. Strength is common to both sexes; heads are large and powerful. Expressions, however, are neutral, devoid of emotion. Moods are instead indicated through poses.

The impression of natural things in human form, whereby the primeval mystical sense of water, wind, and light is retained in the molding of the features of the human figure. "Our admiration of the antique," wrote Emerson, "is not admiration of the old, but of nature."

Balance, with a premium on static equilibrium and poise as opposed to split-second movement. Where motion is required in narrative, it is expressed by means of drapery.

Opposite: Huene by Cecil Beaton, 1933

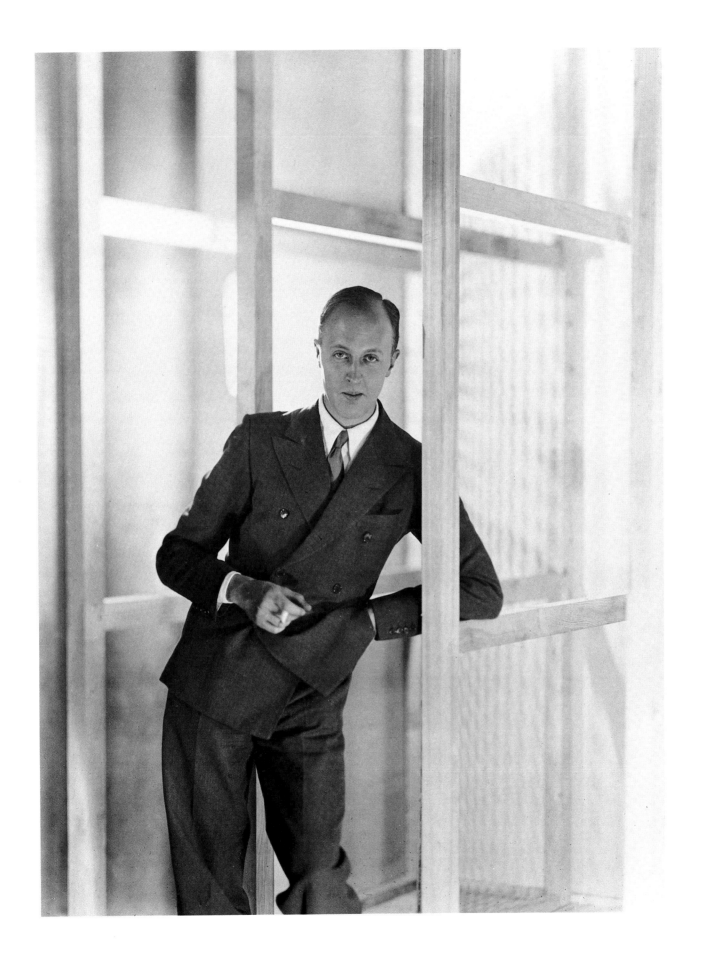

Interest in drapery is expressive, whether to convey movement or to model the human figure. With drapery there is attention to minute detail. As fashion historian Anne Hollander tells us:

the ancient Greeks produced a flexible and enduring model for realistically portraying all kinds of bodies in some convincing harmonious relation to their clothing, whether they were wholly covered or virtually bare. They did this by conventionalizing, with more variety than had ever before appeared in art, the random action of cloth itself, combined with an equally stylized range of seemingly random bodily movements and gestures. From the storehouse of Greek prototypes comes the awareness of the scope of beauty possible to the human body.[14]

That these classical ideals were of central importance to Huene is clearly evident from the most cursory look at his work. "There was a relationship," notes Huene's friend Oreste Pucciani, "between the world of these photographs and the great stone remnants of Western civilization, a relationship of grandeur ... what fascinated him was the heroic dimension that turned mere human beings into mythical creatures of overwhelming power."[15] As in the Greek model, Huene's fashion and portrait studies were free of symbolic intent (except, of course, in the sense that his stagings were meant to allude to Greek culture). Poses are heroic, expressions serene, faces composed, bodies are strong and well-formed, and the musculature clearly defined. Sometimes the poses, expressions, and gestures were direct quotations from Greek sources. And like the Greek sculptors, he preferred his subjects in repose. Certain touches indicate how well versed Huene was in the subtleties of Greek art; for one example, we might point to the bare feet of the model in the Vionnet pyjamas (plate 18), discussed at some length earlier. Compare the bare feet of the Nike by Paionios in the Olympia Museum (for one example among many). The idea of bare feet was direct contact with the powers of the earth.

Classical motifs constantly appear as props. Foremost were Greek columns, which Huene believed to be the greatest problem of form ever resolved by man. Other architectural features were also employed, such as elegantly proportioned steps, balustrades, urns, pedestals, and caryatids. Ancient sites, temples, and ruins were mocked up as sets. The sea, open air, strong sunlight, and views from temples were favored illusions. Torsos, busts, and plaster casts of Greek statuary were utilized frequently. For drapery, the photographer drew on the Greek inventory of prototypes. Numerous examples demonstrate Huene's understanding of modelling and motion lines (in classical art, the former refer to lines that reveal the structure of the body, the latter to lines that convey motion). Easily deciphered also are references to the ancient sculptor's control of complex folds. Among notable sources are such masterpieces as the Nike of Samothrace, the Nike by Paionios, and Victory adjusting her sandal, from the parapet of the temple of Athena Nike, Athens. In all its forms, the Greek achievement was sustenance for Huene's art.

In 1933, the photographer had a portrait taken by his friend and rival Cecil Beaton. In this carefully contrived study, we find Huene the very model of casual elegance. Here he affects "the Baron," high priest of chic. He is at the peak of his career, well-connected and much admired. He is active not only in Paris, but in Berlin and London, and on two occasions has been awarded assignments in New York and Hollywood. A book of some of his best portraits has just been produced in Germany and its cover proclaims him a master (*Hoyningen-Huene: Meisterbildnisse* by H.K. Frenzel).

Beaton's portrait is telling, in that it is Huene who is in control, acutely aware of what he must do to project the required image. He had helped to fashion a world; now he was carefully inserting himself into its pictorial scheme. In a manner of speaking, he had salvaged and reconstituted the elegant life which fragmented when he left Russia.

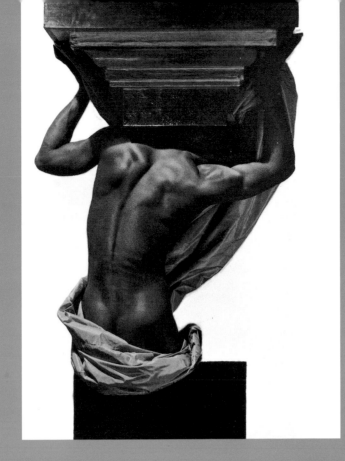

Plates 48-67

SUNLIGHT
AND
SPORTSWEAR

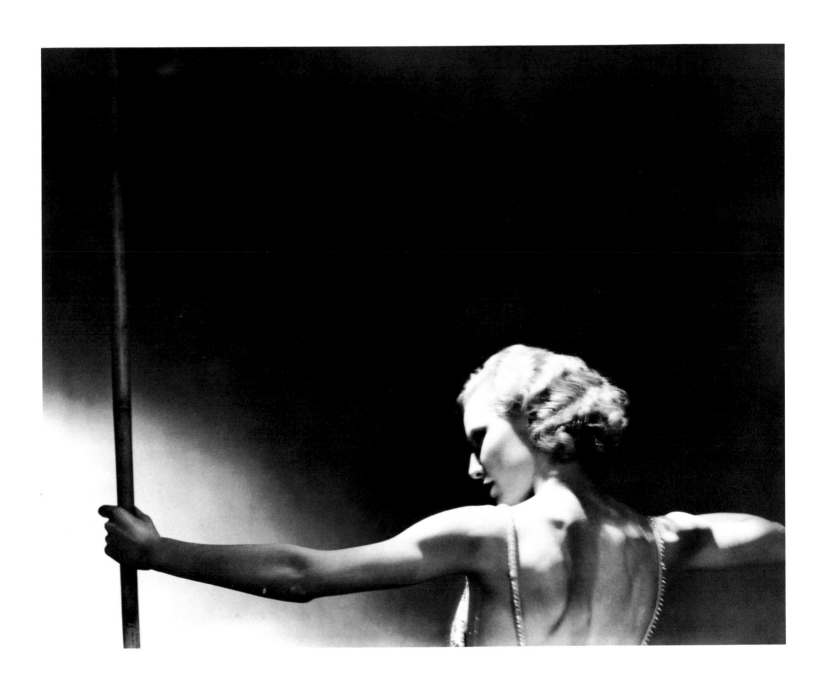

48 Jean Barry, 1931

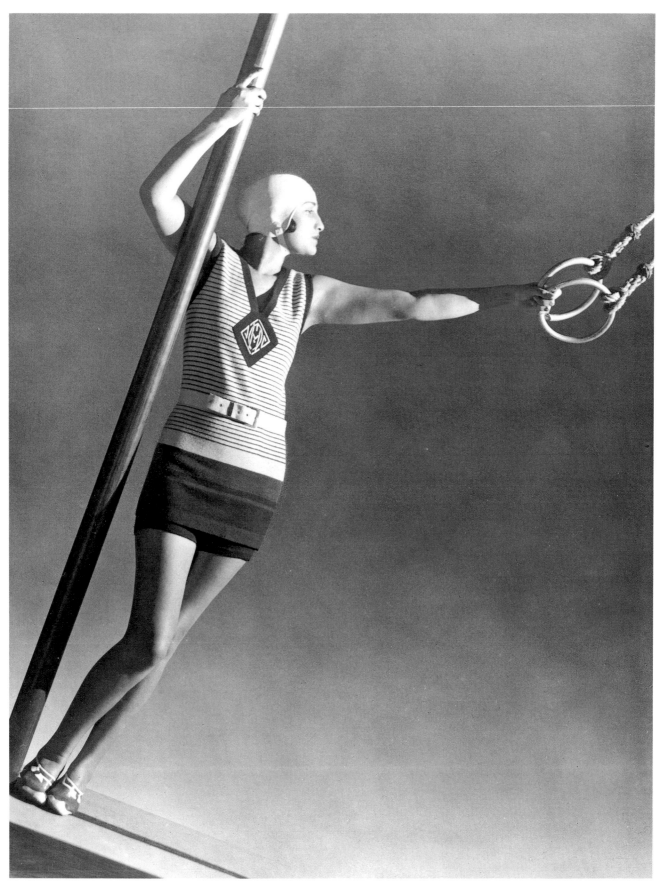

49 Mlle Alicia, swimwear by Patou, 1928

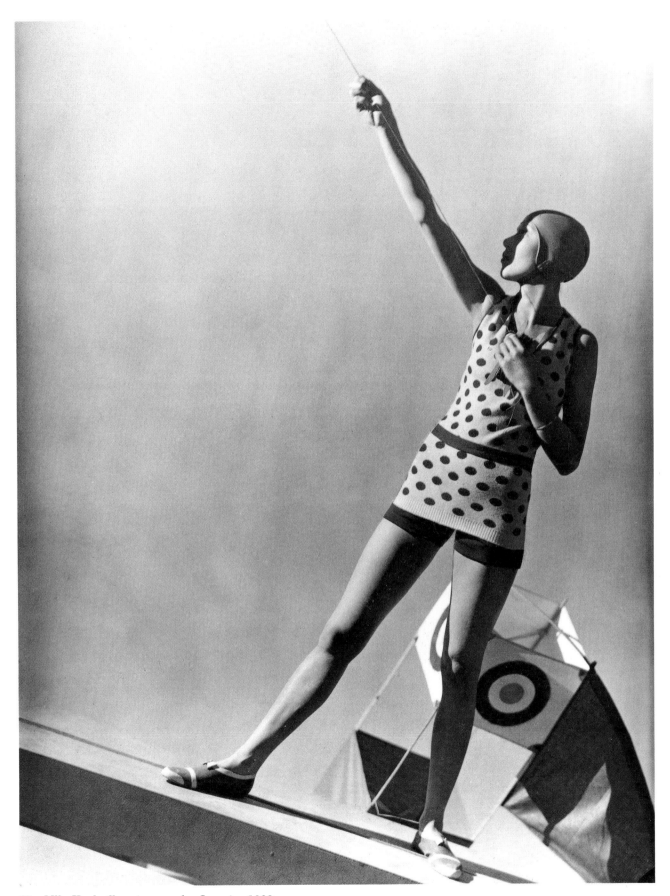

50 Mlle Katkoff, swimwear by Lanvin, 1928

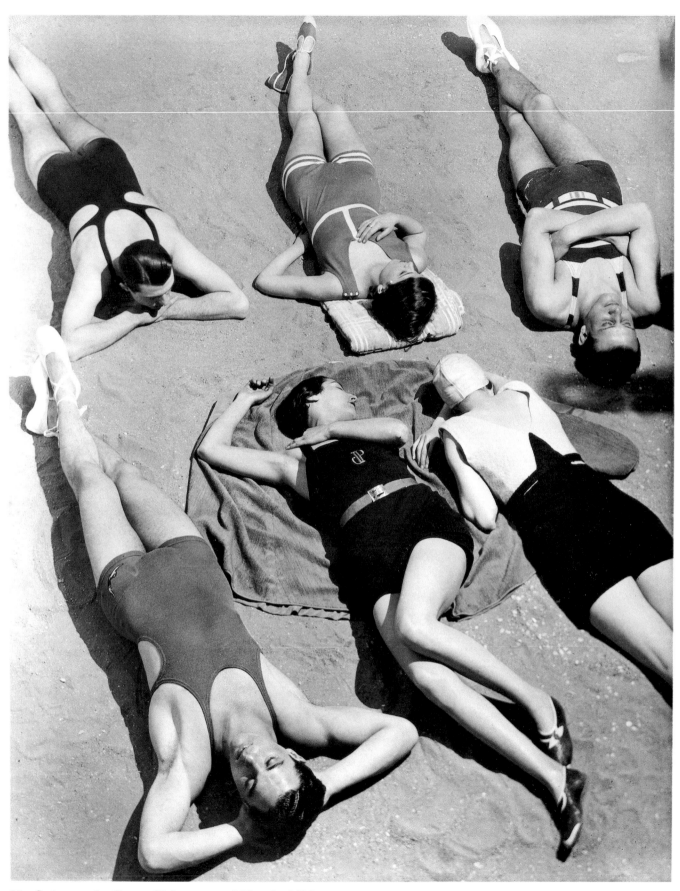

51 Swimwear by Patou, Molyneux, and Yrande, 1930

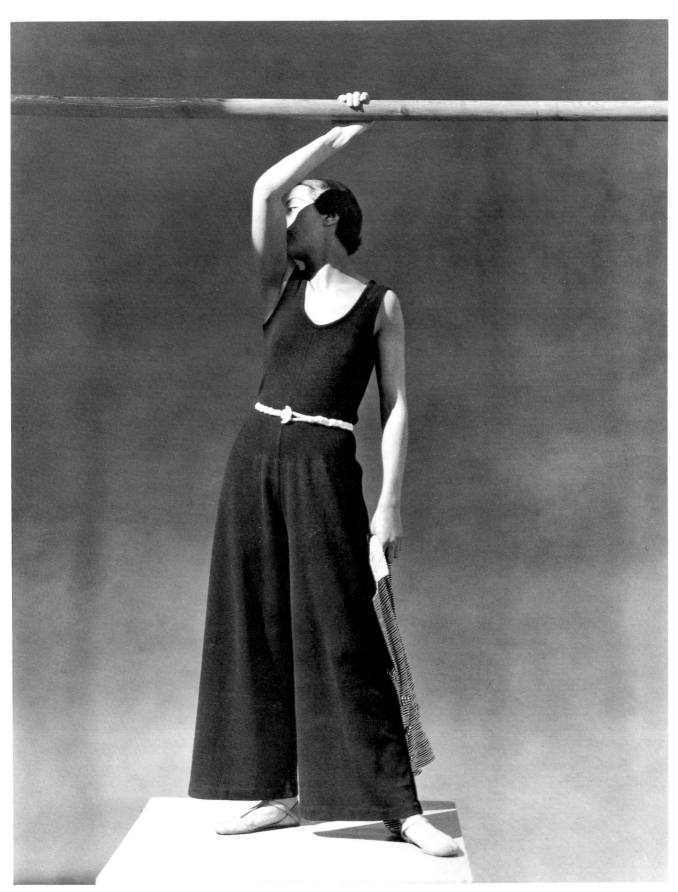

52 Simone Demaria, beachwear by Schiaparelli, 1930

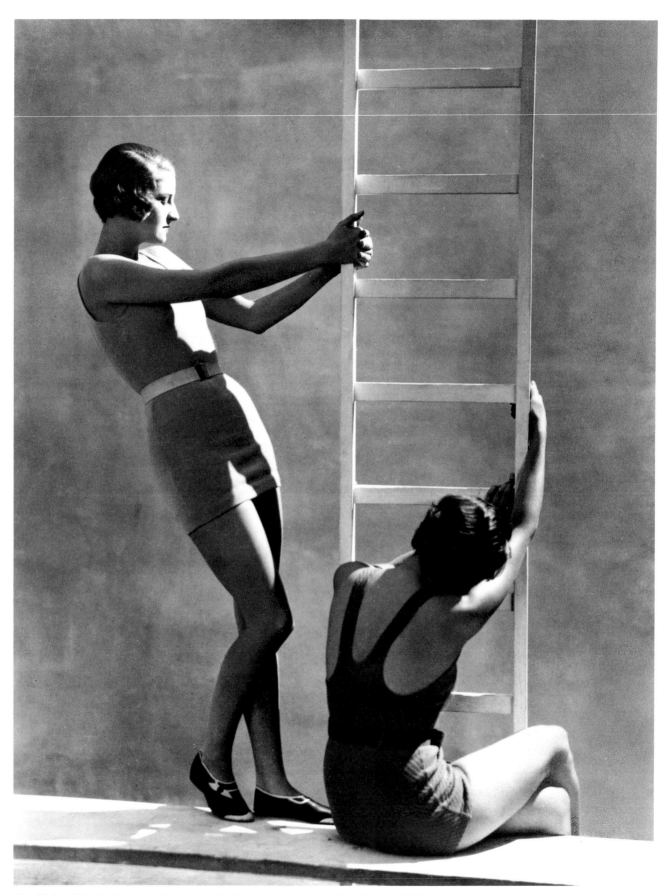

53 Helen Wedderburn and Agneta Fischer, swimwear by Spalding, *c.*1930

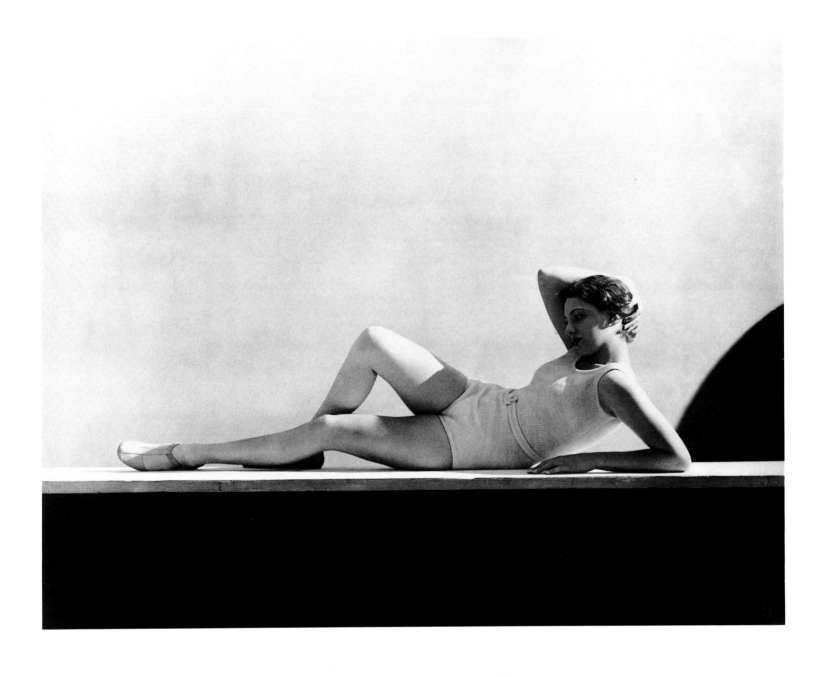

54 Agneta Fischer, swimwear by Schiaparelli, 1931

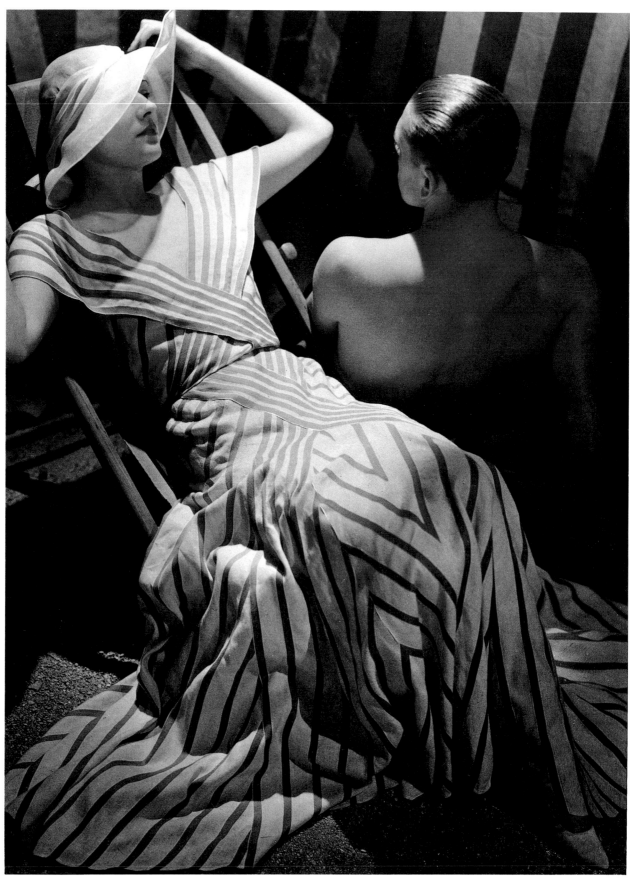

55 Beachwear by Chanel, 1933

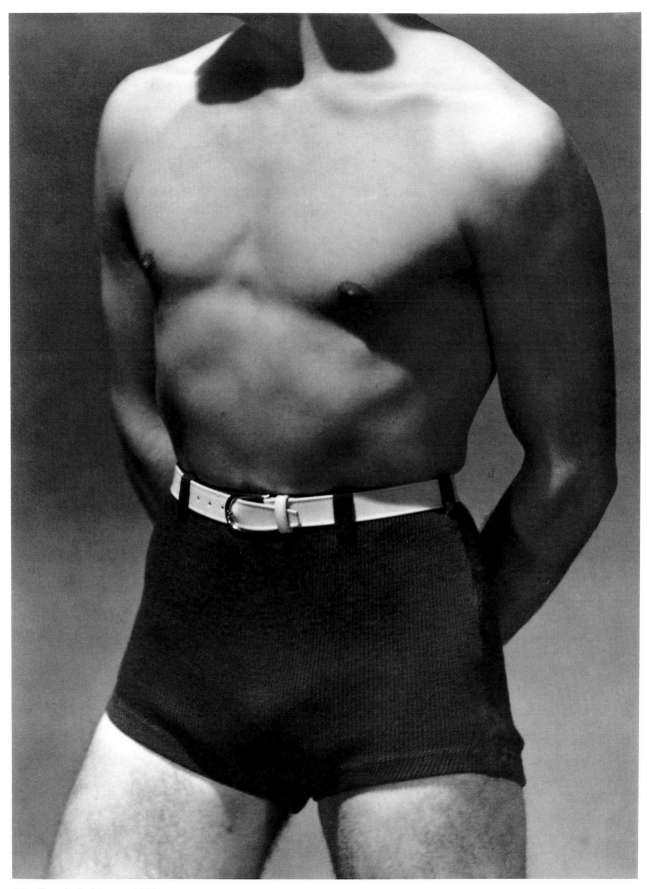

56 Beach fashion, *c.*1930

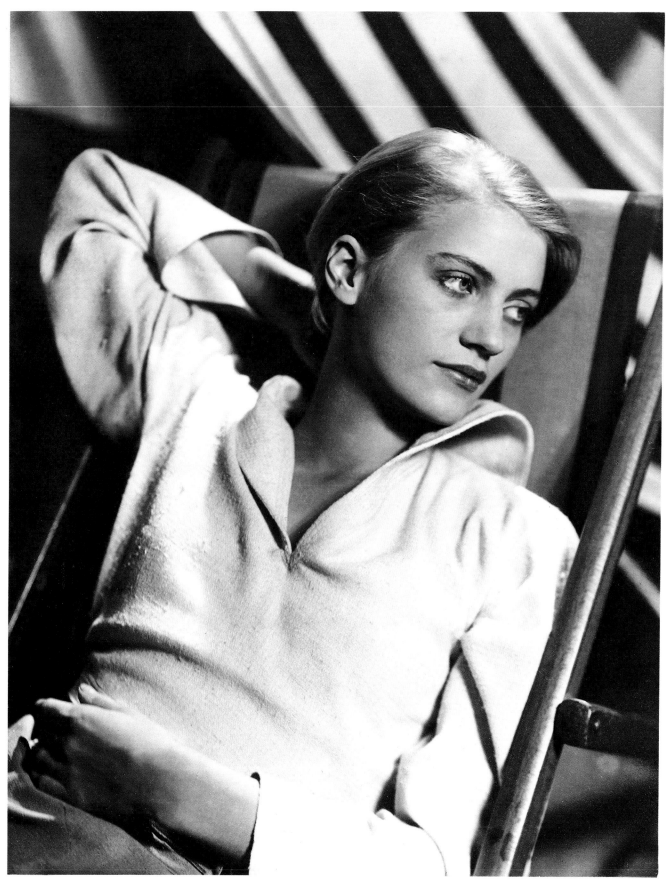

57 Lee Miller, 1932

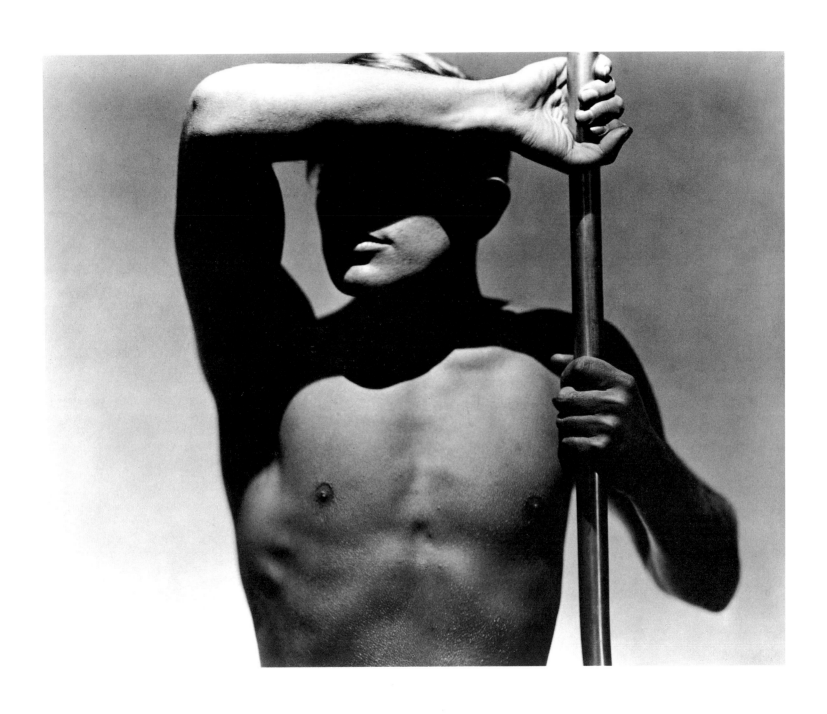

58 Horst, 1931

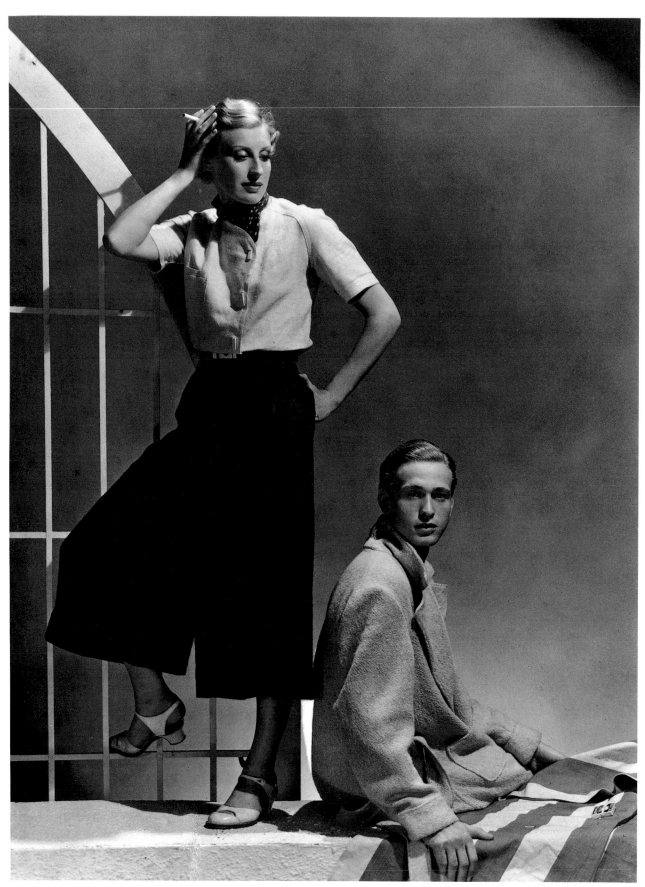

59　Beach fashions, *c.*1930

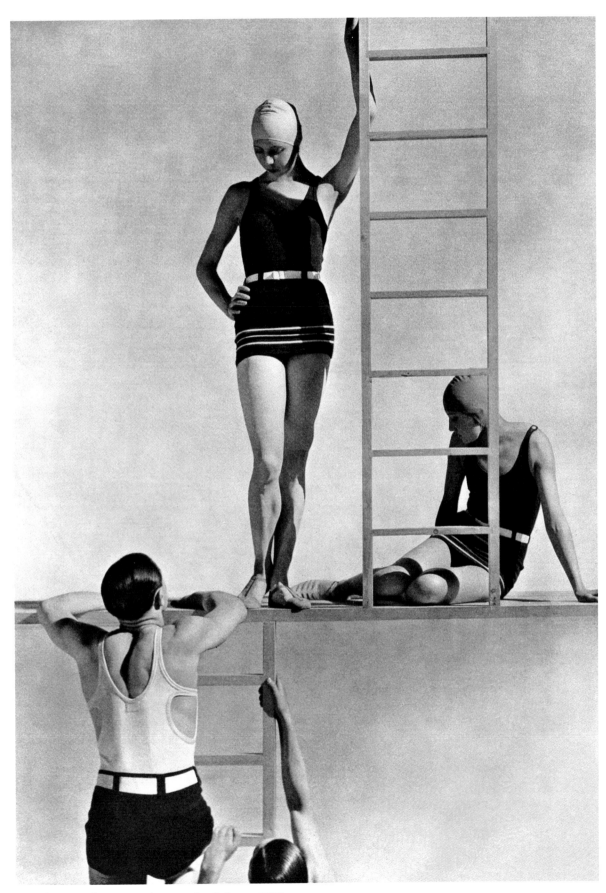

60 Georgia Graves, swimwear by Lelong, 1929

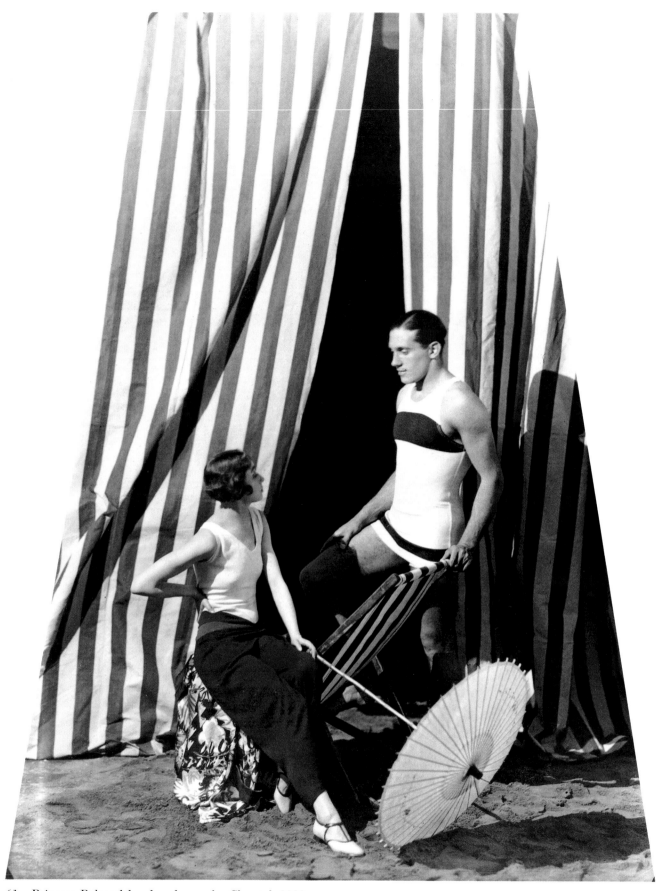

61 Princess Belosselsky, beachwear by Chantal, 1928

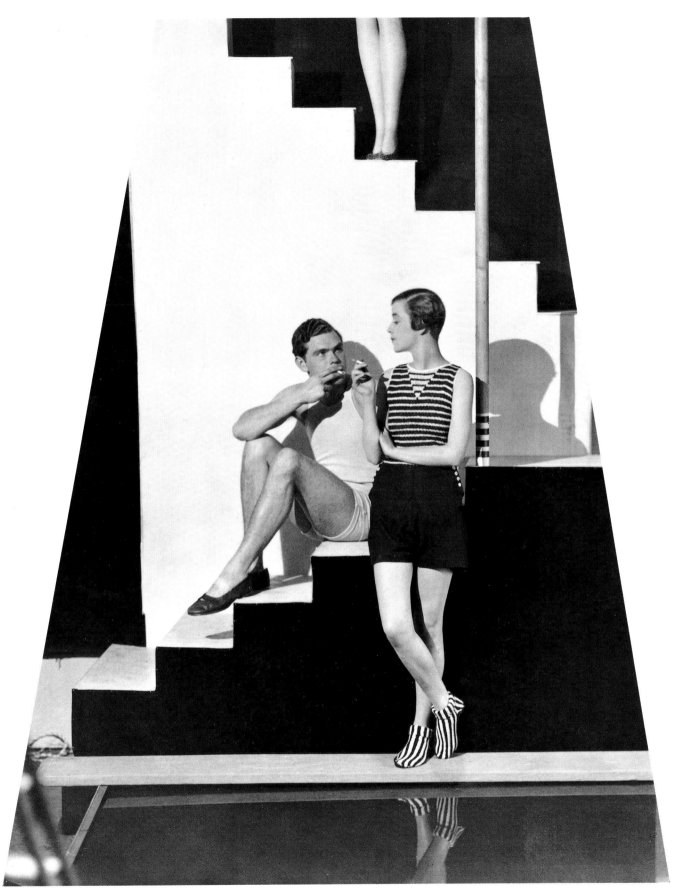

62 Bettina Jones, beachwear by Schiaparelli, 1928

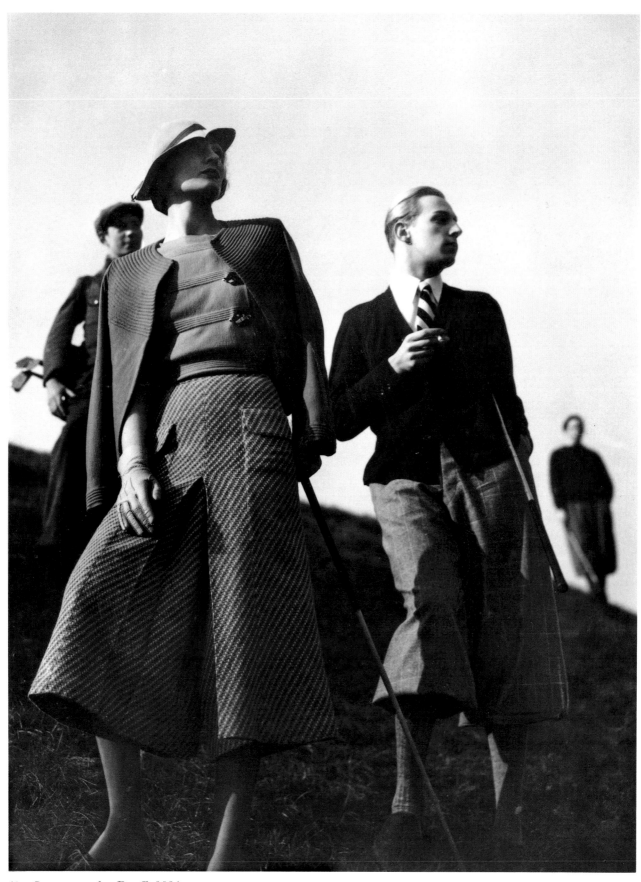

63 Sportswear by Rouff, 1934

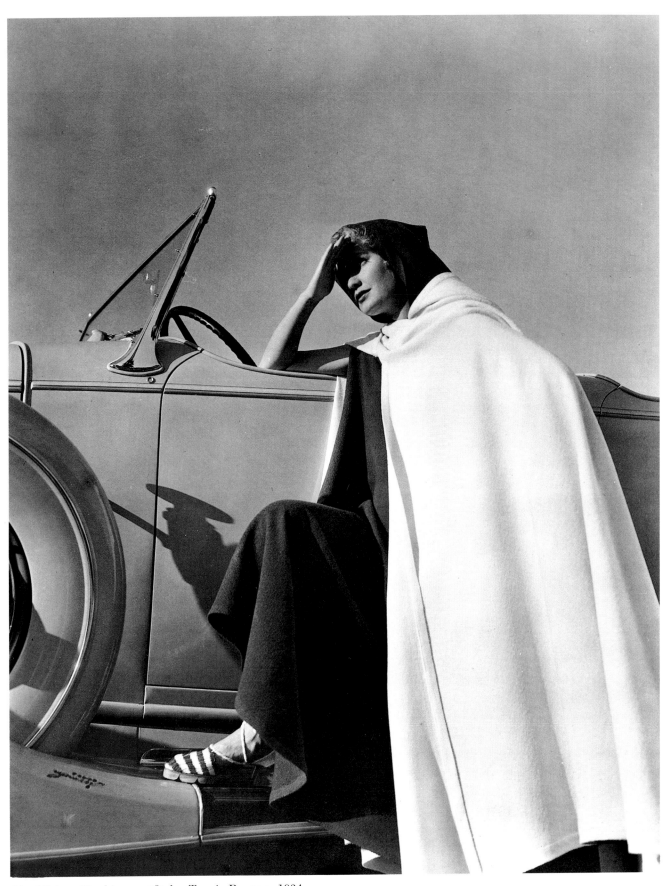

64 Miriam Hopkins, outfit by Travis Banton, 1934

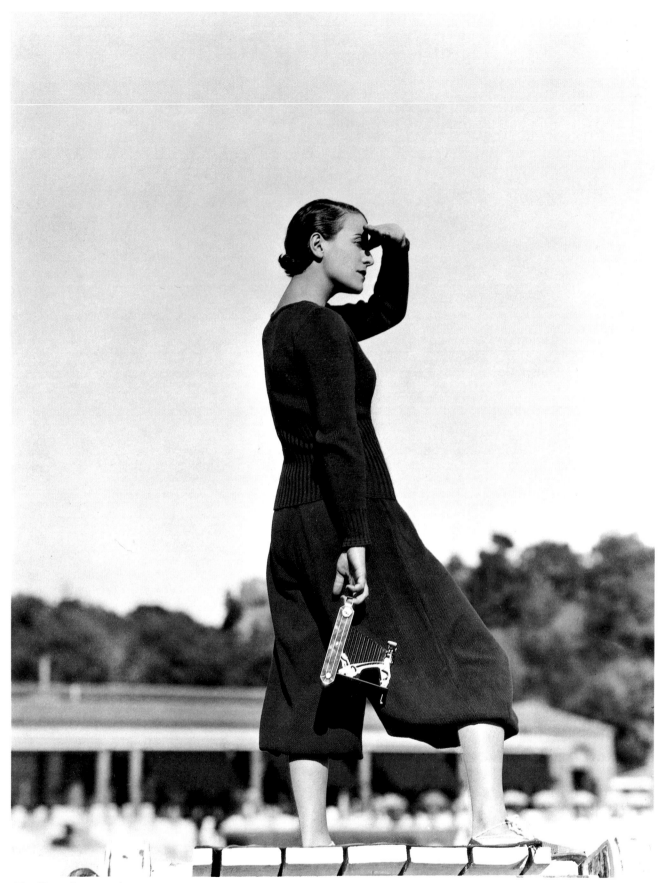

65 Mme Georges Auric, two-piece by Tao-Tai, 1932

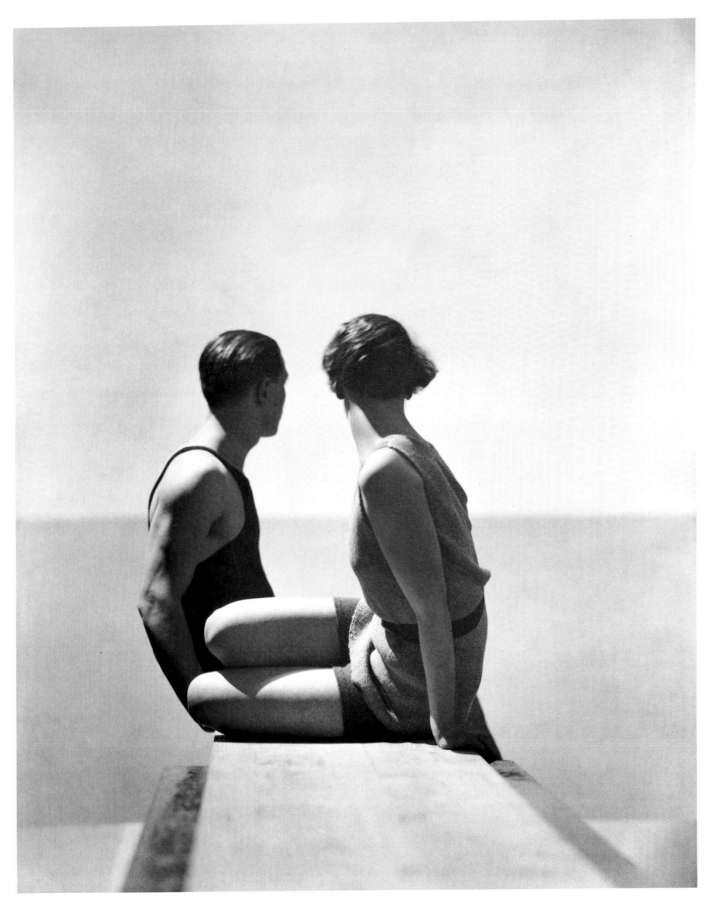

66 Swimwear by Izod, 1930

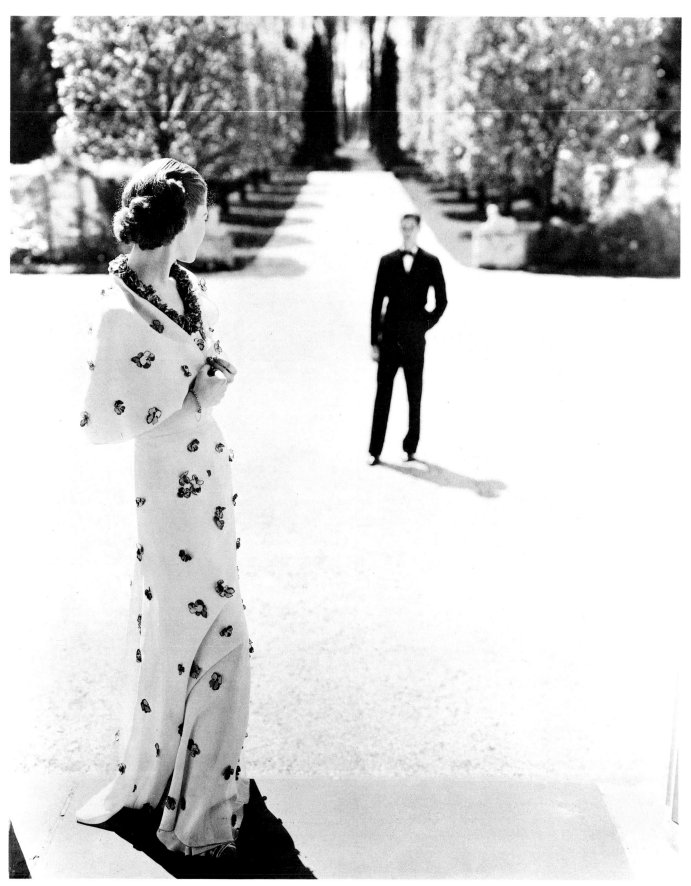

67 Evening wear by Carnegie, 1935

Chapter Five

FRESH HORIZONS

During his nearly ten years with Condé Nast in Paris Huene twice visited the United States on assignment.[1] Both trips had taken him to New York, where he found transplanted friends and quickly made new ones. He enjoyed the city immensely – being half-American he felt at home. Opportunity beckoned and he was tiring of the routine at home.

On their part the Condé Nast organization was losing patience with him. *Vanity Fair*'s editor, Frank Crowninshield, had had occasion to question Huene's work for the magazine in Hollywood (Huene returned without full-face close-ups); when he tackled Huene on the subject, all he got was a tart reply. French *Vogue*'s editor, Michel de Brunhoff, was fed up with Huene's impulsive holiday taking. According to Horst, the editors "may have welcomed the opportunity to show Huene that the magazine could get on quite well without him."[2] In any event, it would seem that Huene had decided to make a break. The actual rupture occurred over a luncheon to discuss renewal of his contract. Told by Dr Agha that they would like him to "behave," he abruptly left the table, outraged that a man of his graces should be scolded like a schoolboy, particularly by a "Ukranian-Turk!"[3] Outside the restaurant he called Carmel Snow, the enterprising new editor of *Harper's Bazaar*, and announced, "I'm on the street and you can have me!"[4] Although initially taken aback, Snow had the presence of mind to offer him a contract, thereby snaring one of her competitor's most talented and respected contributors.

Mrs Snow had been a highly regarded editor at *Vogue* until 1932. Judging from what she made of *Harper's Bazaar* in subsequent years, she must have chafed at *Vogue*'s limitations. There was no question of that magazine's success, but it was the success of formula. For a born innovator, month after month of what was essentially routine must have seemed a treadmill. Snow probably recognized in Huene a similar restlessness; she knew he was a difficult man, but realized he would add vigor to her enterprise.

Huene was intrigued by Mrs Snow's vision of the magazine, which under her leadership had developed a reputation for excellent fashion editorials, high standards of writing, and brilliant illustration and photography. Most importantly, her vision was not parochial. For Snow, fashion was an aspect of highly developed culture, not to be seen in isolation. At Condé Nast she had had ample time to reflect on the strengths and weaknesses of *Vogue* and *Vanity Fair*; her formula for *Harper's Bazaar* was a synthesis of the best of both.

In retrospect, we can see that Huene's years at *Harper's Bazaar* coincided with the zenith of the publication. First-rate illustrations by Raoul Dufy, Cassandre, even Chagall, the latest fiction and poetry by Colette, Evelyn Waugh, W.H. Auden, Christopher Isherwood, Truman Capote, and brilliant photography by Louise Dahl-Wolfe, Martin Munkacsi, Man Ray, George Platt Lynes, and even Baron de Meyer, although now in his decline, contributed to dynamic issues. The components –

Carmel Snow by Huene, 1939

photographs and text – were brilliantly orchestrated by yet another of Mrs Snow's protégés, the Russian art director, Alexey Brodovitch.

Under Brodovitch's direction Huene's work became looser, more realistic and less formal, and in some ways more inventive. He now enjoyed color assignments, and with them the challenge of novel technical obstacles. He was also free to work outside the studio, with cameras of his choice. But the design-format of the magazine, with Brodovitch's penchant for overlaying graphic elements on the photographs, extensive cropping, and the practice of "bleeding" photographs off the edges, did not lend itself particularly well to Huene's highly formal, self-contained style. In fashion itself, the tone had shifted from the cleaner, geometric lines inspired by Art Déco to something softer, flowing and more delicate, to which his style was less well suited. Huene certainly produced strong images in the years that followed, but comparisons show that there was also a reworking of earlier pictures, sadly not as much a matter of learning from the past as relying on it to get by. With the exception of the area of color photography, the problem-solving he had so enjoyed was no longer of much interest to him. He also felt that the standards of fashion were in decline, although one suspects that this was a rationale for his increasing uninterest. He had hoped for a new lease on his creative life by switching magazines, and he enjoyed the regular commuting between New York and Paris, but the commitment of the *Vogue* years was ebbing. His work for *Harper's Bazaar* lacked an equivalent power, and once again he began to entertain doubt about the whole enterprise.

Then, in 1936, the sudden end of a brief love affair with a young man provided impetus for further change. Devastated, Huene abruptly sailed for Tunisia, where he and his close friend Horst had built a vacation home several years before. The house was a short walk from Hammamet, an ancient fortified village on the Mediterranean. It was U-shaped, and its arms pointed towards the sea. Horst's biographer, Valentine Lawford, describes it thus: "Huene's house was strikingly unadorned: almost a Bauhaus version of traditional North African design. Huene wouldn't even allow the builders to make the plain whitewashed plaster benches which were customary in the region ... "[5]

Huene had gone off to Hammamet at every opportunity, much to the annoyance of *Vogue*, but now even this refuge did nothing to dispel the severe depression from which he was suffering. He became a recluse in his own house, confining himself to bed. To make matters worse, he had given his employer no notice, and believed his job – indeed his entire career – had been placed in jeopardy. He remained in this state for several weeks, shunning friends and acquaintances who had come to think of the house in Hammamet as a friendly and inviting stopover.

A profound if unexplained event finally lifted him out of depression. He was roused from bed on a matter of great urgency. A servant's wife was deathly ill; could the master of the house help? Uncertain of what he could do, he agreed to see her immediately. At the woman's bedside he placed his hand on her brow to gauge her fever and it was then that an extraordinary thing happened: he felt a current pass from his body into hers. He had nothing to recommend, however, beyond letting her sleep, and returned to his own home. But when he awoke the next morning and threw open the shutters there was his patient of the night before busy at work in the fields. He was not a particularly superstitious individual, but the event rekindled his faith in life. The worst of his mood had passed and he began to resume his normal social routine.

By chance, one of his first encounters was with an amateur group of explorers about to embark on an expedition across Africa. Huene accepted an invitation to join them, pleased to have the opportunity of a distracting adventure. He recorded in words and

Rita Hayworth, Carmel Snow, Huene, and assistant in the *Harper's Bazaar* studio, New York. Photograph by Philippe Halsman, 1943

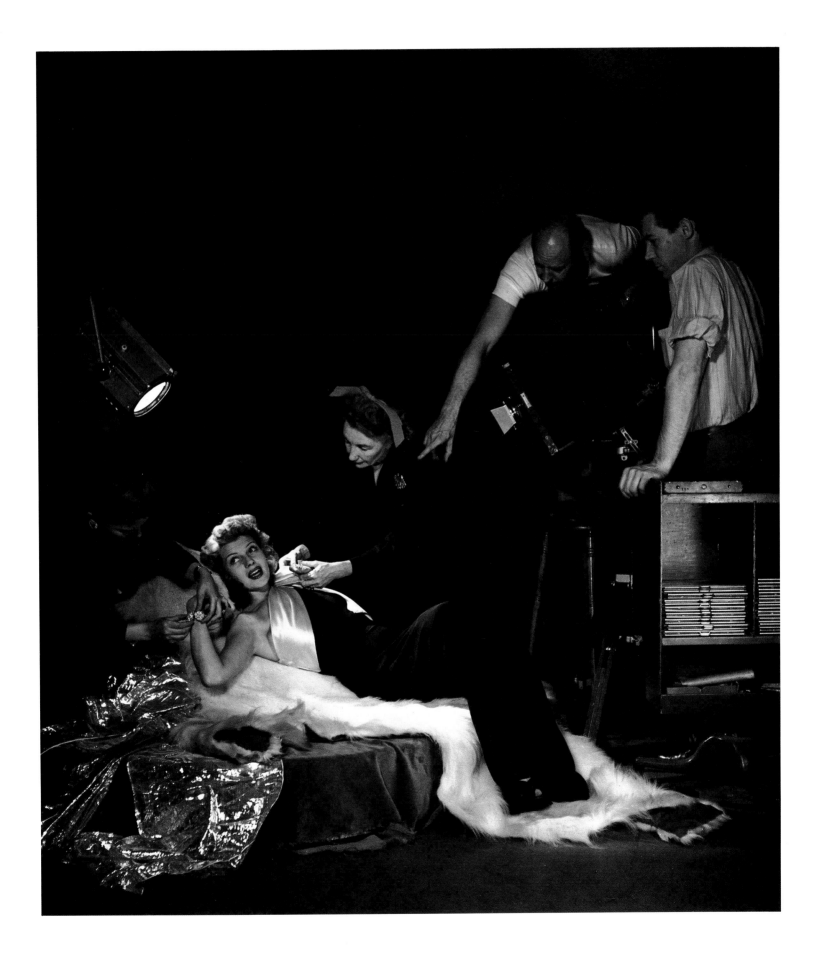

photographs his vivid impressions of the group's travels, first to Egypt, then down the Nile through Tanganyika, French Equatorial Africa, British Nigeria, and finally across the Sahara to Algeria. His style was reminiscent less of the great nineteenth-century explorers than of more contemporary observers – writers such as Winston Churchill (*My African Journey*, 1908), Martin Johnson (*Over African Jungles*, 1935), or, as we shall see, the journals of André Gide. In the preface to the resulting publication, *African Mirage: The Record of a Journey* (1938), he professed modest ambitions for both his writing and photography: "These extracts from my diary have no scientific interest. I merely wish to preserve certain visual impressions ... Those who wish to undertake a similar journey, before it is too late, will see for themselves what my incompetent pen and impromptu photography have attempted to convey."[6]

The disclaimer as to his incompetence can be safely ignored. *African Mirage* is finely written, demonstrating the author's command of visual metaphor. He drew pictures with words: a frieze depicting Rameses smiting his enemies is "a symphony invading and spreading over huge inclined surfaces of stone."[7] The body of a young man is "reedlike and is merely hanging from the broad span of his shoulders, as he stands lightly on one leg like a crane."[8] And the chanting of natives is "a rich sound, rich like the deep colour of their fluent limbs."[9]

Each photograph in *African Mirage* received a respectful half- or full-page treatment. Not all the photographs were distinguished, as Huene had cautioned, but the standard was still high for the genre. Until now he had had little opportunity to photograph outside the studio (Condé Nast was adamant about working indoors) and it was difficult for him to control pictorially the haphazard and disparate elements in the environment. Furthermore, native Africa was exotic, brilliant, and full of absorbing but distracting detail. As he admitted, "We are like a bunch of kids playing at some secret, forbidden game."[10]

Still, a number of the photographs exhibit the fine qualities we associate with his studio work. In several studies of women's heads, for example, his passion for formal values and economical composition is successfully brought to bear. Taking pains with a vantage point, for example, helped to eliminate unnecessary detail. Some of his subjects he shot from the ground upwards; in other pictures the background was thrown out of focus. *Woman of Fort Lamy* (plate 80) suggests that much more than a snap-shot was intended; in directorial control it recalls his earlier study of Dolores Wilkinson (plate 79). Such thoughtfully orchestrated imagery suggests that he secretly hoped them to be the equal of his fashion studies.

Summing up his experiences in Africa, Huene confided a more serious purpose: "Some day, when the entire Black Continent is clothed and reduced to comparative

Dry season on the Nile banks, 1936. Published in *African Mirage* (1938)

banality, these documents may prove of interest, revealing a naturalness of form and movement never found in a world of organised artificiality."[11] Clearly Huene's African adventure was a much needed release from the pretension and artifice of the fashion world. In the farthest reaches of the vast continent he had found a supreme elegance – nature reduced to its essential forms. And he had found a part of himself, "solitude and peace without the nostalgic presence of loneliness."[12]

The experiences had tapped a deeply romantic nature. Describing his rekindled enthusiasm for life and referring obliquely to his fading emotional turbulence, he writes:

Memories appear, and dissolve, giving place to others. Memories, trivial ones, the ones you wonder why you remember, and others which insist, from which there is no escape. But you are as far from everything as you can be. And then, when your mind is washed and refreshed and semi-dormant, you notice a new plant you have not seen before, or there is a turn in the road or a beautiful bird, and you find yourself awake and are returned to the world and become part of the pattern the design of which we so often fail to perceive – the pattern of our lives.[13]

Under the surface of Huene's observation lies a sense of his own mortality. There is an acceptance of the idea of death, although such thoughts are given to us indirectly, much as he only hinted at his homosexuality in his memoirs. Something about Africa appealed to his deep-seated emotional needs as Greece had appealed to his intellect. Africa was a lure to "detach and immaterialize one's self in a world of transparent form, colour and light. A world of luminosity without shadows."[14] But the hypnotic spell is broken by the author as he returns the reader to modern civilization: "Europe. The African mirage disappears, vanishes, dissolves into a commonplace mass of concentrated vulgarity, excitement, noise and futility ... Then you submit and accept, and the rest is a memory."[15]

The "memories" are now long out of print, one might say forgotten, but they deserve a better fate. The book is worthy of comparison with the journals of André Gide (*Voyage au Congo* and *Le Retour du Tchad*, 1927). There are striking parallels. Gide also demonstrated a youthful enthusiasm – "My heart beat as if I were twenty!" – a keen eye for nature, a deep respect for native culture, and an abhorrence for "civilizing" forces, in particular colonialism. "The less intelligent the white man," he observed, "the more stupid he thinks the black."[16]

Both authors followed similar routes, and often commented at length on the same places, such as Fort Lamy. Both accounts give equal weight to personal feelings and external observations. Gide also makes extensive references to art: "The gravity of the forms, the subtlety of the colors, reminds one of certain of Corot's Italian pictures ... "[17] And like Huene, Gide is intrigued by photography, although he sees through the eyes of a filmmaker companion: "The best part of these photographs will be things that have been taken by a happy accident – gestures, attitudes, which were just those we did not expect."[18]

One might even surmise that Gide's journals served as a model for Huene, or at the very least inspired him to recount his adventures. This is reasonable conjecture in view of the fact that Huene had met Gide on several occasions while travelling in North Africa. Of one dinner conversation Huene recalled, "He was a rather dour man. Austere and uncommunicative. But when he did speak he was brilliant and intelligent, and his French was beautiful. I've never heard such beautiful French spoken, unless it was on the stage."[19] Huene might also have been familiar with Geoffrey Gorer's *Africa Dances*, which had been inspired by Tchelitchev, or Evelyn Waugh's *Black Mischief*, both published in the Thirties. Gide, Gorer, Waugh, Huene: here was a group of metropolitan romantics (Gide dedicated his book to Joseph Conrad) who dreamed of

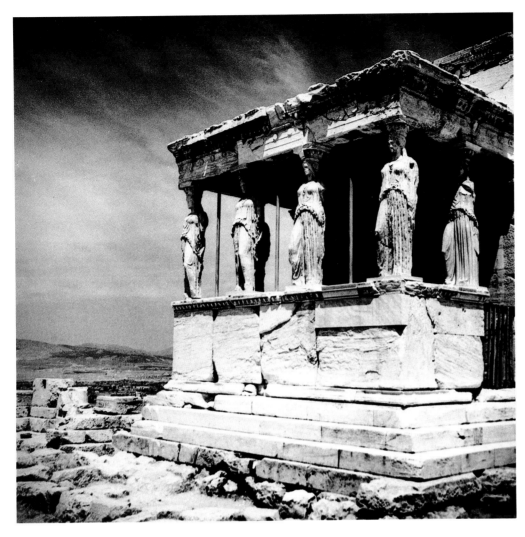

The south porch of the Erechtheion, Athens, 1939. Huene made several studies of the Erechtheion (see also plate 5); this one was not included in *Hellas* (1943)

the exotic in terms of freedom from civilized constraint, and found in native dance, music, and trance, ecstasies prohibited to civilized people.

On his return to Hammamet, Huene had no time for further musings about life, nor any need to fret over his career. He was greeted with a telegram from Carmel Snow urgently requesting portraits of the Duke and Duchess of Windsor. Apparently she was willing to overlook her protégé's intemperance in the light of his talents. Huene left for Europe immediately, and took up his career where it had been left off. But later there were to be other African adventures, with Roland Penrose and Lee Miller, with Cecil Beaton, and with Horst.

Huene had found his expedition and the accompanying book a deeply satisfying experience, and in the years following undertook other publications, although he gave the writing of the texts to scholars. He produced four travel books (for want of a better term): on Greece, on Baalbek and Palmyra, on Egypt, and on Mexico. Photographically the most interesting was *Hellas: A Tribute to Classical Greece* (1943), produced for the Greek War Relief Committee.[20] He had first visited the Parthenon in 1938, but at that time had been overwhelmed by its majesty and was unable to take a single picture. He recalled Steichen's and Isadora Duncan's predicament at the site years earlier, when they too had found themselves initially at a loss how to respond. Not until the following year, after he had carefully thought through his intentions, was Huene able to proceed.

A bold formality, careful attention to light, and his usual attention to detail, in keeping with the considerations of the ancient builders, characterize the photographs. "These would never please the architects, who want blueprints," he admitted, "but I wanted to interpret ancient buildings and ancient sites and glamorize them, just as I have done with beautiful women."[21]

Hellas is more than a compendium of photographs, and more than a lavishly illustrated anthology of texts – as it is conceived, the whole is decidedly greater than the sum of its parts. Edited by Huene with George Davis, fiction editor at *Harper's Bazaar*, and Hugh Chisholm (both good friends of his), the "text" is in fact a skilful marriage of writings and photographs. Quotations from Aeschylus, Aristophanes, Sophocles, Byron, Emerson, Milton, etc., and modern writers are paired with pictures of the Acropolis (in particular the Parthenon and the Erechtheion), the theaters and temples of Argolis and Attica, sculpture in various museums (enhanced with his usual deft studio technique), and grand views of nature, with great cloudy skies, darkened mountains, barren rocks.

The rhythm of the book is marvelous. A large and dramatic format, with plenty of white space surrounding the texts sets the stage; the photographs are never "bled" off the edges, but they still almost fill the pages. Photographs are one to a double spread for the most part, but occasionally two strong images oppose each other on facing pages. These juxtapositions are unorthodox and brilliant; one wonders if Brodovitch, who is credited with the jacket design, had a hand here. In short, the format is imposing, the treatment animated, if spare.

Hellas opens with a study of barren rock, next to a quotation from Aeschylus' *Prometheus Bound*: "Rather, listen to the sad story of mankind ... " A landscape follows, with Sophocles' "tree in Asian soil unnamed." Soon we come upon the works of men, and the text advises us "to respect ruins, not rebuild them."[22] The story continues with the words of Pausanias: "At Delphi are written maxims useful for the life of men, inscribed by those whom the Greeks say were sages ... These sages, then, came to Delphi and dedicated to Apollo the celebrated maxims, 'know thyself,' and 'nothing in excess.' "[23] Eventually the book comes to a close with a picture of a ruined

A double-page spread from *Hellas, a Tribute to Classical Greece* (1943)

Only to gods in heaven
Comes no old age, nor death of anything;
All else is turmoiled by our master Time.
The earth's strength fades, and manhood's glory fades,
Faith fades, and unfaith blossoms like a flower.
And who shall find in the open streets of men,
Or secret places of his own heart's love,
One wind blow true forever?

Sophocles

48

Huene by Herbert List, Glifádha, Greece, 1937

column on the Acropolis, dramatically side-lit with every crack and chip clearly delineated. But the ravages of time cannot obscure its nobility. To each side we glimpse the modern city of Athens far below. How can it compare with this ancient achievement? "Only noble hands, the aristocratic hands of free men, were employed in this place . . . The best of men left here the best that was in them."[24] This quotation by Charles Maurras is the conclusion of a hymn of praise for ancient Greece, a lament for a heroic culture.

Huene also worked in Egypt, where he found that the quality of natural light once again required him to rethink his approach. Unlike the general caress of Greek light, the Egyptian sun flooded the ruins with a brilliant glare, casting harsh and deep shadows. As a characteristic of Egyptian architecture was the elimination of superfluous detail, Huene reasoned, therefore, that his objectives were best served by eliminating middle tones, thus increasing contrast. As with *Hellas, Egypt* (1943)

A double-page spread from *Egypt* (1943)

represents careful consideration of technique in order to project the required ambience.

The proportions of the book and its general design are similar to those of *Hellas* (and also to his later books). The photographs, however, are presented differently. They are not paired and weighted equally with the texts, but function more as illustrations (although certain outstanding images are given full-page treatment). The text is also handled in a different way, appropriate to the intent; George Steindorf's essay is a general overview of politics and culture from the prehistoric period until the time of the Persian conquest.

The book contains a number of remarkable photographs. The tiniest amulets and the most colossal statues are given equal attention. In each case the lighting is superb, whether indoors or out. An ivory gazelle is modelled with light, its tail precisely pinpointed; an alabaster goblet is illuminated from within; a statue of Rameses is treated as carefully as anything he ever photographed in the studio.

In Egypt, Huene presented a culture in terms of tenderly wrought objects, artworks depicting social relationships, and imposing monuments – in short, a culture of true art lovers. As with *Hellas*, he transcended the limitations of conventional textbook photographic illustration. His love and respect for the medium and the subject matter elevate the genre. However, it would not be correct to say that Huene was breaking entirely new ground with the photographs of Greece or Egypt themselves. Almost from the moment of photography's invention the ancient monuments were scrutinized by cameras. As early as 1839, Lerebours, publisher of the celebrated *Excursions daguerriennes* sent practitioners on assignment to Egypt, Baalbek, and Athens, among other exotic locales. By the 1850s there were a number of French and English photographers in Greece and Egypt. One amateur, the Reverend George Bridges, after a grand tour around the shores of the Mediterranean, published an album of fifty-nine plates of the Acropolis in Athens. One typical view shows gentlemen lounging on temple steps. Comments historian Richard Pare: "Bridges' view seems an appropriate one ... concerned with a leisurely perusal of the temple and its setting rather than a rigorous examination of specific architectural aspects."[25]

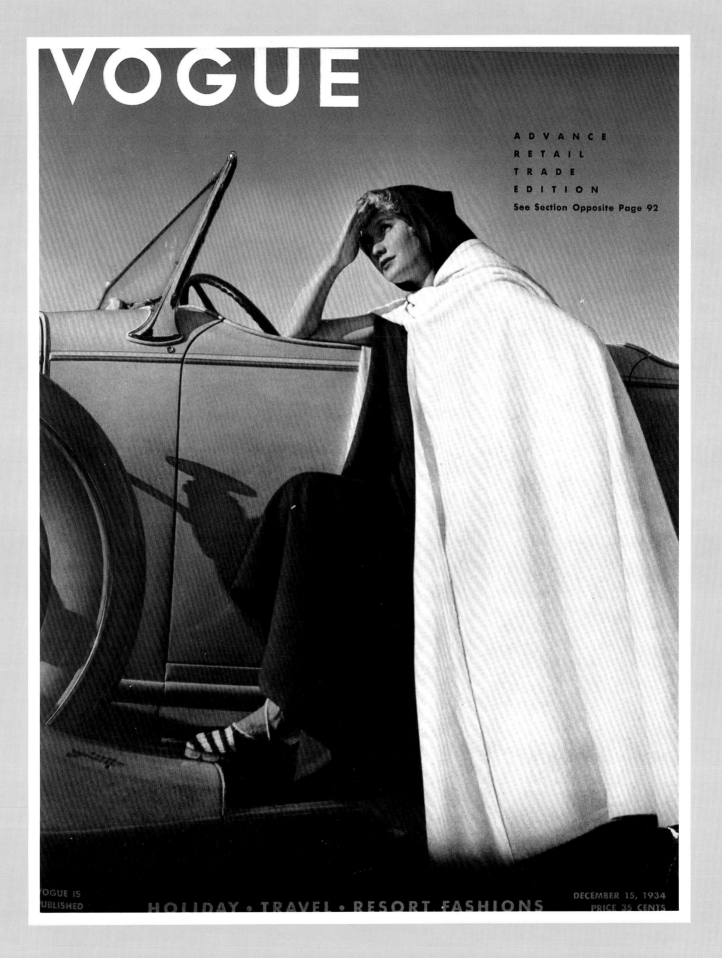

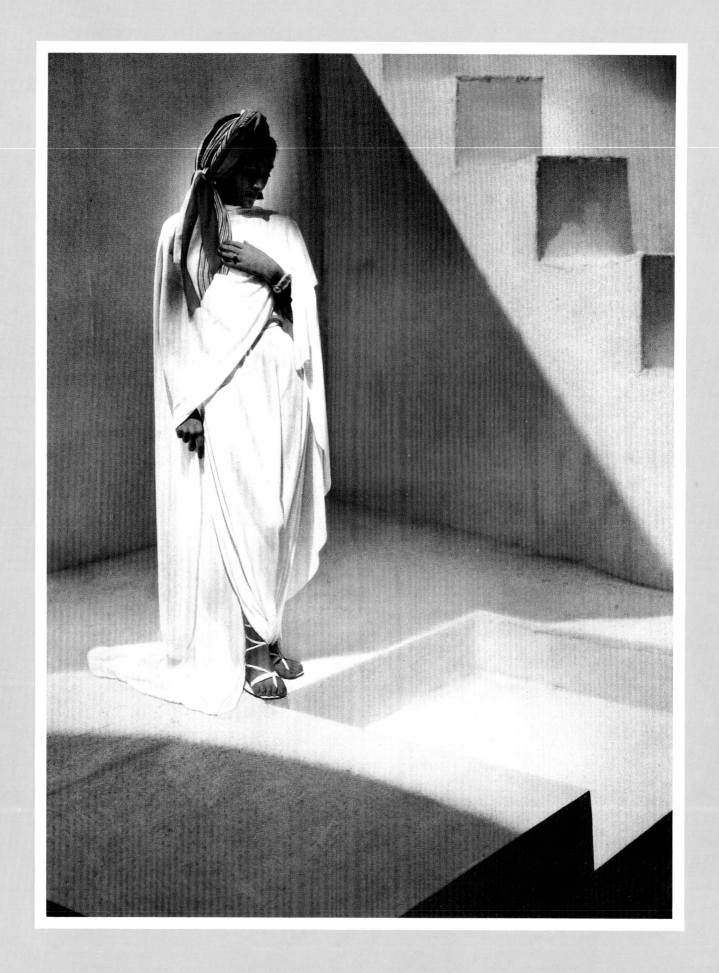

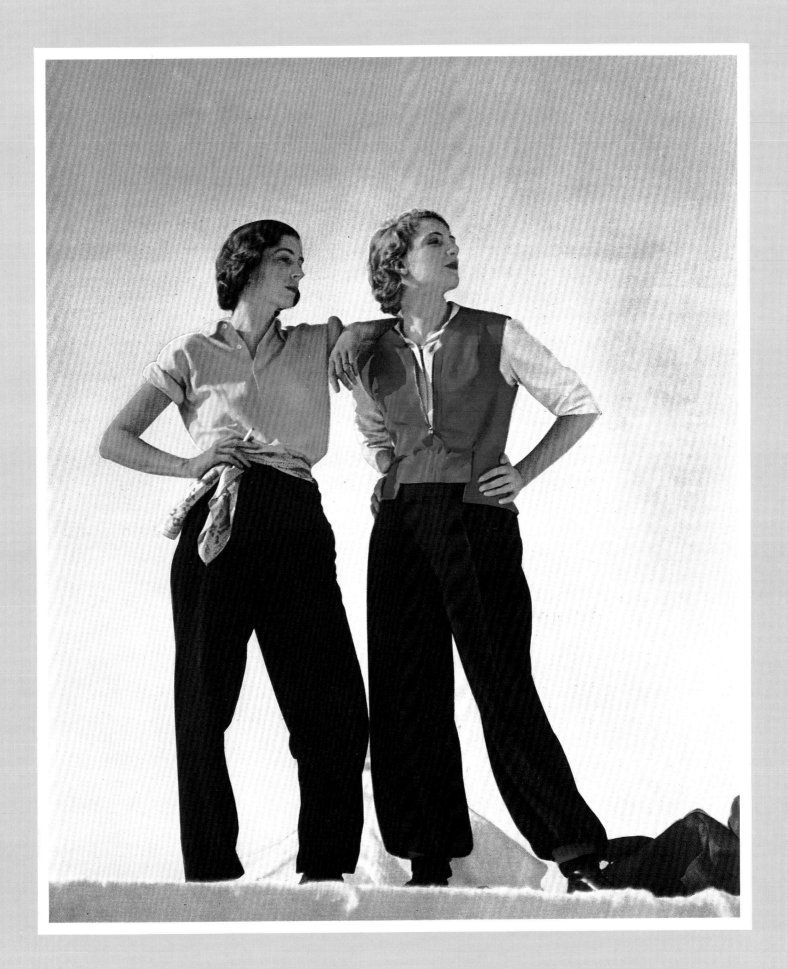

TODAY'S WOMEN

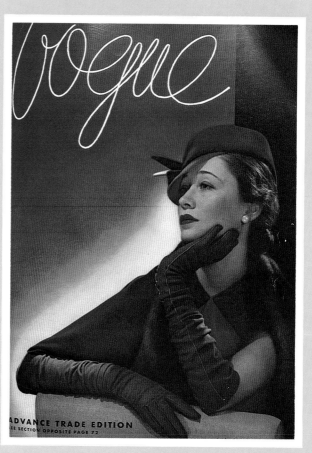

ADVANCE TRADE EDITION

Two untitled nature studies, published opposite each other in *Mexican Heritage* (1946)

Jean Walther, James Robertson, and P. Moraites, a native Greek, were among other men of means who had an understanding of the far-reaching significance of photography for the study of antiquity. Such men were eager to please artists, architects, and archaeologists. Their work, useful for the study of proportions and details of ornament, was published in style manuals. Robertson also worked in Egypt, hard on the heels of Gustave Flaubert's and Maxime du Camp's famous expedition, which had resulted in a lavish folio, *Egypte, Nubie, Palestine, et Syrie* (1852). The great nineteenth-century English photographer Francis Frith was yet another who earned acclaim for his work, and converted his success into ever more ambitious expeditions. In 1859 he managed to attain the Fifth Cataract on the Nile – the farthest point on the great river a photographer had ever reached. Of particular interest to Frith were the Great Pyramids at Giza, which he often photographed in the 1850s. Of his work an anonymous writer took note of: "the mastery of detail which is one of the chief merits of photography."[26] Frith's clarity was unsurpassed.

The earliest views of the ancient monuments are less interesting to modern eyes, however, than the work done by the American William J. Stillman in the 1860s. Stillman had set out unabashedly to take the finest views to date of the Acropolis. Perhaps they were – they certainly imbue the silent ruins with life. The photographs so arrange their subject matter that the viewer is propelled into the picture. Twenty-five such photographs were published as *The Acropolis of Athens Illustrated Picturesquely and Architecturally* in 1870. We have no way of knowing whether Huene was familiar with Stillman or his predecessors. But if he was, it would have been the Stillmans that

Opposite: four magazine covers using photographs by Huene. *Clockwise from top left:* "Toyot" hat by Rose Descat, 1935; cotton gingham by Ameritex, 1943; 1933 (no fashion information published); suit by Carolyn Modes, 1943

he would have admired, for they are the product of a photographer who was not content to describe, but was impelled to interpret.

Huene certainly would have been familiar with the work of Walter Hege, a German photographer who went to Greece in 1928, possibly at the instigation of the Metropolitan Museum of Art. Hege published *Die Akropolis* in 1930, and it was easily accessible to Huene, who was well aware of the Metropolitan's interest in ancient Greece; it is entirely possible that he and Hege even met or corresponded. They definitely shared similar attitudes about their monumental subjects and the role of photography. Both looked upon the works of the ancients as sacred historical sites worthy of reverence.

Huene's *Baalbek/Palmyra* appeared in 1946. The photographer singled out the grand citadel of Baalbek with its magnificent ruins and gigantic stones – among the largest ever used in building – as the most impressive Hellenistic site in Syria. Palmyra was one of the most celebrated cities of Asia Minor, a flourishing trading center in the classical and Hellenistic periods. Perhaps Huene's fascination with Palmyra owed something to a book which he certainly knew, the splendidly illustrated folio *Ruins of Palmyra and Baalbek* by the Englishman Robert Wood (1753), which had caused Catherine the Great to be nick-named Zenobia after the city's great queen and St Petersburg "the Northern Palmyra."

Like his earlier books, *Baalbek/Palmyra* contains fine photographs, in particular panoramic views of the devastated sites, with their otherworldly tomb towers rising from desert expanses. However, the book does not measure up to its predecessors. It seems less inspired in conception, and the layout and ordering of the photographs themselves are lacklustre. There is nothing to compare, for instance, with the dynamic juxtapositions of images found in *Hellas*.

Some of that dynamism is however to be found in *Mexican Heritage*, also published in 1946. One might speculate that *Baalbek/Palmyra* was the concluding chapter of his Old World interests, whereas *Mexican Heritage* represented fresh beginnings. Of all his books, it certainly embraces the widest variety of subject matter – landscapes, ruins, ancient buildings, sculpture, flora and fauna, colonialist architecture (exterior and interior), graveyards. Huene had always tried to depict the environment in relation to man, but here, amid some of the most exotic plant forms on earth, he forgot himself, and concentrated his camera solely on the beauty of nature. A number of images bear a distinct resemblance to those of Edward Weston. Having abandoned studio photography by this time (as we shall see), Huene was evidently revelling in his new-found freedom. In every way, Mexico was a breath of fresh air.

None the less, *Mexican Heritage* is a statement about man's culture in the broadest sense, and the nature studies were carefully positioned within this overall "text." In the introduction, the book's author, Alfonso Reyes, explains that landscape must be compared with "the archeological documents left to us." Art has no meaning, he suggests, "without the interplay of nature's questions and men's answers."[27] By 1946 there was a visual and literary tradition of depicting sacred Mexico in modern times. *Mexico, A Study of Two Americas*, by Stuart Chase, illustrated by Diego Rivera, had appeared in 1931, and Pierre Verger's *Mexico* had been published in 1938. Huene's *Mexican Heritage* compares well with these precursors. As in Africa, Greece, and Egypt, Huene found in Mexico remnants of ancient ways with which he felt great affinity. That the romantic spirit had survived the ravages of time in temples of stone was, he admitted, "a recompense for having lived through all the disillusions of banality."[28]

Chapter Six

THE GOOD YEARS

With his energies now focused on his travel books, Huene found himself disenchanted with fashion photography. Although he was still much in demand at *Harper's Bazaar* and continued to perform professionally, his waning interest began to affect his work. It was not evident then, but a comparison today with his *Vogue* period, or for that matter with his initial period at *Harper's Bazaar*, reveals that the spark was no longer there.

Throughout World War II he remained with the Hearst Corporation, as he was overage for service. With the war's end his discontent deepened. It seemed to him that fashion as it had been was irrelevant and fashion as it existed was banal (this was before the advent of Dior's "New Look" in 1947). It was time to chart a new course of action.

Huene considered moving to Mexico. The climate was extraordinary and he had come to love the flamboyant culture. Mexico wasn't far from California, or even from New York, and some good friends had already settled there. For work and pleasure, it seemed an attractive base. His initial enthusiasm carried over into *Mexican Heritage*, but although the project was gratifying, he realized that books would not earn him a living. He decided to try his hand instead at documentary filmmaking.

Several documentaries on art and architecture were produced, three of which were shot in Spain (these films have all been lost; we know the title of only one of them, *The Garden of Hieronymus Bosch*). But as much as he enjoyed the productions, he was forced to admit that documentaries were too time-consuming and expensive to offer a livelihood. And he was also well aware that the documentary genre was generally out of favor in the filmmaking community.

There was, however, another filmmaking option. For some time his friend George Cukor, the noted director, had been encouraging him to come to Hollywood, where he believed Huene's refined talents would be appreciated. In view of his frustrating efforts in Mexico, the offer was too enticing to pass up, and in 1946 he left for Southern California.

The years that followed were especially fulfilling. He loved the climate of Southern California, greatly enjoyed the teaching he was offered, and his work for the film industry was much appreciated by Cukor, his immediate associates, and other directors with whom Huene had occasion to work – Don Weis, Jean Negulesco, Michael Kidd, and Michael Curtiz. He soon became a familiar figure in the studios, where he brought his talents to bear on cinematic problems of color esthetics. Under the ambiguous title of "Color Coordinator," he was able to make his own way through the studio bureaucracies, advising directors, cameramen, costume designers, and art directors. He planned and designed backgrounds and sets, costumes and titles. To implement his ideas, Huene was required to collaborate with a variety of specialists, many of whom were highly creative and strong-willed individuals. The directorial skills he had learned in the fashion studios were put to good use, convincing, cajoling, flattering. On more than one occasion he invoked the privileges of a Baron.

Greta Garbo by Huene, 1955. Garbo, whom Huene had admired greatly since the early 1920s, became a good friend during his years in Hollywood

Although he admired Hollywood's accomplishments, he was irked by the heavy reliance on technology. "Europeans," he mused, "are very good at improvising. They can do with much less. Here we have an overabundance of facilities."[1] He described the fine art of "coordination" he practised:

In order to design a picture, you have the problem of figuring out what sort of wardrobe goes into what background. You see, my function is to have the art director and the wardrobe people know exactly what the two departments are doing, and then decide on what the overall was going to look like, because you cannot design sets and have the wardrobe disregarded. It wouldn't make any sense. It all has to jell. It has to be coordinated, and that is my function. Now, very often a certain outfit, let's say on the star, has to play against various backgounds, and some combinations are satisfactory and some are not. That, of course, is unavoidable. But on the whole we can always juggle things around …[2]

For Cukor's delightful *Heller in Pink Tights* (1960), a comedy starring Sophia Loren and Anthony Quinn, Huene took stills of Loren which he printed as *cartes-de-visites* (popular nineteenth-century calling cards incorporating the bearer's portrait). The cards were signed "Hoyningen-Huene" in the flamboyant "artistic" style favored by commercial photography studios of the period. One gets a brief glimpse of the cards in the film. What amused Huene was the stylistic appropriateness of his name, which normally seemed so archaic in latter-day California.

Huene also designed backgrounds and costumes for the film and planned complex color effects. One room was painted in brown tones to reflect Quinn's despondency. He is sitting there morosely when the doors are suddenly flung open onto the next room, revealing a ravishing Loren framed by walls of vibrant blue. The effect is galvanic, and Quinn's spirits – and those of the audience – are immediately revived.

Huene explained how such color effects were contrived for another film:

The dance rehearsals for the "Prom" number are over. It is closing time. The producer, director, and the director of lighting will take a last look at the set, which is decked out in red, white, and blue festoons and drapes. A typical college prom in the twenties in a mid-western town in America. Now the men are removing the protective cardboard sheets the dancers have been rehearsing on. The floor is gray. Then I get an idea which unfortunately comes to me late in the day: I suggest to the producer to have it sprayed bright blue, so as to add gaiety and brilliance to the overall effect. The director inquires whether or not this is feasible at this late hour, the unit manager calls for the head of the paint department, the front office is alerted. I have provoked a mild crisis, as last minute changes are frowned upon. However, the plan is put into motion. I know that tomorrow everyone concerned will be pleased, and two days later, when the first rushes are projected, there will most likely be general approval. It better be good, as I have opened a can of worms.[3]

In his film work Huene drew on his broad knowledge of art. One scene was based on a painting by Corot, another on a drawing by Velasquez. Even a news photograph by Weegee, the master of the genre, served as a source. Huene explains the lessons to be learned from art:

In most realistic paintings, and I don't mean abstract or cubist, but paintings that are nearer to photography, you'll find that there is a dominant color: it's either warm or it's cold. For instance, let's say Rembrandt's color schemes are gold and brown and that glowing in-between fleshtone and black, but they're definitely warm, on the sepia side. Corot's landscapes of the later period, when he painted willow trees, and rivers, are mostly of a pearly grey, and various shades of a colder grey. Then you get Corot's early period in Italy, where his skies are not too bright, not too blue, but there are wonderful warm ochres with the sun playing on the Mediterranean buildings, and everything is in colors of ivories and apricots and very subdued greens. Well, you see in all of these instances you have an overall color. If you mix up a lot of

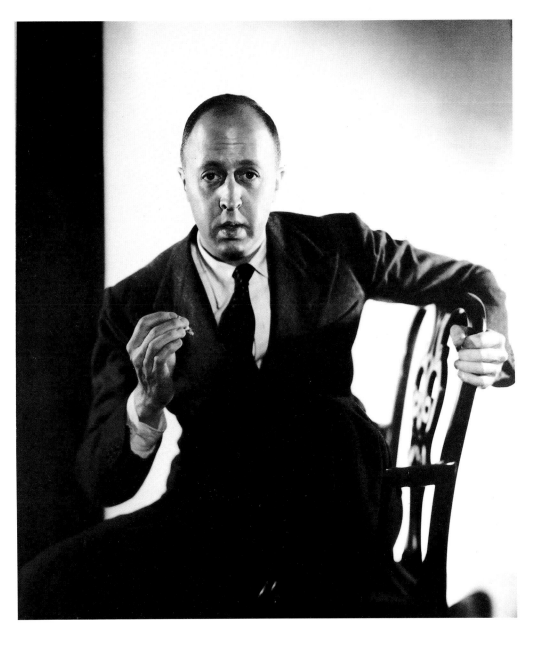

Huene by the Hollywood photographer
George Hurrell. Undated

colors and don't have a dominant color, your eye gets distracted and you don't know what you're looking at ...[4]

His experimentation was not universally admired. Reflecting on *A Star is Born*, the actor James Mason commented:

Encouraged by Hoyningen-Huene, who was engaged as special color advisor on the film, George [Cukor] had a funny idea of relating the theme of any scene he was trying to do to the work of a particular artist–painter, to achieve visual atmosphere. For this particular scene he had decided on Fuseli: he wanted to capture the feeling of one of Fuseli's nightmare paintings. I was not aware of the idea until I was going down a corridor and met a girl most peculiarly painted and got up. I stopped her and said: "Excuse me, what are you playing?" and she said: "Ah ... I play a curtain." It was revealed that Cukor was going to mix these peculiarly painted girls with the curtains, so that they could move as if in a breeze. I would think in my drunken haziness that I saw a girl, and then ... "Ah, it's just a curtain." That was the idea, anyway. It didn't work. He abandoned it.[5]

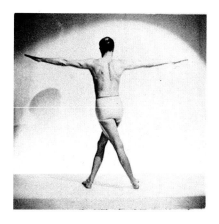

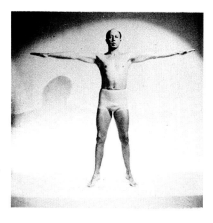

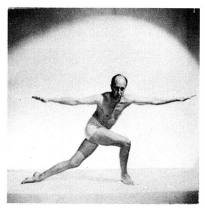

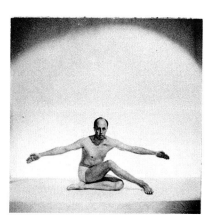

Feature filmmaking did not dissuade Huene from the occasional foray back into documentary terrain. He returned to Greece in 1951 to make *Daphni: Virgin of the Golden Laurels*, an appreciative look at a superb eleventh-century Byzantine church near Athens. Of Huene's own films this alone has survived.

In the late 1940s Huene was invited to teach photography at the Art Center School in Pasadena. He enjoyed teaching immensely, pleased with the enthusiasm of the would-be professionals. He found the students overly concerned with technique. Excellent prints and flawless negatives were commendable, and not to be taken lightly in view of career aspirations, but they were means, not ends, and overemphasis stifled free-wheeling creativity. Absorption with technique also led students to concentrate on their own problems, rather than encouraging them to develop their ideas in concert with others, as true professionals are obliged to do. Huene resolved to make some basic changes in the curriculum.

He devised a plan whereby the students had to produce a magazine. This format would allow for individual efforts and collaboration. *Pacific*, as it was called, was modeled after popular magazines such as *Esquire* and *Holiday*. It was a mix of feature articles, personality profiles, advertisements, artwork, and photography. A magazine meant schedules, deadlines, and the inevitable frustration of compromise, but it mirrored the real world.

To broaden the education Huene introduced art appreciation. Students were required to produce photographic interpretations of realist paintings, such as those of Rembrandt or Vermeer. Another project called for storyboards (scene-by-scene layouts of pictures and text) on Oscar Wilde's *Salomé*, done in the manner of Aubrey Beardsley. The exercise continued with the design and construction of miniature sets, which on completion were photographed. The student actors then struck poses and were themselves photographed. Finally, the two sets of photographs were combined so that the actors appeared "on stage" in correct scale. Huene had taught his students how a professional result could be obtained with meagre resources.

Huene always stressed drawing skills in his teaching, although getting the students to draw proved an uphill battle. He argued: "Look, if you go into the office of an art director to explain a picture you are planning to do, make a thumbnail sketch of it, but it has to be done in a few minutes with a few strokes of the pencil, and it has to look professional. So they had to make drawings before they did the photographs, and that helped too."[6]

In the mid-Fifties Huene was interested in expanding his own horizons, and took mescalin in an experiment conducted by his friends Aldous Huxley and Gerald Heard. "They wished to try mescalin on a visually trained subject whose capacity for perception was precise and accurate," he explained:

I was interested in the experiment and a day was set. Dr Osmond of San Francisco emptied a small quantity of white powder into a glass of water which I drank. After three-quarters of an hour I expressed a strong desire to go out into the garden. During the course of the experiment I observed that the works of human beings were of no interest to me, nor for that fact were people, but going from a tree trunk to a series of flowering shrubs I felt a great sense of elation. The optics seemed to differ, distant views were of no consequence, but details of flowers, leaves, the bark of eucalyptus trees, all these seemed to demand infinite attention, contemplation, study. All these were so exquisite in texture, form, and color, that I realized that I was living on another beam of consciousness, closely related to nature and in complete harmony with natural surroundings. The words in the English language were completely insufficient to express the marvels I was contemplating. For the first time in my life I thought of death as a complete fusion of one's self into nature, perhaps spreading a layer of dirt over one, like a blanket, and dissolving into the universe. However, the idea of violent death or suicide did not enter into this

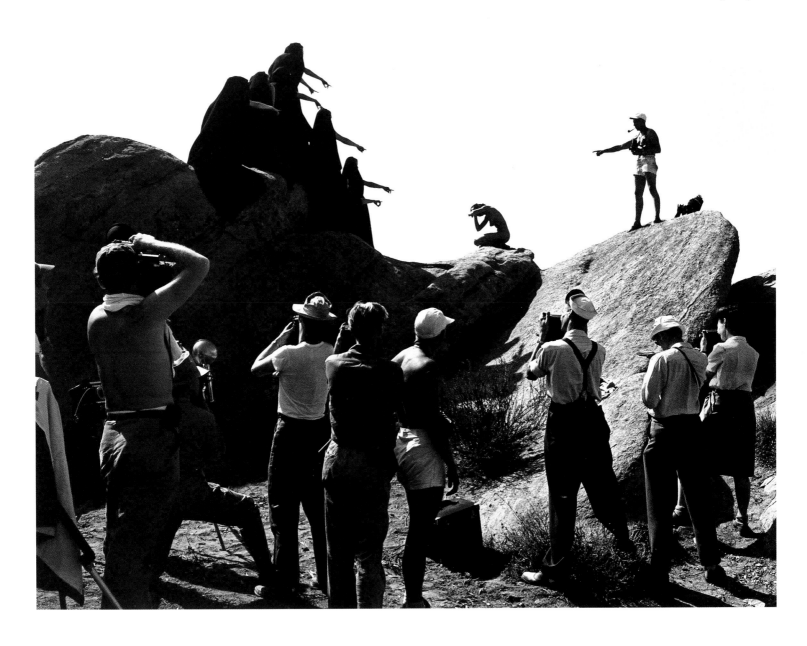

Huene with his class from the Art Center School, Pasadena. Undated

world of natural phenomena. Nature seemed so vast, so prodigiously wealthy, that people, time, the activity of man, seemed trivial by comparison.

After a few hours the effect ceased, and I came back to what we consider "normal." I revisited some of the plants I had been admiring, and they seemed commonplace compared to the sensation of strolling through a gallery where nature had exhibited a series of masterpieces. I have never tried the experiment again, but I remember every detail exactly. In conclusion I dare to compare what I had seen with a few great masters of painting – Turner, Redon, Van Gogh, Tchelitchev. They all seemed to have enjoyed a visual capacity different from that of others. This may be due to the fact that these painters had a highly sensitive reaction to violent colors and used them with a knowledge of the capacity of colors to vibrate and project luminosity on an opaque surface. A few days later I wrote a report and handed it to Huxley.[7]

His admiration for one of the "great masters" – his old friend Pavel Tchelitchev – was reciprocated. On hearing from Huene in 1954 how gratifying his life in California had become, the painter replied:

Opposite: Huene exercising by the Pilates method, part of a series of sixteen similar self-portraits. Undated

151

My Dear, Dear George,

I was so happy to receive your letter with such good news concerning your life and your career. It was wonderful to finally reach the desired goal, in particular as you have never made any concessions; on the contrary, you have made great sacrifices ...

There was one thing which preserved you and protected you from all taint, even in the dubious climate of fashion magazines – the love of perfection ... Then your love of simplicity – a rare quality – for only by aiming at the essence of things does one come upon that which is simple – the essential. And one must admit that you never thought of yourself – you always thought of your work. There was an extraordinary humility which in no way interfered with your dignity, but on the contrary aided you. So now I expect wonders from you ... I believe that when people are confronted by something imbued with the purity of sentiment and devoid of self-obsession, it astounds them, like an avalanche ...[8]

There were, however, moments of doubt. In periods of depression, Huene would retreat into a black bedroom, his *"chambre noire,"* as he called it, and might not emerge for days.

On 12 September 1968 Huene died suddenly of a stroke at his home in Los Angeles. He had already experienced heart trouble, but in a letter to Horst in May of that year, he had written: "I might go to London in the winter and work on the *Right Hon. Gentleman* for Cukor ... it all depends how the pump will work, and as I am not fashionable I shan't have a transplant."[9] He left behind several unfinished projects: a number of film scripts based on historical events and the careers of world-famous historical figures, such as Napoleon; the next of his pictorial travel books, on Spain; and his autobiography, on which he had been working with his good friend Oreste Pucciani, a literary scholar and professor at the University of California at Los Angeles. The autobiography was to have been copiously illustrated, not only with his own photographs, but also with those of photographers he greatly admired, such as Steichen and de Meyer.

Huene also left an archive of rare books supplemented by clippings on a wide range of art subjects from newspapers and magazines, and albums containing tearsheets of his photographs. He was not, however, so considerate of his original prints. With the exception of some of the material at Condé Nast, his prints and negatives were never cataloged or systematicaly filed, and few remained in his possession at the time of his death. Although hundreds of prints have since been discovered, many of his finest images exist only as reproductions in the pages of *Vogue, Vanity Fair,* and *Harper's Bazaar.*

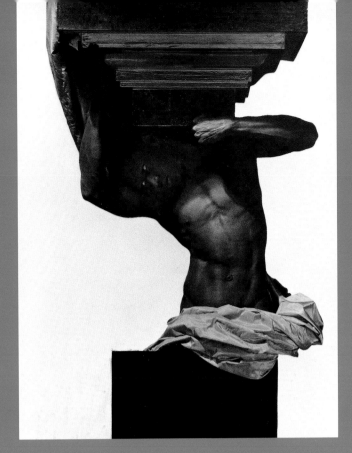

Plates 68–89

TRAVEL
AND
EXPERIMENT

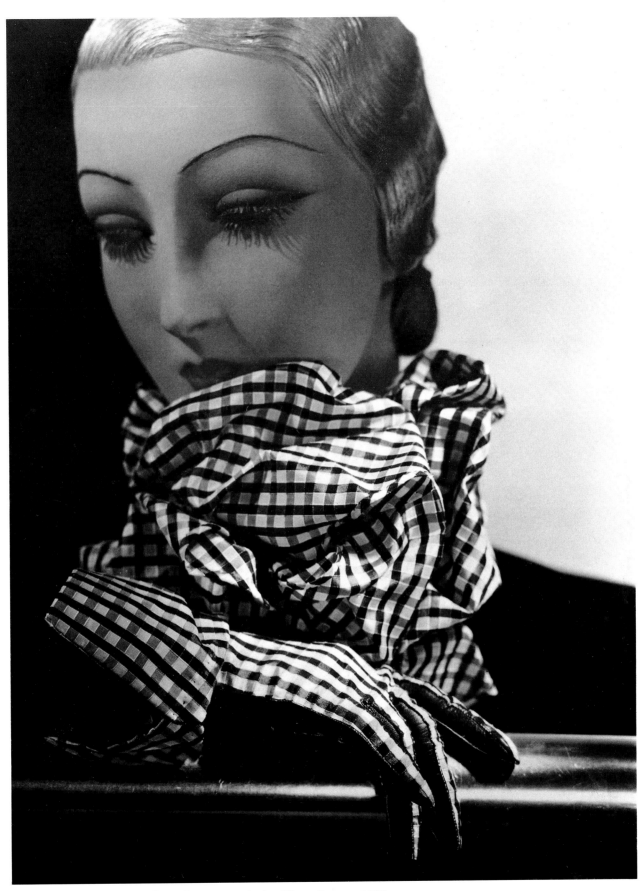

68 Scarf and gloves by Chanel, mannequin by Pierre Imans, 1934

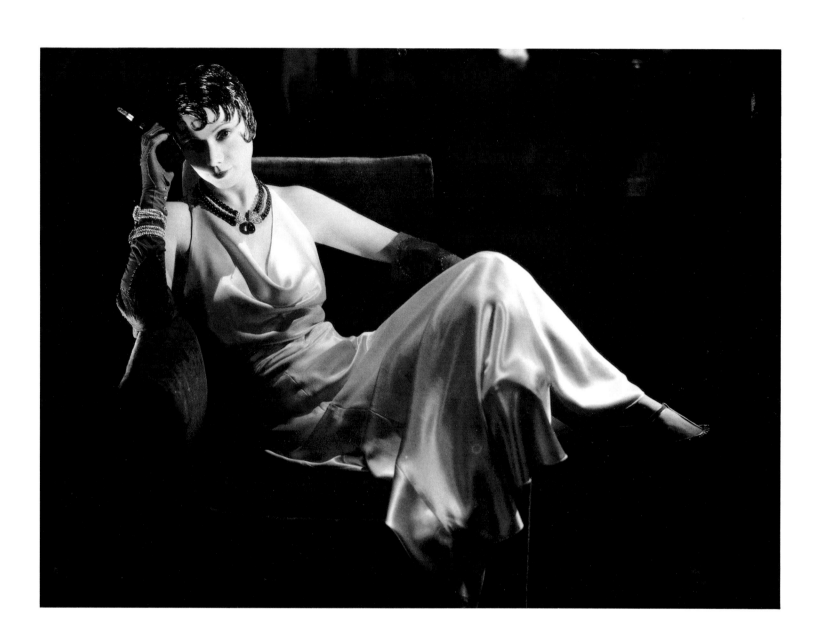

69 Thérèse Dorny, 1931

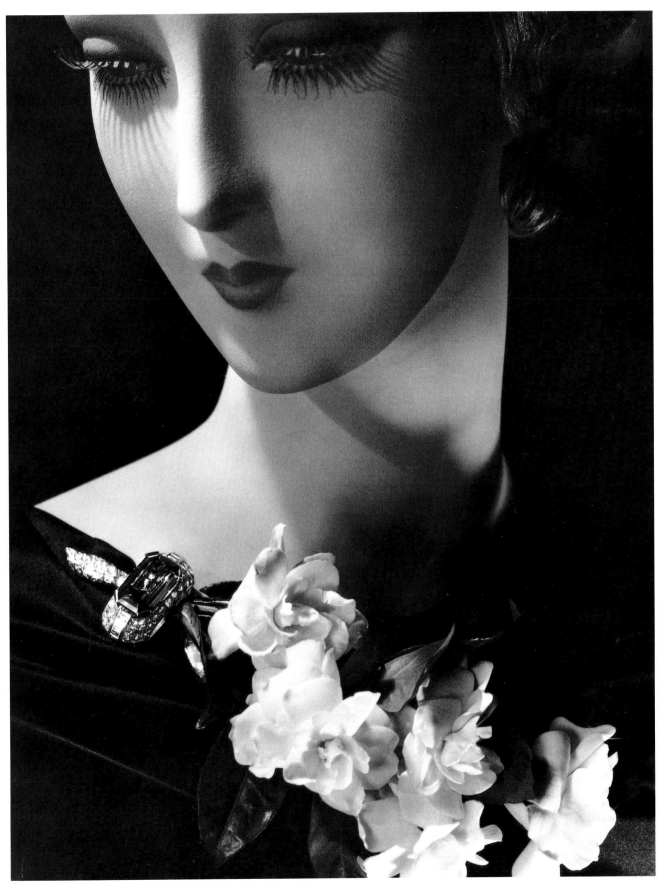

70 Mauboussin diamond-and-topaz corsage clip, mannequin by Pierre Imans, 1934

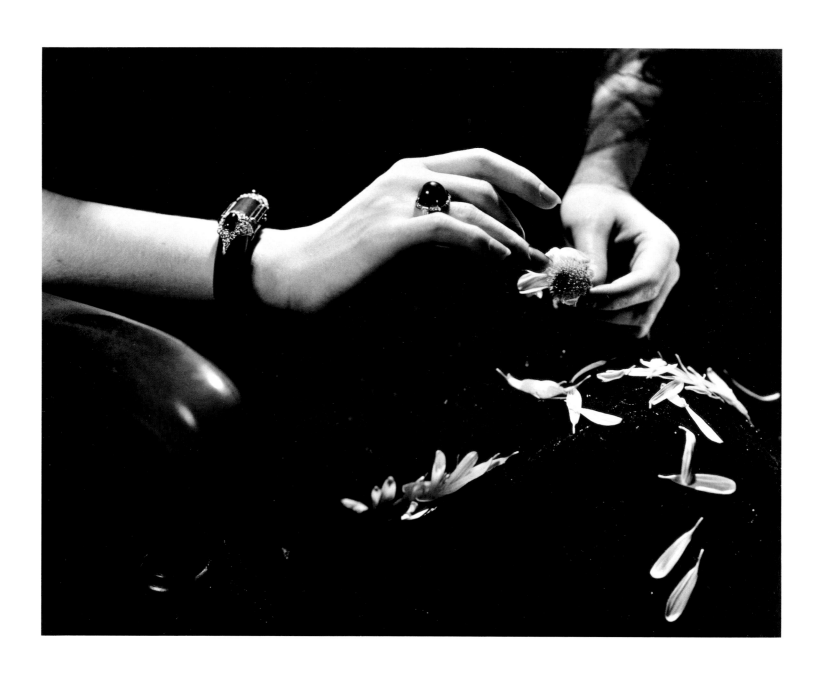

71 New jewelry, *c.*1931

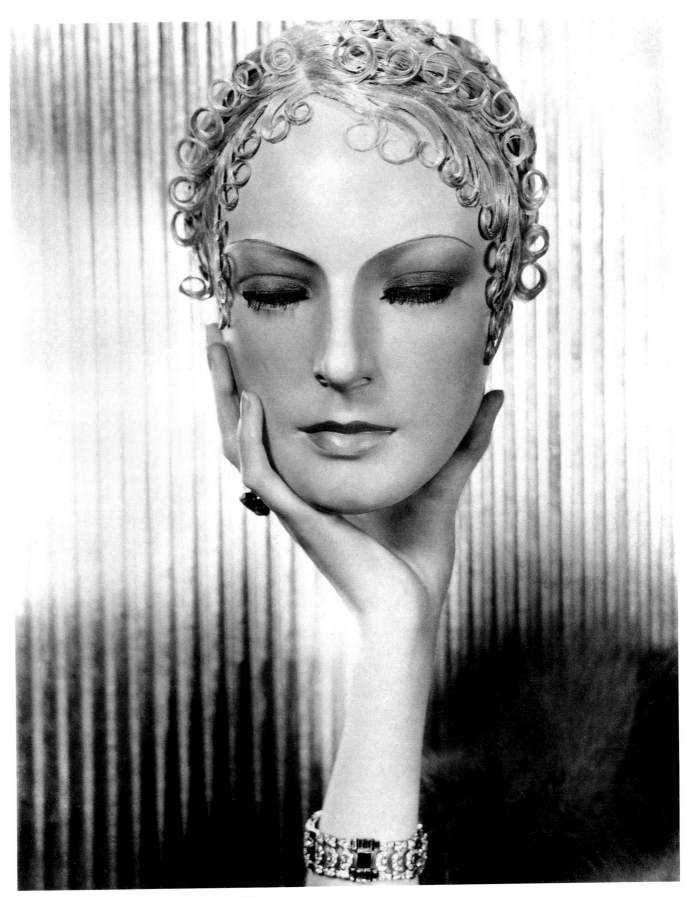

72 Life-mask of Dolores Wilkinson, 1933

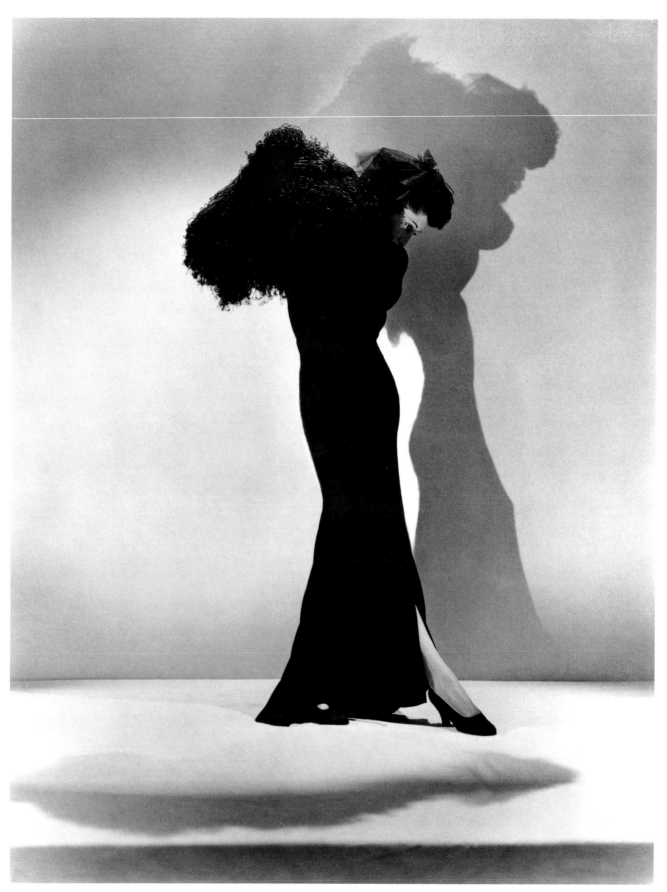

73 Evening wear by Mainbocher, 1938

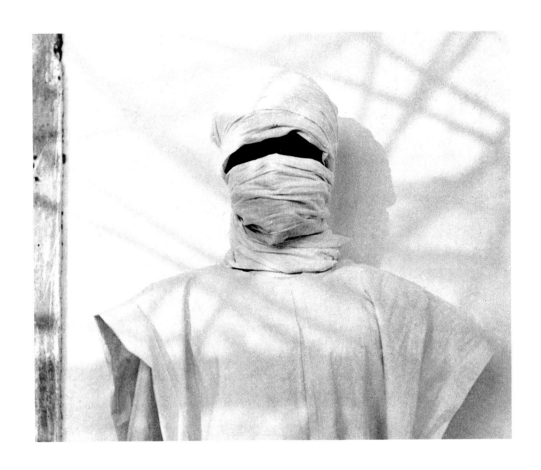

74 Tunisia, 1936

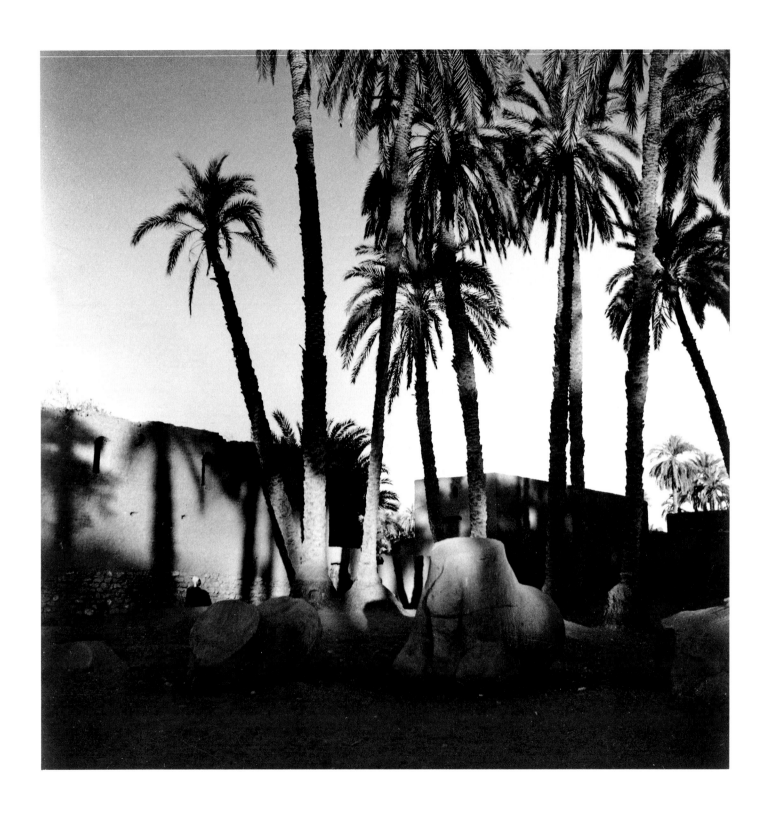

75 Avenue of the sacred rams, Karnak, Egypt, *c*.1939

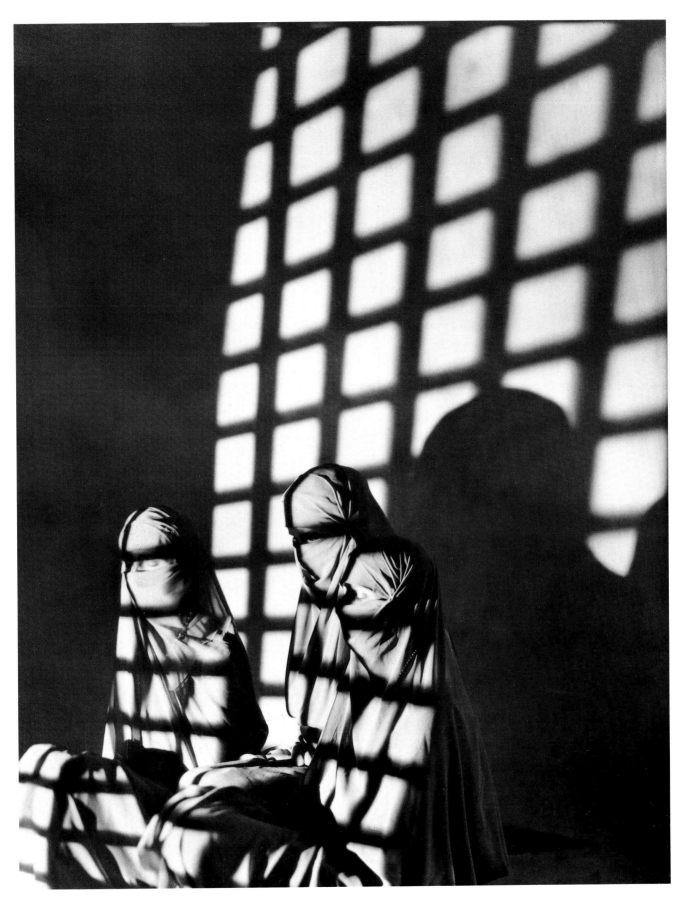

76 "Moslems for a night," costume ball, 1929

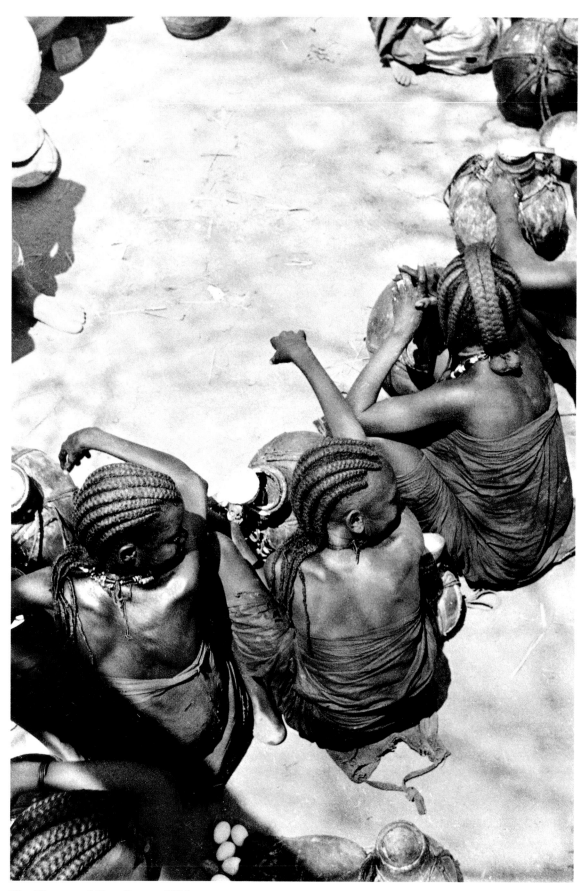

77 Women of Fort Lamy, 1936

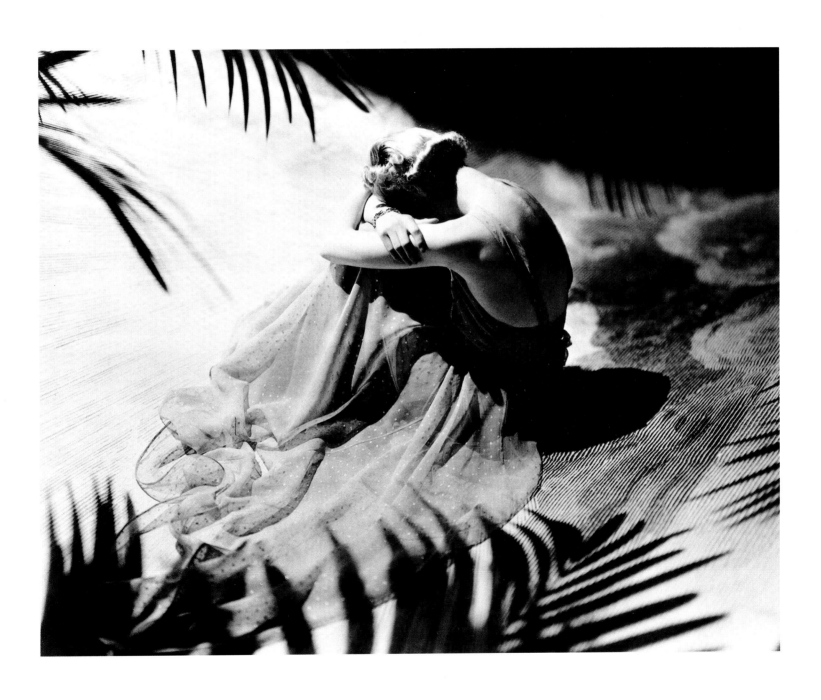

78 Evening wear by Jay Thorpe, 1936

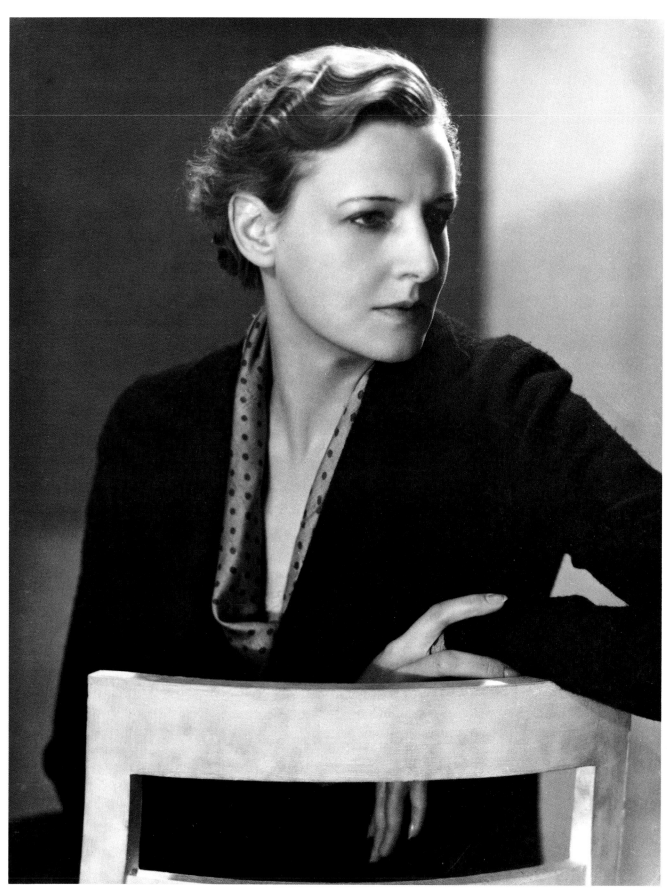

79 Dolores Wilkinson, *c.*1933

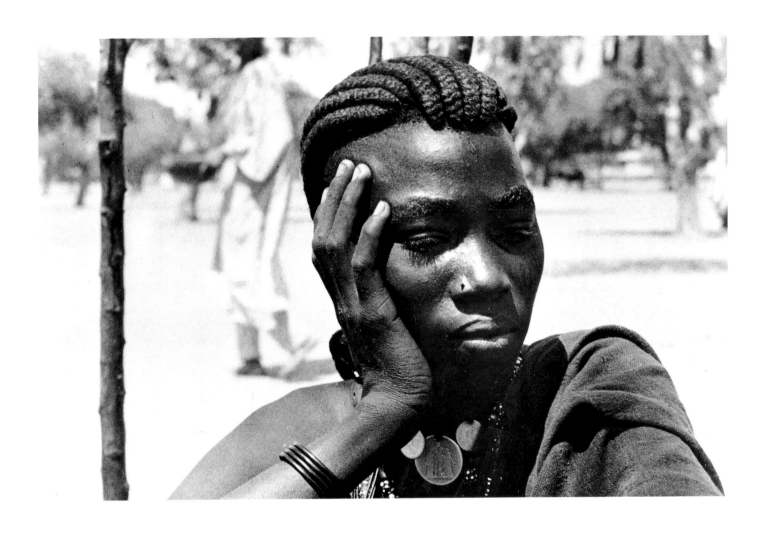

80 Woman of Fort Lamy, 1936

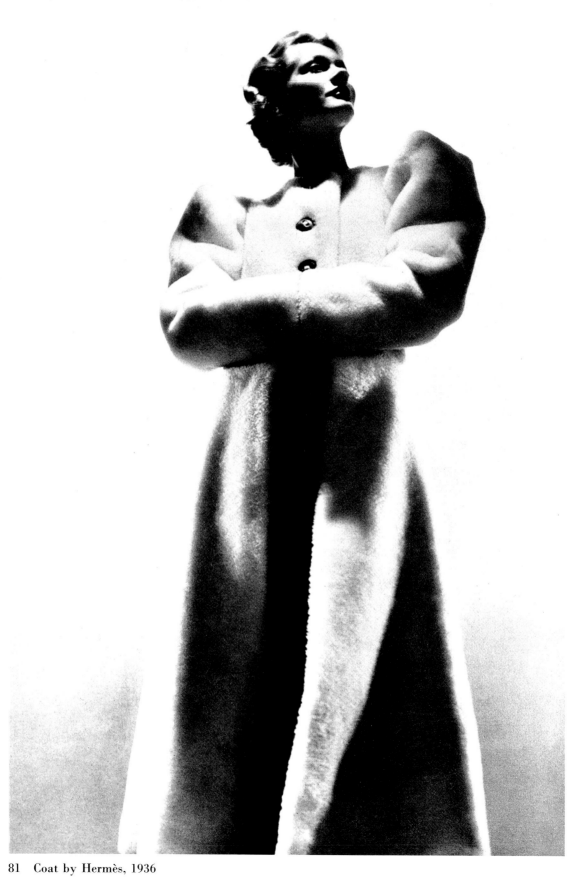

81 Coat by Hermès, 1936

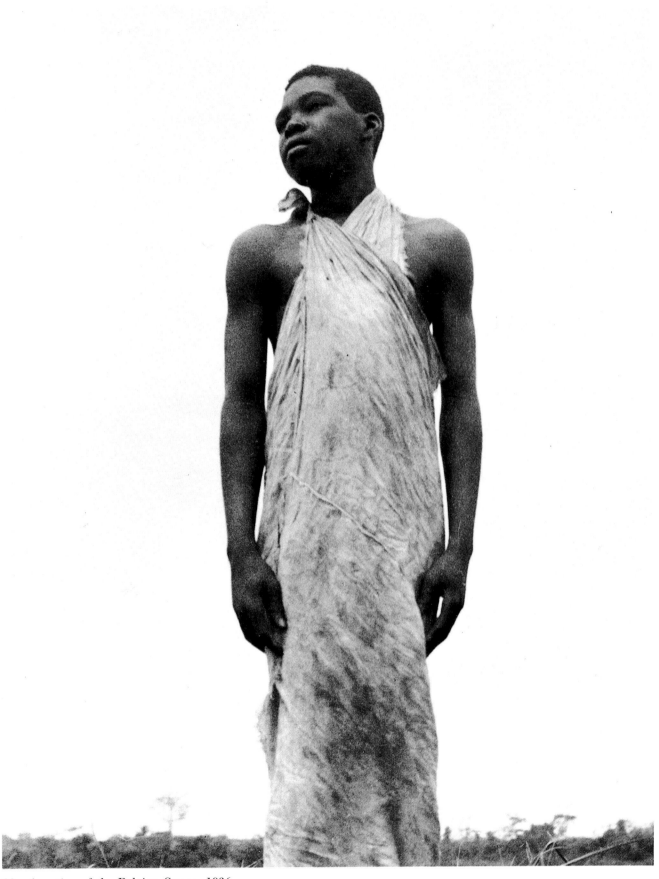

82 A native of the Belgian Congo, 1936

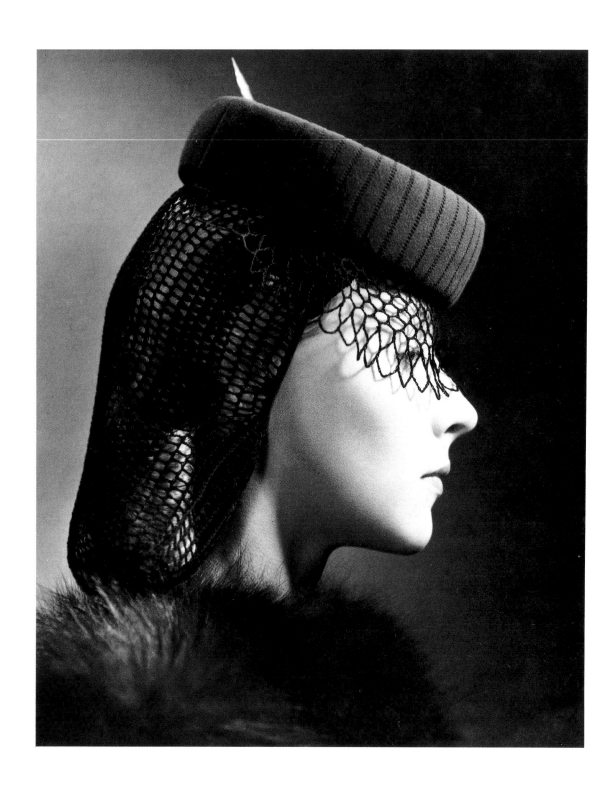

83 Snood by Talbot, 1935

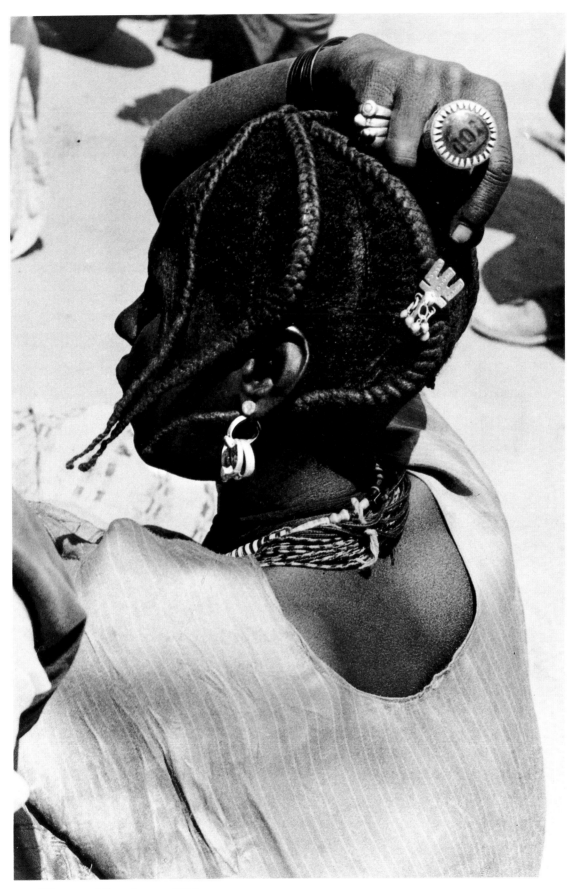

84 Woman of Fort Lamy, 1936

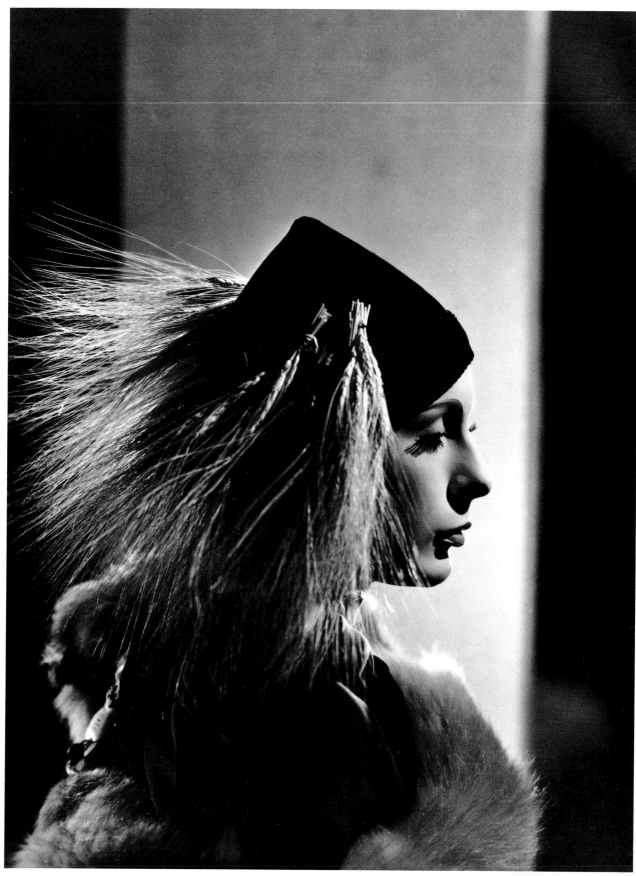

85 Lady Abdy, 1933

86 Crested cranes by the Nile, 1936

87 Temple of Khaf-Rē, Giza, Egypt, *c.*1939

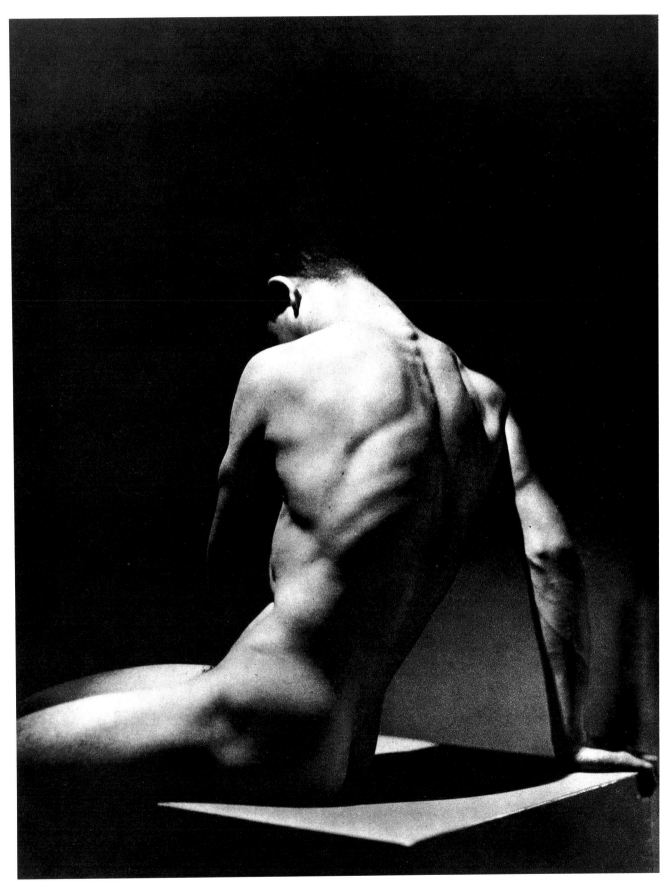

88　Nude, Paris, *c*.1929

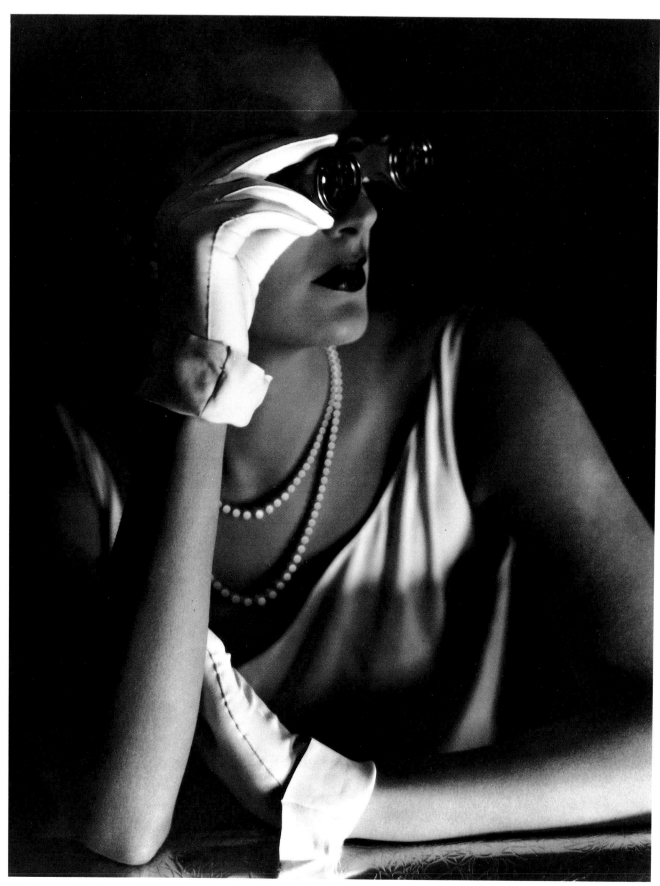

89 Agneta Fischer modelling evening gloves, 1931

Chapter Seven

"THE MASTER OF US ALL"

Although the autobiography was never finished, we know precisely what illustrative matter its author planned to include: sixteen fashion photographs, concentrating on the early Thirties;[1] seven portraits of women, mostly friends, including Chanel, Natalie Paley, the Grand Duchess Marie of Russia, and Lady Abdy; twenty-three portraits of famous actresses, such as Garbo and Hepburn; a dozen or so architectural views of ancient sites in Greece and Egypt; a small number of travel photographs; several studies of African natives; a number of reproductions of works by such notable artist-acquaintances as Dali, Tchelitchev, and Bérard; and twenty-two portraits of men, including Horst, Derain, Weill, Chaplin, Bérard, Tchelitchev, and Cukor. Edward Steichen and Baron de Meyer were also included, as Huene's tribute to his mentors. But what can be said of his own contribution?

The historian Nancy Hall-Duncan has suggested that Huene's influence was less than Steichen's, "as the rigor and compositional clarity of his best work were impossible to imitate,"[2] but it is also true that postwar conceptions of beauty were less tied to European standards and conventions of elegance, and so the urge to allude to the classical world or to high art receded. Many younger photographers could not comprehend this iconography, or if they did, rejected it as outmoded and irrelevant. But *influence* was still there in the example he set, and whatever direction a photographer chose, Huene's standards and achievements were inescapable.[3]

Huene may be impossible to imitate, but certain of his colleagues occasionally made the attempt. Consider, for example, a group of Martin Munkacsi's pictures in the Huene idiom which appear in the September 1938 issue of *Harper's Bazaar*.[4] Here the endeavor to emulate Huene's refined elegance fails dismally, as if shy country girls had been hastily recruited to model haute couture; they appear awkward and stiff, unsure of how to hold themselves. Nor does Munkacsi's lighting enhance the clothing. Similarly, a double-page spread by Louise Dahl-Wolfe in the October 1938 issue of the same magazine falls short of convincing grace.[5] This is not to belittle either photographer; for a time Munkacsi was without an equal in his sporty depictions of the all-American girl, and Dahl-Wolfe's ingenious color compositions were the envy of every photographer. But such comparisons underline Huene's virtuosity.

In fashion photography, the question of influence is not simply resolved. Then, as now, the fashion world placed a premium on innovation and nurtured the mystique of originality in all creative endeavors associated with the promotion of women's apparel. Consequently, the contributors to the magazines guarded their reputations jealously. Novelty was their capital, and they were generally reluctant to admit to any influence—unless that of a great painter, which of course meant validation of their own styles within a grand pictorial tradition. But the facts—as even a cursory overview of the magazines will show—are otherwise. Clearly there was substantial give-and-take. Each photographer's work was displayed prominently, month after month (and during some periods, even twice monthly) on the pages of *Harper's Bazaar* and *Vogue*.

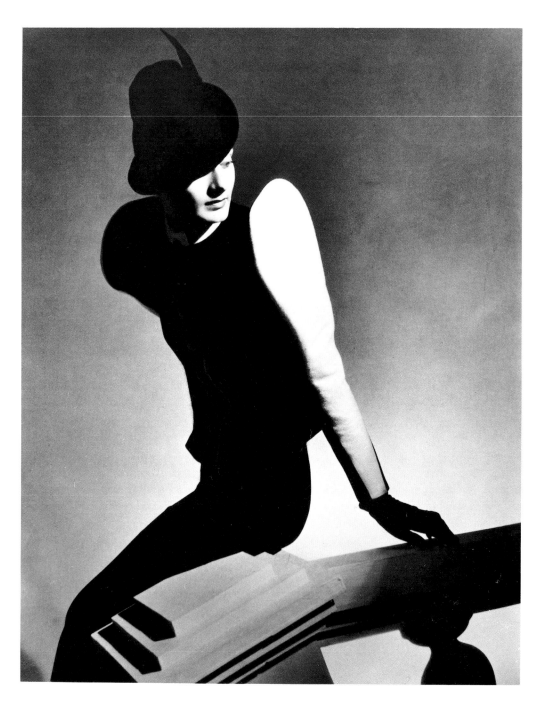

Suit by Piguet, hat by Talbot.
Photographed by Horst, 1936

It would have been difficult for any of them not to keep abreast of their competitors. Even the most innovative individual had to keep an eye on the work of his or her colleagues in light of the grueling pace at which they were required to produce fresh material. Twenty, thirty, or even forty pictures per issue were not uncommon loads for the senior contributors. Is it surprising therefore that they staged raids on each others' stylistic territory? Even Steichen, who had taught Huene so much, responded to the latter's brilliant imagery with bold counter-measures of his own. Perhaps the master sensed a strong bid by his protégé for the position of Chief Photographer at Condé Nast. Many of Steichen's fashion masterpieces, such as "Black,"[6] came well after Huene had established himself as a force to be reckoned with.[7]

Huene's influence on his colleague Louise Dahl-Wolfe is difficult to determine with any precision. Dahl-Wolfe herself only admits to mutual respect; when the two dined out together, they rarely discussed photography.[8] She shied away from grandiose visions – temples had no place in her unpretentious schemes. But the two were on common ground when it came to perplexing situations; problems were solved through intelligence and resourcefulness, rather than expensive technical means. Thus Huene took his models to the roof, while Dahl-Wolfe lit her night bathers with the headlamps of a car.

If her occasional attempts to emulate Huene's imperious studio settings fell short of the mark, she was more than a match for his achievements in the field of color. By her own admission a frustrated painter, she practised "the science and art of color" and used unlikely combinations of unusual colors with great success.[9] Both photographers, in other words, had their respective strengths. The overall picture, therefore, is of two prolific and committed professionals keeping pace with each other's innovative ideas.

For Cecil Beaton, it was not Huene's classicism which was to be emulated, but his less characteristic flights of fancy:

There was something almost frivolous in the way Huene brought a whole new collection of properties to his studios. Rich and illustrious women would play a losing game as they tried to keep their dignity against huge Corinthian columns, plaster casts of Hellenic horses' heads, heads of Greek gods, or plumes of pampas grass ... his models seemed to be disporting themselves among giant porcelain vases filled with gargantuan orchids ... Huene's violent activities in the pages of *Vogue* gave me the greatest incentive to rival his eccentricities.[10]

This reads as a rather backhanded compliment; Beaton bows to Huene's marvels, but questions the ultimate result: the women in his photographs are playing "a losing game." But memoirs can be self-serving, and Beaton's assessment should be taken with a grain of salt. The fierce competitive spirit is more significant.

Horst, on the other hand, being both younger and Huene's protégé, never had a problem acknowledging his debt. What better way to learn photography than in the role of model, with plenty of time to scrutinize the workings of the man behind the camera? Horst took careful note of Huene's concentration and authority. Later, he observed the rigor of Huene's compositions and attention to detail. He learned from

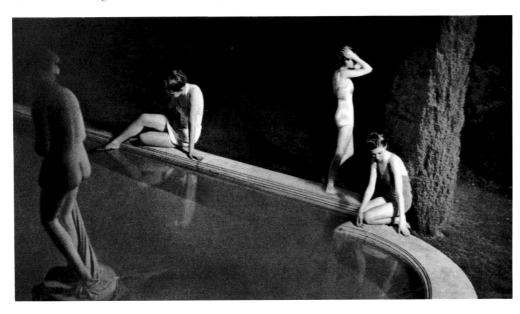

Night Bathing by Louise Dahl-Wolfe, 1939. The models were lit by the headlamps of a car

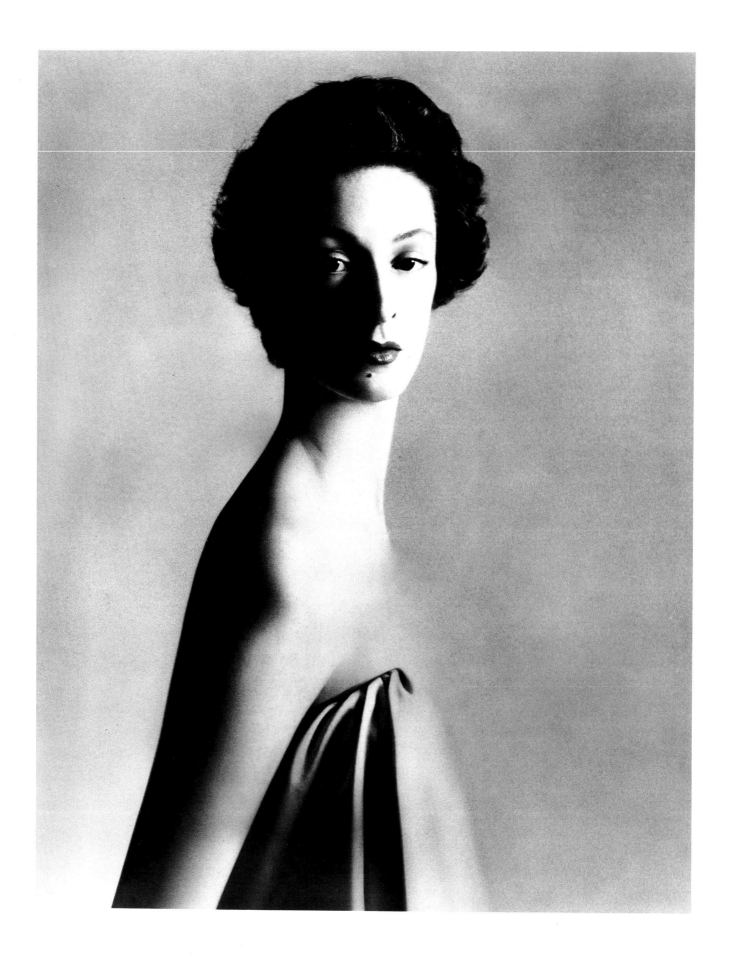

his friend ways in which gestures could be orchestrated to animate an image, the expressive range of chiaroscuro illumination, and the power of classical motifs. Huene also encouraged Horst in the search for ideas in painting and sculpture. Sometimes this results in specific quotations – to a Houdon bust or a Vermeer interior, for example – but it may also be observed in general references to styles, schools, or periods. Thus we see in Horst, alongside flourishes of classicism, something of Ingres' meticulous modeling and Van Dyck's rich rendering of materials. This might explain why some writers have described Horst's style as "Baroque," and others as "Neoclassical." But eclecticism is the key; in a "Horst," classical order lives comfortably with Baroque imagination.[11] Horst paid homage to Huene in *Salute to the Thirties*, published three years after Huene's death. In this book, nostalgically introduced by Janet Flanner, Huene's pictures of the period were printed side-by-side with those of his great friend.

Huene left *Harper's Bazaar* – and fashion photography – in 1945. Some years later he wrote in response to a student's inquiry:

I think the change from slick photography to the present day came about for the following reasons: (a) many photographers started using strobe equipment; (b) most photographers were not particularly partial to intricate lighting, which is time consuming; (c) in fashion photography movement seemed more important than form; and (d) any change from one type or style is normal and healthy.[12]

Thus he relinquished his position gracefully – without apparent doubts or bitterness – to a younger generation of contenders. Foremost among them were the figures of Richard Avedon and Irving Penn.

When Huene decided to leave the field immediately after the war, the studio tradition was still supreme. With Steichen, modernism had triumphed, and the trail of pictorialism, blazed by de Meyer, had grown cold; only the exploits of Beaton could keep it from fading completely. Munkacsi had paved the way for an alternative realism, with his breezy outdoors approach, a route well-travelled by Toni Frissell, Jean Moral, and others. Now, in the postwar era, the once opposing forces of realism and studio formalism came together in the work of Richard Avedon.

Avedon has always spoken highly of Huene. In 1980 he chose to put these thoughts on record in a congratulatory telegram sent to the International Center of Photography on the eve of Huene's retrospective exhibition. "Huene was a genius," affirmed Avedon, "the master of us all." It wasn't just professional admiration, but deeper affinities which prompted these words. Avedon didn't look to Huene for clever ideas which could be adopted for his own use; one detects nourishment on a far deeper level – principles conveyed, values imparted. Avedon never stooped to imitation of Huene, but sought to match his powers. His *Marella Agnelli*, for example, is a fitting companion for Huene's *Toto Koopman, evening dress by Augustabernard, 1933*. The picture may well be read as a tribute to Huene's spare and refined style.

Many fashion photographers took to their assignments little or no knowledge of what had been accomplished by their predecessors. With Avedon, as with Huene, there was a keen awareness and heartfelt appreciation of past achievements, and a desire to develop them – the real meaning of tradition. Not only does Avedon build on the foundations of Huene and Munkacsi, but (as his very early street work in Paris shows) on the poet-cameramen Henri Cartier-Bresson, Bill Brandt, and Brassaï, all of whom appeared regularly in *Harper's Bazaar*.

Right from the beginning, Avedon moved confidently forward with his own ideas. More than any photographer previously, he grasped the real nature of the medium – the open, double-page format of the magazine, *not* the autonomous, bordered,

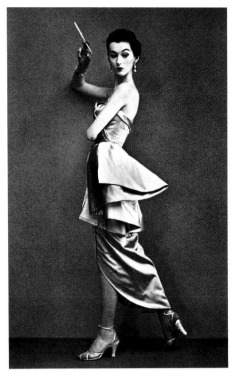

Dovima, evening dress by Fath, Paris studio, 1950, photographed by Richard Avedon (*above*), is an image that looks back to Huene's example; compare, for example, Toto Koopman, evening dress by Augustabernard, 1933 (*below* and plate 26)

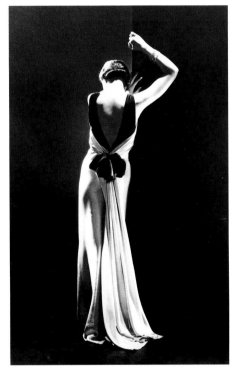

Opposite: Marella Agnelli by Richard Avedon. New York studio, 1953

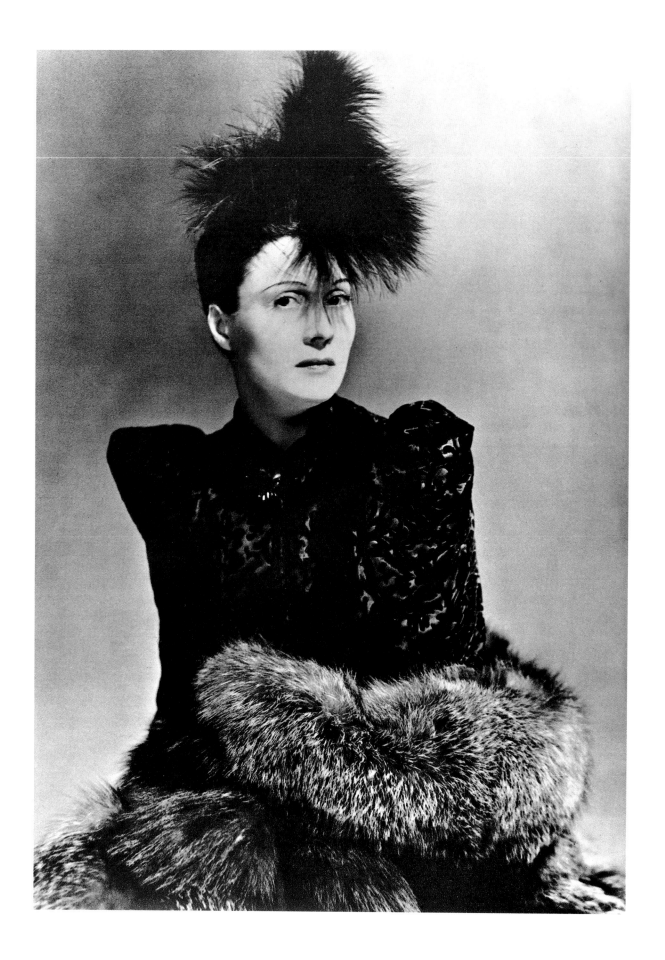

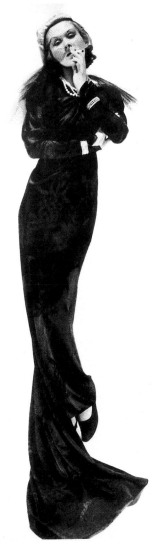

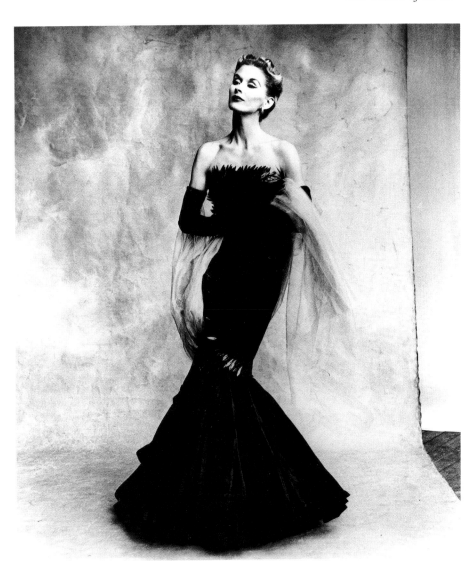

rectangular photographic image. Together with Brodovitch, under whom he had studied before coming to the magazine, he produced the most dynamic marriages of image and text ever seen in a fashion magazine.

These impressive achievements were not lost on Huene himself, and for a brief, fascinating period when the work of both overlaps in *Harper's Bazaar* (1945–6), we see signs of a new direction in his work, signs which – had he continued – may have prefigured a whole new approach to his work. Seen in this light, there is truth in the thinking of some of his colleagues that he abdicated prematurely and squandered his gifts looking for some Byzantium in Southern California.[13]

Unlike Avedon, Penn seems anxious to maintain a certain distance from Huene. European standards and conventions were, he tells us, "beyond my experience, as was Huene's work, which was remarkable, but his aristocratic perfectionism was beyond my aspirations."[14] At first glance this is a surprising disclaimer, in view of extraordinary similarities, not least "aristocratic perfectionism."

Penn's work is admired for its formal clarity and tranquil strength. Equally appropriate descriptions might be monumental and uncompromising. His formal concerns have much in common with those of Huene: an authoritative sense of line, dramatic silhouette, and a love of abstraction characterize his imagery. Both men

Lisa Fonssagrives-Penn, "Mermaid Dress" by Rochas, 1950, photographed by Irving Penn (*right*), presents an ideal of elegance that is a direct descendant of a picture like Dinner dress by Mainbocher, 1937 (*left*), by Huene, with the same model

Opposite: Mme Arletty, outfit by Schiaparelli and hat by Reboux, 1939. This photograph from Huene's later years as a fashion photographer looks forward to Avedon's simplicity of presentation

make use of a full range of tonalities and dramatic contrasts of light and dark, although Penn's opposing whites and blacks are generally more dramatic, as is his crisp geometry. At times this boldness is of a severity bordering on the petrified.

Both photographers loved painting, and what has been said of Huene in this regard may also be said of Penn. This also applies to portraiture; Nadar is the most obvious predecessor of both. And as for learning from the past, are not certain Penns (consider for example *Girl Behind Wine Bottle*)[15] in the pictorial idiom of de Meyer? Moreover, in their fascination with native peoples, Penn and Huene rejected the notion of fashion as frivolity in favor of an appreciation of clothing and adornment as a language of culture. Their actual approaches may have differed (Penn transported his studio into the field, whereas Huene merely fell back on his studio technique) but they shared a common fascination with dress as a product of human ingenuity and the compulsion to produce art.

How then to explain Penn's aloofness? Perhaps the distance is ideological, formal parallels aside. Huene ended with the war, while Penn began with it. It could be speculated that the catastrophe made the realm of high fashion seem detached from the world as it truly was. Would this not explain Penn's propensity to expose the artifice of the studio by showing raw edges of backdrops, cables, and other accoutrements of the trade? If so, Huene's quest for convincing illusions through theatrical means would seem untruthful.

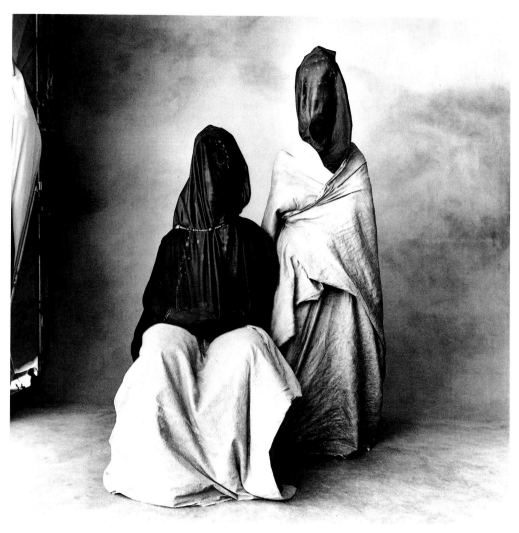

Two Guedras, photographed in Morocco in 1971 by Irving Penn, who shares with Huene a realization that fashion and costume are not frivolous concerns but integral elements of culture

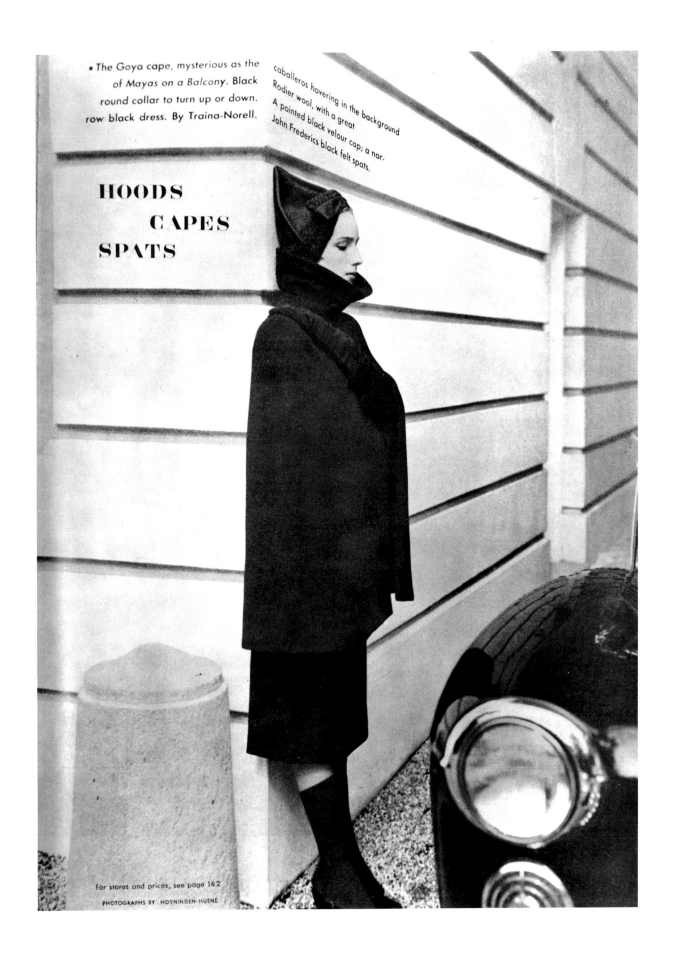

• The Goya cape, mysterious as the
of Mayas on a Balcony. Black
round collar to turn up or down.
row black dress. By Traina-Norell.

caballeros hovering in the background
Rodier wool, with a great
A pointed black velour cap; a nar-
John Frederics black felt spats.

HOODS
CAPES
SPATS

For stores and prices, see page 162

George Hoyningen-Huene was born an aristocrat amid the waning splendor of imperial Russia, to a family long accustomed to the prerogatives of great social standing, power, and wealth. Not the least of these privileges was intercourse with the world beyond a Russia still in many ways medieval, and consequently a broader view of that world. By the time the forces of unrest had sparked chaos and revolution, Huene and others of his class were better equipped than the majority of their countrymen to deal with the results of profound upheaval. Although Huene's material possessions were confiscated and his social amenities forfeited, the intangible attributes of the nobility could never be taken from him: a worldly education, refined manners, a distinguished bearing and unflagging self-confidence enabled him to negotiate the turbulent waters of the Revolution, not to mention the shoals of normal adult life.

Huene was often imperious, even arrogant, although his friends argue that he was never a snob. "Sauvage, revolté, impossible" complained Cole Porter of an intemperate outburst by Huene.[16] But George Cukor held that his high-handedness was generally employed in the face of incompetence, slovenliness, or threats to his fundamental beliefs.

Certainly Huene never harbored pretensions about his professional calling. He regarded his commercial endeavors matter-of-factly as a craft, and as a means of earning a handsome living. Although he was ready to admit that fashion photography called for the utmost ingenuity and offered substantial rewards, it was ultimately of limited consequence in his own eyes. Far more edifying was the study and appreciation of great art, in particular the stupendous accomplishments of the ancient Egyptians, Greeks, and Romans. The cultures of antiquity were not distant, dead and buried, but timeless monuments that vibrated with life, "The past rushes at you," he wrote of his adventures abroad, "crashing through the centuries."[17] In this passion for the classical he was a true *amateur*, in the sense of one who loves and cultivates. Is it any wonder then, that he could abruptly abandon his fashion photography at the peak of a brilliant career to embark on new ventures?[18]

There is no question that Huene made an outstanding contribution to fashion photography, nor that his work is still emulated. What has been overlooked, however, is a much broader accomplishment – that of a complex body of work with relevance far beyond the province of fashion illustration. This is not merely a matter of acknowledging his superb portraiture and architectural studies, nor his prodigious output. The key to Huene's achievement lies in the consistency, intellectual complexity, and inter-relatedness of his ideas. In the final analysis his work must be considered as a coherent system of images, characterized by precision, economy of means, harmony, elegance, and psychological acuity. The best of his photographs require no captions. They call for no special interest on the part of the viewer in fashion *per se*, or, in the case of the portraits, in the identities of the sitters themselves. Creative excellence elevates subject matter. As in the best of art, form transcends function.

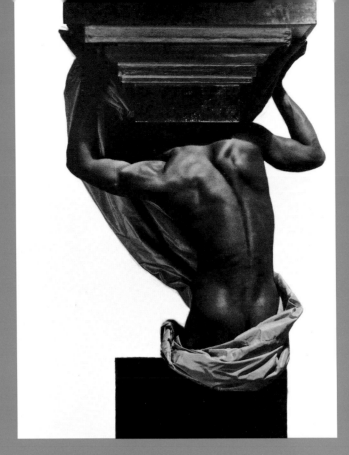

Plates 90–135

FRIENDS
AND
ACQUAINTANCES

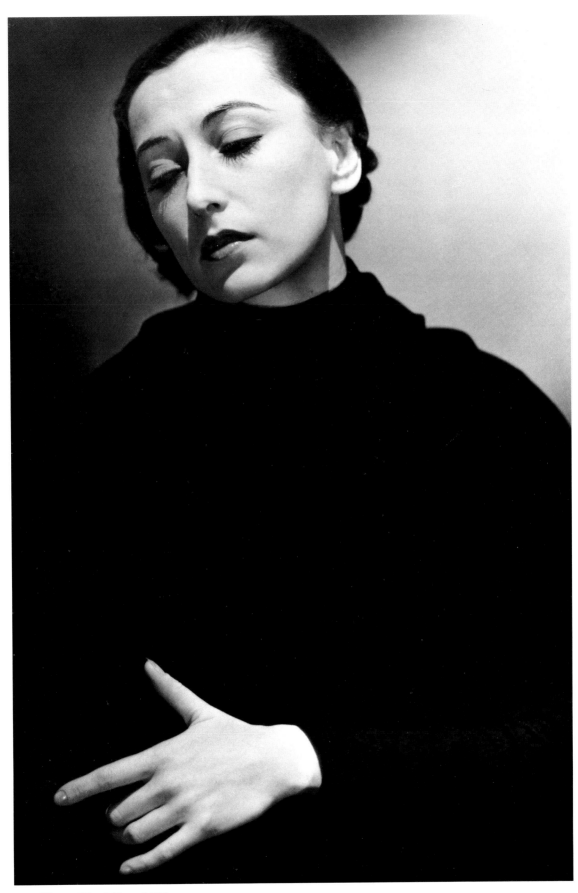

90 Nimet Eloui Bey, 1929

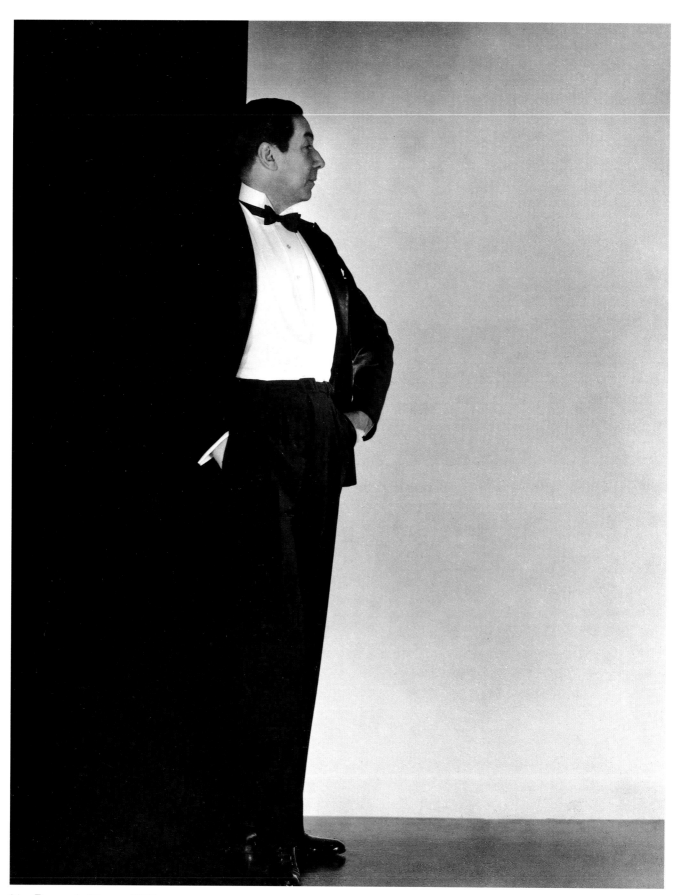

91 Baron de Meyer, 1932

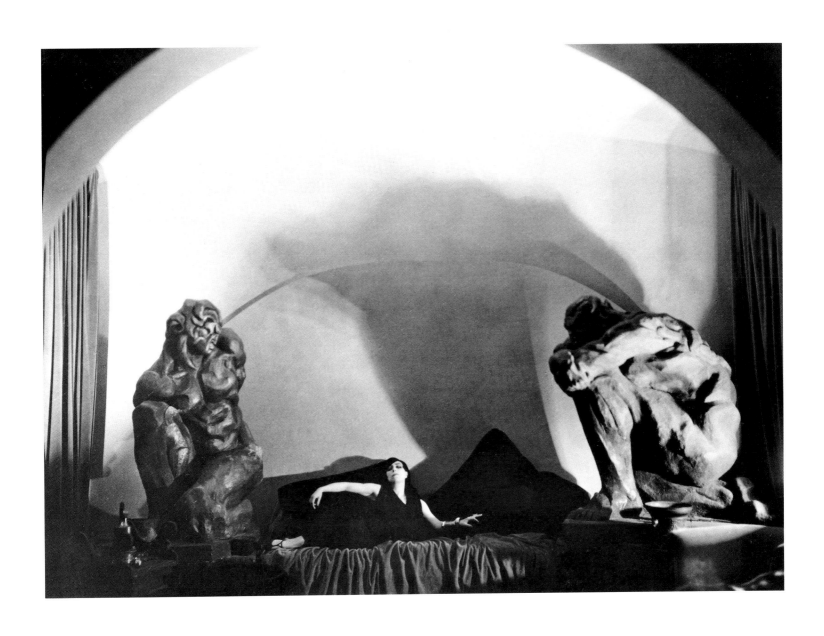

92 Marchesa de Sommi Piccinardi at home, Rome, 1931

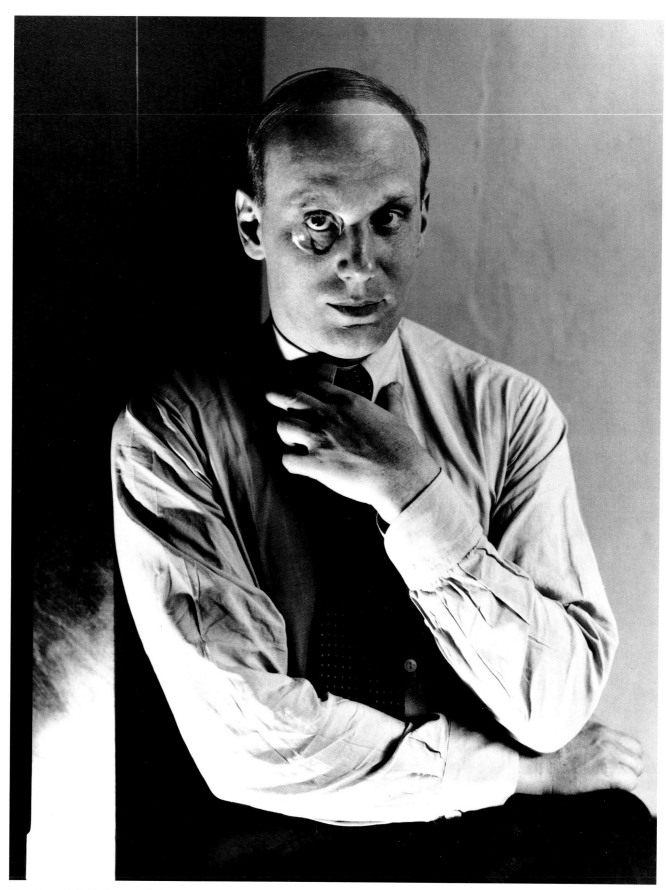

93 Gustaf Gründgens, 1932

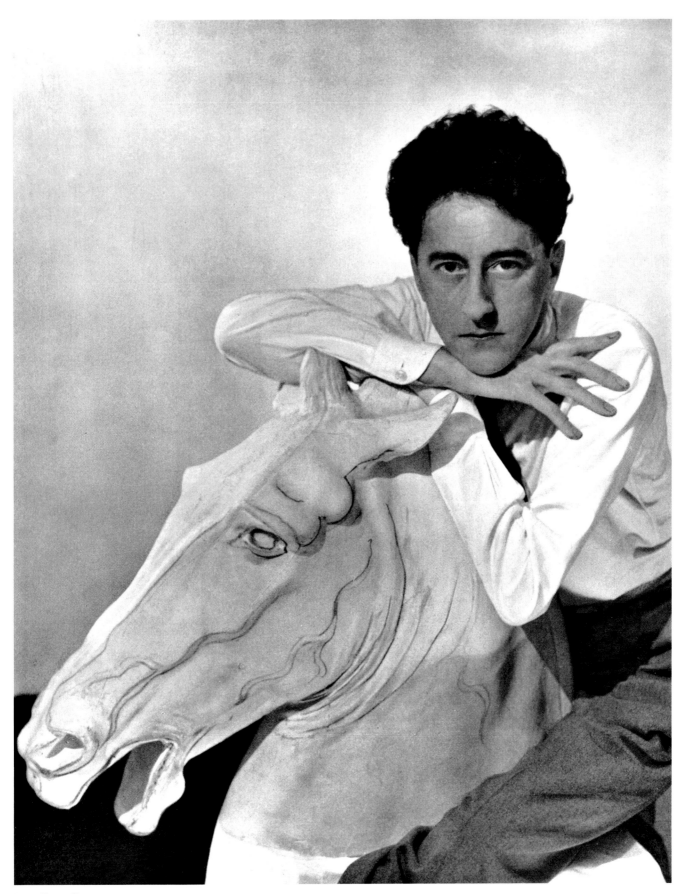

94 Jean Cocteau, 1930

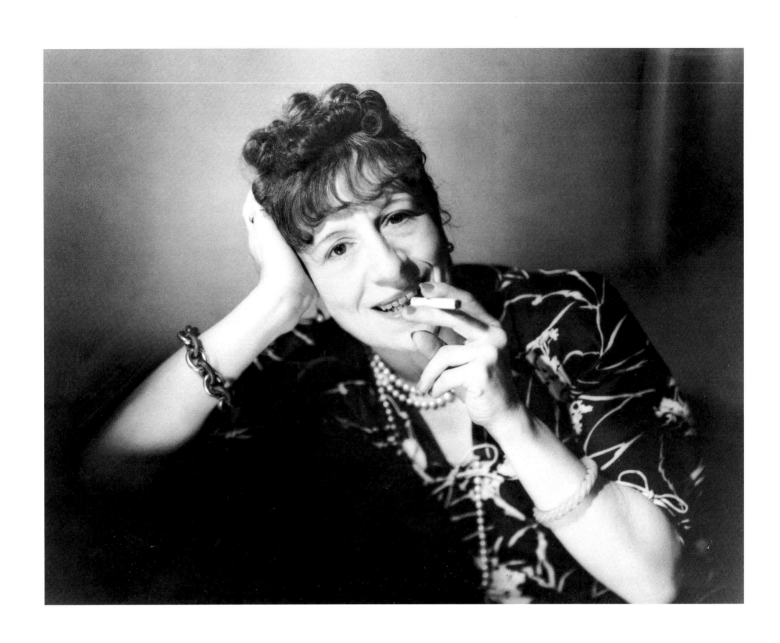

95 Marie Louise Bousquet, *c*.1930

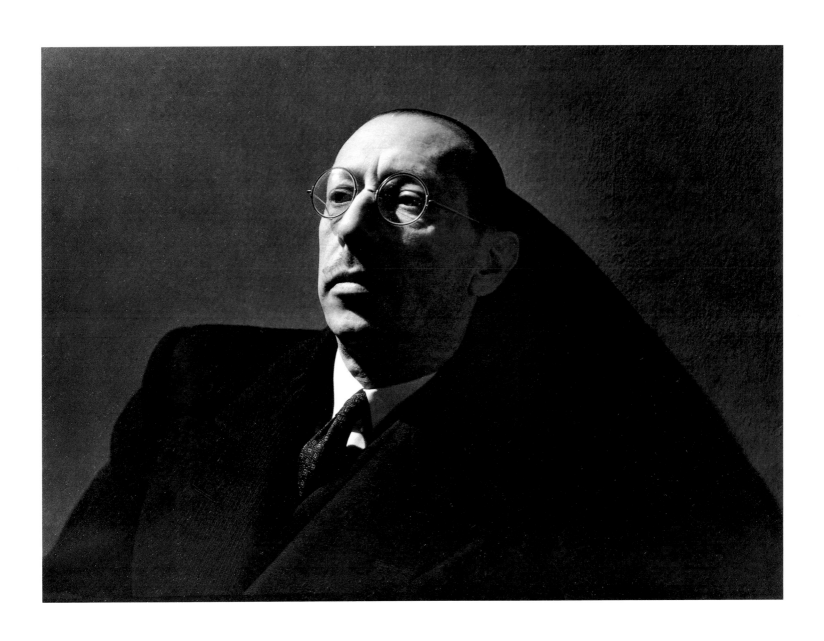

96 Igor Stravinsky, 1927

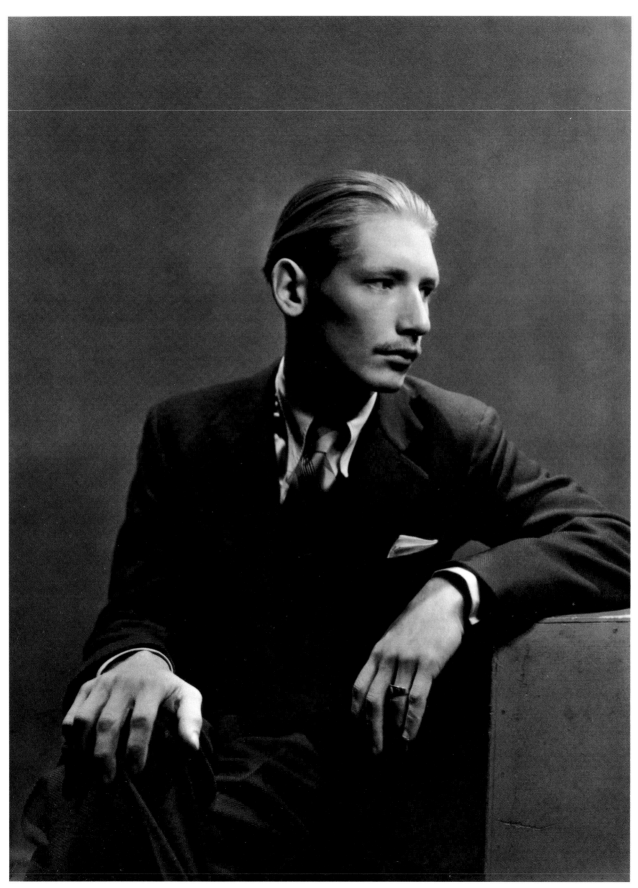

97 Soulima Stravinsky, 1934

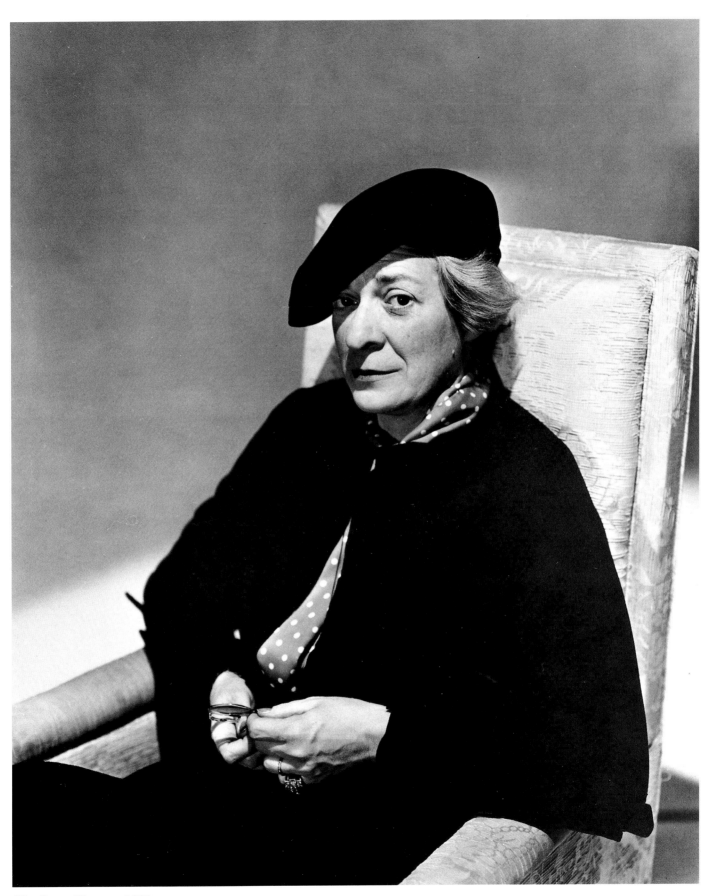

98 Janet Flanner, 1930

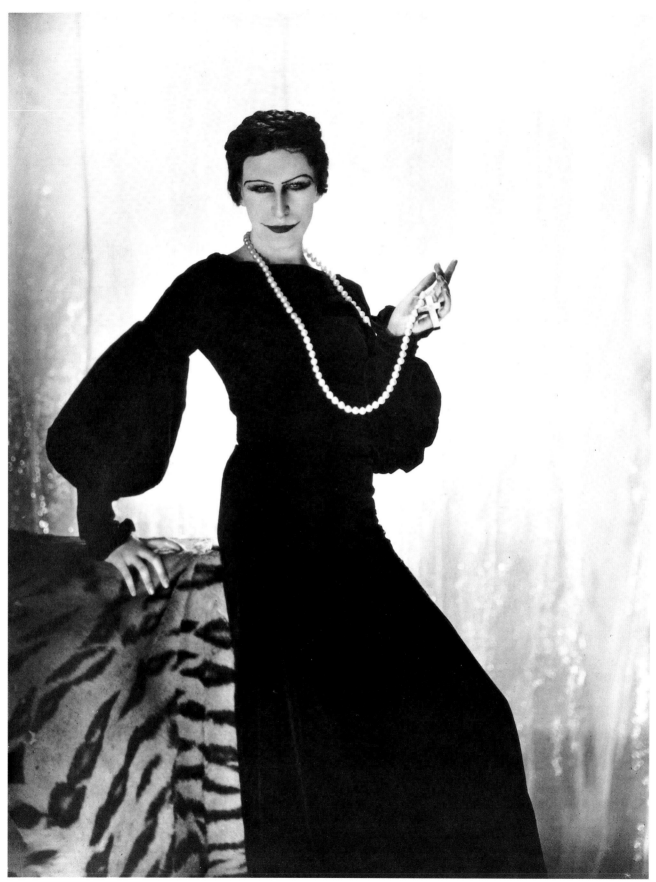

99 Cecil Beaton as Elinor Glyn, 1930

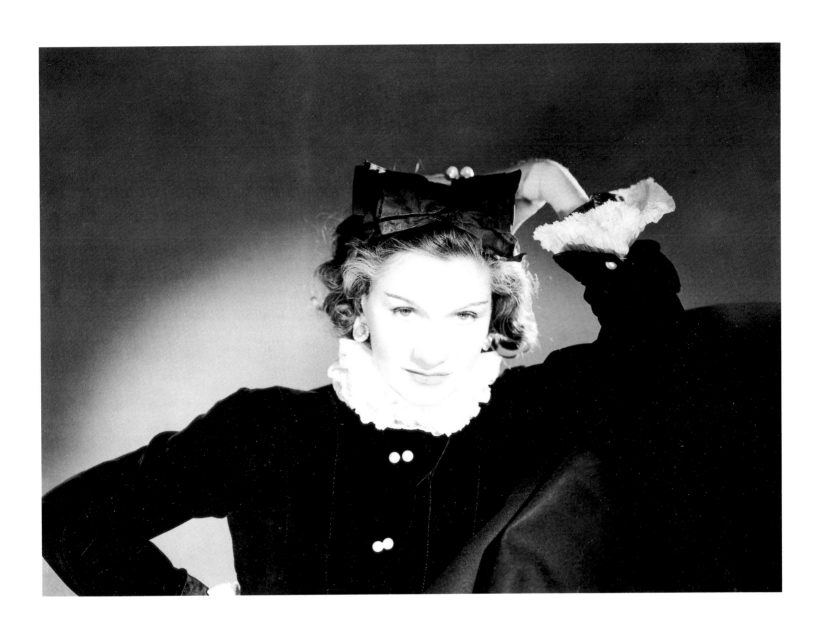

100 Gabrielle "Coco" Chanel, 1939

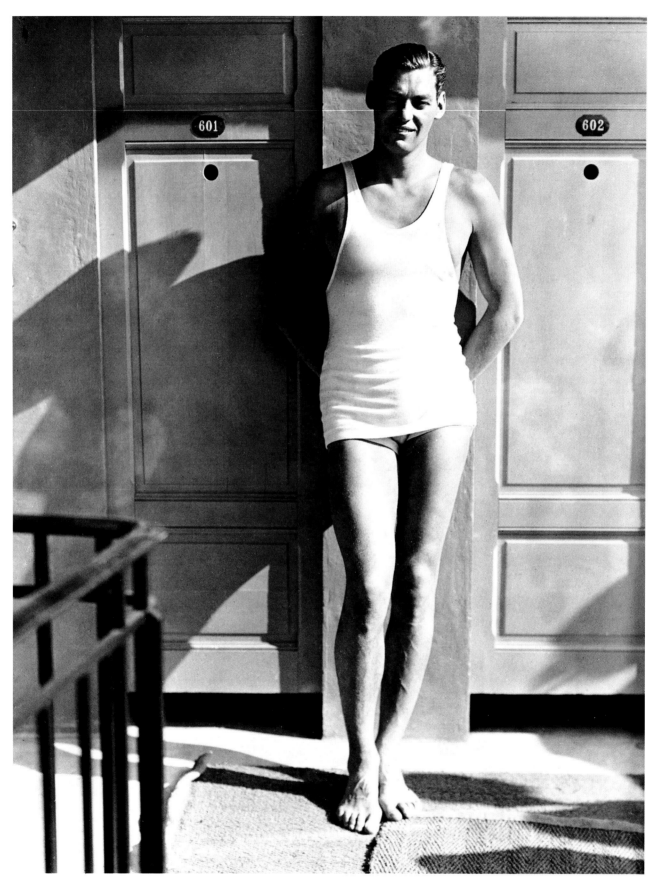

101 Johnny Weissmuller, 1930

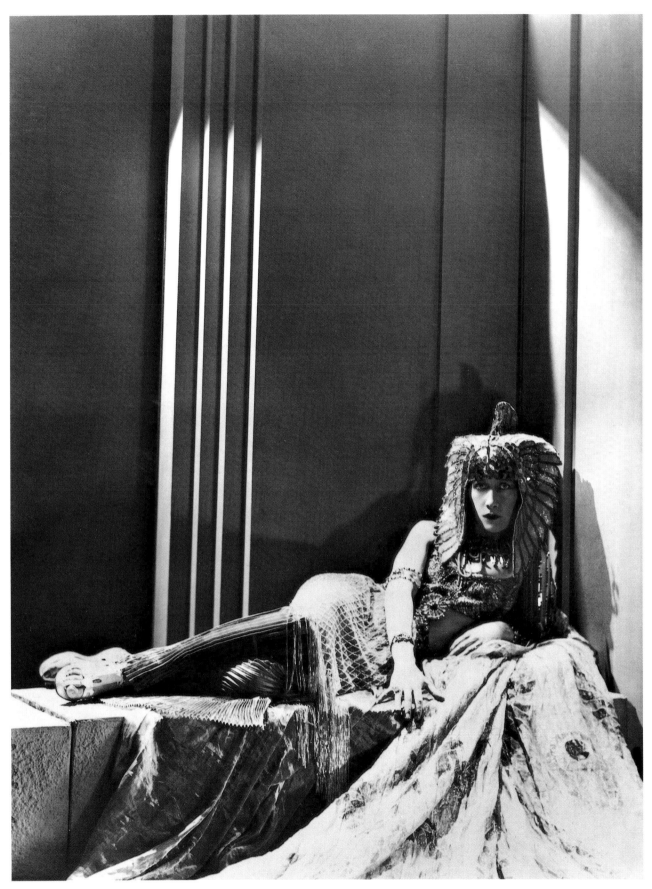

102 Unidentified actress, 1930

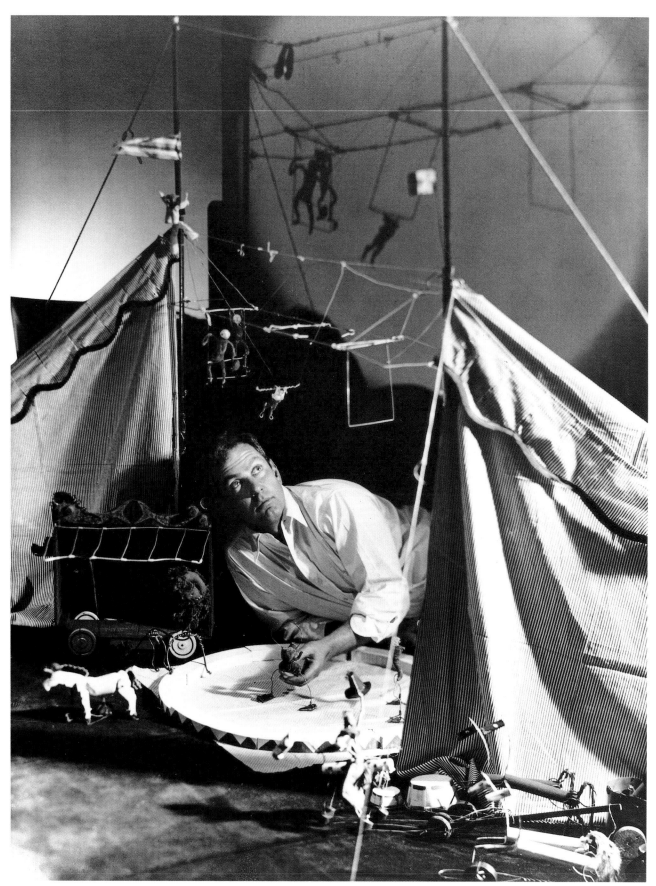

103 Alexander Calder, 1930

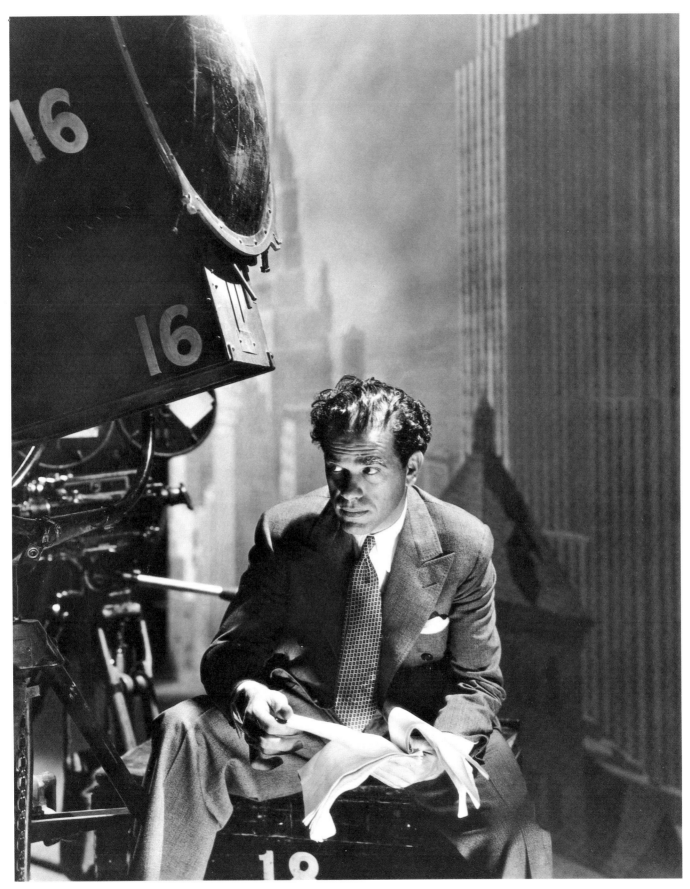

104 Frank Capra, *c.*1934

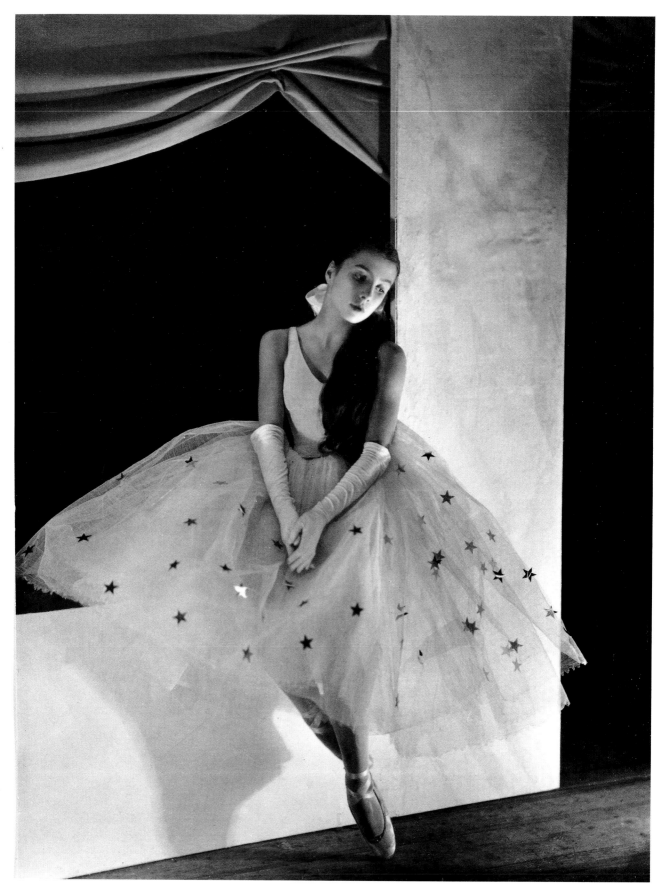

105 Tamara Toumanova in *Cotillon*, 1932

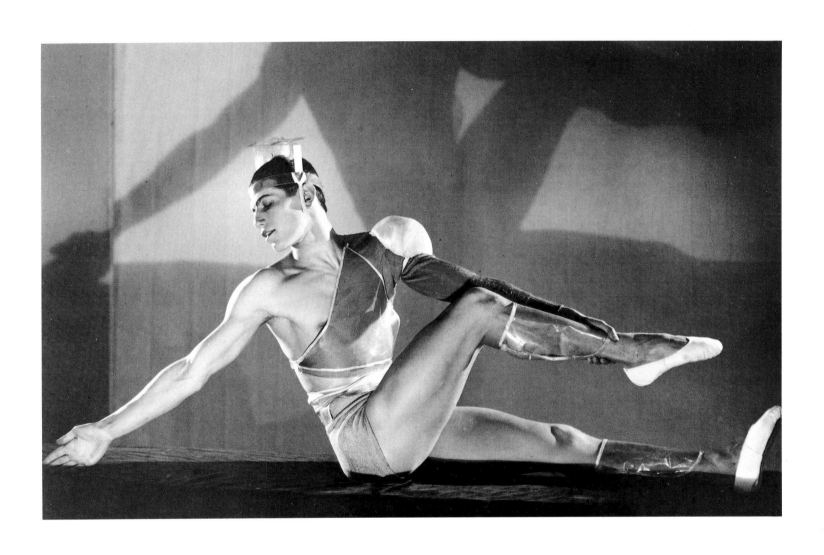

106 Serge Lifar in *La Chatte*, 1927

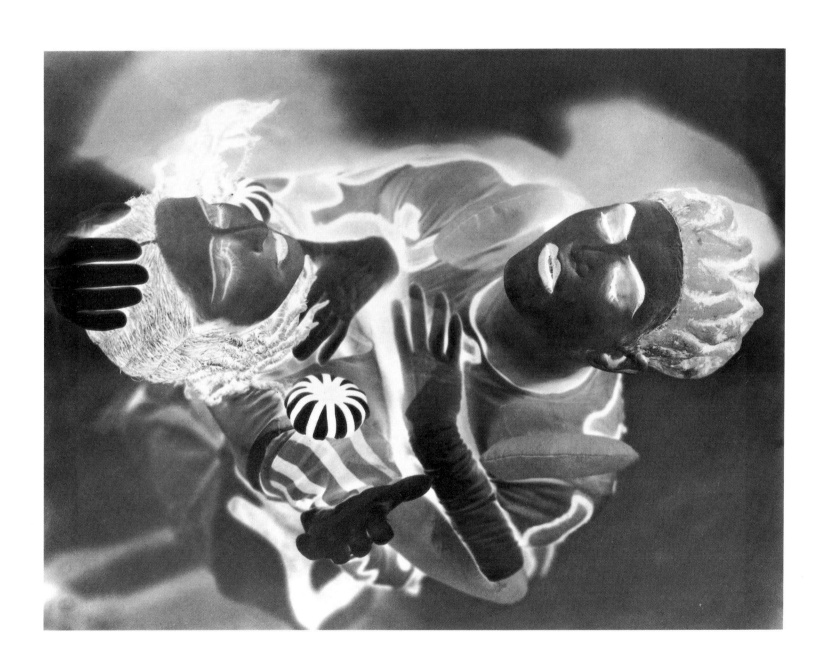

107 Olga Spessivtseva and Serge Lifar in *Bacchus and Ariadne*, 1931

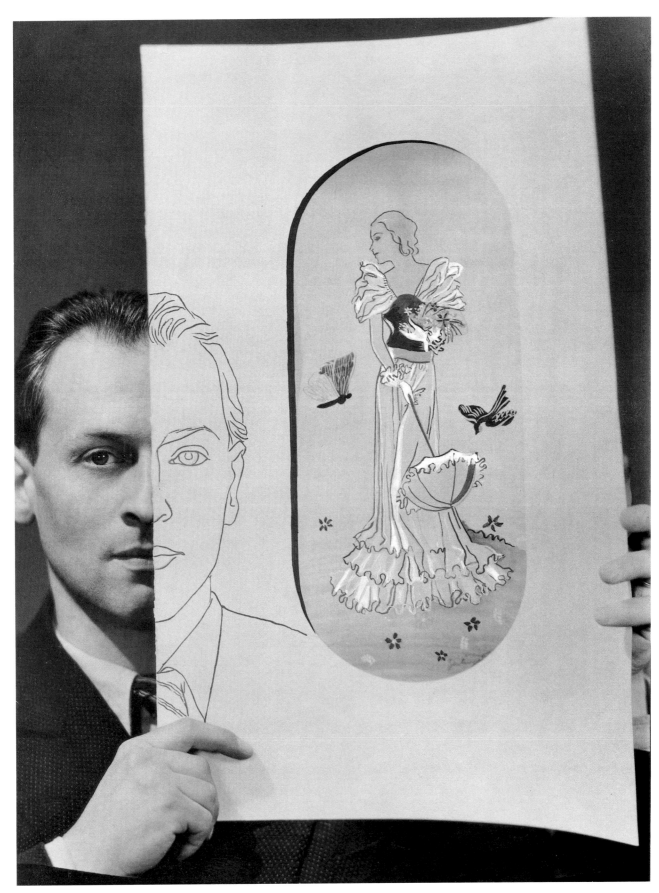

108 Zeilinger with one of his drawings, 1933

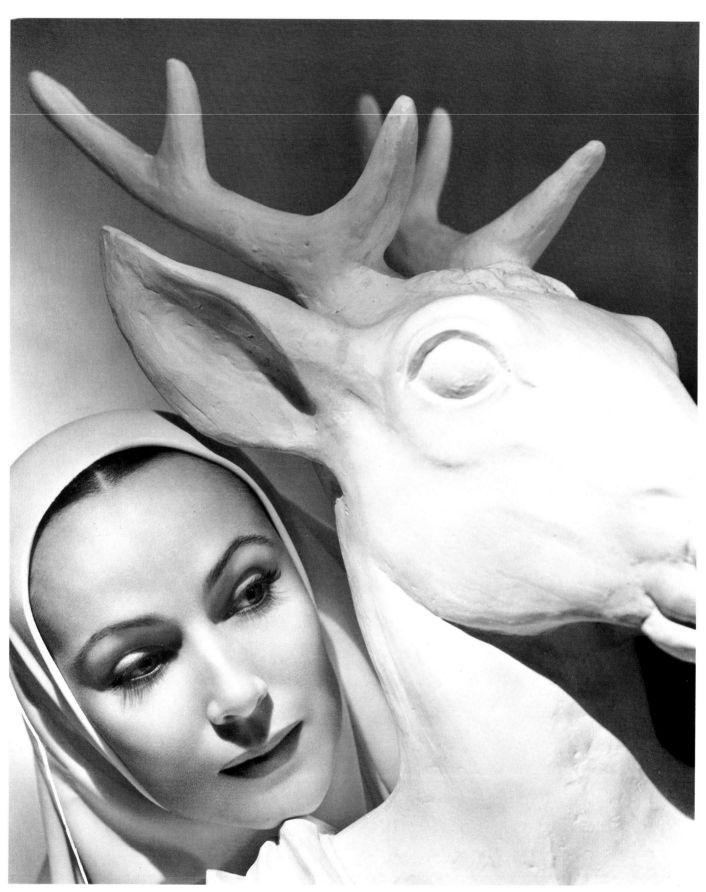

109 Dolores del Rio, *c.*1940

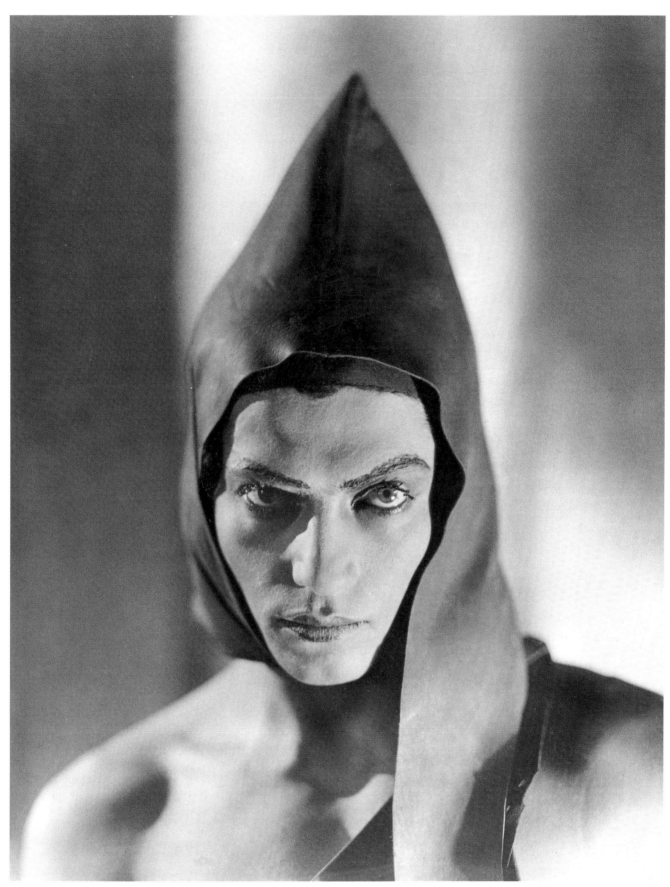

110 Serge Lifar, 1930

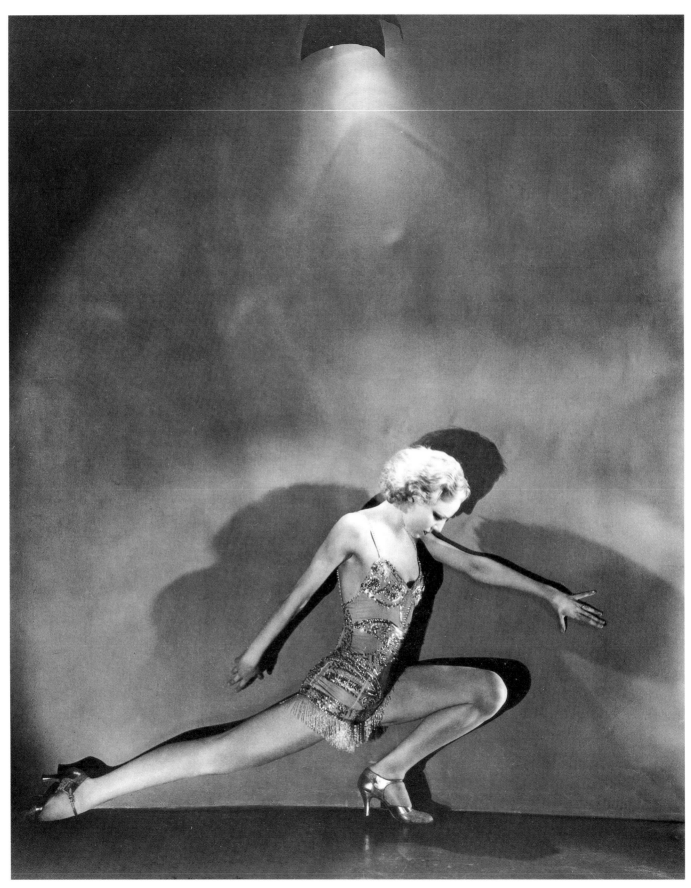

111 Jean Barry, 1931

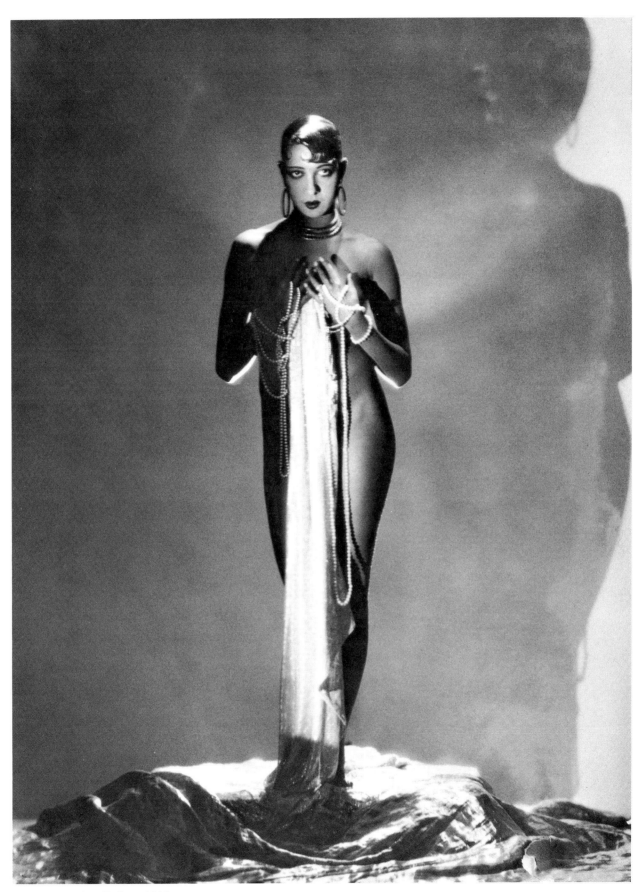

112 Josephine Baker, 1929

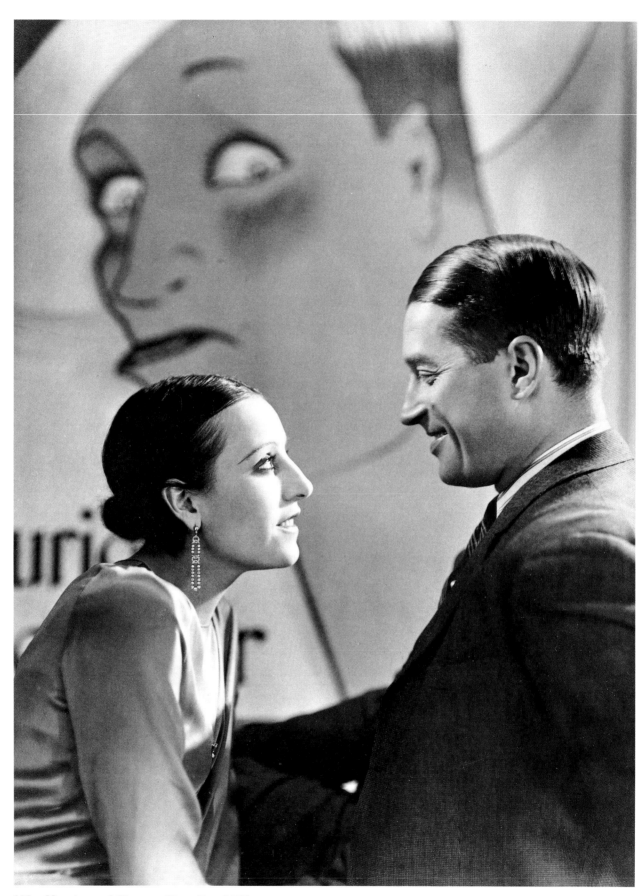

113 Maurice and Yvonne Chevalier, 1927

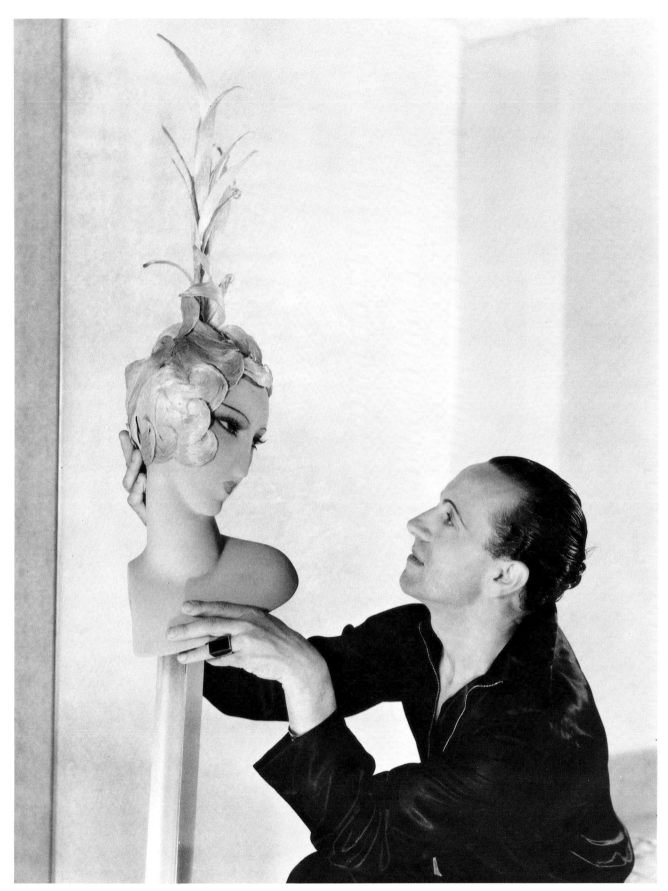

114 Antoine with one of his creations, 1933

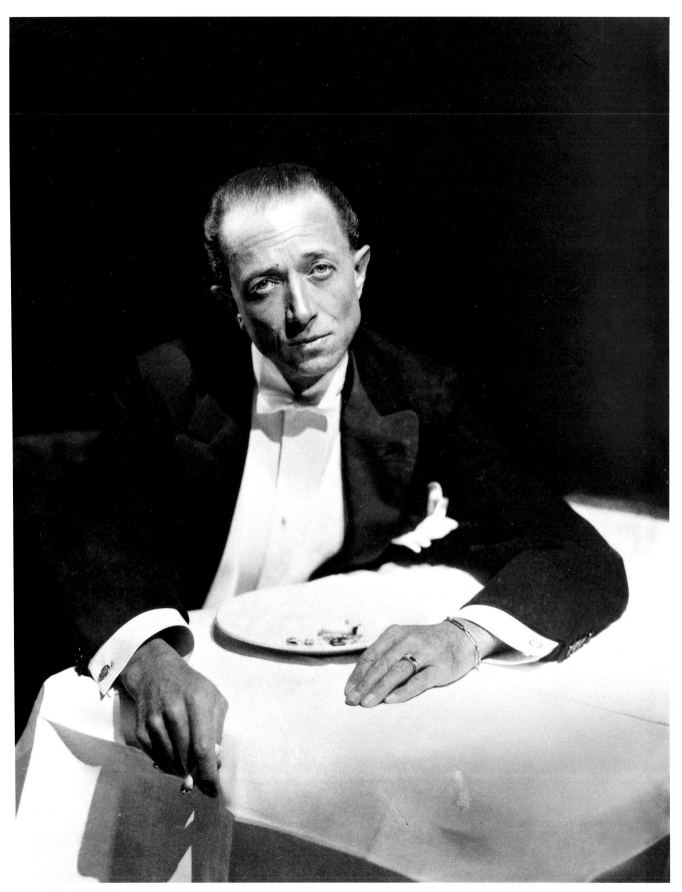

115 Koval, 1927

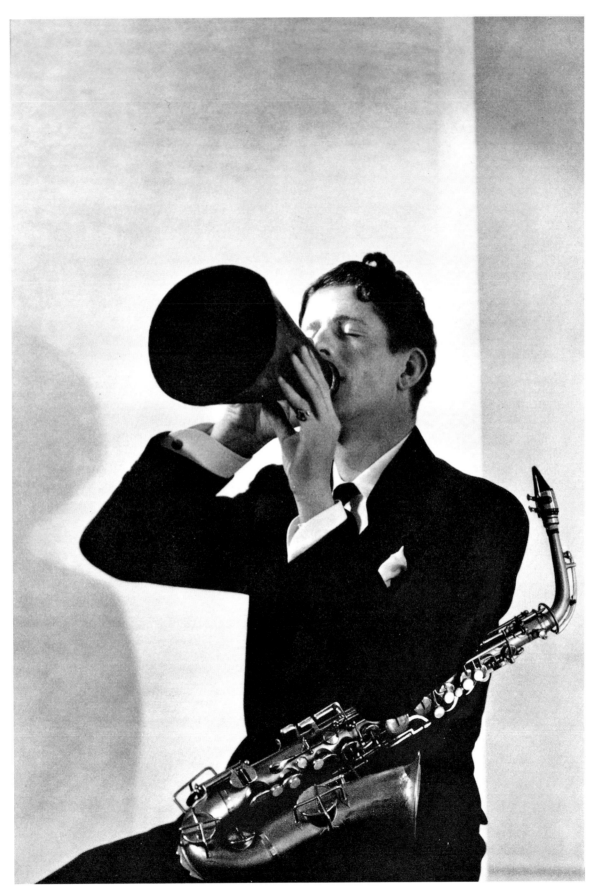

116 Rudy Vallée, 1929

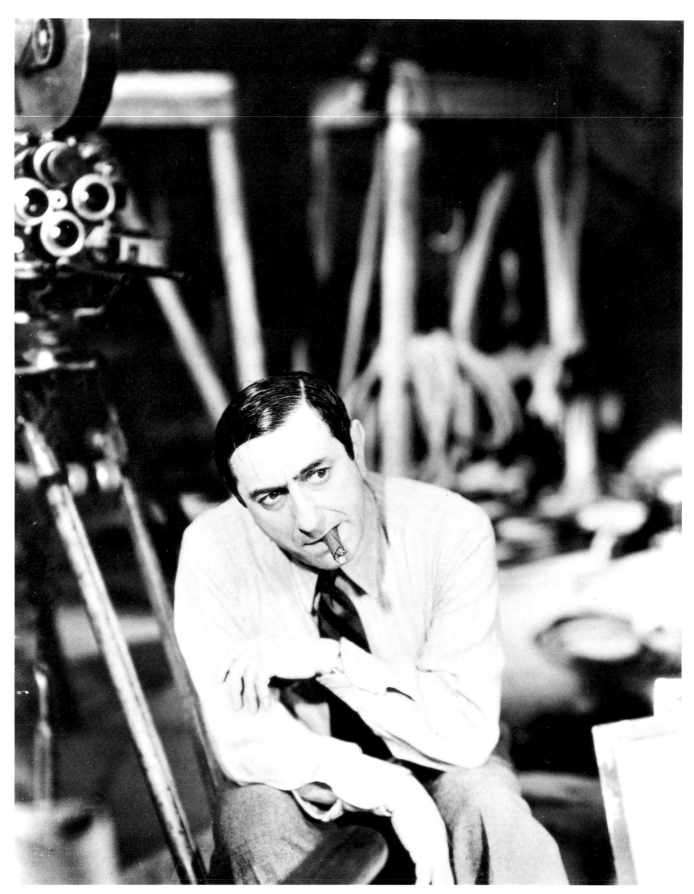

117 Ernst Lubitsch, 1934

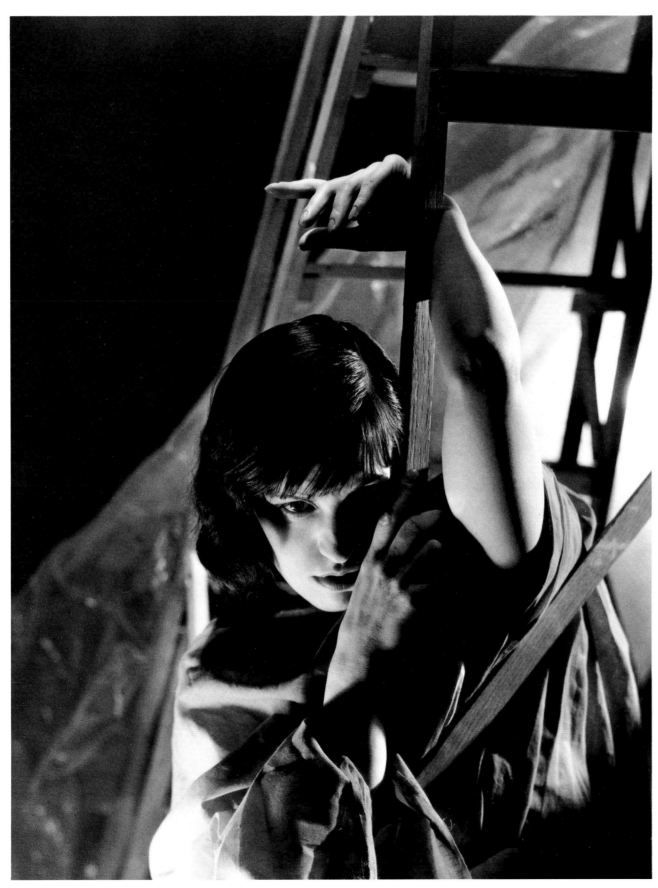

118 Lotte Lenya, 1933

119 Edith Evans, 1930

120 Heinz Klingenberg in *L'Atlantide*, 1932

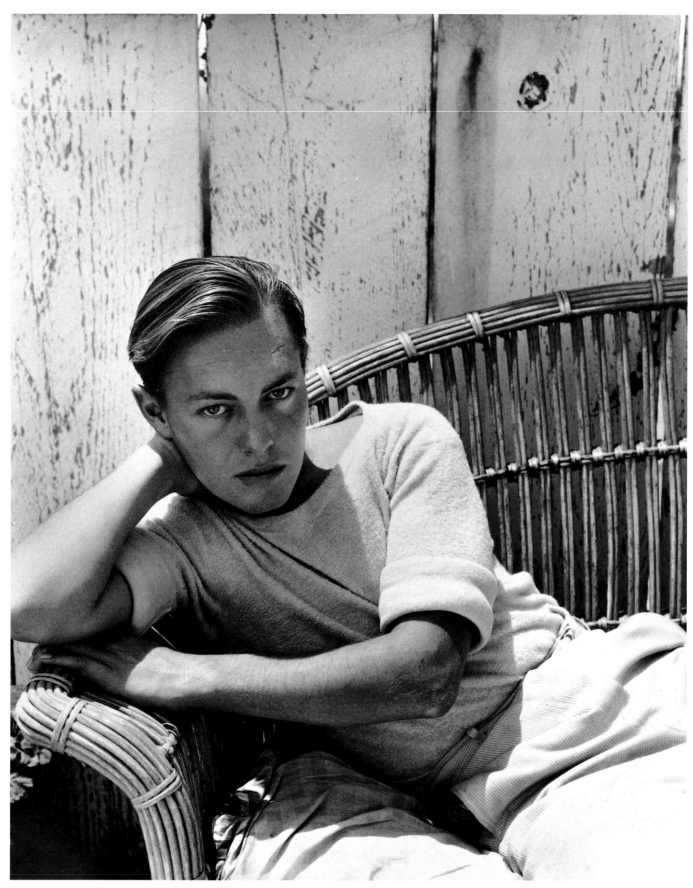

121 Richard Cromwell, 1934

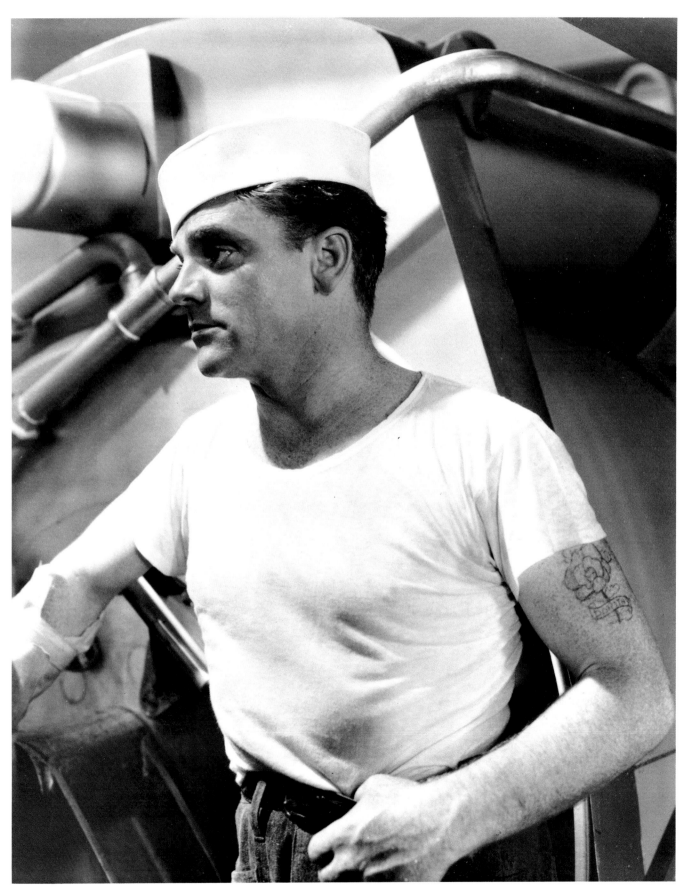

122 James Cagney in *Here Comes the Navy*, 1934

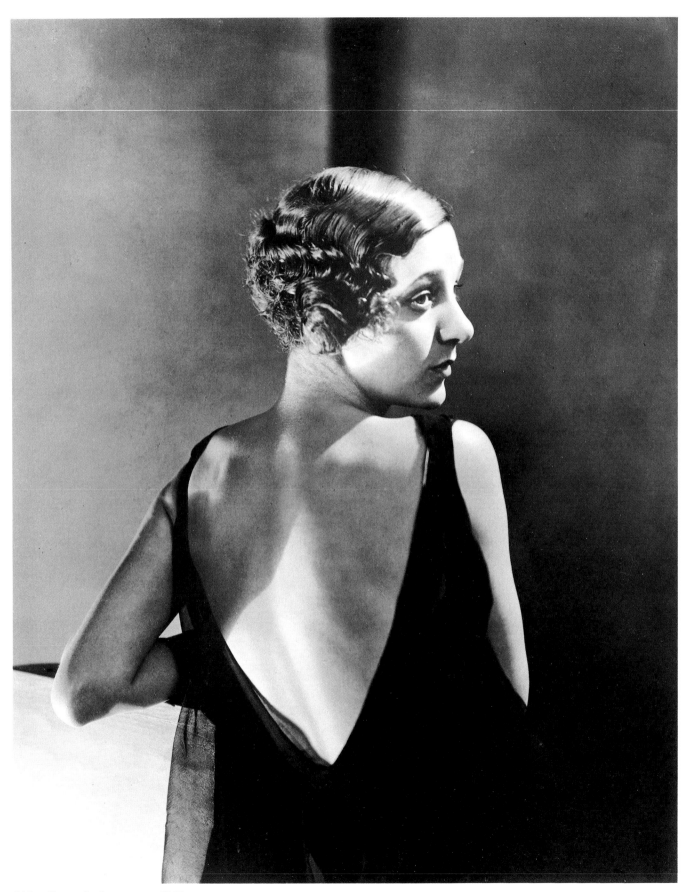

123 Gertrude Lawrence, 1928

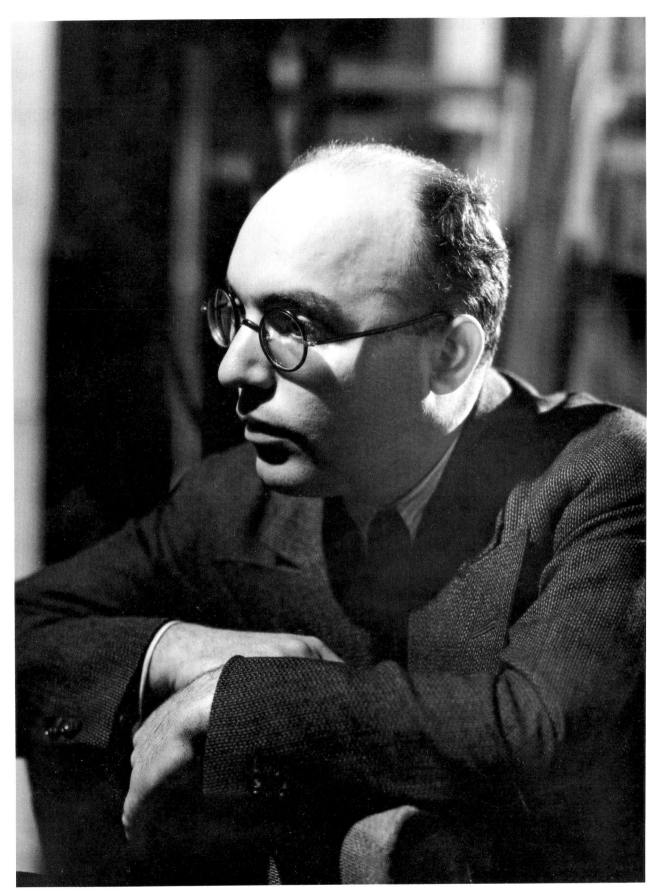

124 Kurt Weill, 1933

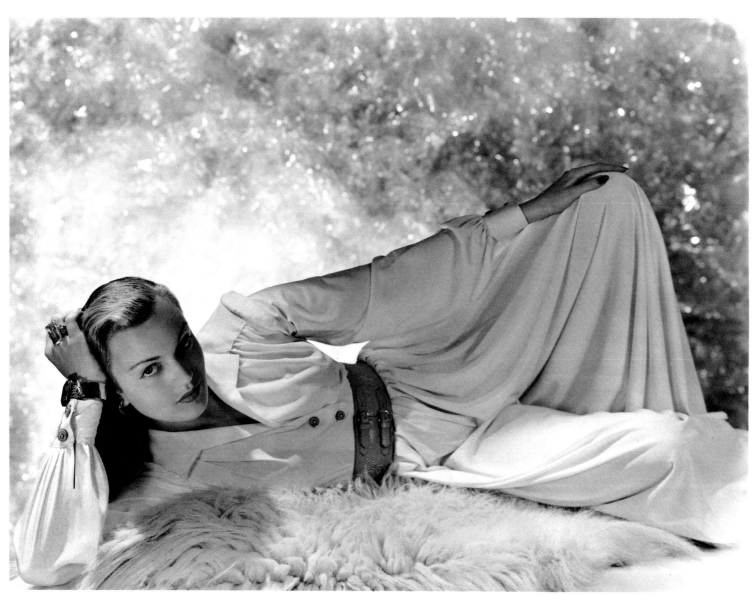

125 Mrs Palmer Thayer Beaudette, 1942

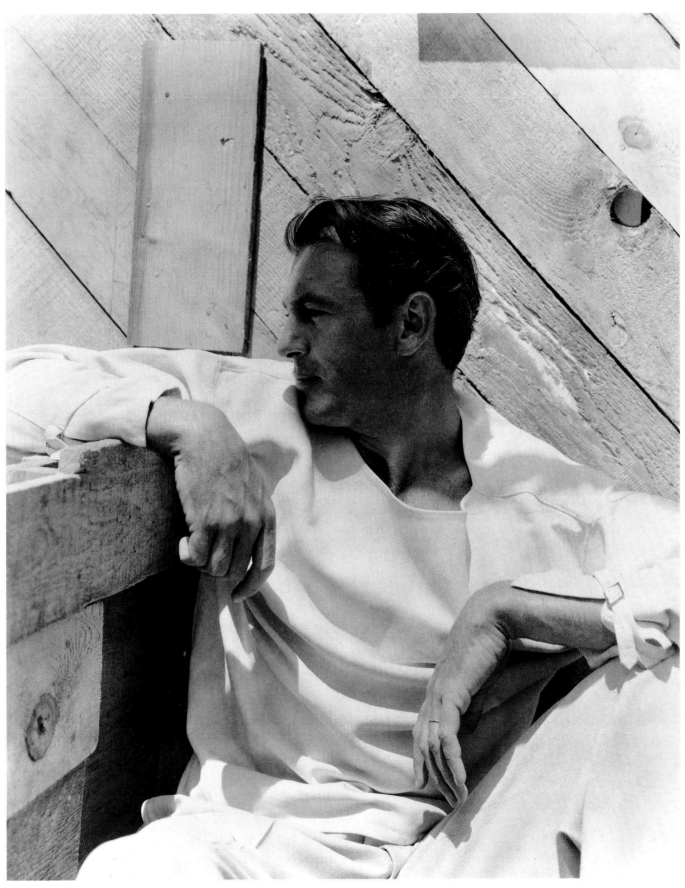

126 Gary Cooper, 1934

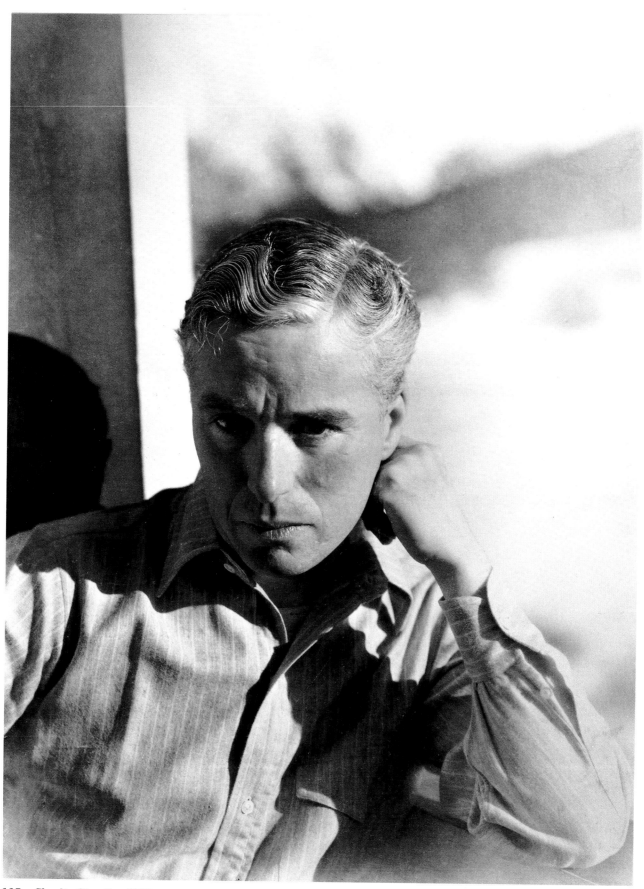

127 Charlie Chaplin, 1932

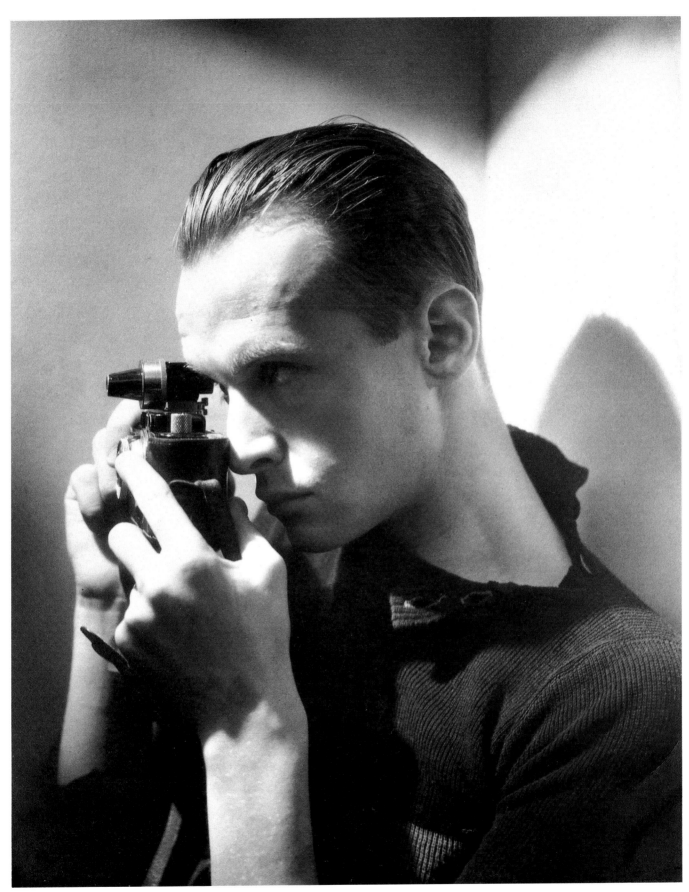

128 Henri Cartier-Bresson, *c.*1933

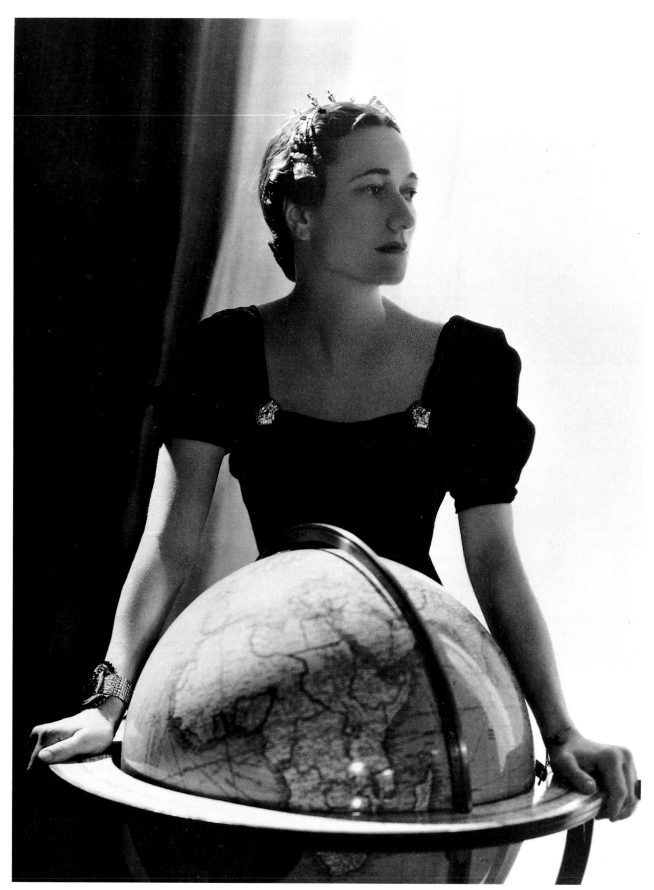

129 The Duchess of Windsor, 1937

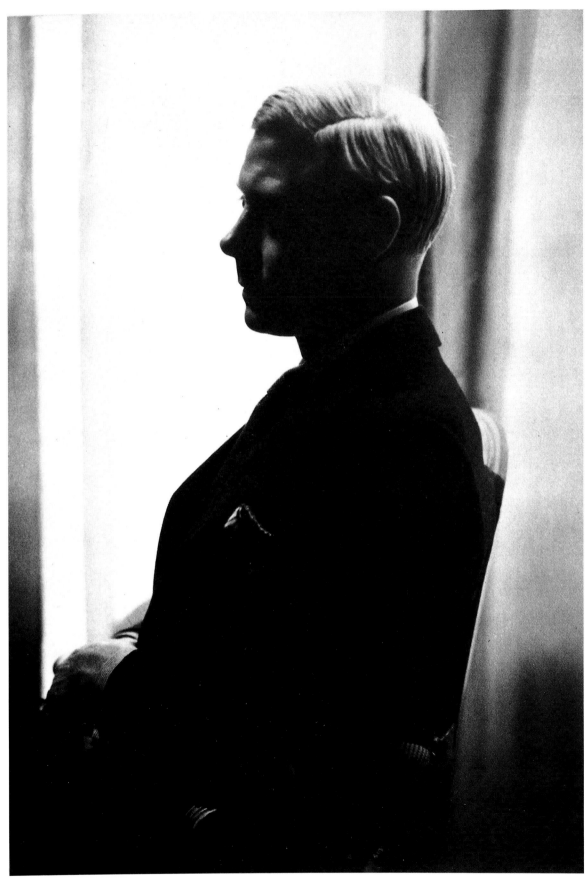

130 The Duke of Windsor, 1937

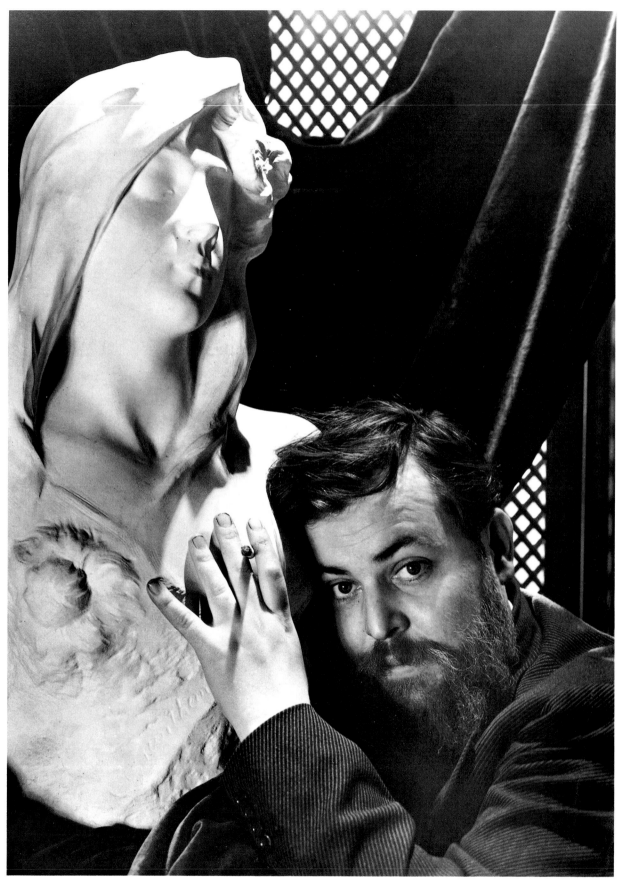

131 Christian Bérard, 1932

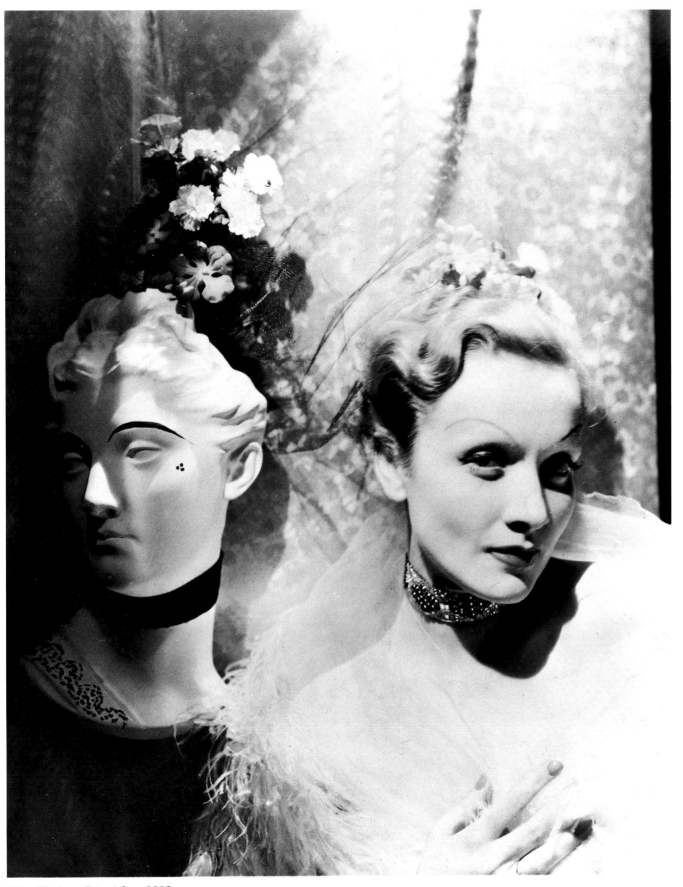

132 Marlene Dietrich, *c*.1932

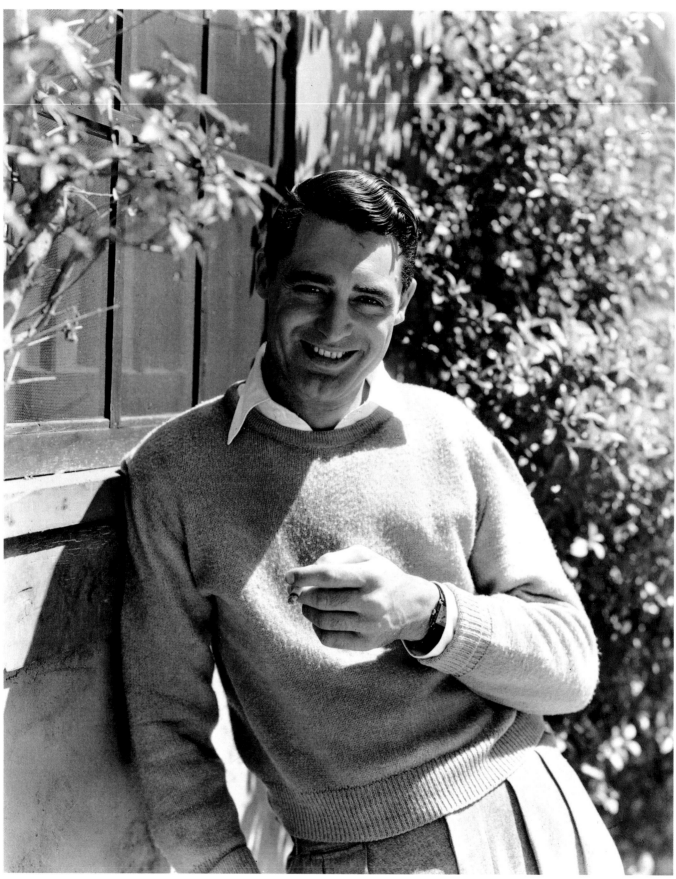

133 Cary Grant, 1934

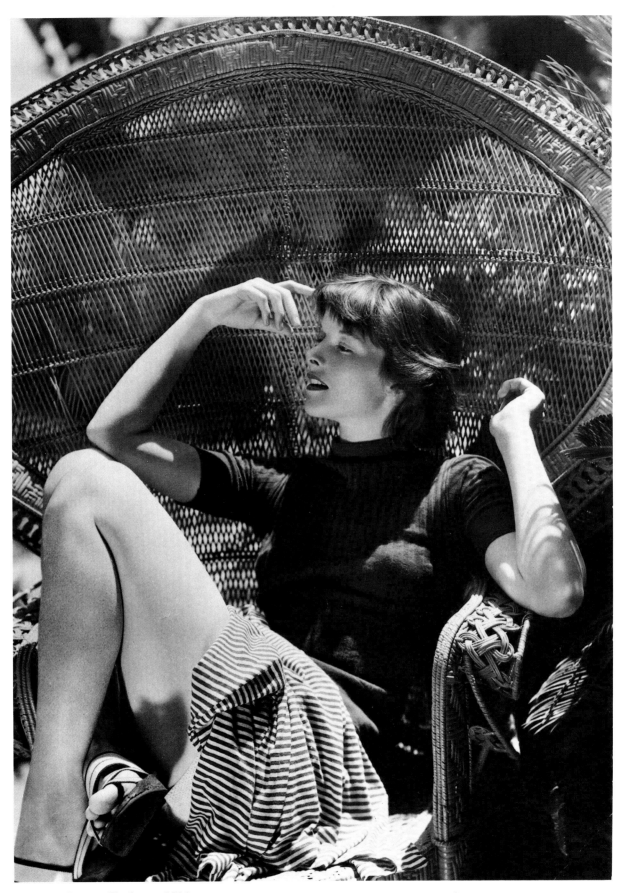

134 Katharine Hepburn, 1934

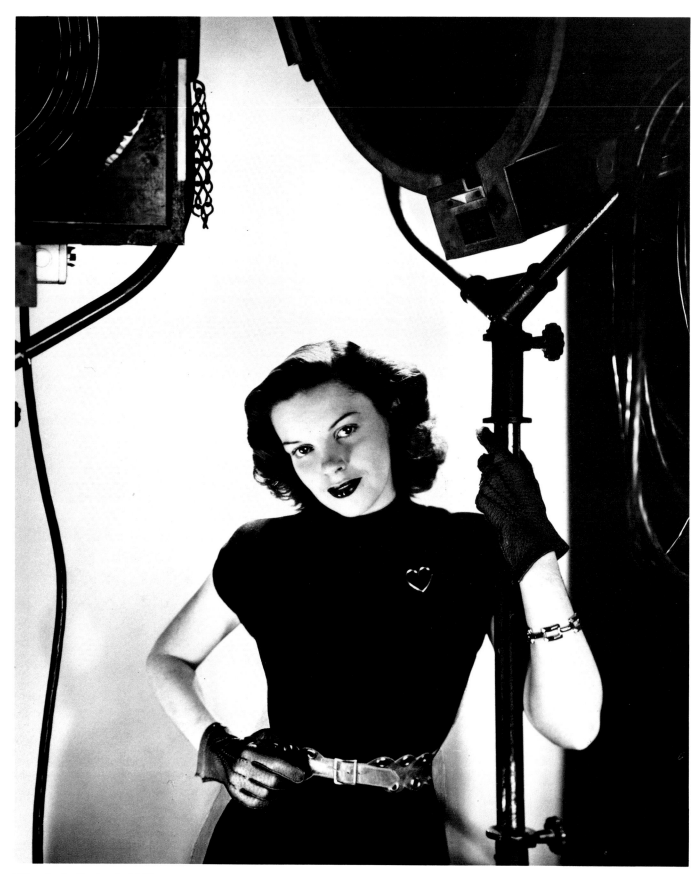

135 Judy Garland, 1945

CHRONOLOGY

NOTES ON THE ILLUSTRATIONS

NOTES ON THE TEXT

BIBLIOGRAPHY

INDEX

CHRONOLOGY

1885 George Van Ness Lothrop, Huene's grandfather, is appointed Minister Plenipotentiary and Envoy Extraordinary to the Court of Alexander III by President Cleveland. Takes up residence in St Petersburg with his wife Elmira and daughters

1897 *Birth of Marxist Social-Democratic Party in Russia*

1900 George Hoyningen-Huene born in St Petersburg, the third child of Baron Barthold von Hoyningen-Huene and Anne, *née* Van Ness Lothrop
Great Universal Exhibition in Paris
Birth of jazz in New Orleans

1902 *Invention of Rayon*

1903 Learns English
In Russia Social Democrats split into Mensheviks and Bolsheviks

1904 *Paul Poiret opens his Paris salon to acclaim*
Triumph of Isadora Duncan in Paris
Gertrude Stein arrives in Paris
In France, the brothers Lumière invent color photography

1905 Family spends part of the winter at their estate, Nawwast, in Estonia
Russo-Japanese war ends with defeat of Russia
"Bloody Sunday" and first Russian Revolution. Marauding peasants burn and pillage manor houses in the Baltic provinces
First exhibition of "Les Fauves" at the Salon d'Automne in Paris

1907 Spends summer in Bad Kreutznach, Germany, and St Moritz, Switzerland
Picasso paints "Les Demoiselles d'Avignon"
Matisse invents the term "Cubism"

1908 *Start of modern fashion with publication in Paris of Poiret's "Les Robes de Paul Poiret," illustrated by Paul Iribe*

1909 First tutor
In Paris, first season of "Ballets Russes de Diaghilev"
Condé Nast buys "Vogue"

1910 Begins schooling

1911 Visits Berlin with his Aunt Anna and is deeply impressed by classical sculpture
"Salles cubistes" at the Salon d'Automne and Salon des Indépendants in Paris

1912 Winter in Reichenhall, Germany, and Cannes, France. Summer in Florence, Rome, Sorrento. Visits Mount Vesuvius

In Paris Madeleine Vionnet opens her first salon
Robert Delaunay paints "La Tour Eiffel"
Invention of cellophane

1913 *Igor Stravinsky composes "Le Sacre du Printemps"*
Charles Chaplin signs with Keystone Films

1914 Learns French. Summer at Nawwast. Attends Imperial Lyceum in St Petersburg. Sisters become nurses. Mother and son move to Yalta
June 28–July 19: series of declarations of war
Winter fighting inconclusive
Baron de Meyer hired as staff photographer at Condé Nast

1915 Summer at Blagoveshchenskoye in the Ukraine. Visits father in Nawwast, which will be occupied by the German army in 1917
Russian Southern Front collapses
Tsar assumes supreme command of Russian armies
Austro-German offensive ends with capture of Vilna

1916 *June 4: On Eastern Front, Great Brasilov offensive stopped by arrival of 15 German divisions. Demoralization in Russian ranks*
December 30: Assassination of Rasputin
Picasso, Jean Cocteau, Erik Satie, and Leonide Massine collaborate to produce "Parade" in Rome
Guillaume Apollinaire anticipates Surrealism in "Les Mamelles de Tirésias"

1917 Helen, one of Huene's sisters, moves to Yalta. Red Sailors search the house and place the family temporarily under house arrest. Mother and son return to St Petersburg while Helen remains. Mother and son journey to England and George is enrolled in preparatory school in Surrey. Betty, Huene's other sister, moves to France
Strikes and riots in St Petersburg lead inexorably to revolution
Tsar Nicholas II abdicates
Bolsheviks consolidate power
Great Civil War begins with the revolt of the Don Cossacks

1918 Huene's father escapes from Estonia. Helen escapes and joins the family, now living in France
World War I ends, but White Russians battle Bolsheviks
British send Expeditionary Force to help Whites
Execution of Russian imperial family

1919 Huene leaves England for southern Russia as an interpreter with the British Expeditionary Force.

Travels to Batum, Tsaritsyn, Ekaterinodar, Taganrog

White Russians advance on Petrograd, but are turned back by Bolshevik forces

1920 Begins the new year in Novorossiisk. Contracts typhus and nearly dies. Evacuated to London. Flies to Paris. Travels to Cannes to meet parents. Returns to Estonia briefly to see if anything from estate can be saved. Returns to Paris

Whites are defeated and evacuated

1921 Series of odd jobs, including one which takes him to Poland for brief trip. Works as a film extra

Man Ray invents the "Rayogramme"

1922 *Union of Soviet Socialist Republics organized*

Man Ray photographs at Poiret's salon

Technicolor invented

1923 Works for sister Betty at Yteb. Studies at open art studios, then takes lessons from André Lhote

De Meyer leaves Condé Nast for "Harper's Bazaar"

Edward Steichen appointed Chief Photographer at "Vogue"

Pavel Tchelitchev arrives in Paris

1924 Collaborates with Man Ray on a fashion photography portfolio, later sold to a New England department store

La Revue Nègre, with Josephine Baker, creates a sensation in Paris

André Breton releases his "Surrealist Manifesto"

Leica camera invented by Oscar Barnack

1925 Huene's freelance drawings appear in *Fairchild's Magazine* and *Harper's Bazaar*. He signs contract with French *Vogue* as an illustrator and works as photographic assistant to American photographer Arthur O'Neill

The "Exposition des Arts Décoratifs" is held in Paris

The Bauhaus moves to Dessau

Sergei Eisenstein's "Battleship Potemkin" is released

Chaplin stars in "The Gold Rush"

1926 First fashion photographs for *Vogue*

First sound films

Coco Chanel unveils her "little black dress"

1927 First photographs for *Vanity Fair*. Produces several amateur films

1928 Huene's photographs are exhibited for the first time, in the "Premier Salon Indépendant de la Photographie," Paris

Elsa Schiaparelli begins her career

1929 Visits New York and Hollywood for first time. Exhibits in "Film und Foto" exhibition, Stuttgart. Designs a mannequin for French *Vogue*

Women's skirts sag; Chanel "invents" trousers for women

Salvador Dali's first Paris exhibition

Marlene Dietrich stars in "The Blue Angel"

Martha Graham establishes her own modern dance company

1930 Meets Horst P. Bohrmann (later Horst P. Horst). Together they visit Cecil Beaton in England. Visits Hammamet in Tunisia, the site of his future vacation home

In fashion, the boyish look disappears

Jean Cocteau directs "Le Sang d'un Poète"

Christian Bérard designs the sets for Cocteau's "La Voix Humaine"

Walter Hege publishes "Die Akropolis"

1931 Visits Berlin on assignment; travels to London, New York, Chicago, Hollywood, and Hammamet, where he decides to build a vacation home for himself and Horst. In London he rents the studio of photographer Howard Coster

Designs the lighting for a new nightclub in Paris, "Bricktop"

Horst begins career with Condé Nast

1932 *Hoyningen-Huene: Meisterbildnisse* is published in Germany. Visits Berlin on assignment, where he sees G.W. Pabst making *L'Atlantide* and decides to make his own version. Hammamet house under construction

"Vogue" has its first color photographic cover (by Steichen)

Ballet Joos in Paris

Picasso retrospective in Paris

1933 At about this time makes a fashion documentary film for French *Vogue*

Louise Dahl-Wolfe takes first fashion photographs

1934 Huene's work at its zenith. Schiaparelli and Beaton visit Hammamet. Huene commissions Bérard to paint Horst's portrait. *Vanity Fair* sends Huene to Hollywood

Alix opens her own dressmaking establishment

Martin Munkacsi introduces "realism" into fashion photography in his work for "Harper's Bazaar"

1935 Leaves Condé Nast after a contract dispute and immediately goes to work for *Harper's Bazaar* in Paris. Travels regularly to New York on assignment. From now on makes regular visits to Hammamet. Meets George Cukor at about this time

1936 Isolates himself at Hammamet. Later in the year he embarks on an African expedition with a group of amateur explorers. Photographs people and scenery. Meets André Gide

1937 *African Mirage, the Record of a Journey* is published
Steichen leaves "Vogue" and fashion photography abruptly

1938 Spends more and more time in New York. Undertakes considerable amount of advertising work. Visits Greece for first time and travels to Southeast Asia and Australia

1939 Second visit to Greece. Remains at *Harper's Bazaar* in New York throughout the war as he is overage for military service
Nylon first produced; advent of synthetic fabrics

1940 Active in Greek war relief. Photographs published in *US Camera* and *Coronet*

1942 Works on book (*Hellas*) and exhibition to aid the Greek War Relief Committee. Photographs appear in *Popular Photography* magazine
Irving Penn's photographs appear in "Vogue" for the first time

1946 Leaves *Harper's Bazaar* and New York; settles briefly in Mexico. *Mexican Heritage* and *Baalbek/Palmyra* are published. Becomes naturalized American citizen
Between 1946 and 1950 makes three documentary films in Spain, including *The Garden of Hieronymus Bosch*
Richard Avedon begins work for "Harper's Bazaar"
Death of Baron de Meyer

1947 Leaves Mexico for Southern California with the encouragement of George Cukor. Secures teaching appointment at the Art Center School of Los Angeles
Steichen made Director of Photography at the Museum of Modern Art, New York
Christian Dior launches the "New Look" in Paris

1950 Works briefly for *Flair* magazine. Exhibits at the USA Mission in Greece. Visits Egypt. Published in *US Camera*

1951 Films *Daphni: Virgin of the Golden Laurels* in Greece

1954 Starts works as Color Coordinator, beginning with George Cukor's *A Star is Born*
Chanel makes comeback in French fashion industry

1955 Takes mescalin in a controlled experiment for Aldous Huxley

1963 Wins Photokina Photographic Award in Cologne

1965 Participates in group exhibition "Glamour Portraits" at the Museum of Modern Art, New York. Conceives of a television project on the French Revolution and the life of Napoleon I
Huene's friend Rudi Gernreich unveils the "topless" swimsuit

1967 Participates in "Oral History" project organized by the University of California, Los Angeles. Starts work on memoirs with Dr Oreste Pucciani

1968 Dies of a stroke at his home in Los Angeles

1970 Exhibition and catalog produced by The Friends of the Libraries of the University of Southern California, Los Angeles, on the occasion of a bequest of Huene's rare books. Tributes by Katharine Hepburn, George Cukor, Horst, Leo Lerman, Mainbocher, and others

1971 Photographs by Huene published in *Salute to the Thirties* by Horst, with foreword by Janet Flanner

1980 Retrospective exhibition and catalog produced by the International Center of Photography, New York. Exhibition travels to London, Paris, Minneapolis, and Long Beach, California

NOTES ON THE ILLUSTRATIONS

Plates 2–4, 10, 13–15, 17, 18, 21–24, 26–28, 30, 40, 43, 44, 47–50, 52–56, 58–66, 68–72, 76, 79, 85, 89, 93, 94, 96–99, 101, 103, 105–108, 110–118, 119–124, 126–128, 131–134, and the illustrations which appear on pages 2, 17, 22, 36, 41, 92–95, 97, 100, 101, 109, 141, 144 (*Vogue* covers only), 152, 181 (bottom), 186, 240 (right), and 241 (left) are copyright © 1927 (renewed 1955); 1928 (renewed 1956); 1929 (renewed 1957); 1930 (renewed 1958); 1931 (renewed 1959); 1932 (renewed 1960); 1933 (renewed 1961); 1934 (renewed 1962) by the Condé Nast Publications, Inc.

All other illustrations by George Hoyningen-Huene are copyright © 1986 Horst P. Horst, New York.

Each note records, where relevant, the magazine which commissioned the photograph (if this is known), and the place in which the photograph was taken. The source of the print is given in every case. Abbreviated references to books are to editions listed in the bibliography.

Abbreviations

Horst = Courtesy Horst P. Horst, New York. (Horst's collection of original prints by Huene is now owned by Harvard Theatre Collection, Harvard University, Cambridge, Mass.)
Condé Nast = Courtesy Condé Nast, Inc.

Numbers in *italic* at the beginning of each entry refer to pages; numbers in **bold** refer to plates

2 *Vogue*. Paris, 1930. Captioned "Style this Summer." The editorial, "*Vogue*'s Eye View of the Mode," commented: "The mode is making us deliciously comfortable and free . . . our sense of modesty has obligingly changed in favor of comfort." Condé Nast
6–11 Horst

Chapter One A gentleman's education

12–15 Horst; the portrait of Huene by Horst (page 12) was probably taken *c.* 1934, but was not published until 1952
16 Musée du Louvre, Paris
17 *Vogue*. Paris, 1932. Mlle Diplarakou, "Miss Greece," later became Lady Russell. Horst
20 Horst

Chapter Two A new life in Paris

22 *Vogue*. Paris, 1934. Horst
24 André Lhote, *The Artist's Wife* (1923), gouache on paper, $15\frac{1}{2} \times 11\frac{3}{8}''$. Collection, The Museum of Modern Art, New York. Gift of Mr

and Mrs Sidney Elliot Cohn
25–30 Horst
31 *Harper's Bazaar*. New York, 1939. Dali, "caught in one of his own dreams," as the magazine commented, painted this picture while staying at Chanel's Monte Carlo villa. Courtesy *Harper's Bazaar*
32–34 Horst
35 Courtesy Henri Cartier-Bresson, Paris
36 *Vogue*. Paris, 1927. Courtesy Holly and Horace Solomon, New York
37 Author's collection, New York
38 Courtesy Richard Tardiff, New York
39–40 Horst
41 Decoration from *Vogue*. Paris, 1934. Horst

Plates 1–47: Couture and classicism

1 *Vogue*. Paris, 1934. A variant of this picture, much cropped, was chosen for publication. "Lanvin housecoat of silver lamé with mammoth sleeves of silver and chiffon stripes over a white crêpe gown finely shirred at the neck and waistline . . . The tea gown shown beside it is a . . . chiffon redingote in a rich burgundy-red, tied over a gleaming white satin slip." Horst
2 *Vogue*. Paris, 1932. The dress was called "Baghdad;" the jewels were from Boucheron. Lee Miller was one of Huene's favorite models and later a distinguished photographer; for an account of her extraordinary life see the biography by her son, Antony Penrose, *The Lives of Lee Miller*. See also plates 43 and 57 and pages 103 and 104. Courtesy Lee Miller Archives
3 *Vogue*. Paris, 1930. Captioned "*Vogue*'s Eye View of the Mode," it was used as a general illustration to an editorial and no fashion information was given. "Question your personality," says the editorial. "This is a highly individual mode, and she who does not know herself is lost . . ." The picture is a composite photograph, not a genuine reflection. Condé Nast
4 *Vogue*. Paris, 1932. Horst
5 A column of the northern portico and the northeast corner of the Erechtheion. Published in *Hellas*, 1943, where Huene quotes Lacretelle: "The Greek column impresses me as the greatest problem of form ever resolved by human genius. As I approach it I become aware of one element that embraces all. Here once and for ever are united all the quests of the spirit and the needs of the heart, the invitation of nature, the laws of numbers and the imagination of art; it is a unique fusion of matter and thought." Courtesy International Center of Photography, New York

6 *Harper's Bazaar*. New York, 1940. Nana Gollner became prima ballerina with the original Ballets Russes company in 1941. Courtesy Photocollect, New York
7 *Harper's Bazaar*. New York, 1940. "The blond streak in the hair – like an errant shaft of sunlight it strikes across the heads of smart young girls from Maine to Texas . . . for that witching sunwiped touch." Courtesy Catherine Negroponte, London
8 *Harper's Bazaar*. Paris, 1936. Horst
9 *Harper's Bazaar*. New York, 1938. A variant of this photograph was chosen for publication. For other photographs of Lisa Fonssagrives (who became Lisa Fonssagrives-Penn after her marriage to photographer Irving Penn), see page 183. Courtesy Lisa Fonssagrives-Penn, New York
10 *Vogue*. Paris, 1928. The subject, another of Huene's favorite models, was a photographer herself. See also plates 53, 54, and 89, and page 105. Courtesy John C. Waddell, New York
11 *Vogue*. Paris, 1934. Jewels by Boucheron. A variant of this photograph was chosen for publication; see also overleaf. For other treatments of Miss Koopman, see plates 1, 17, and 26. Horst
12 A variant of this photograph was published in *Hellas*, 1943. This is a view of the columns of the southern peristyle, from the interior. Courtesy International Center of Photography, New York
13 *Vogue*. Paris, 1934. Horst
14 *Vogue*. Paris, 1934. Aumont established his international acting reputation in the year this photograph was taken when he starred in the first production of Cocteau's *La Machine infernale*. Horst
15 *Vogue*. Paris, 1934. Jewelry by Herz; coiffure by Emile. Condé Nast
16 A variant of this photograph was published in *Hellas*, 1943. Courtesy International Center of Photography, New York
17 *Vogue*. Paris, 1934. See also the variant printed overleaf. Horst
18 *Vogue*. Paris, 1931. "Bas-Relief" by Vionnet: "We wonder how on earth Vionnet cut these pyjamas to such perfect proportions, how a twentieth-century young woman can have so much of the glory that was Grecian, and most of all how the photographer posed the whole business so as to give us once again in a new medium the symmetry, the balance, the look of restrained flight, and the same magnificent massing of drapery . . . Photography is the newest of artistic mediums; pyjamas are the newest of sheaths for the female form." Courtesy F.C. Gundlach, Hamburg
19 Published in *Hellas*, 1943. Courtesy

Toto Koopman, evening dress by Vionnet, 1934. A variant of plate 11

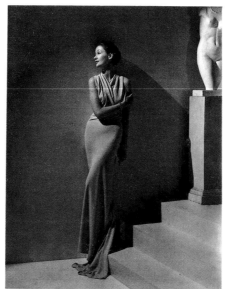

Toto Koopman, evening dress by Augustabernard, 1934. A variant of plate 17

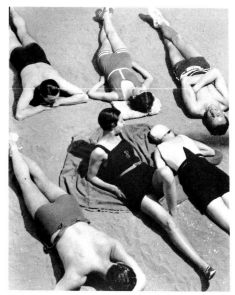

Swimwear by Patou, Molyneux, and Yrande, 1930. A variant of plate 51

International Center of Photography, New York

20 *Harper's Bazaar.* New York, 1943. Paxinou was at this time working in New York, where she played Hedda Gabler on Broadway (1942), and in Hollywood (*For Whom the Bell Tolls,* 1943). Horst

21 *Vogue.* Paris, 1934. Horst

22 *Vogue.* Paris, 1934. Jewelry from Mauboussin. "Deeper and deeper descend Jeanne Lanvin's neck-lines – consider the one of this sea-blue satin dress, which swoops down into a sharp V in front . . ." Horst

23 *Vogue.* Paris, 1934. Schiaparelli "giving you her idea of what a modern picture frock should be." Horst

24 *Vogue.* Paris, 1934. "Embossed in gold . . . it isn't leather, but a gold-and-black ciré satin, Alix's own speciality, pressed and worked to suggest leather." Horst

25 *Harper's Bazaar.* New York, 1935. Horst

26 *Vogue.* Paris, 1933

27 *Vogue.* Paris, 1934. Horst

28 *Vogue.* Paris, 1933. "Velvet in a Big Way . . . Paris is interested in profiles again . . . Made of black velvet and glycerinized ostrich, it's a hat that has set Paris buzzing." Horst

29 Taken in New York, *c.* 1940, probably for *Harper's Bazaar.* Courtesy Photocollect, New York

30 *Vogue.* Paris, 1931. For another portrayal of Natalie Paley, see page 34. Horst

31 *Vogue.* Paris, 1929. Gloves by Alexandrine. "Yellow chamois adds a new note to white." Condé Nast

32 *Vogue.* Paris, 1927. Horst

33 *Vogue.* Berlin, *c.* 1930. Horst

34 *Vogue.* Paris, 1931. Horst

35 *Vogue.* Paris, 1930. Ensemble "Miramar:" "Grosgrain is a soft and supple material for a sports hat. Alphonsine combines it in red and white for a bicorne shape, rolled off the face . . ." Condé Nast

36 *Vogue.* Paris, 1931. "Cocktail party" tricorn: "the new over-the-right-eye, behind-the-left-ear movement expressed in black panama papier. Pink organdie camellias fill in the dégagé space at the back of the head, balancing the tilted movement and softening the asperity of the brim, which is turned back sharply and pinched in an exaggerated point just over the right eye." Condé Nast

37 *Vogue.* Paris, 1932. Hat by Rose Descat. Horst

38 *Vogue.* Paris, 1929. Hat "Estudiantina." "The beret is of black hemp braid topping a band of turquoise blue grosgrain ribbon . . . A black galiak scarf accompanies the black crêpe-de-chine dress." Horst

39 *Vogue.* Paris, *c.* 1932. Horst

40 *Vogue.* Paris, *c.* 1932. Horst

41 *Harper's Bazaar.* Paris, 1935. Horst

42 *Harper's Bazaar.* Paris, 1935. Jewels by Cartier; mirror by Serge Roche. Horst

43 *Vogue.* Paris, 1930. Courtesy Lee Miller Archives

44 *Vogue.* Paris, 1931. Horst

45 A photograph taken in Paris in 1929, when Anna May Wong was working in Europe, both lecturing and starring in several British and American films. Horst

46 Unpublished. Horst

47 *Vogue.* Paris, 1934. "Made in Hollywood . . . Given as premises such drowsy, haunting beauties as these two actresses [Ames and Carole Lombard], the master couturiers of Hollywood create out of stuff and line illustrations of eternal grace . . . For Adrienne Ames, Howard Greer has designed a simple Grecian gown of white chiffon with a white ostrich cape for luxury (feathers are still rampant, especially in Paris)." Horst

Chapter Three Foundations for a style

92 *Vogue.* New York, 1920. Condé Nast

93 *Vogue.* New York, *c.* 1941. Horst

94–95 *Vanity Fair.* Paris, 1933. The magazine commented: "Huene has brilliantly imitated the stately composition of D.O. Hill, the twisted pathos of de Meyer, the flowery chaos of Beaton, the masterly simplicity of Steichen, the dissolutions of Man Ray, and the determination of Lerski . . . Does the lady look the same when pictured in different techniques? Does the style of the photographer obliterate the personality of the sitter? Is photography art?"

96–97 Condé Nast

Chapter Four The elements of style

100 *Vogue.* London, 1934. Horst

101 Above: *Vogue,* Paris, 1934; below: *Vogue,* Paris, 1931. Horst (both pictures)

103 Horst

104 Courtesy Lee Miller Archives

105 Horst (both pictures)

106 Pablo Picasso, *Seated Bather* (early 1930), oil on canvas, $64\frac{1}{4} \times 51''$. Collection, The Museum of Modern Art, New York. Mrs Simon Guggenheim Fund

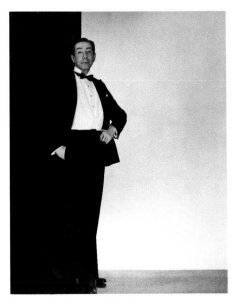

Baron de Meyer, 1932. A variant of plate 91

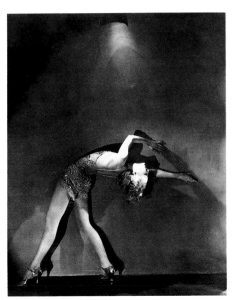

Jean Barry, 1931. A variant of plate 111

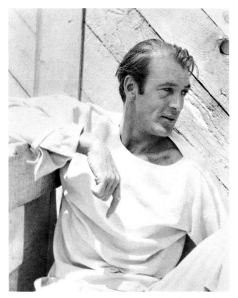

Gary Cooper, 1934. A variant of plate 126

107 Horst

109 Decoration from *Vogue*. Paris, 1934. Horst

Plates 48–67: Sunlight and sportswear

48 *Vogue* and *Vanity Fair*. London, 1931. "Here are some famous dancers who are entertaining New York this summer." Jean Barry was a celebrated cabaret performer. See also plate 111. Condé Nast

49 *Vogue*. Paris, 1928. Patou's "Vrai de vrai." "Here is the practical bathing suit in two pieces with burgundy red-wool jersey trousers; the sweater top is in white, navy, and burgundy jersey." Condé Nast

50 *Vogue*. Paris, 1928. Lanvin's "Lunaire." Condé Nast

51 *Vogue*. Paris, 1930. "Beach fashions fear neither sea nor sand." Women's swimwear: Molyneux (top), Patou (bottom left, modelled by Simone Demaria), Yrande (bottom right); men's costumes from Jantzen. "Very chic is the Jean Patou swimming suit of heavy black jersey, in the center of this lazy, sun-bathing group . . . The suit from Molyneux is of heavy beige tricot with encrusted bands of white jersey, in one piece, smart and practical for swimming." Photographed in the *Vogue* studio; a variant was chosen for publication (reproduced opposite). Horst

52 *Vogue*. Paris, 1930. "Coal black, with a narrow, braided white kid belt . . . with it goes a straight, short jersey jacket . . . Schiaparelli's white crepe rubber sandals are the correct footnote here." Condé Nast

53 *Vogue*. Paris, c. 1930. Horst

54 *Vogue*. Paris, 1931. "No. 800, along with crepe sandals . . . about the smartest thing on the seven seas. It fits as if you were poured into it." Horst

55 *Vogue*. Paris, 1933. The male model is probably Horst; the female model is unidentified. Horst

56 *Vogue*. Paris, c. 1930. Courtesy John C. Waddell, New York

57 The purpose of the photograph is unclear; Lee Miller was often used as a model by Huene at this period, but this is almost certainly not a fashion shot. Courtesy Lee Miller Archives

58 *Vogue*. Paris, 1931. Horst was frequently used by Huene as a model at this time; see also plates 55 and 66. Horst

59 *Vogue*. Paris, c. 1930. Horst

60 *Vogue*. Paris, 1929. Lelong's "Ondine" was captioned "Bare facts about fashion." Horst

61 *Vogue*. Paris, 1928. Chantal's "Les Jambes cachées," captioned "Pyjamas keep high and dry on the sands of fashion." Slippers from Ducerf-Scavini. See note on plate 62. Condé Nast

62 *Vogue*. Paris, 1928. "Striped bathing suits are small for diver's reasons." Plates 61 and 62 were published on adjoining pages and cropped as here. An uncropped reproduction of plate 62 may be seen in the exhibition catalog *Eye for Elegance: George Hoyningen-Huene*, p.8. Condé Nast

63 *Vogue*. Paris, 1934. Maggy Rouff's "Mireille." Condé Nast

64 *Vogue*. California, 1934. See also page 141. The image appeared in color on the cover of American *Vogue*'s 15 December 1934 issue. This monochrome print was probably made from the kodachrome negative. Condé Nast

65 *Vogue*. Photographed on the French Riviera, 1932. Horst

66 *Vogue*. Paris, 1930. "Izod contributes this two-piece swimming suit . . . with red-and-white top of machine-knit alpaca wool." The male model is Horst; the female model is unidentified. Condé Nast

67 *Harper's Bazaar*. New York, 1935. Horst

Chapter Five Fresh horizons

131 Courtesy Sotheby's, New York

133 Courtesy Yvonne Halsman, New York

134–135 Horst

137 Courtesy International Center of Photography, New York

138 Author's collection, New York

139 Copyright Max G. Scheler, Munich

140 Author's collection, New York

141 Condé Nast

142 Courtesy *Harper's Bazaar*, New York

143 Condé Nast

144 *Vogue* covers: Condé Nast; *Harper's Bazaar* covers: courtesy *Harper's Bazaar*, New York

145 Author's collection, New York

Chapter Six The good years

148 Horst

149 Courtesy George Hurrell, Los Angeles

150 Horst

151 Courtesy François Meyer, Paris

153 Decoration from *Vogue*. Paris, 1934. Horst

Plates 68–89: Travel and experiment

68 *Vogue*. Paris, 1934. Condé Nast
69 *Vogue*. Paris, 1931. Thérèse Dorny was a model. Horst
70 *Vogue*. Paris, 1934. Horst
71 *Vogue*. Paris, *c*. 1931. Horst
72 *Vogue*. Paris, 1933. See also plate 79. Horst
73 *Harper's Bazaar*. Paris, 1938. Horst
74 Horst
75 Horst
76 *Vogue*. Paris, 1929. "Swathed in the yellow and orange chiffon veils of Mohammedan women, the Comtesse Max de Pourtales, the Baronne Mallet, and the Baronne Jean de Nervo attended the costume ball given by Madame Jean Schneider and the Baronne de Guerre." Condé Nast
77 Published in *African Mirage*, 1938. Horst
78 *Harper's Bazaar*. New York, 1936. Jewels by Udall and Ballou. "The material is Bianchini's, and there's lots and lots of it . . . Charles Bock arranged the coiffure." Horst
79 *Vogue*. Paris, *c*. 1933. Fashion unidentified. Horst
80 Published in *African Mirage*, 1938. Horst
81 *Harper's Bazaar*. Paris, 1936. Horst
82 Published in *African Mirage*, 1938. The young man's feet are shown in the original print; this reproduction follows the cropping Huene chose for *African Mirage*. Horst
83 *Harper's Bazaar*. New York, *c*. 1935. Courtesy International Museum of Photography at George Eastman House, Rochester, New York
84 Published in *African Mirage*, 1938. Horst
85 *Vogue*. Paris, 1933. Fashion unidentified. Horst
86 Published in *African Mirage*, 1938. Horst
87 Published in *Egypt*, 1943. Horst
88 Taken for Condé Nast but unpublished. First published in *Photographie*, No 16, 1930.
89 *Vogue*. Paris, 1931. "Evening gloves are selling short." Lead illustration for "Here begins *Vogue*'s Portfolio for Limited Incomes." Horst

Chapter Seven "The master of us all"

178 Horst
179 Courtesy Louise Dahl-Wolfe and Staley-Wise Gallery, New York
180–181 (top) Copyright 1950 and 1953 by Richard Avedon, Inc. All rights reserved
181 (bottom) *Vogue*. New York, 1933. Condé Nast
182 *Harper's Bazaar*. New York, 1939. "On her small neat head is a crest of shiny black egrets, massed to suggest a Greek warrior's helmet . . ." Courtesy *Harper's Bazaar*, New York
183 *Right*: Courtesy Irving Penn, New York; *left*: *Harper's Bazaar*. New York, 1937. Horst
184 Courtesy Irving Penn, New York
185 *Harper's Bazaar*. New York, 1945. Courtesy *Harper's Bazaar*, New York
187 Decoration from *Vogue*. Paris, 1934. Horst

Plates 90–135: Friends and acquaintances

90 Paris, 1929. For other treatments of this famous society beauty of Circassian descent (whose husband, Aziz Eloui Bey, left her for Lee Miller), see plates 28 and 42. Horst
91 Paris, 1932. *Vogue* chose another shot from this sitting for publication (see page 241). Horst
92 The Marchesa was a flamboyant society figure in France and Italy before the war. Huene shows her reclining between two of her own sculptures. Horst
93 *Vanity Fair*. Photographed in Berlin, where he was starring in the comedy *Liselott*. Condé Nast
94 *Vogue*. Paris, 1930, the year in which Cocteau made *Le Sang d'un Poète*. Horst
95 Paris, *c*. 1930. Bousquet was a popular society hostess who attracted many artists to her Paris salon. Horst
96 *Vanity Fair*. Paris, 1927. Horst
97 *Vanity Fair*. Paris, 1934. Soulima, b. 1910, is Stravinsky's younger son. Horst
98 *Vogue*. Paris, 1930. Janet Flanner was the *New Yorker* Paris correspondent. Horst
99 *Vogue*. Paris, 1930. Condé Nast.
100 *Harper's Bazaar*. Paris, 1939. "Chanel poses for us in a black velvet dinner suit, after Watteau." The results of an earlier sitting by Chanel for Huene were published in the June 1931 issue of *Vanity Fair*. Horst
101 *Vanity Fair*. The Molitor Pool, Paris, 1930. When Huene took this photograph Weissmuller was known as a Olympic gold medallist swimmer; he did not begin playing Tarzan until 1932. Horst
102 Horst
103 *Vanity Fair*. Paris, 1930. The sculptor is photographed with his "circus." Condé Nast
104 Los Angeles, *c*. 1934. Capra was at the height of his career when Huene took this photograph: in 1934 he was awarded his first Oscar, for the direction of *It Happened One Night*. Horst
105 *Vogue*. Paris, 1932. The costumes and sets for the one-act ballet *Cotillon* were designed by Bérard; it was first produced on 21 April 1932 in Monte Carlo. Horst
106 *Vogue*. Paris, 1927. *La Chatte*, based on a fable by Aesop, caused a sensation for its Constructivist décor by Naum Gabo and Antoine Pevsner. The choreographer was Balanchine. Horst

107 *Vogue*. Paris, 1931. *Bacchus and Ariadne* was choreographed by Lifar himself; the décor was by de Chirico. Horst
108 *Vogue*. Paris, 1933. Zeilinger, a fashion illustrator for *Vogue* in the 1930s, applied white paint to the dress on the surface of the original print. Horst
109 The J. Paul Getty Museum, Los Angeles
110 *Vogue*. Paris, 1930. Horst
111 *Vogue* and *Vanity Fair*. London, 1931. See also the variant on page 241. Horst
112 *Vogue* and *Vanity Fair*. Paris, 1929. Huene photographed the American nightclub sensation on several occasions, but no prints appear to have survived for his most spectacular images of her in motion (see, for example, the July 1932 issue of American *Vogue*). Horst
113 *Vanity Fair*. Paris, 1927. "The French Music Hall Star Who is Soon to Make an American Debut . . . Chevalier married Yvonne Vallée (blissfully depicted above), who was an actress and later his stage partner in the revues . . ." Condé Nast
114 *Vogue*. Paris, 1933. Antoine, the famous coiffeur, is best known for his experiments with non-natural-colored hair-dyes, the introduction of shingled hair and the design of Greta Garbo's long bob. At the time Huene photographed him he was commuting between Paris and New York, where he ran a beauty establishment. Horst
115 *Vogue*. Paris, 1927. Koval was a popular Parisian cabaret performer. Horst
116 *Vanity Fair*. Paris, 1929. "The young orchestra leader has rapidly become the jazz idol of the current scene," commented *Vanity Fair* in the caption accompanying Huene's portrait of the celebrated saxophonist, crooner, and film star. Horst
117 *Vanity Fair*. Los Angeles, 1934. Lubitsch was photographed by Huene in the year he directed *The Merry Widow*. Horst
118 Paris, 1933. Lenya emigrated to the USA in 1935 with her husband Kurt Weill (see plate 124); after his death in 1950 she married Huene's friend the American writer George Davis. Horst
119 *Vogue*. London, 1930. Horst
120 *Vogue*. Paris, 1932. *L'Atlantide* was directed in two versions, French and German, by G.W. Pabst. Horst
121 *Vanity Fair*. Los Angeles, 1934. Cromwell played youthful leads and supporting parts in numerous films, most famously *The Lives of a Bengal Lancer* (1935). Horst
122 *Vanity Fair*. Burbank, California, 1934. Horst
123 *Vogue*. Paris, 1928. Horst
124 *Vogue*. Paris, 1933. Horst
125 *Harper's Bazaar*. New York, 1942. Mrs Palmer Thayer Beaudette was a socialite. Courtesy Otto Fenn
126 *Vanity Fair*. Los Angeles, 1934. See also

the variant on page 241. Courtesy John C. Waddell, New York
127 *Vogue*. St Moritz, 1932. Horst
128 *Vogue*. Paris, *c.* 1933. Courtesy Dominique Nabokoff, New York
129 *Harper's Bazaar*. London, 1937. Horst
130 *Harper's Bazaar*. London, 1937. Horst

131 *Vogue*. Paris, 1932. Courtesy Dominique Nabokoff, New York
132 *Vogue*. Paris, *c.* 1932. Courtesy Dominique Nabokoff, New York
133 *Vanity Fair*. Los Angeles, 1934. Condé Nast
134 *Vanity Fair*. Los Angeles, 1934. Horst

135 *Harper's Bazaar*. New York, 1945. Horst

240 *Left and center*: Horst; *right*: Condé Nast
241 *Left*: Condé Nast; *center*: Horst; *right*: courtesy Geoffrey Banks, New York

NOTES ON THE TEXT

Abbreviated references are to texts listed in the bibliography

Chapter One A gentleman's education
(pages 13–21)

1 Excerpted from various notes which appear with Huene's unpublished memoirs (written *c.* 1967). Both the notes and memoirs were partially edited by Dr Oreste Pucciani and remain in his possession. As the pagination is irregular and incomplete, specific locations cannot be given. The text is cited here as "Memoirs."
2 Memoirs
3 Lothrop, *The Court of Alexander III*, p. 159
4 Memoirs
5 "George Hoyningen–Huene, Photographer," completed under the auspices of the Oral History Program, University of California, Los Angeles, 1967, p. 2. Cited here as "Oral History."
6 Ibid., p. 1
7 Memoirs
8 Ibid.
9 Ibid.
10 Ibid.
11 Oral History, p. 2
12 Curator of Jewelry and a renowned scholar, highly thought of today by Hermitage staff.
13 Memoirs
14 Huene does not mention any Russian writers; given the golden age of Russian literature, it seems strange not to find Tolstoy or Dostoyevsky. If, for whatever reasons, the family had not encouraged a love of Russian literature, would not his governess or tutors have instilled an appreciation? Vladimir Nabokov's thoughts on the subject help clarify: for the nobility, the Russian writers were unpatriotic, as they exposed rends in the social fabric; as for the idealistic socialist tutors, the writers did not go far enough – their writings suggested universal, immutable human traits not to be done away with by any social order. In turn-of-the-century Russia, these now-recognized classics were anathema to right and left. This attitude was strengthened by a burning sense of inferiority to Western culture.

15 Memoirs
16 Ibid.
17 Vladimir Nabokov, *Lectures on Russian Literature*, Harcourt, Brace, Jovanovich, New York, and Routledge Kegan Paul, London, 1981, p. 5
18 Memoirs
19 The Baron's model farm houses would not be sufficient to protect him from the wrath of the peasants. This was consistent with the larger pattern, as Adam Ulam explains: "Often the peasants would appear at the landlord's residence and declare that while they did not have anything against them personally, they were going to take over their land one way or another. Outright violence, killing of the gentry, and burning of their residences was also rife." (Adam Ulam, *The Bolsheviks*, Collier Press, New York, 1968, p. 234.)
20 "One day news came that the Tsar has abdicated. A few months prior to that, friends of ours whom we knew very well had conspired to murder Rasputin, the disgrace of Russia, and by that save the monarchy. But it was too late. My father always criticized Prince [Felix] Yussupov and said that although it was a very good thing he did away with the charlatan monk, his action was in the tradition of the Borgias', to invite them and poison them." Oral History, p. 5
21 "The rioting and the fighting in the streets was decisive, but so was by now the firm hostility of the upper and middle classes, including many of the military commanders ... The news of the overthrow was greeted not only by a demonstration, but by nationalist elation. Now Russia could legitimately take her place in the rank of nations fighting for freedom." (Ulam, *op. cit.* in note 19, p. 318.)
22 Memoirs
23 Oral History, p. 7
24 Huene's "artist's record" at the Museum of Modern Art, New York, claims a matriculation from the University of St Andrews, Scotland. However, the university has no such record on file.
25 Oral History, p. 9
26 Diary in possession of the Estate of George Cukor, Los Angeles
27 Oral History, p. 11

Chapter Two A new life in Paris
(pages 23–40)
1 Memoirs
2 Ibid.
3 Ibid.
4 Oral History, pp. 12–13
5 Memoirs
6 Ibid.
7 Ibid.
8 Lawford, *Horst*, p. 34
9 He first worked for Arthur O'Neill.
10 Memoirs
11 Ibid.
12 Ibid.
13 Leo Lerman, "The Self Education of George Huene," in Pucciani, *Hoyningen-Huene*, p. 10
14 Memoirs
15 Lincoln Kirstein, "Pavel Tchelitchev, An Unfashionable Painter," in *SHOW*, March 1964, p. 22
16 Ibid.
17 A full account of Horst's early career and his relationship with Huene may be found in Lawford, *Horst*, pp 22–65.
18 In conversation with the author, 1982
19 Condé Nast Inc. has no record of such a film for *Vogue*, but it was reported at length in a feature in the magazine, 15 November 1933, pp. 44–47.
20 Bricktop (with James Haskins), *Bricktop*, Atheneum Press, New York, 1983, p. 158
21 Janet Flanner [Genêt], *Paris was Yesterday*, Viking Press, New York, 1972, p. xiii
22 At one point the two photographers jointly signed a photograph of a clothed mannequin; it is probable that one designed the mannequin while the other took the photograph. In the November 1929 issue of *Vogue*, Huene is credited with such a design: "These young ladies have been executed by Siegel and Stockmann in Paris in the manner of well-known *Vogue* types as drawn by *Vogue*'s collaborators – Baron Hoyningen-Huene, Jean d'Ahetze ..."
23 Hollander, *Seeing Through Clothes*, pp. 335–336
24 James Laver, *A Concise History of Costume and Fashion*, Thames and Hudson, London, 1982, p. 224
25 Roland Barthes, *The Fashion System*, Hill

and Wang, New York, 1983, pp. 8–9
26 Seebohm, *The Man Who Was Vogue*, p. 187
27 James Laver, *Women's Dress in the Jazz Age*, Hamish Hamilton, London, 1964, p. 16
28 "Lady Abdy on the Riviera," *Vogue*, 15 June 1932
29 Frenzel, *Hoyningen-Huene: Meisterbildnisse*, introduction
30 Memoirs
31 Elizabeth Ewing, *History of Twentieth Century Fashion*, B.T. Batsford, London, 1974, pp. 100–101
32 Memoirs

Chapter Three Foundations for a style
(pages 91–98)

1 See Hall-Duncan, *The History of Fashion Photography*, pp. 14–32
2 Philippe Jullian (ed. Robert Brandau), *de Meyer*, Alfred Knopf, New York, and Thames and Hudson, London, 1976, p. 26
3 Ibid., p. 161
4 Ibid., p. 14
5 Ibid., p. 40
6 Memoirs
7 Ibid.
8 Ibid.
9 Ibid.
10 Edward Steichen, "A Fashion Photographer," *Vogue*, 12 October 1929, p. 99
11 William Packer, *Fashion Drawing in Vogue*, Thames and Hudson, London, 1983, pp. 33–96
12 Memoirs
13 Ibid.
14 Ibid.

Chapter Four The elements of style
(pages 99–108)

1 K.–J. Sembach, *Into the Thirties: Style and Design 1927–1934*, Thames and Hudson, London, 1972 (published in the USA as *Style 1930*, Universe Books, New York, 1972), p. 13
2 Carolyn Hall, *The Thirties in Vogue*, Octopus, London, 1984, p. 15
3 Albert Renger-Patzsch, "Photography in Art," in *Das Lichtbild*, 1929
4 Memoirs
5 In conversation with the author, 1981
6 Seebohm, *The Man Who Was Vogue*, p. 204
7 Memoirs
8 Devlin, *Vogue Book of Fashion Photography*, p. 118
9 Memoirs
10 Quoted in Ian Jeffrey, *Photography, A Concise History*, Oxford University Press, New York and Toronto, and Thames and Hudson, London, 1981, p. 41
11 Memoirs
12 Quoted in Massimo Carrà, *Metaphysical Art*, Praeger, New York and Washington, and

Thames and Hudson, London, 1971, p. 21. In the photograph, the horizon line effectively divides the pictorial space into two parts, reinforcing the essential duality of the subject – sky, sea; male, female.
13 Here I follow primarily the formulation of Brunilde Sismondo Ridgway, *Fifth Century Styles in Greek Sculpture*, Princeton University Press, New Jersey, 1981, pp. 12–13
14 Hollander, *Seeing through Clothes*, p. xiii
15 Pucciani, *Hoyningen-Huene*, pp. 3–4

Chapter Five Fresh horizons
(pages 131–146)

1 In New York in 1929 he rented the studio of Charles Scheeler, the Precisionist painter and photographer.
2 Lawford, *Horst*, p. 97
3 Ibid., p. 112
4 Ibid., p. 112
5 Ibid., p. 89
6 Huene, *African Mirage*, preface
7 Ibid., p. 5
8 Ibid., p. 14
9 Ibid., p. 12
10 Ibid., p. 46
11 Ibid., preface
12 Ibid., p. 17
13 Ibid., pp. 66–67
14 Ibid., p. 57
15 Ibid., p. 110
16 André Gide, *Travels in the Congo*, Alfred A. Knopf, New York, 1929, pp. 11–14
17 Ibid., p. 268
18 Ibid., p. 16
19 Memoirs
20 He even managed to work his pro-Greek sympathies into a fashion assignment: he had a model pose against sacks of grain stored in the Relief Committee's warehouse, with brightly colored tags bearing its name clearly visible.
21 Oral History, p. 34
22 Huene, *Hellas*, p. 12
23 Ibid., p. 18
24 Ibid., p. 133
25 Richard Pare, *Photography and Architecture: 1839–1939*, Canadian Centre for Architecture, Callaway Editions, 1982, p. 240
26 Preface to Francis Frith, *Egypt, Sinai, and Jerusalem: A Series of Twenty Photographic Views*, William MacKenzie, London, n.d., quoted in Richard Pare, ibid., p. 17
27 Huene, *Mexican Heritage*, p. 9
28 Huene, *African Mirage*, p. 27

Chapter Six The good years
(pages 147–152)

1 Oral History, p. 41
2 Ibid., p. 37
3 Memoirs
4 Oral History, pp. 36–37

5 "The Fall and Rise of Star," in *The Times*, London, 7 December 1983, p. 12
6 Oral History, p. 20
7 Memoirs
8 Letter in possession of the Estate of George Cukor, Los Angeles
9 Lawford, *Horst*, p. 370

Chapter Seven "The master of us all"
(pages 177–186)

1 Surprisingly, Huene didn't plan to include any of his work from the Twenties, which indicates that he judged it undeveloped.
2 Hall-Duncan, *Fashion*, p. 64
3 Fernand Fonssagrives, in conversation with the author, recalled the pervasive influence of what were called "Huene's women" on the entire field.
4 September 1938, pp. 110–111
5 October 1938, pp. 104–105
6 "Black," *Vogue*, 1 November 1935, pp. 68–69. Reproduced in Hall-Duncan, *Fashion*, p. 52
7 On hearing in 1965 of Huene's decision to write his autobiography, Steichen wrote, "I will certainly look forward with great interest to your book with the rich experiences you have had in so many areas and facets of photography." (Letter to Huene, 8 January 1965, now in the collection of Dr Oreste Pucciani, Los Angeles.)
8 Louise Dahl-Wolfe, in conversation with the author
9 Louise Dahl-Wolfe, *A Photographer's Scrapbook*, St Martin's Press, New York, 1984, p. 2
10 Cecil Beaton, *Photobiography*, Odhams Press, London, 1951, p. 38
11 For a further analysis of Horst's style, see William A. Ewing, "A Linear Romance," in *Horst* (exhibition catalog), International Center of Photography, New York, 1984, pp. 3–6.
12 Memoirs
13 A fascinating example of a Huene photograph which prefigures Avedon can be seen in *Harper's Bazaar*, October 1941, pp. 92–3.
14 Devlin, *Vogue Book of Fashion Photography*, p. 137
15 Reproduced in Hall-Duncan, *Fashion*, p. 151
16 Quoted in Lawford, *Horst*, p. 112
17 Huene, *African Mirage*, p. 5
18 The harshest appraisal of his fashion work came from his one-time colleague Dr Agha: "It is a cross," he wrote, "between stagecraft, interior decoration, ballet, and society portrait painting done by camera." But this was an insider talking, one thoroughly familiar with behind-the-scenes machinations, and, one suspects, unforgiving of Huene's upstaging of him – and of *Vogue* – during the contract dispute of 1935.

BIBLIOGRAPHY

1 Exhibitions

(An asterisk indicates a one-man exhibition.)

"Premier Salon Indépendant de la Photographie," Salon de l'escalier, Paris, 1928

"Film und Foto der 20er Jahre," Stuttgart, 1929

U.S.A. Mission in Greece, 1950

Photokina, Germany, 1963

"Glamour Portraits," Museum of Modern Art, New York (traveling exhibition), 1965

"Huene and the Fashionable Image," Los Angeles County Museum of Art, Los Angeles, California, 1970*

1930s Portraits and Fashion Photographs, Sonnabend Gallery, New York, 1974

"Fashion Photography: Six Decades," Emily Lowe Gallery, Hofstra University, Hempstead, New York and Kornblee Gallery, New York (traveling exhibition), 1975

"Fashion 1900–1939," Victoria and Albert Museum, London, 1975

"History of Fashion Photography," International Museum of Photography, Rochester, New York, 1977

"Photographs by Hoyningen-Huene," Sonnabend Gallery, New York, 1977*

"France Between the Wars 1925–1940," Zabriskie Gallery, New York, 1979–80

"Fashion Photographers," Hastings Gallery, New York, 1980

"Masks, Mannequins and Dolls," Prakapas Gallery, New York, 1980

"Eye for Elegance: The Photography of George Hoyningen-Huene," International Center of Photography, New York, 1980; Musée Carnavalet, Paris, 1980; Art Museum of Long Beach, California, 1981; Walker Art Center, Minneapolis, Minnesota, 1981; The Photographers' Gallery, London, 1981*

Staley-Wise Gallery, New York, 1984*

The Chrysler Museum, Norfolk, Virginia, 1984*

2 Books by Huene

African Mirage, the Record of a Journey, Charles Scribner's Sons, New York, and B.T. Batsford Ltd, London, 1938

Egypt, J.J. Augustin Publishers, New York, 1943

Hellas, a Tribute to Classical Greece, J.J. Augustin Publishers, New York, 1943; second (revised) edition, 1944

Baalbek/Palmyra, J.J. Augustin Publishers, New York, 1946

Mexican Heritage, J.J. Augustin Publishers, New York, 1946

3 Short films produced and directed by Huene

(An asterisk indicates that no copies are known to exist.)

Amateur film with Serge Lifar, c. 1927*

Amateur film, subject unknown, 1932*

Fashion documentary produced for French Vogue, 1933*

Amateur film based loosely on Pabst's L'Atlantide, made with friends, c. 1933*

Daphni: Virgin of the Golden Laurels. Script by Aldous Huxley. Radim Films, Inc., 1951

Three color documentaries filmed in Spain, including The Garden of Hieronymus Bosch, n.d.*

4 Feature films for which Huene was Color Coordinator

A Star is Born, Warner Brothers, directed by George Cukor, 1954

The Adventures of Haji Baba, Allied Artists, directed by Don Weis, 1954

The Rains of Ranjipur, Twentieth-Century Fox, directed by Jean Negulesco, 1955

Bhowani Junction, MGM, directed by George Cukor, 1956

Les Girls, MGM, directed by George Cukor, 1957

Merry Andrew, MGM, directed by Michael Kidd, 1958

The Five Pennies, Paramount, directed by Melville Shavelson, 1959

A Breath of Scandal, Paramount, directed by Michael Curtiz, 1960

Heller in Pink Tights, Paramount, directed by George Cukor, 1960

It Started in Naples, Paramount, directed by Melville Shavelson, 1960

Let's Make Love, Twentieth-Century Fox, directed by George Cukor, 1960

The Chapman Report, Warner Brothers, directed by George Cukor, 1962

A New Kind of Love, Paramount, directed by Melville Shavelson, 1963

5 Major corporate and public collections containing one or more original prints by Huene

Library of the Fashion Institute of Technology, New York

The J. Paul Getty Museum, Los Angeles

Harvard Theatre Collection, Harvard University, Cambridge, Mass.

International Center of Photography, New York

International Museum of Photography, Rochester, New York

Metropolitan Museum of Art, New York

Museum of Fine Arts, Boston, Massachusetts

New Orleans Museum of Art, New Orleans, Louisiana

University of Southern California, Los Angeles, California

6 Unpublished biographical sources

George Hoyningen-Huene Photographer, completed under the auspices of the Oral History Program, University of California, Los Angeles, 1967

Memoirs, c. 1967, partially edited by Dr Oreste Pucciani and currently in his possession

7 Books pertaining to Huene and to fashion photography

Bailey, David, Shots of Style (exhibition catalog), Victoria and Albert Museum, London, 1985

Beaton, Cecil and Buckland, Gail, The Magic Image: The Genius of Photography from 1839 to the Present Day, Little Brown & Co, Boston, 1975

Brandau, Robert, ed., de Meyer. Introduction by Philippe Jullian. Alfred A. Knopf, New York, and Thames and Hudson, London, 1976

Chase, Edna Woolman and Chase, Ilka, Always in Vogue, Doubleday & Co., Garden City, New York, 1954

Devlin, Polly, Vogue Book of Fashion Photography 1919–1979, Simon & Schuster, New York, 1979, and Thames and Hudson, London, 1979

Ewing, William A., Eye for Elegance: George Hoyningen-Huene (exhibition catalog), International Center of Photography and Congreve Publishing Company, New York, 1980

Ewing, William A., and Hall-Duncan, Nancy, Horst (exhibition catalog), International Center of Photography, New York, 1984

Fashion 1900–1939, Victoria and Albert Museum, London, Idea Books International, London, 1975

Frenzel, H.K., Hoyningen-Huene: Meisterbildnisse, Verlag Dietrich Reimer, Berlin, 1932

Hall-Duncan, Nancy, The History of Fashion Photography, Alpine, New York, 1979

Hall-Duncan, Nancy, and Richardson, Diana Edkins, eds., Fashion. Introduction by Alexander Liberman. Gallery of World Photography, Shueisha Publishing Company, Tokyo, 1983

Hollander, Anne, Seeing Through Clothes, Viking Press, New York, 1978

Horst, Horst P., *Salute to the Thirties*. Foreword by Janet Flanner. The Viking Press, New York, 1971

Lambert, Eleanor, *World of Fashion*, R.R. Bowker Co., New York, 1976

Lawford, Valentine, *Horst: His Work and His World*, Knopf, New York, 1984, and Viking, London, 1984

Lothrop, Elmira, *The Court of Alexander III, Letters of Mrs Elmira Lothrop, wife of the late Honorable George Van Ness Lothrop, former Minister Plenipotentiary and Envoy Extraordinary of the United States to Russia*. Edited by William Prall. The John C. Winston Company, Philadelphia, 1910

Penrose, Antony, *The Lives of Lee Miller*, Holt, Rinehart and Winston, New York, 1985, and Thames and Hudson, London, 1985

Pucciani, Oreste, ed., *Hoyningen-Huene* (exhibition catalog), University of Southern California Press, Los Angeles, 1970

Seebohm, Caroline, *The Man who was Vogue: the Life and Times of Condé Nast*, Viking Press, New York, 1982

Snow, Carmel and Aswell, Mary, *The World of Carmel Snow*, McGraw-Hill Book Co., New York, 1962

Steichen, Edward, *A Life in Photography*, Doubleday & Co, New York, 1963

Trahey, Jane, *Harper's Bazaar: 100 Years of the American Female*, Random House, New York, 1967

8 Articles and reviews pertaining to Huene and to fashion photography

"Background to Fashion: Surrealism in Fashion Advertising," *Art & Industry* 32, February 1942, pp. 45–47

Deal, Joe, "Horst on Fashion Photography," *Image* 18, September 1975, pp. 1–11

"Documentation of Glamour: Fashion Photography," *The Arts Chronicle*, October 1980, p. 5

Edkins, Diana, "George Hoyningen-Huene's View: a spare world filled with riches," *Vogue*, November 1980

Edwards, Owen, "Blow-Out: The Decline and Fall of the Fashion Photographer," *New York Magazine*, 28 May 1973, pp. 49–56

Edwards, Owen, "The Elegant Hoyningen-Huene," *Saturday Review*, October 1980

Everard, J., "Advertising to Women by Photography," *Communication Arts* 17, July 1934, pp. 1–7

Ewing, William A., "The Munkacsi Movement," *Spontaneity and Style – Munkacsi*, International Center of Photography, New York, 1978

Goldberg, Vicki, "George Hoyningen-Huene," *American Photographer*, October 1980, pp. 78–86

"Hoyningen-Huene: Carnavalet: l'age flamboyant de la photo de monde," *Photo*, French edition No. 158, November 1980

Malcolm, Janet, "Photography: Men without Props," *The New Yorker*, 22 September 1975, pp. 112–121

Maloney, Tom, "Hoyningen-Huene," *U.S. Camera Annual 1950*

Marks, Robert W., "They Chose Photography – By Accident," *Minicam LX*, June 1941, pp. 34–39

Martin, Richard, "George Hoyningen-Huene," *Arts Magazine*, December 1980, p. 6

Muchnic, Suzanne, "Elegant Side of a Photo Era," *Los Angeles Times*, 9 February 1981

Osman, Colin, "Martin Munkacsi/1896–1963," *Spontaneity and Style – Munkacsi*, International Center of Photography, New York, 1978

Thornton, Gene, "The Trend Is a Backward Look," *New York Times*, Sunday, 5 October, 1980

INDEX